W9-CFU-563

Early
American
Folk Pottery

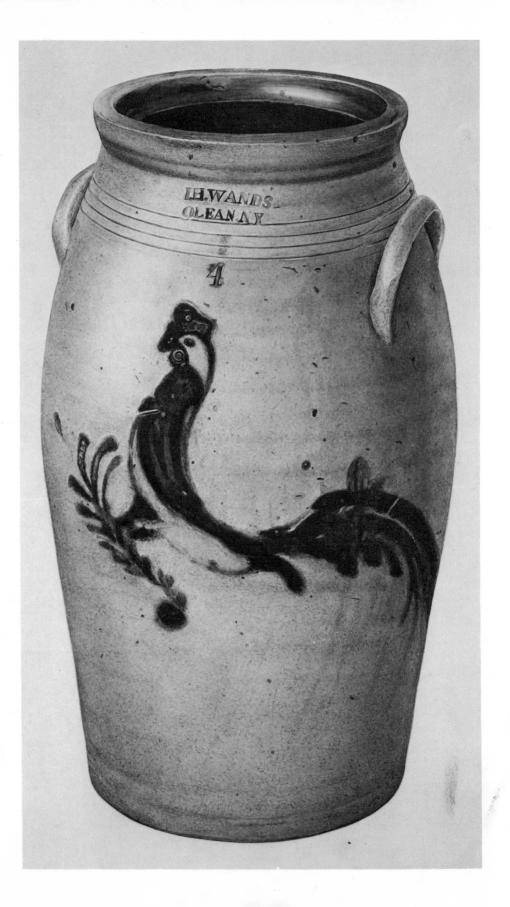

Early American Folk Pottery

Harold F. Guilland

CHILTON BOOK COMPANY
Philadelphia New York London

Copyright © 1971 by Harold Guilland
First Edition
All rights reserved

Published in Philadelphia by Chilton Book Company
and simultaneously in Ontario, Canada,
by Thomas Nelson & Sons, Ltd.

ISBN 0-8019-5436-3

Library of Congress Catalog Card Number 70-159513
Designed by Cypher Associates, Inc.
Manufactured in the United States of America

Early American Pottery and China by John Spargo. © 1926 by John Spargo. By permission of Hawthorn Books, Inc.

American Potters and Pottery by John Ramsay. © 1947 by John Ramsay. By permission of Tudor Publishing Company.

"The Pottery Business in Sterling, Mass." by Edwin Coolidge from *Old Time New England.* © 1932 by Edwin H. Coolidge. By permission of The Society for the Preservation of New England Antiquities, Inc.

Early New England Potters and Their Wares by Lura Woodside Watkins. © 1950 by Lura Woodside Watkins. By permission of Harvard University Press.

Colonial Craftsmen by Carl Bridenbaugh. © 1950 by Carl Bridenbaugh. By permission of New York University Press.

From *History of Manufacturers in the United States* by Victor Selden Clark. © 1929 by Victor Selden Clark. Used with permission of McGraw-Hill Book Company.

"Ceramics in the South" by Arthur W. Clement, "Toy Banks" by Willard Emerson Keyes, "Nathan Clark, Potter" by Janet R. MacFarlane and "Toby Jugs" by Edward Wenham. By permission of *The Magazine ANTIQUES*, 551 Fifth Avenue, New York, N. Y. 10017.

"William H. Bloor" from "Communications in Ceramic History" in the *American Ceramic Society Bulletin.* © 1937 by The American Ceramic Society, Inc. By permission of The American Ceramic Society, Inc.

Note: Renderings denoted by asterisk were selected by
Bernard Leach, Shoji Hamada and Soetsu Yanagi
from the Index of American Design in 1952 for a slide show
to illustrate fine examples of American folk pottery.

To Linda

550

Contents

Preface

There are several reasons for writing this book. The foremost is that I hope to arouse an interest among contemporary studio potters in the designs of early American folk pottery. Very few present-day potters working in the United States are aware of the tremendous design heritage left to them by early traditional craftsmen. One of the major reasons for this is the lack of information which would be of interest to them, particularly books with pictures showing the immense variety of wares made by early American folk potters. I hope that this volume will provide a new source of design, as well as an impetus, to American potters working in the traditional vein.

I also found in my research that few collectors or antique dealers knew very much about the function of a particular piece of American folk pottery. Because of this, I included a great deal of descriptive information about how each type of pot was used in the various processes of food preparation and preservation and the particular part that it played. For example, the milk pan was used for storing milk as the name implies. Milk pans were also used in the process of making

cheese, cottage cheese and butter. In making butter, the cream rose on the milk and was skimmed from the pan into a cream pot for storage, or immediately into the churn. The butter, after being removed from the churn, was thoroughly worked in a butter bowl and was then packed in a butter crock for household use or for shipping to market.

This information not only relates the milk pan to the cream pot, churn, butter bowl and butter crock in the process of food preparation used by pioneer Americans, but also adds a great deal of interest to the piece on the collector's shelf. I hope that collectors, antique dealers and students of Americana will find the book a useful reference manual to identify and explain the use of pieces of early American folk pottery that come into their hands.

Finally, I hope that this book will in some small way inspire cultural and local historians to do more research on the lives and work of our early country potters before the sources of information are completely lost.

The introductory text to the plates is a very general view of the folk-pottery tradition as a whole in this country. In actuality there were hundreds of traditions, each one needing intense research and recording.

I am at best a good potter and a layman historian. My main desire was to show how important the early folk potters' wares were to the culture and economy of preindustrial America. I realize that broad generalizations about the past may not give the exact picture, but until all the pieces are gathered, it will be impossible to have a full understanding of the traditions of early American folk pottery.

I would like to express my thanks to the following people for their help in preparing my manuscript. I extend my appreciation to Dr. Grose Evans, Curator, and his assistant Lina A. Steele, Index of American Design, National Gallery of Art; to C. Malcolm Watkins, Curator, and staff, Division of Cultural History, Smithsonian Institution; to Stanwyn G. Shetler and Dr. Richard L. Zusi, Smithsonian Institution; to J. Paul Hudson, Museum Curator, and staff, Colonial National History Park, Jamestown, Virginia; to Helen H. Edwards, Historian, Agriculture History Branch, United States Department of Agriculture Library; to Evelyn Fitz, Reference Librarian, Library of Congress; and to Paul M. Fink, Local Historian, Jonesboro, Tennessee, for helping me obtain pictures and information.

For helping me with the labor of typing and research, my thanks to

Laurie Glassman, Nancy Anderson, Pam Brooke, Marcia Freeman and Pam DeGaines.

My hearty thanks to Joe Vitek for patiently rendering many fine drawings and maps and for the long and fruitful discussions on design. My thanks also to Roland Freeman for his help and advice on photography.

My thanks to Martin Amt, Freer Gallery of Art, and Lee Magdanz, The Kiln Room, Bristol, Virginia, for arranging a field trip to meet Willie Cole, a ninety-five-year-old potter from Galax, Virginia, and visits to local kiln sites and collections.

Last, but by no means the least of my gratitude, I extend to John F. Marion and Elizabeth Powers, my editors of Chilton Book Company, for their patience and help in bringing this project to completion.

Harold Guilland
Washington, D.C.

The Index
of American Design

The Index of American Design was organized in 1935 by the national staff of the Works Progress Administration's Federal Art Project as a nationwide activity to record pictorially the designs of primitive, folk and popular art of America. The Index, along with other programs, was established by the Federal Art Project to provide employment and maintain the skills of thousands of artists referred to local WPA agencies throughout the country.

Objects to be rendered were first screened by the state research supervisor for authenticity and historical significance before they were assigned to an artist. Most of the objects were rendered using the transparent watercolor technique, but no one method was used exclusively. The emphasis of the Federal Art Project was on quality rather than on medium or technique. Holger Cahill, one of the directors of the Project relates that: "What was insisted upon was strict objectivity, accurate drawing, clarity of construction, exact proportions, and faithful rendering of material, color and texture so that each Index drawing might stand as surrogate for the object."

A data sheet with all the pertinent information about the object was pasted on the back of the finished rendering before it was sent to Washington. The National Index Office in Washington checked on the quality of work done by state projects, coordinated research and worked out new techniques.

The objects chosen for rendering were mostly regional: local crafts of historical significance which had not been thoroughly studied and were in danger of being lost. The area of research and recording was limited to material culture of America stemming from people of European origins, from colonial times to the end of the nineteenth century.

The subjects studied and recorded were classified under the following broad categories: agricultural equipment, architectural decoration, arms and armor, costume, decoration and ornament, fire extinction, fireplace equipment, furnishings, furniture, hardware, household equipment, implements, jewelry, landscape gardening, lighting devices, luggage, mechanical devices, musical instruments, religious articles, saddlery, sewing equipment, ship's decoration and equipment, shoemaker's equipment, smoking equipment, spinning equipment, tableware, textiles, toys, vehicles, and writing materials. These collections include more than 750 types of objects made from bone, clay, cloth, glass, leather, paper, stone and wood.

The compiling of the Index of American Design continued under the Federal Art Project for four years, until 1939, when the program was turned over to the administration of each of the participating states. By 1941, thirty-five states were involved. They employed a yearly average of three hundred artists throughout the country from 1935 until the beginning of World War II. By the end of the Federal period of sponsorship a total of seventeen thousand renderings had been sent to the National Gallery of Art in Washington to be preserved.

This collection is the largest of its kind in the world and is of great value to contemporary craftsmen, designers, collectors, historians and students of Americana. Most of the renderings are works of art in themselves, which is a tribute to the many unacclaimed artists who worked on the project. An excellent preview of the collection is presented in Erwin O. Christinsen's book, *The Index of American Design*, published in 1950.

H. F. G.

Early
American
Folk Pottery

Introduction

The tradition of American folk pottery grew from designs and styles brought to this country from England and Europe. There was little, if any, conscious effort on the part of early potters in the development of this new tradition. It evolved through a series of changes as the necessities of the environment forced the early colonial potter to be inventive and original. The adaptation of local clays and the lack of glazing materials, the scarcity of both skilled and unskilled labor, the great need for storage containers and cooking pots, the lack of time and the hardships of making a living in the New World all contributed to the development of new pottery techniques and designs.

Later in the eighteenth and nineteenth centuries further innovations in style came about because of changes in social habits and economic conditions. The adoption of new foods and drinks and the subsequent changes in methods of food preparation and preservation led to specific alterations in design. The combined effects of democracy and a rapidly expanding economy after the Revolution hastened the breakdown in the apprentice system which, along with the appearance of itinerant potters, gave rise to a greater exchange of ideas among potting groups. Increased knowledge of local materials and the discovery of new techniques at the beginning of the industrial era gave potters greater flexibility in forms and decorations. The changes in design caused by these later developments were not as radical as the

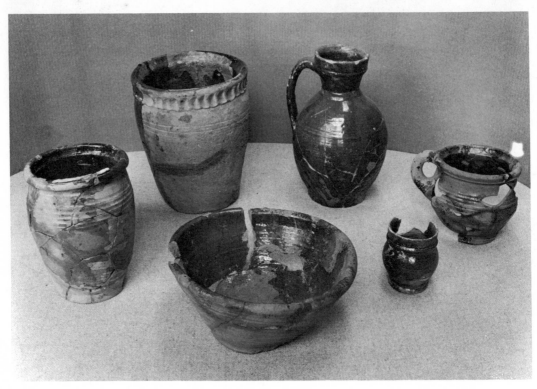

Fig. 1. Lead-glazed earthenware made at Jamestown, Virginia, about 1640. (Courtesy of United States Park Service.)

limitations placed on the early colonial potters by their environment, but they did emphasize and reinforce the trends in style and design which had already begun.

The first colonial potters were trained in the European tradition and many of them doubtlessly knew how to make the highly decorated wares which were being produced in Europe at the time. These immigrant potters, however, lacked a sufficient amount of lead, tin and other glazing materials to produce such elaborate ware. Thus, the early potters were forced to change their decorative style. They continued to make traditional European forms for some time but, slowly, most of these basic forms were also altered as the potters and colonists generally adapted to their new environment.

As in all early traditional crafts, the closely guarded secrets of the potters' trade were passed on from father to son, master to apprentice, by word of mouth and example. Decorative processes and forming techniques no longer used because of the lack of time or materials were omitted from the apprentice's training. Consequently, the old or European way was lost to the succeeding generations. Later, when materials became more available and time was not so pressing, colonial

2

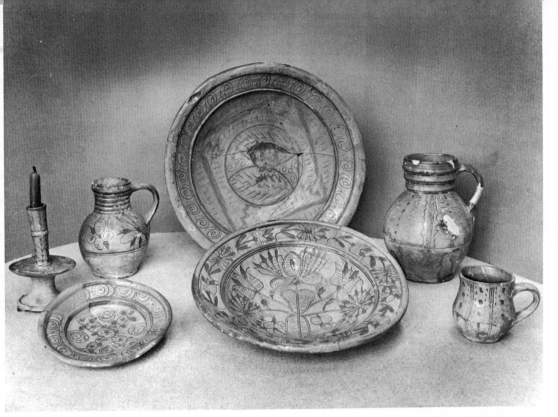

Fig. 2. Imported English sgraffito ware unearthed at Jamestown, Virginia, *ca.* 1640. (Courtesy of United States Park Service.)

potters slowly began to develop and expand their decorative styles. These new decorative motifs and processes continued to be developed throughout the eighteenth and nineteenth centuries.

Until new forming and glazing techniques were developed in the early industrial period almost all pottery made in America was folk pottery. Folk potters for the most part were highly skilled, traditionally trained craftsmen, largely unconscious of the artistic possibilities of their media. Tradition dictated simple methods, materials and designs. Their wares were made for the common man to use and were always directed toward satisfying a particular need or function.

American folk pottery can be divided roughly into two periods and traditions: earthenware and stoneware. The earthenware tradition began about 1640 and dominated American pottery production until the end of the colonial period in 1781. The first stoneware potteries began in the early 1700's and the tradition continued until 1880. Stoneware replaced earthenware after the Revolution because of the demand for sturdier vessels and popular opposition to the use of toxic lead glazes. The folk traditions declined with the expansion of industry over a period of several decades in the mid-1800's.

3

Some stoneware and earthenware potteries continued to operate in "out-of-the-way" places into the twentieth century. Even today a few old potteries continue making ware in the folk tradition.

To understand how American folk pottery grew from its origins in Europe into a separate and distinct tradition requires an examination of the environment and conditions under which the early potters lived and worked.

The Colonial Environment

The first colonies in America were established as business enterprises to supply raw materials to the mother countries and to provide markets for manufactured products. Both England and Holland, in efforts to keep their colonies economically dependent, applied strong restrictions on trade and colonial manufacturing. Craftsmen were not encouraged and trade was allowed to exist only on a small scale. Nevertheless, as settlements grew, craftsmen in all the trades began to produce wares to meet the needs of their local communities.

As the colonies thrived, people in the Old World began to view America as the land of opportunity. Settlers came seeking land, economic opportunity and freedom from the religious and political institutions of Europe. Even though the early colonists came from various national groups with widely different customs, language and economic skills, they had many things in common in the New World.

Life was a struggle which made hard work necessary for survival. Misfortune and death were accepted as God's will and a part of life. Epidemics, famine and attacks from hostile Indians were common.

5

Most settlers were poor and had to work long hours, six days a week and often on Sunday, to eke out an existence. Large families provided an increased labor force. Children began helping their parents at an early age; chores were assigned according to age, ability and sex. Girls helped the older women care for the garden, barnyard stock and poultry, as well as preparing, preserving and cooking food, caring for the house and younger children, nursing the sick, making clothing, spinning, weaving, baking, brewing and churning. Younger boys helped the women while the older boys assisted the men in clearing land, erecting fences and buildings, plowing, cultivating, harvesting, threshing, grinding, shearing the sheep, gathering firewood, butchering, smoking meat, making maple sugar, hunting and fishing, blacksmithing, coopering, cabinetmaking, shoemaking, tanning, harness making, and in caring for work animals. Although life was hard, it was possible to get ahead, to own land and better one's lot, if not for oneself, for one's children.

Most settlers were dependent on the land and subsisted on what they grew. Villagers were generally less self-sufficient but shared the values and beliefs of the farmers. Villagers made a living by keeping a shop, working at a trade or craft, or were simply common laborers. "Among the poorer colonists, who composed nine-tenths of the colonial population, life was a humdrum round of activities on the farm and in the shop." [1]

The colonial social structure was divided roughly into three classes: at the top the gentry or "better sort," which was composed of the rich merchant and planter, the well-educated ministers, doctors and lawyers; the "middling sort" included landowning farmers and shopkeepers; poor people, indentured servants and slaves made up the lowest class or "meaner sort." The saving grace of this early class system was the existence of social mobility through readily available free land which endowed the owner with status as well as means of making a living. After a period of indenture it was possible even for a bondsman to become a highly respected and relatively successful man.

The whole colonial period was a time of instability but the settlers in America lived in relative comfort compared to European standards. Building material for housing was within reach in the surrounding forests; clothing was at first imported, but was later homemade, and food was usually plentiful.

The first settlers lived on wild game, fish and seafood, and various indigenous fruits and vegetables which they learned how to cultivate

from friendly Indians. One of the main problems throughout the colonial period was the preservation of food for use in winter and at other times of shortage. Techniques of food preservation were essentially the same as those which had been used in Europe for generations. Salt, vinegar, sugar, woodsmoke and spices were the principal agents used to prevent spoilage.

During the warmer summer months perishables were kept in the buttery or springhouse, well box or icehouse. Fresh fruits and vegetables for winter use were stored in root cellars which were made by tunneling into nearby hillsides. The thick walls of the cellar insulated the food from extreme changes in temperature, keeping it cool in summer and dry and protected against freezing in the winter. The cellar walls were lined with bins for apples, potatoes, cabbage, turnips and carrots. The vegetables were packed in straw to separate them and to stop the spread of spoilage as well as to provide added insulation. The cellar was also used to store barrels and crocks of salted meat and fish, and dried and pickled fruits and vegetables.

In the house dry storage was used to preserve rye, wheat, corn, beans, nuts and other seeds. Sugar preserves, jams, and jellies were stored on cupboard shelves. Bundles of dried herbs, onions and corn hung from the rafters. Dry storage worked well for preserving solid fruits, vegetables and seeds, but meat presented the colonists with a difficult problem.

Large stock was usually butchered in the winter so that fresh meat would keep as long as possible. The remainder was salted, smoked, pickled in brine or "jerked" in Indian fashion.

Meat and corn were the basic foods throughout the colonial period. Meat was cooked in a stew or roasted over an open fire on a spit. Corn was served in season as roasting ears, hominy, pone and various breads. Leavened bread was also made from wheat and rye.

In most areas cabbage was the favorite garden vegetable. Apples provided fresh fruit, applesauce, apple butter, vinegar and hard and soft cider. Dairy products such as milk, cream, butter, buttermilk, cottage cheese and cheese were found in most colonial households by the early part of the eighteenth century.

The list of colonial foods is extensive but the common man, especially on the frontiers, subsisted primarily on a simple diet of bread and meat. Early settlers had no knowledge of nutrition or the value of cleanliness in food preparation. Until well into the nineteenth century all food was thought to have the same nutritive value. Settlers had no

idea why milk soured, why butter turned rancid, why bread molded, why fruits and vegetables rotted or meat decayed. Practical knowledge led them to protect food from only the obvious types of spoilage, such as that caused by animals, insects, weather and fire.

The preserving agents available to the colonists worked well enough to preserve some foods for winter use but there were many disadvantages in the early preservatives. Some foods "kept fairly well smoked, salted, or pickled, though these methods of preservation had such strong flavors in themselves that they could be used only on certain foods with which their flavors blended." [2] Salt caused a disagreeable harshness in flavor and hardened meat fibers. Meat had to be soaked in water before cooking to remove the salt, thus robbing the meat of much of its nutritional value. Vinegar could be used only to preserve a limited number of foods. It changed the flavor considerably and completely destroyed the food value. Sugar was imported and expensive, and this prohibited its extensive use in preserves. Honey was often substituted or used in combination with sugar. In either case, the natural fruit flavors were reduced. And, finally, drying and smoking shriveled meat fibers and altered natural flavors and aromas. Little improvement in methods of food preservation was made until Nicholas Appert, a Frenchman, developed a method of canning meat and vegetables in corked bottles in 1810. Although food preservation methods were primitive, the colonists generally had plenty to eat and housing conditions improved rapidly after the first years of settlement.

Houses of the first settlers in the colonies were hastily built structures with one room which served in turn as living room, bedroom and kitchen. A small fireplace at one end of the dwelling provided both cooking facilities and heat. This type of temporary shelter was used by the first settlers in all the colonies and later by the pioneers inhabiting the rapidly expanding western frontiers throughout the eighteenth and nineteenth centuries.

The later colonial and early nineteenth century kitchens centered around a large fireplace which took up most of one wall. Cooking was done in large iron pots hung over the flames in the fireplace, or in smaller pots placed directly in the coals. Bread and biscuits were baked in cast iron Dutch ovens with recessed lids which were covered with coals, or in sheet metal reflecting ovens placed in front of the fireplace.

In New England, as more permanent homes were erected, fireplaces sometimes had a bake oven or ash oven built in beside the main firebox. Ash ovens were filled with hot coals and allowed to heat for

several hours to bring them to baking temperature. When the oven had reached the proper temperature the ashes were removed and the oven was swept clean. The bake goods were then placed directly on the hot oven floor. Ash ovens and bake ovens were used in the middle colonies and in the South, but were usually built under separate cover, out of doors, and a little way from the house. Summer kitchens under separate roofs were sometimes used in the northern colonies in hot weather. In the South, kitchens in outbuildings were used year round. This separation lessened the danger of fire to the main house and kept it cooler and free from cooking odors and flies. Some New Jersey and Pennsylvania settlers dug basements which were used for kitchens in the warmer months. These basement kitchens often had running water from springs under the house to insure a supply of drinking water in case of Indian attack. Regardless of where the kitchen was located, the fireplace continued to be used for cooking until the iron cookstove came into common use about 1830.

The first settlements were widely scattered. Political organization developed slowly. The church provided the strongest governing power in many communities, especially in New England.

The New England colonies were settled by English Puritans and Congregationalists who at first discouraged the immigration of settlers of different faiths and ethnic origins. They built small communities along the seacoast, near good ports and along the larger rivers. The soil was hilly and rock strewn. Most New England farms were too small to grow substantial cash crops, so the settlers depended on subsistence farming or turned to the woods or sea to make a living.

Ultimately the economy of New England came to be based on shipbuilding and sea trade. The New England merchant became famous for his far-flung fleets and for a shrewd eye for business.

People living in the smaller towns and villages of New England were absorbed in extracting a living from their small farms. "The average New England county household was a sort of self-sustaining unit which depended little on the world beyond its own gates." [3]

Unlike New England, the middle colonies of New York, New Jersey, Pennsylvania and Delaware welcomed settlers of all faiths and national origins. The mild climate and fertile soil of the Hudson, Mohawk and Delaware Valleys allowed settlers to grow wheat, corn, and to raise livestock for market. Most small farmers did not own the land outright but were tenants who paid a "quitrent" to the absentee landlord for use of the land.

The Dutch settled in New Amsterdam in 1624 and eventually

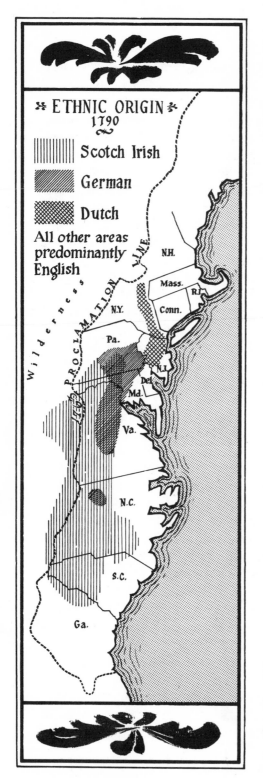

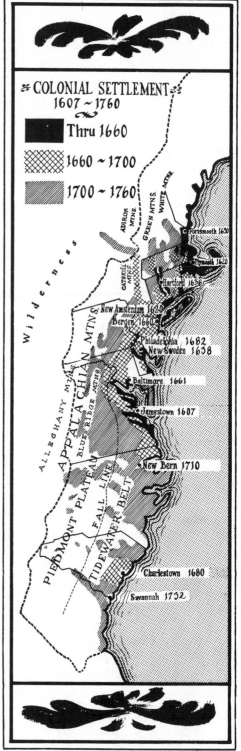

spread over parts of Long Island, New Jersey and the Hudson River Valley. They were primarily interested in trapping and fur trade, and had little interest in farming. Social and political rights were limited in New Netherland by the oligarchic nature of the Dutch colonial government. Consequently, few immigrants came before the English took control of the colony in 1664. The cosmopolitan nature of New York was already established by this time. ". . . No fewer than eighteen languages were being spoken around New Amsterdam before the English came to power." [4]

Although New York had a better harbor, Philadelphia became the commercial center of the New World. English Quakers settled in the Delaware River valley and later their influence spread over most of New Jersey, Delaware and Pennsylvania. The Quakers were peaceful settlers who made friends with the Indians and respected their treaties. The Quakers' "tolerant, optimistic and humanitarian doctrines . . ." appealed to immigrants from the lower classes of Europe and even among some of the nobility. William Penn gained control of Pennsylvania and established the city of Philadelphia in 1682. Under Penn's guidance and liberal policies, Pennsylvania grew rapidly and became the colonial leader in educational and scientific activities.

The southern colonies, with the exception of Georgia, were settled by the English, in the seventeenth century. The wide rivers allowed easy access to the Tidewater plains as far as the fall line, and by 1700 hundreds of plantations flourished in the area. The fertile soil, warm climate and abundant rainfall were ideal for the cultivation of tobacco in Virginia and Maryland, and of rice and indigo further south in the Carolinas and Georgia. The demand for labor to cultivate these cash crops opened the South to anyone who wished to settle there and eventually led to the importation of Negro slaves.

There were many small landowners and tenant farmers in addition to the large plantation owner in the South. With the exception of the coast, there were few villages or towns of any consequence. The larger plantations were small, self-sufficient villages in themselves. Like the rich merchant of the North, the large plantation owner had expensive mansions furnished with fine imported furniture, silver and china. The common man in the South, as in all the colonies, was not able to afford such luxury. Some ". . . owned china, delft ware and furniture of plain wood, with perhaps a few silver spoons, a porringer, and an occasional mahogany chair and table; still others, and

FIG. 3. Ethnic distribution in settlements by 1790, and areas of colonial settlement, 1607–1760. (Drawing by Joe Vitek.)

these by far the largest number, used only pewter, earthenware and wooden dishes, with the simple essentials [of a] spinning wheel, flat irons, pots and kettles, lamps and candlesticks, but no luxuries." [5]

The fifty years between 1710 and 1760 was the period of greatest stability in the colonies and the period of mass immigration from Europe. Before this time the colonies were predominately English except for the Dutch in New York and a small settlement of Finns and Swedes in Delaware. Small numbers of Protestant French Huguenots fleeing from repression in France settled in New England in the late 1600's. A few Portuguese Jews also immigrated to New England by way of Brazil and the West Indies, and, like the Huguenots, settled in the larger coastal cities. By 1700 the colonies were populated by 220,000 people, a figure which doubled every twenty years until immigration was suspended at the outbreak of the Revolution.

The largest number of new settlers were the German farmers from the Palatinate area along the Rhine and Rhone Rivers and the Scots from North Ireland. The Germans settled in the eastern counties of Pennsylvania. Many were of mystical faiths such as the Moravians, Mennonites, Schwenkfelders and Dunkards. They were simple, peaceful people with rigid economies and social structures. The Germans took little part in politics and were primarily involved in farming. They added substantially to the prosperity of the new country.

The Scotch-Irish settled the western part of Pennsylvania and drifted southwest along the eastern slopes of the Appalachian Mountains into Virginia and the Carolinas. They were restless people who sought the independence and free land of the back country. They contributed to the pioneer spirit which led to the westward expansion of the frontiers. The Scotch-Irish expressed strong political views and ignored the earlier treaty right of the Indians in their persistent hunger for new land.

Like the Scotch-Irish, the Germans moved west when the opportunity arose. They usually waited until the Scotch-Irish had driven the Indians out and had cleared some of the land before moving into the new areas. Villages grew spontaneously at mill sites, trail crossings and ferries. The back country settlements were often isolated communities with a separate agricultural and industrial life of their own.

Other smaller groups of Europeans settled in the colonies. Among the German settlers were small groups of Swiss Mennonites. Huguenots, Jews and Celtic Highlanders established themselves in older coastal trading towns. The Jews excelled in trade and commerce and

the Huguenots and Highlanders often became influential planters and merchants. A few Danes settled in New Hampshire; Irish and Welsh Quakers migrated to Pennsylvania. Small settlements of Austrians, Germans and Greeks were established in Georgia and a few Irish and Italian settlers were scattered throughout the colonies.

In 1763 a "Proclamation Line" divided the colonies and Indian territory on the western frontier. By this time colonial discontent with British rule had grown. Grievances concerning trading rights and taxation were especially widespread. The Stamp Act of 1765 incited the first major confrontation between colony and mother country and finally led to revolution.

Living conditions for the common man gradually improved throughout the colonial period, but ways of doing things and means of making a living essentially remained the same. A few advances in technology were made such as the use of the water wheel for mill power, but intercolonial transportation and communication were still primitive until the early 1800's.

The Earthenware Tradition

The lack of written records makes it impossible to establish precisely when pottery making first began in the colonies. There is little documentary evidence before the early part of the eighteenth century. The first mention of a potter in America is that of Philip Drinker who arrived at Charlestown, Massachusetts, in 1635. Two other potters, William Vincent and John Pride, arrived in New England in the same year and settled at Salem.

Another clue as to when pottery production began in an area is provided by records of the establishment of brickyards. In most cases earthenware began to be produced about the same time as brickmaking. Brickyards and potteries often were run by the same men.

The best source of information lies in the pottery sites themselves. Excavations at the pottery site at Jamestown, Virginia, unearthed pieces of earthenware made between 1625 and 1650. The first ware made at this site was unglazed and, like all earthenware, was quite porous and easily broken. By 1640 many pieces were being lead glazed, at least on the inside. The ware made at this early pottery in

Jamestown included storage jars, jugs, pitchers, bowls, cups, mugs, porringers and milk pans. Although pottery was produced at Jamestown, most of the pottery used there was imported from Europe.

Even though few records exist before 1700, it is possible to imagine what the potter's life must have been like in the early colonies. The basic materials for making pottery were available in all areas of settlement. Earthenware clay and wood for fuel were abundant throughout the colonies.

No doubt life for the early potter, as for all the settlers, was one of hardship, involving long hours of daily work just to survive. In most cases the potter turned to farming as his first endeavor and later, when his needs for food and shelter were assured, began making pottery as a secondary occupation. The potters were often "jacks-of-all-trades" and could do many things to supplement their incomes. The potter usually settled on a piece of land which would supply him with both clay and wood for fuel. Hopefully, it would be situated near a harbor or along a navigable river which provided the main trade routes of the day.

The potter worked at his craft in season along with farming. In the fall, when the ground was dry, he dug, prepared and stored clay for later use. In the winter he chopped wood and peddled his wares, which

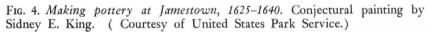

FIG. 4. *Making pottery at Jamestown, 1625–1640.* Conjectural painting by Sidney E. King. (Courtesy of United States Park Service.)

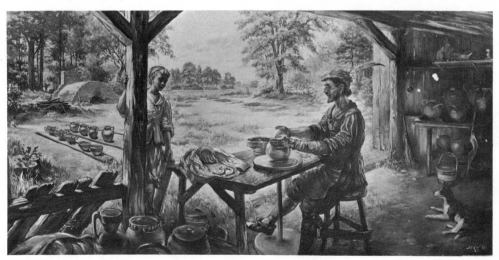

had been made the previous season. In the spring and summer, when farming allowed, he "turned" and fired his ware. These early potters for the most part worked alone; occasionally they were assisted by their wives and older children who helped with glazing and stacking the kiln. Additional labor was sometimes hired to help with the heavier tasks of digging clay and chopping wood. Labor was exchanged or paid for with pottery or other trade goods.

The potter's workshop was usually a small shed near the house or attached to the back of the barn. In the shelter of the workshop the potter worked at his wheel, placing the newly formed ware on long boards which, when filled, were shelved on pegs protruding from the walls and allowed to dry. An assortment of tubs, sieves, jars or powdered galena and simple forming tools were also found in the workshop.

Water was drawn from the household well or from a nearby stream or spring. In one early method of clay preparation there were two pits located outside the workshop. Freshly dug clay was first placed in a shallow "bunging pit," covered with water and thoroughly mixed with a wooden spade. This preliminary mixing of the clay and water into a "slurry" served two purposes: it brought the mass of clay to a uniform consistency and it allowed rocks and pebbles to sink to the bottom of the pit. The slurry was then dipped from the bunging pit and strained through a horsehair sieve into the second adjacent pit which was called a "sun kiln."

The bottom of the second pit was covered to a depth of three or four inches and the clay was allowed to dry into working consistency. Then another layer was added on top of the first and, as each layer dried, another was added until the pit was filled with workable clay. Finally the clay was cut into blocks and stored in the potter's shed or cellar.

Kilns were placed a short distance from the shop and other out-buildings to provide fire protection against flying wood sparks. The kiln used at Jamestown was of rectangular form and similar to the English New Castle type. It was a simple design with a longitudinal arch ten to twelve feet long, built of brick. At the front of the kiln was a 2-foot opening which served as the fire mouth and door. At the far end there was a short stack which created the draft. The floor was made of tamped earth and brick. Pots were stacked "open" on a raised platform in back of the firebox in direct contact with the flame. The kiln was fired for the day with wood from the nearby forest.

16

Wood for firing was cut in 4-foot lengths and stored in "ricks" near the kiln to dry.

Earthenware made by the early potters was extremely simple. The ware was strictly utilitarian and limited to a few basic shapes, all of which were formed on the "frame" or wheel. Until the early 1700's, decoration was restricted to simple finger impressions, or straight and wavy lines made with pointed sticks. Most of these decorations were executed at the end of the forming process on the wheel. Pure lead glazes were common and were applied by "leading" or sifting powdered galena over the surface of the pot. This type of application only gave the pot a very thin coating of glaze, but it was sufficient to make the pot watertight and easy to clean. Later, liquid glazes in which the pots were dipped were made by combining a large percentage of raw lead in the form of galena, litharge or red lead, usually imported from England, and fine white sand and water. Clay or loam was sometimes added to the lead and sand to give the glaze body and color. Because of the shortage of materials, however, most vessels were glazed on the interior only.

Like most American folk pottery, this early earthenware was "once fired," eliminating the time and effort required to do a preliminary bisque firing, which is common practice by today's potters. The pots were formed, set aside to dry, and then glazed and fired. The application of glazes presented a major problem with "once fired" ware. If the glaze materials were mixed with water, there was a chance that the "green" pots—which were extremely fragile—would be broken while dipping them in the glaze, or would crack from being rewetted. Consequently "leading" was an ideal method of glaze application for "once fired" earthenware. The resulting glazes were not so attractive and not so durable as later colored glazes, which were mixed with water, but when time and real necessity for cooking and storage pots were primary considerations, this method of glazing was adequate. The dry glazes were transparent and did enhance the red, yellow and brown colors of the clay body.

Although the early potters worked only part time, they were able to produce more than they could sell to the local community. In the winter, when farm chores were light, the potter would load a small boat with his unsold wares and peddle them in nearby villages along the coast.

Money was generally scarce in the colonies. Barter was the means of exchange and in many areas pottery was considered a kind of cur-

rency. Potters took butter, eggs, corn, meat, whiskey, cloth, hides, scrap metals and other trade goods in exchange for their wares.

Labor of any kind was scarce and expensive. When colonial potters wanted to expand their operations they often had trouble finding sufficient labor. The problem was partly solved by the continuation of the indenture system in the colonies which was common in Europe. In this way the potter obtained the necessary labor and passed on the "arts and mysteries" of the trade to his indentured servants.

The indentured apprentice, usually a boy about the age of fourteen, was bonded to the potter for a period of seven years or until he became twenty-one years old. The apprentice was given clothing and lodging and usually was taught to read and write.

These young apprentices worked long, hard hours and had little time for education. During the seven years of apprenticeship the young potter was thoroughly taught the methods and materials of the trade which were requisite to good craftsmanship.

The "master potter" passed on to his apprentice all the knowledge he had acquired about clay, throwing, mixing and applying glazes, stacking and firing kilns and how to make all the necessary hand tools and shop equipment used in the trade. Along with the technical information, the apprentice was also instilled with his "master's" attitude toward his craft.

Good craftsmen had a healthy respect for work and the thoroughness which went along with completing a task. Although uneducated in principles of design, early potters had an instinct for good form and decoration. The potter's high standards and personal integrity instilled in him pride in his ware and his craftsmanship.

Some apprentices had neither the inclination nor the discipline for the hard work necessary to learn the potter's craft. Some were mistreated and ran away. Colonial newspapers often carried advertisements with rewards of a penny for the return of a runaway apprentice. Many potter's apprentices, on the other hand, were related to the master potter or were sons of family friends and were treated very well.

On the completion of his term the young potter worked for wages as a journeyman until he had saved enough money to set up and become the master of his own shop. Wages for journeymen potters, like those of unskilled labor, were usually paid in trade goods unless otherwise agreed upon. Sometimes a young potter took a piece of land in return for a period of work; otherwise he was paid a few shillings

This Indenture witnesseth

THAT _____

_____ *apprentice to*

_____ *in the county of* _____

and bound after the manner of an apprentice with him, to serve and abide the full space and term of _____ _____ *thence next following, to be full, complete and ended; during which time the said apprentice his said master faithfully shall serve, his lawful secrets shall keep, and commands shall gladly do, damage unto his said master he shall not do, nor see to be done of others, but to the best of his power shall give timely notice thereof to his said master. Fornication he shall not commit, nor contract matrimony within the said time. The goods of his said master, he shall not spend or lend. He shall not play cards, or dice, or any other unlawful game, whereby his said master may have damage in his own goods, or others, taverns, he shall not haunt, nor from his master's business absent himself by day or by night, but in all things shall behave himself as a faithful apprentice ought to do. And the said master his said apprentice shall teach and instruct, or cause to be taught and instructed in the art and mystery as* _____ *finding unto his said apprentice during the said time meat, drink, washing, lodging, and apparel, fitting an apprentice, teaching him to read, and allowing him three months towards the latter end of his time to go to school to write, and also double apparel at end of said time. As witness our hands and seals, interchangeably put to two instruments of the same purpose* _____

Fig. 5. Indenture contract, including the usual terms of agreement during the colonial period. (Conjectural drawing by Joe Vitek.)

a week plus room and board. He often continued in the shop where he had been indentured and sometimes he married into his employer's family.

Potters as a whole were as educated as their fellow colonists and were generally respected members of the community. Frequently they held responsible positions in the church and local government. Apprentices entered the trade from all walks of life, but usually potters were from the midde class.

There were stores in all the settlements where imported products could be purchased and locally made goods could be traded. By 1680 many of these stores carried earthenware and stoneware, most of which was imported. People usually preferred imported ware to the simply made local potter's product and, until the latter part of the eighteenth century, there was a general feeling that European ware and craftsmanship were superior to those of the colonies. Store owners sometimes requested potters not to mark their pieces so that they could be sold as imported ware which was more readily disposed of and which brought higher prices. Misleading advertisements about merchandise were common in colonial times. "False weight, under-sized casks, and misrepresented goods constantly plagued buyers and officials." [6] Misrepresentation was probably not the main reason that most pottery made during the colonial period was unmarked. Lack of time and the early folk potter's attitude toward his craft were probably more responsible.

The folk potter's craft was a humble one. His materials were gathered from the earth and his ware was peddled from door to door. He was not favored by the patronage of the wealthy as other crafts were. This general attitude probably also accounts for much of the failure of the early chroniclers to record the establishment of potteries.

In the homes of the wealthy merchants and planters the use of "commonpots" was limited to the kitchen, pantry, buttery and cellar. For the front rooms, the rich purchased silver and glass (usually imported from Europe), porcelain from China, sgraffito, slip, and delft wares from England, and highly decorated maiolica from Spain and Italy. Folk pottery made for serving food and table settings was used by the middle and lower classes who could not afford the standards of taste set by the wealthy.

The colonial housewife may have desired some of the luxuries of the rich, but generally she was content to use the simple craft objects made by a member of the community. Most early settlers were from

peasant stock and were simple people with practical tastes. They built their own houses, made their own furniture and clothing, grew their own food, and created most of the household objects.

Although of simple taste, these people were certainly not unaware of the beauty of line, form and decoration. Everything they made to use, inside or out, harmonized with nature. Pioneer design dictated by need was practical, functional, and reserved to the point of austerity. American folk pottery designs reflected these community attitudes, beliefs and styles. Pottery, like the other household objects in colonial America, was made in response to a need and its mood and attitude were in harmony with the surroundings. The quality of the ware depended on the materials available and the skill of the craftsman. Fine silver, glass and porcelain gave status to the table and were therefore desirable. But these luxuries would have been abstractions in relation to the common man's other household furnishings.

Wood turners and pewter makers were the potter's main competitors. Woodenware was less expensive than both pottery and pewter, and consequently was extensively used by the economically minded common man in the colonies. Pewter was more expensive than either wood or pottery and was desired because it resembled silver and added grace and status to the kitchen and table. Pottery was likewise a symbol of growing prosperity and was also desirable because it added color to the collection of humble household items.

Pottery also met some particular functions for which pewter and wood were unsuitable. When hot drinks and foods became popular in the eighteenth century, pottery cups and mugs, and serving vessels were used extensively because they conducted less heat than pewter. Pottery was also suitable for cooking vessels and small preserve and storage jars. Pottery was easier to clean than woodenware but was, of course, more breakable.

A great deal of woodenware and pewter, more durable than pottery, has survived until today, and has given the impression that wood and pewter were the only items used on the table and in the kitchen. "The myth of the colonists having nothing but wood and pewter for tableware must be discounted. The wood and pewter have survived; the redware, except for shards in potters' dumps, has not. Its cheapness and fragility contributed to its disappearance from the household effects that were so carefully handed on from one generation to another. Today there are to be found only occasional, rare pieces from the eighteenth century and, except in fragmentary form, virtually

none from earlier pioneer days. In fact, redware of any period is so little known that many persons have never become conscious of its existence. Neither the potters nor their wares hold a position in history commensurate with their one-time importance." [7]

Although there were some potters among the first settlers, the largest numbers came to this country during the mass immigration of the eighteenth century. Like all immigrants coming to America, potters tended to settle in communities where the people had similar ethnic backgrounds, religion and cultural traditions. However, because any given community could support only a limited number of potters the geographic distribution of potters of the same origin was somewhat more haphazard than that of other settlers. In any case there was often a strong guild feeling among potters working in the same locale; their children often married into the family of another potter, further solidifying the potters settled in a particular area into a group. These potting groups, established within proximity of each other in the same hollow, river valley or mountain ridge, shared the same materials and used the same equipment and techniques. Consequently, they made very similar wares. When one of the potters in the group made an improvement in his ware or techniques, the innovation soon spread to all the potters working in the group. Over a period of time this resulted in the evolution of a local style peculiar to that area.

Potters working in the larger coastal cities were often very competitive, occasionally to the point of stealing another potter's whole working crew by offering higher wages. Even though the amenable guild-feeling of the country potting groups did not exist among the more competitive potters on the coast, the evolution of local styles developed in the cities also.

Immigrant potters sometimes went to work in shops which were already operating full time, but usually just long enough to save money to open up a small shop in a nearby community or to push on west. The actual cost of setting up a pottery was small because materials for building equipment and the basic materials to produce the craft product were the same: wood and clay. The potter's main problem was to accumulate enough money to buy land or rent a shop and still have enough money to live on until he could market his first ware. Not many of the early settlers were willing to work for other people when they could work and succeed on their own.

Craftsmen's wages in the colonies varied considerably but were generally higher than those paid in England and Europe because of

the scarcity of labor. Trade goods were usually taken in lieu of currency for payment of wages throughout the colonial period. British sterling was used to figure accounts, but Spanish silver dollars and pieces of eight were the coins most commonly used in transactions involving hard cash.

Victor S. Clark, in his *History of Manufactures in the United States,* compares wages and prices of commodities in the colonies between 1629 and 1775 to the time when he wrote the book in 1929. Clark indicates that colonial wage statistics are sometimes misleading because wages were often set for a particular task rather than as a standard daily pay scale: ". . . figures indicate that skilled artisans following a single trade earned from 60 cents to $1.25 a day, the normal wage apparently rising during the eighteenth century." [8] According to Clark, this amount was about one-fourth higher than the wages paid to craftsmen working in towns of comparable size in England. Wages also varied between summer and winter because the length of the working day (which was from sunup until sundown) depended on the season.

"As the purchasing power of money of the same nominal value has varied widely at different ages, the following miscellaneous data will afford some basis for a comparison of colonial conditions in this respect with those of the present [1929]. A Salem grocery bill, dated 1629, contains such items as: loaf sugar, 30 to 35 cents a pound; pepper, 45 cents a pound; nutmegs, 10 cents an ounce; starch, 10 cents a pound; Castile soap, 15 cents a pound; almonds, 30 cents a pound; salad oil, $1.40 a gallon; candles, 12 cents a pound; rice, 8 cents a pound; butter, 10 to 15 cents a pound; vinegar, 45 cents a gallon; cheese, 12 to 15 cents a pound. In 1775, at the other extreme of the colonial period, in the same town, loaf sugar was 14 cents a pound; cheese, 5.5 cents a pound; butter, 11 cents a pound; molasses, 20 cents a gallon; chocolate, 17 cents a pound; candles, 10 cents a pound; beef and mutton, 4 to 5 cents a pound; rye or Indian meal, 62 cents a bushel. Board in the country cost about a dollar a week; and in 1748, in Philadelphia, the board of two gentlemen, including lodging and three meals a day, but not fuel, was about $2.60 a week. Without attempting more than a very loose estimate, we may conclude that during most of the colonial period wages were about one-fifth of their present rate and that their purchasing power, in relation to the standard of living, was fully five times what it would be at present." [9]

The earliest full-time shops were quite small, sometimes employing

only one other man. They were often quite premature and of short duration. Lack of sufficient supply of materials, the limited and costly transportation facilities, the expense of skilled labor, and the size of the local market all conspired against their success.

The main problem of the ambitious potter who wanted to expand his operation was labor. Most journeymen who were willing to work for other people before the Revolution, were either incompetent or of bad character. They were quite often drunkards and perpetual drifters who never worried about their jobs because of the severe shortage of labor.

In the larger towns and settlements, the transition of potters from part-time work to full-time production came early. These potteries had a greater chance of survival than those distant from the rapidly expanding city markets and port facilities. Potteries in the larger towns also failed but often for different reasons. They were occasionally set up by speculators who hoped for a good return on their money. If these profits were not immediately forthcoming, the investors were quick to sell their shares and invest elsewhere. As the frontiers expanded and were permanently settled, potters moved west looking for land and new opportunities. On the frontier small potteries evolved in much the same manner as those of the first colonial settlements. The potter usually divided his time between farming and working at his craft until the settlement and trade routes developed enough to absorb his full-time production. Decoration reverted to a more primitive style because of the lack of glazing materials, skilled labor, and time. Materials shipped inland from the coast were very expensive because of the high cost of transportation throughout the eighteenth and early part of the nineteenth century. This added expenditure, however, had advantages as well as disadvantages, for the potters working in the back country. Freight costs substantially increased the price of material brought in from the coast, but it also acted as a protective tariff against surplus output from the full-time shops on the coast and imported wares from Europe.

Unlike the potteries established as business enterprises, the small country shops operated by traditional craftsmen were sometimes run by the same family for generations. These small potteries were owned and operated by the master craftsmen who had complete control of the shop. They sought to meet the needs of the community by producing well-constructed, pleasing ware and, at the same time, strove to make an adequate living. Production was geared to actual demand,

which limited the number of journeymen and apprentices who could be employed. Workmen and apprentices usually lived with the potter and his family. As head of the household, the master potter was often called upon to settle disputes among his workmen. Along with these domestic responsibilities the master potter was his own technician, production manager, purchasing agent, salesman and bill collector. He sold retail from his shop to the local community and wholesale to stores, overland traders, rivermen and peddlers. Clay was dug on his property or purchased by the wagonload from a nearby clay pit. By 1750 glazing materials such as powdered galena or lead, white pipe clay for slips and coloring oxides were generally available, although expensive.

Before lead was readily available, potters oxidized "tea lead," from the linings of tea chests, and scrap lead in order to get their basic glazing ingredient. This was a troublesome and time-consuming process. Thus, imported "soft" or red lead was preferred, even though it was relatively more expensive.

Iron oxide could be obtained locally from the blacksmith in the form of "anvil dust" which collected about the base of the anvil stand. Yellow ochre and umber were also natural slips containing large amounts of iron oxide and could be dug in many areas. Iron produced shades of reds and browns in lead glazes and slips.

Manganese oxide which gave a wide range of brown and black tones was inexpensive and generally available in refined form. Manganese was probably the oxide most commonly used to color glazes throughout the earthenware tradition. Two other oxides were used in the production of earthenware, but mainly for decorative purposes: copper oxide for green, and yellow from imported antimony. Copper was expensive in any form. Potters often took old copper and brass utensils in trade for ware and oxidized them in the kiln.

The variety of decorative effects obtained by early American folk potters is amazing, considering their limited number of oxides and decorative techniques. The predominant colors were earthen shades of brown from light to tan to deep chocolate and black. However, the restriction in their methods and materials may have been a blessing, just as it was to the potters of ancient China, who produced some of the finest pottery known to man. The lack of glazing materials and techniques limited the potters to a narrow range of decoration; at the same time this limitation pushed the potters to the peak of their creative ability.

The principal areas of earthenware production in the colonies were New England and the eastern counties of Pennsylvania. In New England most of the earthenware production was carried on in Connecticut, Massachusetts and the coastal towns of New Hampshire. Earthenware production in Maine—which was settled at a comparatively late date—developed slowly, but operation continued there well into the nineteenth century. The production of both earthenware and stoneware was very limited in Rhode Island. As potters moved west into Vermont in the late 1700's, earthenware began to be produced there but was soon displaced by a steadily developing stoneware industry.

In Pennsylvania, earthenware production was carried on by potters of German origins who settled first in Germantown and in the vicinity of Philadelphia. As land became scarce around Philadelphia, settlement followed in Montgomery, Lancaster, and Berks counties. Later German settlers crossed the Susquehanna River into York, Cumberland, Northampton, Dauphin, Lehigh, and Lebanon counties until the whole area east of the Appalachian Mountains was filled. By the latter part of the eighteenth century, the Pennsylvania-German earthenware tradition spread over parts of Maryland and Western Virginia as the potters moved south into the newly opened western frontier near Fort Cumberland and the Shenandoah Valley. Earthenware similar to that made by the Pennsylvania German potters was also made in the German settlement at Wachovia [Salem], North Carolina.

Little earthenware was made in the South. The plantation culture of the Tidewater Belt developed few home industries or small manufacturers before the Revolution because of the extensive cotton and tobacco trade with England. Potters producing inexpensive earthenware items costing only a few cents each, would have found it extremely difficult to compete against the abundance of cheap imports coming in from England. The return from a quick cash crop in itself was enough to lure most craftsmen from their trade. Also the lack of skilled labor, a negligible apprentice system, the scarcity of towns and markets, long credit terms and slow payment of debits, the low cost of wages for Negro artisans, plus the negative attitude of southern settlers towards colonial craft products made it almost impossible for a craftsman to make a living at his trade.

In the southern highlands or back country, which was separated from the coast both culturally and economically, just the opposite

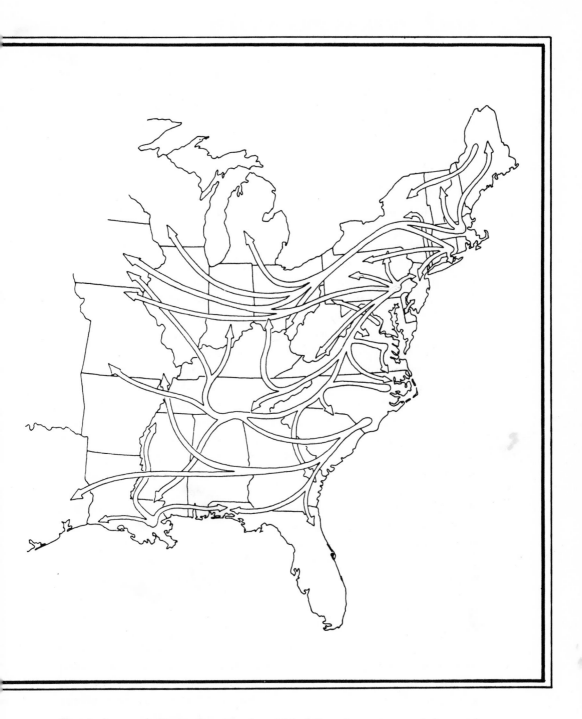

Fig. 6. Arrows indicate directions in which folk culture was carried out of source areas by diffusion and migration. (Courtesy of University of Pennsylvania.)

27

situation for the craftsmen prevailed. The potters there could not produce enough ware to meet the needs of the settlers. The following excerpt from the Moravian Church Diary at Bethabara, North Carolina, in 1761, is indicative of the situation: "June 15. People gathered from 50 and 60 miles away to buy pottery, but many came in vain as the supply was exhausted by noon." [10]

The Moravian Church diaries indicate that the demand for pottery in the North Carolina frontier increased as the years went by until 1778, when pottery sales were discontinued to outsiders because of the crowds the sales drew.

Folk potters categorized their wares by the color of the fired clay body. Earthenware was thus advertised and sold under that name. Redware was the most common but yellowware, brownware and whiteware were also made. Earthenware produced in the more commercial nineteeth century potteries was sold under names derived from the color of the glaze, name or location of the pottery, the method of forming as well as the body color.

Standard production items made by earthenware potters before the Revolution varied a great deal. Most potters' output included the following: milk pans, pudding pans, bread pans, bowls, pitchers, mugs, lard pots, bean pots, chamber pots, butter crocks, jars and jugs. A few of the more skilled potters made complete lines of thin glazed redware for the table, which included plates, platters, beakers, cups, mugs, pitchers, bowls, and even tea sets as well as the more standard production items. Potters also took special orders for items usually not included in their regular production.

Decorative techniques developed slowly until the mid-1700's. Most pottery by that time was glazed inside and out with either a transparent or colored lead glaze. In New England potters continued to use the straight and wavy line banding which had been common in the seventeenth century. Some potters daubed or brushed coloring oxides on their ware which blended with the glaze and flowed down the side of the pots adding complementary shading to the glazes. Simple patterns applied with a slip cup (Page 287) and covered with a clear lead glaze were also a common decorative process used in New England potteries. This type of "painted ware," as it was known in the trade, was very common in Connecticut. (Page 143) Decorative bands applied with a coggle wheel (Page 135) were used by potters both in New England and Pennsylvania. Coggle wheels were small, round, wooden or clay rollers on which a con-

tinuous pattern was engraved. The wheel was held in place by an axle between a forked handle which allowed the wheel to turn against the pot leaving the pattern impressed in the leather-hard clay. The decoration on ware made by New England potters was relatively simple and restrained in comparison to that of the Pennsylvania German potters.

German potters who settled in Pennsylvania after 1730 were able to carry on their pottery traditions much the same as they had in Europe. No doubt the potters that had immigrated prior to this time had been restricted in their decorative techniques because of the lack of materials, but generally wares produced in the Pennsylvania-German tradition did not go through the same kind of radical change and evolutionary development as wares produced by English potters immigrating to the colonies in the seventeenth century. Red earthenware clay was abundant in Pennsylvania, lead for glazes and pipe clay for slip were readily available in Philadelphia and the need for pottery and labor was not as pressing as it had been at the time of the earlier settlements.

The New World environment did, however, cause some changes in the German potter's traditions. German settlers remained aloof and avoided changes in their native culture. One of the few areas of assimilation and readily accepted cultural change was in the culinary arts. Fruit, which was very scarce in Europe and could only be afforded by the wealthy, was abundant in the colonies. Fruit pies and tarts, originally made by English colonists, were soon a favorite dessert on the German immigrant's table. The German potter began to produce pie plates similar to those made by English potters.

It has been mistakenly assumed that these pie plates were a completely new shape originated by the Pennsylvania-German potters in the eighteenth century. However, Bernard Racham and Herbert Read's book, *English Pottery*, written in 1924, shows several examples of plates which had been made in England during the seventeenth century that are identical in form to Pennsylvania-German pie plates.

The covered bean pot (Page 199) was also made by some German potters. These pie plates and bean pots indicate that changes in eating habits of German settlers in the New World resulted in the introduction of new forms to the German potter's tradition. The Pennsylvania-German potter's decorative style, however, remained the same as it had been in Europe, although occasionally new motifs appeared

which were derived from the colonial environment (Page 269).

Some would argue that the Pennsylvania-German potter's tradition could never be classified as American, but was simply a continuation of the German folk tradition in the New World environment. It is true that the German potter's tradition was the least affected by assimilation but, like all traditions, it was a growing thing and was continually being affected and changed by the environment. When a German potter living in America put a traditional German decoration which had originated in England on a pie-plate form, in what tradition was he working?

German potters immigrating to America, like most potters, turned to farming to make a living and made pottery on the side. But unlike potters of other origins, the Germans were more traditional than ambitious and usually continued to farm as well as make pottery long after the demand for their wares would have allowed them full-time work at their craft. The first types of decorated ware that the Pennsylvania-German potters made here were plain sgraffito or "scratched ware" (Page 267) as it was called, and simple slip-decorated ware (Page 264). Both of these early decorative processes were monochrome, executed in white slip which was covered with a clear lead glaze. When coloring oxides became more available, polychrome sgraffito, and slip ware (Page 223), usually made for household ornaments or presentation pieces, appeared. Occasionally an engobe of colored slip was the only decoration applied to redware before glazing (Page 92).

Earthenware made by Swiss potters was similar in form and decorative style to the ware made by potters of German origin, but occasionally they made some elaborately modeled pieces which were peculiar to their own tradition (Page 279). The Swiss were as fond of brightly decorated slip ware as the Germans and no doubt the forms and decorative styles of both their central European traditions had the same cultural origins.

German potters belonging to various religious sects also developed traditions reflecting their earlier European training, their communally oriented societies, and their New World environment. By 1756 Gottfield Aust, working at the Moravian settlement at Bethabara, North Carolina, was making well-designed earthenware shapes which were usually undecorated and covered with a plain black glaze (Page 196). About 1810, potters working in the Harmony Society pottery at Economy, Pennsylvania, made both undecorated storage vessels

and some ware decorated with simple bands of colored slip (Page 207). In contrast to the Harmonists' societies, which depended on trade with the surrounding communities for survival, the German Pietists of Zoar, Ohio, followed a strict, monastic life and avoided the outside world. Solomon Purdy established the Zoar Pottery about 1817, and made common redware which was usually glazed on the interior only. Occasionally, pieces were covered with a light coating of yellow or buff slip before glazing or were decorated with simple, incised lines.

Several other religious societies operated potteries which produced earthenware in the eighteenth and nineteenth centuries: the Swiss Mennonites at Ephrata, Pennsylvania; the Shaker Community at Pleasant Hill, Kentucky; the Mormons at Nauvoo, Illinois, and the monastic communities at Bishop Hills, Illinois and Amana, Iowa. The wares produced by potters living in these religious communities directly reflected the values of the societies' culture. Their pottery was extremely simple in design, formed directly, lacked superfluous ornamentation, was rarely marked and, above all, functioned well. Most of the potteries made earthenware at first and later developed stoneware and other commercial wares as they became more established.

As materials and markets were becoming increasingly available to colonial craftsmen in the mid-1700's, potteries in England were speedily industrializing. By 1740 the larger commercial potteries in England had begun to employ a division of labor with the introduction of the factory system. Laborers and craftsmen became specialists in one area of work which resulted in increased efficiency and output of the pottery. New materials, forming processes and types of ware were continually being discovered and developed. John Saddler discovered a method of decorating ware with printed patterns in 1752. About this time, too, Ralph Daniel of Colbridge returned from a visit to a porcelain factory in France which used plaster of paris molds to make slip-cast ware. Slip casting required only semiskilled labor which was readily available in England. This new forming process and the industrial genius of such men as Josiah Wedgwood soon revolutionized the pottery industry in England.

Wedgwood set up his first shop at Burslen about 1760. Unlike the traditional folk potter, he was very conscious of the artistic possibility of clay and soon developed several new types of ware. He improved the old "cream colored" ware, which was a white earthenware covered with a cream colored lead glaze, with such success that many

31

competitors stopped producing it altogether. Wedgwood later changed the name of his "cream colored" ware to "Queensware" in honor of Queen Charlotte. Wedgwood was not only a creative potter and designer, but also a shrewd businessman and a farsighted industrialist. He set up warehouses in London to sell his wares directly to the public, helped promote a canal system to reduce the cost of transportation and the percentage of broken ware going to market. Wedgwood also introduced the steam engine, banned drinking, trained women, schooled artists, helped his workers to avoid lead poisoning by insisting on cleanliness, and insured punctuality by using an early version of the time clock.

Wedgwood was one of the first men to realize the immense purchasing power of the rising middle class. His aim was to produce simple, inexpensive ware to meet their tastes. Unlike the folk potters in England and America who were satisfied to make a living from meeting the needs of the local community, Wedgwood foresaw a day when English potteries would dominate the world market.

When china clay, discovered in South Carolina, was shipped to some English potteries in 1765 for testing, Wedgwood expressed his fear of losing the colonial markets. In a letter to Sir William Meredith he wrote: "Permit me, Sir, just to mention a circumstance of a more Public nature, which greatly alarms us in this neighbourhood. The bulk of our particular manufactures are, you know, exported to foreign markets, for our home consumption is very trifling in comparison, to what is sent abroad; & the principal of these markets are the Continent & the Islands of North America. To the Continent we send an amazing quantity of white stone-ware & some of the finer kinds, but for the Islands we cannot make anything to rich and costly. This trade to our Colonies we are apprehensive of losing in a few years, as they have set on foot some Potworks there already, and have at this time an agent amongst us hiring a number of our hands for establishing new Pottworks in South Carolina; having got one of our insolvent Master Potters there to conduct them. They have every material there, equal if not superior to our own, for carrying on that manufacture; and as the necessaries of life, and consequently the price of labour amongst us are daily advancing, it is highly probable that more will follow them, and join their brother artists and manufacturers of every Class, who are from all quarters taking a rapid flight indeed the same way! Whether this can be remedied is out of our sphere to know, but we cannot help apprehending such conse-

quences from these emigrations as make us very uneasy for our trade and our Posterity." [11]

Wedgwood's fears about the loss of colonial markets soon materialized but not because of a budding pottery industry in South Carolina, which soon failed after it started. England had tried with varying degrees of success to suppress manufacturing and intercolonial trade since the first colonies had been established in America. The Stamp Act of 1765 brought about a series of nonimportation agreements between the colonies which banned the purchase of European goods.

The nonimportation agreements were a popular patriotic cause particularly in the northern and middle colonies, and imports from England steadily declined until they were completely suspended in some colonies by the outbreak of the Revolution. During the boycott, trade between the colonies steadily increased and the rebel colonists, determined to avoid using imported goods, were proud to buy wares made by local craftsmen. Imported products were occasionally allowed to enter the colonies when the nonimportation agreements were relaxed. Potters working in the eastern seaport towns no doubt felt an economic squeeze caused by the large amount of cheap, imported wares which flooded the markets from time to time, but merchants were forced more and more to meet the needs of the community with domestic wares because they lacked a steady supply from Europe and because of the changing attitudes of their customers.

The colonial economy fluctuated considerably during the twelve years prior to the Revolution in 1776. "Had American manufactures been organized on a factory basis, employing large capital and an operative population, these violent market changes would have been ruinous, even though the relative consumption of domestic goods was increasing. But homespun and workshop industries expanded and contracted with a minimum of displacement of labor and capital. They silently adjusted themselves to changing conditions and at the outbreak of the Revolution were more adequate than they otherwise would have been to supply the immediate needs of the colonists." [12]

During the war years imports from England were completely suspended except in the coastal cities held by the British army. Potters, as a class, sided with the colonies and those that were not actually fighting in the war were, like all craftsmen, quick to take advantage of the boom in business. Pottery and trade goods became extremely scarce and costly. Potteries, particularly in New England, were rapidly expanded to meet the need for earthenware products which

previously had been imported. New potteries immediately set up, but many survived only to succumb to the more experienced competitors or the market which was soon flooded by overproduction.

Potters brought with them from the Old World various methods of preparing materials, forming ware and designing kilns. Each potter made his own tools and equipment and employed them in the manner of his particular tradition. The methods of mixing clay varied considerably among craftsmen of different origins and groups. In some areas clay was mixed by hand in pits or wooden troughs with a spade or hoe to blend the hard lumps of dry clay with water. Sometimes a primitive type of wet pan was used to grind the clay. This mechanism consisted of a shallow, circular pit lined with boards around which animals pulled heavy wheels made of wood, iron or stone. At Zoar, Ohio, potters and tile makers spread wagonloads of clay on a stone floor, dampened it with buckets of water and drove cattle in a circular path over it until the clay reached the proper consistency. After the Revolution, the vertical pug mill sometimes called a "flying dutchman" became universally used in most locales. The pug mill consisted of a vertical, wooden shaft with blades at the base which were turned in a stationary tub made from a hogshead. The mill was powered by work animals hitched to a long sweep. Children were sometimes paid a penny by the potters to keep the animals moving. A hundred and fifty pounds of wet clay could be ground in about an hour.

When the clay had reached a smooth consistency, the potter scooped it from the mill with his hands and formed it into balls weighing about fifty pounds. These balls were piled in a closet or cellar to keep them moist and prevent them from freezing. As the potter needed clay, he took a ball from storage, cut it into small pieces with a wire and picked out any roots and pebbles that had not been removed earlier. Just before throwing, the clay was kneaded to remove trapped air bubbles and to give it a final inspection.

There were two types of throwing wheels used by early American potters. The treadle wheel, called a "kick wheel", was commonly used by potters from England. The treadle wheel, as the name implies, was powered by moving a lever attached to a crank in the wheel shaft back and forth with the foot. The potter stood resting against the wheel, or leaning against the wall, and treadled the lever while he formed his ware. The other type of wheel called a "kick and paw" wheel was used by Continental potters. This wheel was also foot

powered. The potter sat on the wheel frame and pushed the heavy flywheel with his foot until it gained enough momentum to begin centering the clay with his hands.

Basic hand tools used in "turning" ware were much the same as those used by potters today. A sharpened stick, pointed wire, or porcupine quill was used for trimming cylinder tops. Small pieces of pliable leather helped to smooth and form the rim. Sponges or rags removed water from the inside of the pots and the wheel head. Metal and wood ribs were used to shape and smooth the outer surface of the forms. Finely twisted wire or string cut the pot from the wheel head. Lifters made of metal or wood transferred the pot to the carrying boards.

Making glazes presented a difficult problem for early potters. Glaze materials were expensive and often had to be transported over long distances. Glazes were ground by hand until the materials were reduced to a fine particle size and were thoroughly mixed. This was extremely tedious work, requiring considerable time, energy, and patience.

Mills for grinding glazes and slips were constructed much like the stone mills which were used to grind grain into flour. Mill stones were made of granite and varied in diameter from a few inches for grinding pigments, to two feet in diameter for grinding large quantities of glaze. The principle of operation was the same for all sizes. The liquid mixture was poured into the funnel-shaped opening at the center of the top stone. As the upper stone was turned by hand, the mixture was ground between the rotating top stone and the stationary bottom one. On larger mills the upper stone was supported on a pivot at the center and was turned by a wooden stick which extended from a beam in the ceiling to a hole at the outer edge of the stone. The glazing ingredients were thoroughly ground and blended to an even consistency as the liquid glaze flowed slowly outward between the surfaces of the stones. The mill stones were enclosed in a box with an open top and set on a waist-high stand. The ground glaze flowed from between the stones into the box and from there through a drain spout into a crock or large jar. With minor variations, the stone glaze mill and vertical shaft pug mill continued to be used by most folk potters until the decline and end of the folk traditions in the late 1800's.

There have been no extensive studies of the kilns used by potters in the seventeenth and eighteenth centuries. In 1932 F. H. Norton did

a study of the Exeter pottery works at Exeter, New Hampshire, in which he included detail drawings of the kiln. It was wood burning, up-draft, of rectangular form with a stacking area measuring seven feet in width and height and twelve feet in length. This kiln was constructed of red brick with iron strapping to hold the 16-inch thick walls and sprung arch in place. There were three fire mouths at each end running lengthwise under the kiln. Dry pine was used throughout the thirty-hour firing cycle. The flames entered the kiln from the combustion chambers up through ports in the main floor and circulated through the ware. The gases escaped from the kiln through a series of exit ports in the arch and passed upward and out of the kiln house through trap doors in the roof.

A small door in one end, which was bricked up for each firing, was used for stacking and "downing" the kiln. The larger pots and jars were inverted and stacked in staggered tiers, mouth to foot. Small pots were placed inside larger ones, and "picked shaped" setting tiles were used to stack thinner and lighter ware such as pitchers and mugs between rows. Milk pans, leaning one against the other on edge in long rows from the back wall, were used to top off the charge. The maturing temperature of the earthenware fired at the Exeter works was about 1800° F. The completion of the cycle was judged by looking at the charge through a spy hole to see how much it had settled. This kiln was typical of those used around Exeter and Gonic, New Hampshire, in the late 1700's.

Rectangular kilns were used in all the colonies. In the South they were horizontal draft, similar to the English Newcastle kiln which was probably the forerunner of the "groundhog" kiln so universally used there in the nineteenth century. The name "groundhog" was derived from the fact that the kiln was built into the hillside like an animal burrow. The earth provided the thick walls and arch with support and insulation. The capacity of the average "groundhog" kiln was about five hundred gallons.

Kilns used in eastern Pennsylvania by potters of German origins were usually round. Some had square exteriors with a round stacking area. Most of them were eight to twelve feet in diameter and six to eight feet in height inside. The walls, some of which were three feet thick, were made of stone with brick linings. The crowns were slightly arched and made of bricks. The crowns were kept in place with iron bands around the upper part of the outer walls to prevent

spreading. Long hardwood boards were driven between bands and the kiln walls to take up the slack as the kiln settled and deteriorated after many firings.

Wood was used for firing in all areas and the average-size kiln required thirty to forty hours to fire and four to six days to cool before the pots could be removed.

At the beginning of the firing cycle a "soaking fire" made of large, slow-burning pieces of wood warmed the kiln and completely dried the pots. This was continued for six to eight hours and then the heat was slowly advanced until the flames were drawn through the pots and the kiln walls took on a faint red glow. At the first sign of this color the potters began to stoke the fire boxes with as much fuel as they would burn. As the firing continued, thinner wood—which burned more rapidly—was used to increase the heat. When the kiln neared maturity, the inside walls and the charge glowed a bright yellow color and a clear blue flame shot several feet in the air from the exit ports.

Some potters judged the end of the firing by the color of the glowing pots and the length and color of escaping flames. Others used glazed "draw trials" that were formed in loops or long strips which could be fished from the kiln with an iron rod or tongs to check the progress of the melting glazes.

The potter usually had two or three other men to help him attend the fire mouths, which they worked in shifts. The potter himself usually got little sleep because of the critical nature of firing hundreds of pots which took several weeks to make. "The 'burning of the kiln' was always a great event at the pottery, especially for the boys employed there. For thirty-six hours, while firing continued, they were relieved from the exacting duties of their regular employment. While the men were attending to the fires, the youth of the neighborhood were accustomed to assemble in force to employ to the fullest extent the novelty of being permitted to stay up all night. All sorts of games were indulged in, "Hide and Seek," "Silly Bunk" and "Tag" in the moonlight outside, and checkers and dominoes, in the light of the roaring kiln." [13]

Changes in techniques of stacking and firing, clay preparation, throwing and glazing usually came about because of the influence of an outside potter. After the Revolution, there were many itinerant craftsmen who moved from one pottery to another, working for a

while before moving on. Some of these potters were highly skilled craftsmen with knowledge of advanced techniques and methods of making different types of wares.

By this time the public and the potters were becoming increasingly aware of the defects in earthenware, particularly the health hazard of lead glazes.

A social-minded writer expressed his views and urged the ban of lead glazes in the following article printed in the *Pennsylvania Mercury*, February 4, 1785: "The best of Lead-glazing is esteemed unwholesome, by observing people. The Mischievous effects of it fall chiefly on the country people, and the poor everywhere. Even when it is firm enough, so as not to scale off, it is yet imperceptibly eaten away by every acid matter; and mixing with the drinks and meats of the people, becomes a slow but sure poison, chiefly affecting the nerves, that enfeeble the constitution, and produce paleness, tremors, gripes, palsies, &c, sometimes to whole families.

"It is wished the Legislature would consider of means for discountenancing the use of Lead in glazing Earthen-Ware, and encourage the application of the most perfect and wholesome glazing, produced only from Sand and Salts: materials, these, everywhere to be collected within these states. A small bounty or exemption, on this, might be sufficient to the end. But, what if public encouragement was to be given on home-made Stone-Ware, rather than on Earthen-Ware?

"Stone-Ware is now scarce and dear amongst us, as the housewife knows. This is owing to its great bulk and low value, that scarcely affords to pay the freight on measure. . . . It is this circumstance that renders the manufacturing these wares an object to our enterprising people, peculiarly promising of profit and permanent advantage." [14]

This article also points out that imported stoneware had become scarce because of changes in shipping rates after the Revolution. During the colonial period freight on stoneware was based on the value of the ware rather than on the measure or weight. This prohibitive increase in freight rates on imported stoneware coupled with the public's increasing awareness of the health hazard of lead-glazed earthenware, the desire for more durable utensils, and the appearance of itinerant potters were the main factors leading to the increased production of stoneware after the Revolution.

The Stoneware Tradition

Stoneware was first produced in Europe along the Rhine Valley as early as the fifteenth century. As the tradition developed in the sixteenth and seventeenth centuries, large quantities of brown-glazed Rhenish stoneware were sent to England. This ultimately led to the production of stoneware in England. The first patents to produce stoneware in England were applied for in 1626, but it is doubtful that any great amount of this type of ware was made there until the latter part of the seventeenth century.

Stoneware differs from earthenware, which is relatively low fired, porous and fragile, in that the clay body is vitrified and will hold water without a glaze. True stoneware is fired to about 2300° F. and is extremely dense and durable.

The beginnings of stoneware production in America, like that of earthenware, are obscure. The earliest piece of dated stoneware (1722) is a jar made in New Jersey by Joseph Thiekson. Records show that Anthony Duché, a French Huguenot immigrant, and his older sons were making stoneware in Philadelphia by the late 1720's.

The 1854 edition of D. T. Valentine's *Manual of the City of New York* lists a "stoneware furnace" which was built in 1730 at the Corselius Pottery. The kiln was probably built by William Crolius because the name of the pottery was soon after changed to the Crolius pottery.

Crolius was born near Coblenz, Germany, in 1700, and immigrated to New York in 1718. He married Veronica Corselius in 1726. The Crolius pottery was operated by succeeding generations in New York City until it finally closed in 1887.

In 1735 John Remmey emigrated from the town of Neuweid, on the Rhine to New York City and shortly thereafter married Veronica Corselius' sister Anna. Remmey set up a stoneware pottery on a lot adjacent to the Crolius pottery which remained in competition with the Crolius pottery until 1820. The area in the city where the two potteries located was to become known later as "potters hill" or "pot bakers hill."

The beginning of stoneware production in any given locale depended on the discovery of deposits of high-temperature clays. For this reason the area around New York City became one of the earliest centers of stoneware production in America. Shortly after 1700 a bank of fine white clay, suitable for making stoneware, was discovered at Bayonne, New Jersey, on the other side of New York's Upper Bay. The same type of clay was also found on the northern shore of Staten Island and at Huntington, Long Island. These deposits were readily accessible by sloop and barge to the stoneware potters working in New York City, northern New Jersey and on Long Island. Later, clay from these deposits was used by potters working in settlements in Connecticut, Massachusetts and on the upper Hudson River.

The first endeavor to make stoneware in New England was the abortive attempt of Isaac Parker at Charlestown, Massachusetts, about 1740. Parker was a very successful earthenware potter and expended a great deal of his personal wealth on the venture. He first went to New York in hope of learning the "arts and mysteries" of making stoneware. Parker obtained little information from the New York potters and afterwards hired James Duché, one of Anthony Duché's sons, to come from Philadelphia in 1742 to help him. Parker petitioned the General Court for additional funds. This was a common way of promoting business during the colonial period that would be of advantage to the whole settlement. Parker's petition was granted but

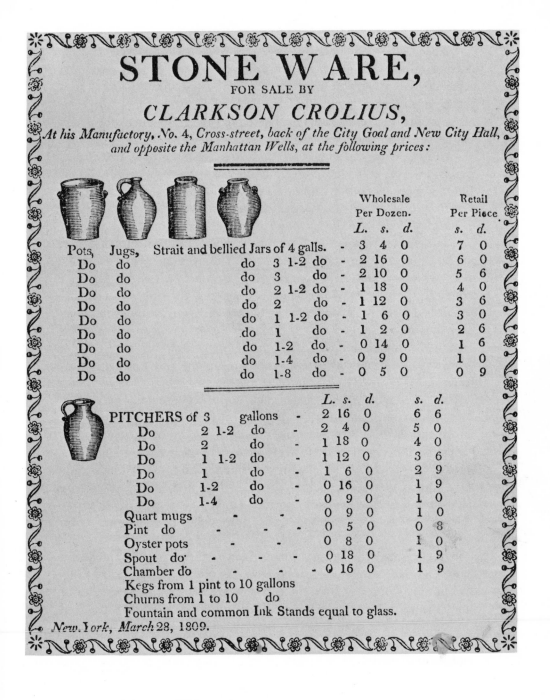

Fig. 7. (Courtesy of American Antiquarian Society.)

he died shortly thereafter. Parker's wife Grace continued, hoping to succeed in producing stoneware with the help of Duché and her brother-in-law, Thomas Symmes. After local clays proved unsuitable some degree of success was attained with clay shipped from New Jersey and Philadelphia, but the cost of transportation left them little profit. The unfortunate affair ended in 1754 when both Mrs. Parker and Thomas Symmes died.

The first successful stoneware pottery in Massachusetts was that of William Seaver at Taunton. Production was started between 1772 and 1790. Seaver shipped in stoneware clay from New Jersey and mixed it with a local clay from Martha's Vineyard, which lowered the cost of his clay body enough for him to realize a profit from his ware.

Adam States, who is thought to have migrated from Holland, was the first potter to produce stoneware in Connecticut. He first settled in New Jersey, but later moved to Greenwich where he set up a stoneware pottery in 1750. Other members of the States family also established stoneware potteries in Connecticut at Stonington, Norwich and New London. Like all stoneware potters working in New England during colonial times, Adam States and his relatives got their clay from nearby deposits at Huntington and northern New Jersey.

The abundance of high-firing clays and the consequent early production of stoneware in New Jersey and Delaware is probably the reason that little earthenware was made in either of these colonies. Except in the German settlements in eastern Pennsylvania, earthenware potters could not successfully compete with those making stoneware. When stoneware began to be produced in an area, earthenware sales declined. Earthenware potters either went out of business, learned how to produce stoneware, or moved on to another community.

In the eighteenth century Pennsylvania stoneware was made by many German potters emigrating from the Rhine Valley. Some German potters worked at both the earthenware and stoneware traditions simultaneously, producing their colorful slip and sgraffito wares and simple, plain, but functional stoneware. There was an abundance of local stoneware deposits in eastern Pennsylvania, as well as those deposits discovered very early across the river in New Jersey, and in Delaware.

Philadelphia, like New York, was a pioneer center in the production of stoneware. Both cities had excellent seaports which provided ready

transportation of wares to New England, the southern colonies, and the Caribbean Islands. A considerable amount of stoneware was transported to these areas where stoneware potteries had not yet been developed. However, most of the stoneware potter's production was absorbed by the rapidly growing population in these two cities and the surrounding communities.

Philadelphia, the cultural and educational center in the colonies, was also the place where a great deal of scientific experimentation and invention was carried on. There were several early attempts to produce commercial bone china, cream-colored ware and porcelain from the fine white clay located near Philadelphia. Most of these early ventures were unsuccessful and of short duration.

Although the plantation economy of the southern colonies was not conducive to craft production there were some stoneware potters operating in the South during the colonial period.

A report to the Smithsonian Institution entitled, "The Poor Potter of Yorktown," by C. Malcolm Watkins and Ivor Noel-Hume, strongly indicates that stoneware was being produced in considerable amounts at Yorktown, Virginia, in the 1730's. And that William Rogers, to whom the governor of Virginia referred as the "poor potter" in his reports to the British government, was in fact quite successful and was actually exporting pottery to other colonial settlements. The pottery produced at Yorktown was very high quality by early colonial standards and was produced over a period of twenty to thirty years.

Many of the Crown's colonial governors were sympathetic toward the colonists' pursuits of intercolonial trade and home manufacturing: "Some governors were colonials, who sympathized with the commercial and manufacturing ambition of the colonists. Even governors from England sometimes preferred easy duties and local popularity to the commendation of home authorities at the price of a tumultuous, embarrassed and unpopular administration. Other governors formed profitable business connections in America. Therefore many royal officers either ignored or obeyed in form rather than in spirit, general instructions of the home government that did not accord with the interests and wishes of the colonists. But some governors were alertly jealous of colonial manufacturers, advised the government of their progress, and suggested measures to supress them; and their official correspondence even conveys the impression that the home authorities were lukewarm, as compared with their representatives in

America, in the desire to keep the colonists industrially dependent upon the mother country. Where such officers were sincere and energetic, their political and social influence combined may have prevented some manufacturing undertakings, but they possibly did more to promote American consumption of English goods by introducing new fashions and personally setting the mode for imported articles than by directly discouraging local manufacturers." [15]

In 1735 Andrew Duché, another of Anthony Duché's sons, was making pottery at New Windsor, South Carolina. Upon the urging of General Oglethorpe, he moved to Savannah, Georgia, and successfully produced ware there until 1738. Andrew Duché had been trained in the stoneware tradition at his father's pottery in Philadelphia and in all probability the pottery he was making in the South was stoneware. In the latter part of 1738, Duché claimed that he had learned the secret of making true porcelain and petitioned the trustees of the colony to give him a fifteen-year patent on its production and money for further development. Duché had sent a porcelain cup along with his petition to verify his discovery, ". . . but when one of the trustees asked him to duplicate in porcelain two cups which he sent, Duché replied that he could not until he had a suitable kiln. With the aid of General Oglethorpe, Duché made a trip to England, in May, 1743, in the hope of interesting someone there in his porcelain discoveries. There is circumstantial evidence that he was the man who furnished the Cherokee Indian clay to the proprietors of the Bow pottery which made the first recorded English porcelain in 1744.

"Because of Duché's secrecy, and the conflicting claims and doubts which fill the Savannah records, it may never be known whether he did or did not make porcelain. There can be no doubt, however, that he was the first English speaking person to recognize the porcelannous quality of Cherokee Indian clay and to identify it as kaolin." [16]

China clay, or kaolin, was discovered within "the Cherokee Indian Nation" some three hundred miles inland from Charleston. The clay was first used at the Bow pottery in Middlesex County, and later at a number of other English potteries until William Cookworthy discovered a deposit of china clay at Cornwall, England, in 1768.

When American clays were shipped to the Worcester and Bristol china works in 1765 and 1766 for testing, Josiah Wedgwood expressed his concern that English potters could lose their colonial markets to the "new Pottworks in South Carolina; having got one of our insolvent Master Potters there to conduct them." [17]

Fig. 8. An exhibition of wares made by the United States Pottery Company at the New York Fair of 1853 in the Crystal Palace. (Woodcut reproduced from *Gleason's Pictorial*, October 22, 1853.)

The "insolvent Master potter" was John Bartlam who immigrated to Charleston about 1766 to set up a "pottery and China manufactory." Bartlam's ill-fated venture in Charleston was related by Josiah Wedgwood in 1783 in an "Address to the Workmen in the Pottery on the Subject of Entering into the Service of Foreign Manufacturers:

"About seventeen years ago, Mr. Bartlam, a master potter who had been unsuccessful here, went to South Carolina, and by offers made from thence, very advantageous in appearance, prevailed upon some of our workmen to leave their country and come to him. They took ship at Bristol and . . . they at last arrived safe and began a work near Charleston. This adventure being encouraged by the government of that province, the men, puffed up with expectations of becoming gentlemen soon, wrote to their friends here what a fine way they were in and this encouraged others to follow them. But change of climate and manner of living accompanied perhaps with a certain disorder of mind . . . carried them off so fast, that recruits could not be raised from England sufficient to supply the place of the dead men. In Mr. Goodwin's own words to me, whose son was one of them, 'they fell sick as they came and all died quickly,' his son among the rest.

"Mr. Bartlam thus deprived of his whole colony returned once more to England, in order to raise some fresh supplies. In a little while by dint of great promises he prevailed upon four to go with him, but the event of this expedition was only more labor and more lives lost. For though the people there were disposed to encourage this infant manufactury, and the assembly of that state gave him at different times five hundred pounds to keep him on two legs as long as they could, yet all would not do; the work was abandoned and only one man returned to England, the rest, with Mr. Bartlam himself are either known to be dead or have not been heard of since." [18]

The moral of the story was, no doubt, aimed at dissuading local potters from emigrating to the United States.

The only known survivor of Bartlam's adventure was William Ellis, who arrived at the Moravian pottery at Salem, North Carolina, December 8, 1773, and who, during the following year, taught Gottfield Aust how to make both "Queensware" and stoneware.

The development of different wares and processes at the Moravian pottery operated by Aust is well documented and fairly typical. Aust was born in Germany and was trained in the earthenware tradition

before immigrating to Bethlehem, Pennsylvania. He moved from Bethlehem to Bethabara in 1755, where he set up the first Moravian pottery in North Carolina. In 1771 Aust moved his pottery to the new Moravian settlement of Salem where he worked until he died in 1788.

The following excerpts from the Moravian Church Diaries at Bethabara and Salem indicate how and when new ware was introduced: "April 1756: Brother Aust made a small oven and burned some earthenware. June: A [larger] potters' kiln was begun. August 23: Brother Aust glazed pottery for the first time today. Sept. 10: Brother Aust burned pottery today for the second time, the glazing did well, and so the great need is at last relieved. July 31, 1768: Brother Aust, the potter, moved here from Bethabara, and will conduct his business for Salem. Dec. 10, 1773: On the 8th a journeyman potter named Ellis had arrived of his own accord. He claims he understands how to glaze and burn Queens Ware. He was to be given food, clothing and a doneceur, and Aust was to learn from him all he knew of glazing, of which Aust already knew a little which he had also learned from a travelling potter. 1774: It is not until May of this year that Ellis made a burning of Queensware, and also one of stoneware. They will serve as a sideline for our pottery and can be further developed. The good man found our town too narrow for him, so for the present has bid a friendly farewell." [19]

Although it is not mentioned in the diaries, Ellis also introduced the use of press molds in making some forms.

Some historians indicate that traditional craftsmen fiercely clung to the "old ways" and accepted changes very slowly. This is probably true of craftsmen working in primitive cultures and later cultures that were stable and unchanging. But, in the case of most early folk potters working in America, innovation was readily accepted, but the means to make use of new ideas were often lacking.

Potters continued to produce lead-glazed earthenware after the Revolution even though there was a growing awareness that the use of lead glazes presented a considerable health hazard. The reason for this was simple. In most cases it was the only ware the potter knew how to make and consequently, the only cheap pottery available in the area for the people to buy. Most earthenware potters would have gladly switched to stoneware production, but the lack of technical knowledge and readily available materials forced them to continue to produce wares that they had traditionally learned to make. Trade secrets were closely guarded at most stoneware potteries and any

knowledge about methods and materials was hard to obtain. Changes in techniques or the transition from earthenware to stoneware production usually came about because of the influence of an outside potter.

By 1790 there were many itinerant craftsmen who moved from one pottery to another. Unlike the journeymen drifters before the Revolution, some of these potters were highly skilled craftsmen with knowledge of advanced techniques of clay preparation, throwing, glazing, decorating, kiln design, stacking and firing, as well as the ability to produce various types of ware.

After the Revolution there was an increase in immigration of skilled craftsmen from Europe who were attracted by the idealism of democracy and independence, high wages and the opportunities in the United States.

Generally, folk potters were quick to accept changes in techniques, particularly those attempting to run full-time shops. Their attitude toward production was highly pragmatic, as is evident in the simplicity of their designs. Except in cases in which potters were attempting to make the change over from earthenware to stoneware production, changes in technology, such as clay and glaze preparation, had little effect on the basic designs of their ware. Advances in techniques served to increase the rate of production of the kind of ware a potter was currently making. As new techniques spread from group to group, however, changes in design inevitably occurred.

Where earthenware potters were attempting to make stoneware, changes in form, and later in decoration, probably came about quite naturally and spontaneously. Some earthenware forms adapted to stoneware functions with little alteration in design. But unless the earthenware potter was completely trained in stoneware, he undoubtedly had to innovate in order to complete the transition. Ordinarily, the potter did not have the benefit of thorough training in stoneware, and had to rely on his own resourcefulness to compensate for the knowledge that he lacked.

The transition from earthenware to stoneware production constituted a major change in the potters' tradition. They usually continued to make earthenware along with stoneware until they completely mastered the new medium. Many potteries failed because of the lack of skill or insufficient knowledge of stoneware production methods. They had little difficulty with such techniques as clay preparation, throwing and stacking which were essentially the same

in both traditions. The major problem for the earthenware potter was in adapting to the use of new materials and the technique of firing to a much greater heat. It was very hard to get a high percentage of quality ware through the "burning" without a great deal of training and experience.

Early stoneware kilns were very similar to those used to fire earthenware. The main difference was in the use of more refractory materials in the construction of stoneware kilns to withstand the increased temperatures. Kilns were sometimes constructed from a type of a sandstone known as "firestone," which was commonly used to build blast furnaces. Bricks were also used which were made from the same clay used to form the ware. In either case the often short-lived structures required considerable repair before each firing.

In 1837 Christopher Webber Fenton patented a firebrick made from kaolin and fine sand. This new firebrick, which was produced and sold at the Norton stoneware pottery at Bennington, Vermont, was a great improvement over earlier kiln building materials.

After the Civil War most of the larger commercial stoneware potteries were using kilns similar in design to that of the cupola ovens or common pottery ovens used in England. They were round, updraft kilns with a stacking chamber about ten feet in diameter and eight feet high. A steep, conical stack erected on top of the kiln walls enclosing the arch carried the exhaust gases up through the roof of the pottery.

The techniques of forming, stacking and firing stoneware in the early 1800's were summarily recorded in the records of the Clark pottery at Athens, New York. The following "Rules for Making and Burning Stone Ware" were possibly written by Nathan Clark:

"1st. Let the wheelman be careful to have every piece run exactly true on the wheel. Make them of a kind precisely of the same height & width, have the ware turned light, handsome shape, smooth inside & outside, the bottom a suitable thickness, and a good top.

2nd. Let it be handsomely handled & smoothly polished in the proper season.

3rd. Let the ware when dry be carefully set in the loft washed and blued.

4th. Let the plats be well made Kiln cleaned out and mended in complete order for setting.

5th. Care must be taken to set the courses plum & one piece exactly over another.

6th. Have your wood in good order, raise your fire progressively, neither to fast nor to slow, examine well & understand the management of your Kiln so as to heat all parts alike, be careful not throw your wood in the arches to soon or do any other act that may have a tendency to retard the heat, when fit to glaze have your salt dry. Scatter it well in every part of your Kiln (during this act you must keep a full and clear blaze so as to accelerate the glazing and give the ware a bright gloss) stop it perfectly tight and in six days you may draw a good kiln of ware." [20]

The heyday of the earthenware tradition in New England, which began about 1740, was brought to a close in the years following the Revolution. Trade with England was reestablished at the end of the war in 1783, and a "madness for foreign finery" prevailed in America. Imports of all kinds flooded the country, including quantities of English earthenware. English pottery factories, in hopes of regaining their rich prewar markets in America, turned out tons of cheap ware decorated with the faces of Washington and Adams, Revolutionary War symbols and slogans, and other anti-British sentiments, which would have meant treason during the war.

These imported wares were very popular and were the final blow to many earthenware potteries that were barely surviving the extreme competition and overproduction during the war years.

Other effects of the flood of imports were the lowering of prices, overstocking by merchants and overbuying by the public, the loss of circulating currency to Europe, and general indebtedness which led to a depression. The crisis was not sufficiently far reaching to affect small manufacturers on the frontiers but enough sentiment was aroused among craftsmen in New England and Pennsylvania to pass their local tariff laws of 1785 and 1786.

During the war the Tidewater South developed a considerable amount of self-sufficiency. For the first time potters and other craftsmen were patronized and their wares appreciated. The southern buying public reverted somewhat to prewar attitudes when imported goods became available at the end of the war, but by 1790 the "madness" was over; American public sentiment called for economic and industrial independence from Europe.

The desire for the development of home industries that could meet the needs of the American public was further heightened by uncertain and unfavorable trade relations with England; the quasi-war with France in the latter part of the century and the need to produce commodities for the large population settling the inland frontiers.

50

In 1789 the newly formed Federal Government passed a tariff imposing a duty on all imported goods. The purpose of this tariff was primarily to raise revenue to support the government and pay off public debts, but it was also aimed at encouraging and protecting home manufacturers. The duty on all pottery was 10 percent of sale value in the United States. In 1795, the valuation was based on the place of exportation. On some commodities the lowering of the tariff, by changes in the base of valuation, was compensated for by raising tariff rates. The duty on pottery, however, remained the same until 1862 when the tariff rate was raised to 20 percent for undecorated wares and 35 percent on glazed and decorated wares.

These tariff statistics indicate that the pottery industry in the United States before the 1860's was of little economic importance to the country as a whole. Most pottery was made in small shops for local consumption. Even the largest full-time shops in the seaport cities were small, usually employing less than a dozen men.

Stoneware potters experienced a boom in business after the war. Common stoneware vessels were too expensive to ship from England because of the new, prohibitive shipping costs. Stoneware potters seldom made decorative pieces or tableware, so they were not in direct competition with the inexpensive imports.

After the economic crisis in the decade following the war, many new stoneware potteries were set up and old ones were expanded to meet the increased demands for ware. By 1790 the economy was stable and growing, money was fairly sound and trading areas, both domestic and world wide, were expanding. The China trade had already begun in 1785. New roads and bridges were being built, the first canals were being dug, the mail service improved, and throughout the nation the means of communication and transportation were rapidly improving.

Labor, either skilled or unskilled, was still one of the greatest concerns of master potters operating full-time shops. Lack of skilled labor was offset somewhat by the influx of well-trained journeymen from Europe, but inexpensive, semiskilled labor, which during the colonial period had been provided by apprentices, was rapidly disappearing. The spirit of democracy and independence that had won the Revolution had also eroded the willingness of the youth to accept the apprentice system. The idea of having a "master" in a free society was repugnant. In the larger towns paying jobs were always available for young and old and many boys and their families now chose the immediate return of wages over the long term of appren-

ticeship to learn a trade. The population was substantially rural and involved in farming. Farm families usually were reluctant to give up the help of a teenage son either for wages or for the opportunity of learning a trade. Consequently, by the early 1800's the general level of craftsmanship in America was on the decline.

Wages, except for temporary depressions, steadily increased after the Revolution. "According to an investigation made early in the last century, the average wage of unskilled workers, without board, in the principal cities of the United States for the first six months of each year mentioned was: 50 cents in 1785, 50 cents in 1790, 95 cents in 1795, 90 cents in 1800, and 75 cents in 1805. However, after the beginning of the canal and railroad building era, about 1820, the nominal day's wage of common labor, without board, seldom fell below 75 cents and ranged from that point to $1.25, according to locality and seasons." [21]

Most labor in America during the first half of the nineteenth century was agricultural and wages for both skilled and unskilled workers were somewhat regulated by this. Journeymen potters' wages were still often paid in trade goods, and accounts were figured in English sterling until well into the century. The cash wage for potters was about a dollar a day with room and board, or fifteen dollars if hired by the month. In some areas potters' wages were figured on a "piece work" basis by the gallon. A gallon pot was worth one or two cents each and the average daily wage by this system was about the same as a daily wage.

Wages were generally higher in the United States than in Europe, but the difference was greater for unskilled workmen than for craftsmen. As larger pottery factories began to develop in the mid-1800's, the lack of skilled men was the first concern of American producers, and they induced many experienced English potters to cross the ocean for wages as high as three or four dollars a day. This, of course, led to "hostile foreign legislation" but did little to stop the emigration of individual craftsmen seeking higher compensation for their work.

The scarcity of money and long-term credit, which was settled once a year, was not so hard for potters as most other craftsmen. Pottery was relatively inexpensive and was usually sold by the piece through the shop or peddled door to door throughout the nearby countryside. If the buyer did not have hard cash, the potter accepted trade goods in exchange. He, in turn, used these trade goods to pay wages and other expenses. His basic materials were compara-

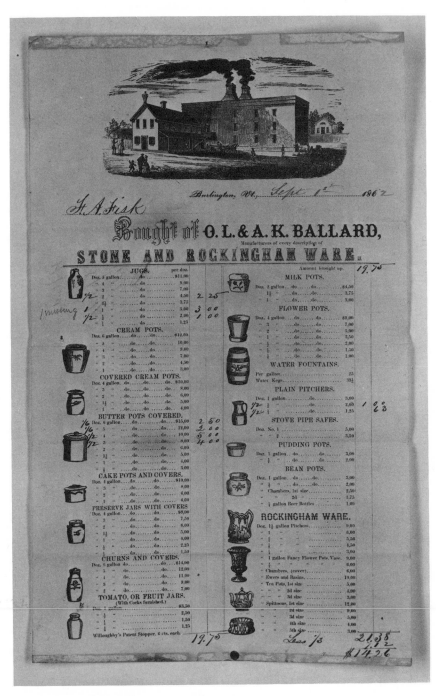

Fig. 9. (Courtesy of Shelburne Museum.)

tively inexpensive and the potter, unlike many other craftsmen, had a relatively small cash investment in his finished product. However, as shops grew larger, credit sales were inevitable, but credit was usually a minor factor in the closing of a shop. In most cases the lack of skilled labor, technical knowledge and the high cost of transportation were the major factors in the failure of full-time stoneware potteries in the early decades of the nineteenth century.

The main power source in most potteries before 1800 was hand or horsepower. Water power was made use of in some areas by the larger shops, but the first reliable power source was the steam engine.

The first steam engine used to drive mill machinery in America was installed just after the turn of the century. The first pottery to use steam power is unknown, but by the mid-1800's, all the larger shops used power from steam engines to mix clay, grind glazes, and drive their potters' wheels.

By 1800 inland roads were being greatly improved. Some were made all-weather thoroughfares by a covering of stone and tar. Trails were widened to accommodate wagons and slowly new inland markets became available to craftsmen working on the coast.

With the new markets came increased competition and a steadily growing demand for better wares. The demand for better crafted and more functional wares not only heightened the competition between potters, but also all craftsmen trying to meet the same household functions. This increased competition and the decline in craftsmanship were factors which helped to bring on the factory system in American potteries.

Improved roads not only increased markets and competition, but also increased the mobility of potters and of the public in general. Where there had been one itinerant moving from pottery to pottery before there were now ten. Peddlers sold goods of all kinds, door to door, from their one-horse carts. And traders' wagons filled the roads.

Along with all this increased business energy, transportation and mobility at the beginning of the nineteenth century came the great expansion westward; the new roads opened easy routes west and masses of people migrated inland into the Ohio Valley, Kentucky and Tennessee.

The spread of the stoneware tradition coincides with that of western expansion, the discovery of new deposits of high-firing clay and the development of transportation systems. In the state of New York,

the Hudson River was a natural link between up-river towns and New Jersey clays. Stoneware production developed rapidly along the river at Poughkeepsie, Kingston, Athens, Albany, and Troy.

Later in 1825, when the Erie Canal opened, stoneware potteries were established at Utica, Geddes, Lyons and Rochester. Competition among these stoneware potteries in New York was intense and potteries often failed after a few years of struggling operation. However, many of these potteries were sold or reorganized under another name and were soon reopened for business after they had gone out of business under previous management.

As the tradition was spreading to towns up the Hudson River, stoneware potters from lower New York and northern New Jersey were moving to Connecticut, Massachusetts, and the coastal towns of New Hampshire. The stoneware potteries operating in western Vermont in the early years of the nineteenth century were examples of successful transitions from the earthenware to stoneware tradition. When stoneware clay from New Jersey became available at nearby Troy, New York, Vermont potters who were making earthenware were soon making stoneware as well.

In Pennsylvania the growth of the stoneware tradition was somewhat different than it was in New York and New England. In New England stoneware vessels replaced earthenware whenever and wherever they began to be available. In Pennsylvania, stoneware production was secondary to that of earthenware. Considerable amounts of stoneware were being made in that state to meet local demands, but not on the competitive and ambitious scale as in the northern potteries. Earthenware continued to be the dominant tradition in Pennsylvania until after 1840 when colorful imports and cheaper commercial wares made in this country forced many of the traditional potters out of business.

The stoneware tradition in Pennsylvania spread southward: at first to western Virginia, Maryland, Delaware, and the southern highlands; and later on westward to Ohio, West Virginia, Tennessee, and Kentucky.

The stoneware made by folk potters in America generally can be divided into two traditions or styles: northern and southern. The northern tradition centered around New York City and towns in northern New Jersey and spread north and west; the southern tradition centered around Philadelphia and eastern Pennsylvania, and spread southward and westward.

In the northern tradition, stoneware production was a primary concern, highly competitive and every possible means was used to expand markets and production. Because of the competition the ware, as a rule, was extremely well formed and finished. Elaborate decorative motifs were developed which were at first incised and later brushed and slip trailed in cobalt blue slip.

The southern stoneware tradition, on the other hand, developed more slowly and was less intense, possibly because it was more removed from large ready markets and was often not the primary ware made by the potter. Stoneware made in Pennsylvania and the South, although well formed, was usually not highly decorated. Potters, particularly of German origin, probably saved most of their decorative efforts for their favored earthenware pieces. Also, as potters moved farther inland in the southern back country, they were long distances from the sources of coloring oxides and other materials and the demand for ware was so extreme that people cared little if the pieces were decorated or not.

The spread and development of potteries in the South is extremely hard to trace, even in the nineteenth century, because crafts and other industries played a negligible role in the development of the southern economy. Consequently, few local historians made any record of the establishment of potteries and many of the official records preserved in county courthouses were lost in fires during the Civil War.

Although the lack of records make documentation of the establishment of many individual country potteries impossible, Carl Bridenbaugh in his *Colonial Craftsmen* explains that, "in the South conditions beyond human control frustrated their progress everywhere except in the back country, whereas in the northern provinces a different environment nourished them and caused them to proliferate. The principal explanations of this profound contrast lie in the staples produced and the nature of the settlement of each area. Where a village society could emerge there the crafts could take hold and grow; there artisans might dwell together and specialize, each in his trade, certain of a demand for his wares. Given ample resources, a maturing economy, and an expanding market, men's minds would eventually turn to ways of increasing production and even to invention." [22]

It should be noted that there was not an "ordered gradual growth" in the development of the folk-pottery tradition, either in the North

or in the South, but all types and grades of pottery were being made during any given period. Some cheap wares were haphazardly formed, carelessly finished and poorly glazed. In some locales these low-grade wares were all that was available and the people were forced to use them for lack of better pots.

Although most American stoneware made in the folk tradition was salt glazed, occasionally pieces can be found that were unglazed, possibly because they were made when there was an extreme shortage of salt, or maybe the potter lacked the knowledge of the age-old process of salt glazing.

The process known as salt glazing was accomplished by firing the ware to maturity, and then throwing salt into apertures in the kiln, causing the salt to volatilize into a vapor which combined with the free silica in the clay body, covering the ware with a thin, mottled glaze.

This technique of glazing stoneware was first used in Germany. The process is believed to have been brought to England about 1688 by John Philip and David Elers, who were Dutchmen of German descent. There are no existing pieces of early English salt glaze ware, but it is fairly certain that the process was being used there in the late seventeenth century. There are no records indicating when salt glazing was introduced to the colonies, but no doubt some of the earlier stoneware potteries were using the process by the 1730's.

The period between 1806 and the signing of the Treaty of Ghent, which ended the second war with England in 1815, was reminiscent of the earlier period of nonimportation agreements in the colonies at the time of the Revolution. In 1803, with the resumption of the intermittent Napoleonic Wars between Great Britain and France, both countries placed heavy restrictions on shipping by neutral countries in hopes of depriving each other of the means of making war. England's violation of the United States' neutral status by the continued seizure of vessels and the impressment of American seamen led to the first nonimportation act during this period in April, 1806. The harassment of American merchant ships by the British fleet continued and President Jefferson sent the Embargo Act to Congress which cut off all trade by land and sea with foreign countries. This act, and others that followed until the end of the war, isolated American markets from European goods.

Because of the 1806 nonimportation act and the outbreak of the war, earthenware potteries along the east coast which had survived

earlier periods of intense competition and economic crisis flourished again for a few years. Potters on the frontier during this period, as in earlier times, were little affected by the political crisis and the conditions of the eastern markets. Earthenware was usually the first type of ware made in the frontier settlements because of the abundance of low-fire red clay throughout the country. The rapidly expanding population caused by the western migration provided ready markets and premium prices for earthenware products until transportation facilities developed enough so that other wares could be shipped in or stoneware potteries established in the area.

Red earthenware glazed on the inside only was being made at Lexington, Kentucky, in 1793 by at least two potters. An earthenware gallon jug made at Lexington cost 2S.6d which was the same price as a salt-glazed, gallon stoneware jug in New York City.

The Revolution primarily stimulated the expansion of home industries and hastened the transition from part-time to full-time shop production in many locales. The end of the second war with England marks the introduction of the first factories in America and the foundation of true economic and industrial independence from Europe.

By the time the Treaty of Ghent was signed American merchants could stock their stores completely with American manufactured goods except for textiles. But with the signing of the treaty English imports, brought in on ships involved with the cotton trade, again flooded the country. Inexpensive, well-made white crockery and other wares met many of the functions which previously had been filled by wares made by traditional folk potters in this country.

The American public was becoming much more sophisticated and the sales of fancy imported wares flourished over the following years. The real threat to the traditional folk pottery markets was, however, not to come from abroad but was steadily growing in this country.

Many preindustrial pottery centers developed during the period between 1810 and 1830. Natural waterways and canals were still the only means of "smooth transportation" for freight wares to distant markets and were an important factor in the location and growth of these centers, as was the availability of good clay and fuel.

Besides the already mentioned centers of production in New York State, New England, and eastern Pennsylvania, several important areas of pottery production developed in western frontier settlements.

The first pottery west of the Allegheny Mountains was established in 1784 at Morgantown, West Virginia, by an earthenware potter

of French descent named Jacob Foulke. William McFarland moved north from Kentucky, settled in Cincinnati, Ohio, and was making earthenware about 1799. By 1819 there were three earthenware potteries in Cincinnati employing fourteen men.

Stoneware was first made in Ohio by Samuel Sullivan at Zanesville, Muskingum County, about 1808. Sullivan's success was followed by the establishment of a large shop by Joseph Rosier at Jonathan Creek near Zanesville, about 1814.

In the years to come so many stoneware potters followed Sullivan and Rosier to Muskingum County, "attracted by the fine stoneware clays of the vicinity, that by 1840 there were twenty-two potteries in the county, representing a capital of eighteen thousand dollars, nearly half of that invested in the industry in the entire state at that date. Being close to the Ohio River, they were able to take advantage of the transportation it offered, and supplied the entire Ohio and Mississippi valleys as far south as New Orleans with stoneware." [23]

During the same period, several stoneware potteries were established in Tuscarawas, Stark and Summit counties in Ohio. Deposits of stoneware clay were found in Springfield Township, Summit County, in 1806, but it was not until 1828 that Fisk and Smith established the first stoneware pottery in the county. By 1840 five potteries were operating in the county and by 1870 that number had risen to upwards of thirty-five or more: Akron, the county seat, was known as "Stoneware City."

Until 1820, most areas of pottery production were decentralized. A shop with a staff of six men was considered a large operation but production was limited. In Ohio the fast-growing population absorbed most of the wares made locally and surpluses were shipped down river to other settlements.

Merchants were looking for cheaper wares and wider markets. Potters hastened to develop easier ways to produce wares and cut expenses. Potters often moved to the source of materials to set up shop, but even then so many problems beset most of these prefactory shops that they often failed.

Many highly skilled eastern potters moved to the Ohio River Valley during this time to take advantage of the growing business opportunities provided by the rapidly expanding population and the natural resources of good clay, abundant fuel, and inexpensive and ready transportation provided by the Ohio River.

One of the outstanding characteristics of most early potters op-

FIG. 11. Evolution of the American Bean Pot. (Drawn by Joe Vitek.)

erating full-time shops was their strong desire to get ahead in the world. Many of them strove to industrialize but lack of markets and means of trade and transportation hindered the growth of mass production.

The first successful pottery factories in America were established in the late 1830's, almost a hundred years after the same transition had taken place in Great Britain. The evolution from full-time shops to factories in this country, however, happened a great deal more rapidly than in England. The advanced processes of mass production developed in English potteries were brought to this country by immigrant potters. Some potters even brought molds and patterns with them which they had used at home. The imported techniques were readily adapted to American materials in several small factories throughout the country. As industrialization accelerated and the problems of capital, credit, markets, raw materials, labor, power and transportation were solved, several centers of mass-produced pottery began to appear.

Pottery centers in England had developed near available sources of coal because wood for firing was very limited. In America wood for fuel was abundant in all areas, consequently the industrial potteries developed near deposits of superior clay.

Strangely enough, neither New York City nor Philadelphia—the beginning centers of stoneware production in the eighteenth century —developed into important industrial centers of the mid-nineteenth century. The areas that did emerge in the mid-1800's were centered around Bennington, Vermont, and later East Liverpool, Ohio, and Trenton, New Jersey.

The first mass-produced pottery in America was made in two-piece press molds. The process was very simple and required little training. The ware was formed in plaster of paris or bisque clay molds by pressing a layer of clay in each side of the mold and smoothing the inside of the pot. The pot was then allowed to dry and shrink enough to be removed from the mold and finished.

The process of press molding was soon replaced by slip casting which was faster and more efficient. Clay slip, the consistency of heavy cream, was poured into dry plaster of paris molds. The plaster absorbed the moisture from the slip touching the sides, forming a shell. When the shell, or sides of the pot, reached the proper thickness the mold was inverted and the slip was poured from the inside of the cast pot. The pot was then allowed to dry in the mold until it was leather hard. The mold was then taken apart so that the pot could be removed and finished.

The transition of potteries from part-time to full-time shops to small factories in the United States often coincided with the development of different types of ware. The whitewares that were ultimately made at East Liverpool and Trenton, like the imported white crockery from England, did not directly compete with most functions met by traditional stoneware products. The thing that hurt traditional folk potters was that factories continued to make and distribute traditional wares along with their mass-produced products.

John Norton first made earthenware at Bennington in 1795, and by 1815 was also producing stoneware. Christopher Webber Fenton, sometimes refrerred to as the "American Josiah Wedgwood," in 1837 joined the Norton pottery, which was then owned by Julius Norton, John's grandson. By 1840, Norton had advertised "fancy pitchers" which were probably the first Rockingham ware made at Bennington. In 1843 Norton and Fenton formed a partnership.

"During the four years of his association with Norton Christopher Webber Fenton, ambitious to make Bennington the Staffordshire of America, experimented with new clays and new techniques. Towards the end of 1843, John Harrison, who had been employed at the Copeland works in England, came to Bennington to help bring the project to fruition." [24]

Harrison taught Fenton a great deal about glazing and the development of clay bodies as well as how to make and glaze porcelain. In 1847 the partnership with Norton was dissolved, and Fenton moved into the north wing of the Norton pottery where he continued to

61

experiment and develop a new line of decorative wares. During this period of experimentation Fenton developed a new method of coloring the transparent flint glaze he was using and patented the process in 1849.

The technique was simple: coloring oxides were sprinkled over the ware, which had first been bisque-fired and dipped in the clear glaze. The result was a mottled glaze combining tones of blue, yellow, orange and green. Fenton's "flint enamel ware" was considered a great improvement over the earlier Rockingham ware with its mottled brown glaze.

In 1853 Fenton was able to interest a group of backers in his wares and a corporation was formed under the name of the United States Pottery Company. By this time Fenton was using kaolin from Charleston, South Carolina, for his clay body. The United States Pottery Company was soon mass-producing wares valued at $1,500 a week, finding ready markets.

The United States Pottery Company produced several types of wares, including common white crockery, yellow earthenware, flint glazed ware, Parian porcelain, a semiporcelain, and lava or scoddled ware. Fenton's price lists included a large number of production items: "water urns, soda fountain domes, coffee urns, stove urns, slop jars, foot baths, ewers, wash basins, chambers, bed pans, bread bowls, soap boxes, brush boxes, spitoons in five sizes, pitchers in seven sizes from one-half to six quarts, molasses pitchers, coffee pots in three sizes, teapots in five sizes, sugar bowls, creamers, pipkins, cake pans, oval bakers in six sizes, nappies from six inches to eleven inches, pie plates eight inches to eleven inches, lift cake pans, Turk's-head cake pans, milk pans, butter, soup and pickle plates, flower vases and pots, preserve jars in four sizes, round preserve jars, plug basins, goblets, flange mugs, tumblers, tobies, candlesticks, and low candle sticks, each in three sizes, fancy bottles, book bottles, one pint, two quarts and four quarts, pocket flasks, wafer boxes, shovel plates, picture frames, lamp bases and pedestals, eight inches, nine inches and thirteen inches in height, sign letters, doorplates, Parian or enameled, number plates with figures, curtain pins, furniture knobs, and doorknobs, enameled.

"It is amazing that such a variety of objects and so many kinds of bodies and glazes should have been developed in the short space of ten years, for the Bennington venture died in 1858 after little more than a decade. It is said that over-production combined with poor methods of marketing the wares were contributing causes to the fail-

ure of the works. Fenton's pottery was sold just as in the old days of peddling redware, by sending it out to country stores on wagons." [25]

The whiteware industry which developed around East Liverpool, Ohio, and Trenton, New Jersey, became the industrial pottery centers of the nation in the last half of the nineteenth century. It is somewhat surprising that the industry developed first in East Liverpool and that a potter from Trenton went there to induce three potters, William Bloor, Henry Speeler and James Taylor, to move back east to help set up the Trenton factories.

"Whiteware, which in a broad sense may be considered to include creamcolored, white granite, semi-porcelain, and china or porcelain ware, is one of the progressive steps in the evolution of pottery which began with rude earthenware and ends with fine porcelain. In Ohio, the transition from the lowest to the highest grades required time, owing largely to lack of suitable materials rather than to lack of knowledge in preparing or of skill in making the finer products.

"The successive stages in the development of whiteware in Ohio are marked in a general way by the production of red earthenware by William McFarland of Cincinnati in 1799; of stoneware by Samuel Sullivan at Zanesville about 1808; of yellow and Rockingham ware by James Bennett at East Liverpool in 1840; and of whiteware by William Bloor at East Liverpool in 1860." [26]

By 1840 steamboat and rail transportation began to determine the location, organization and distribution of factory shops. Commodities could be brought from distant factories to the country store and the farmhouse cheaper than they could be made locally. Markets expanded rapidly beyond local consumption and traditional craftsmen who had previously completed their products from start to finish, were now being replaced by designers, technicians and laborers in the factories.

The increased demand for wares led to the installation of numerous labor-saving devices in the factories, the modification of old techniques and the invention of mechanical shortcuts. Clay bodies and glazes were standardized and most wares were modeled after contemporary, imported Staffordshire. New forms and decorative motifs were slowly developed with "an efforescence of ornamental design not always in the best of taste." [27] The industrialist generally had little interest in good design. His main interest was in increased production and monetary return.

As the factories replaced the true craftsmen with semi-skilled la-

borers doing just one phase in the production of ware, standards of quality, good workmanship, integrity and pride in the finished product disappeared. With the increased use of machinery, workmen became less conscientious and the quality of wares decreased considerably.

Small industrial potteries started up all over the country, many only to close their doors because of competition or technical problems. One of the major problems was ground materials, mainly feldspar and flint. There were no public grinding mills available and all ground materials had to be imported until 1864 when Golding, Gillingham, Morrison and Carr started a grinding mill in New York City to supply the industry in New York and New Jersey.

By 1860 larger towns that had earlier boasted a half a dozen full-time traditional stoneware potteries were down to one shop. And the overproduction of mass-produced items made many of these supplement their income with the production of firebrick and drain tiles.

Railroads were sufficiently developed by mid-century to be the main mode of transportation; freight rates were falling and country potters even in remote areas were feeling the squeeze of domestic wares. The pottery factories had large inventories on hand and could make shipments on short notice. Postal service was greatly improved and "drummers" (or salesmen) began to stop at the stores along rail lines at regular intervals. The competition made many country potteries close their doors just before the Civil War.

During the Civil War, some potteries in the northern states continued to produce only traditional wares, but most shops strove to take advantage of markets for newer types of wares. In Maine the Corliss pottery was still producing earthenware. A price list put out by John Corliss about 1863 specifies: cream pots, bean pots, milk pans, stove pans, bread pans, jugs, and flower pots. "It is interesting to note that the demand for common redware cooking pots and pans was still strong at this comparatively late period. A little arithmetic shows that the Corlisses turned out more than seven thousand of these vessels, besides bean pots and stew pots, in about one year. Lighter and more convenient receptacles of tin and other ware were soon generally used, however, and during the next ten years the need for redware gradually became limited to flowerpots." [28]

The South, during the Civil War, was cut off from commodities produced in northern factories and relied heavily on homespun and folk industries. When the war broke out, the first concern of the

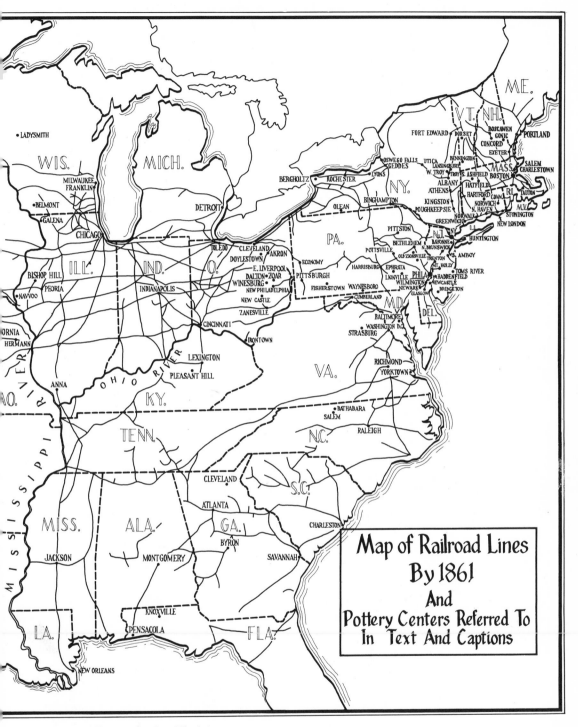

Fig. 10. (Drawn by Joe Vitek.)

Confederate government was to equip and supply an army. The major problems in doing so were the lack of factories and skilled labor. Potters in some places were conscripted and held under guard while they produced bowls, mugs, medicine jars and telegraph insulators.

The situation faced by the southern potters after the war is recorded by Alvin H. Rice in his *Shenandoah Pottery:* "After the war all business was at a stand-still. An attempt was made to re-open the pottery. Money was scarce and materials were hard to obtain. Copper kettles, zinc utensils, and lead weights were melted and used for glazing." [29]

With the end of the war in the spring of 1865 the country was again united and business interests switched their emphasis from the manufacture of war goods to commodities usable in the home. In the years that followed, as manufacturing techniques became more industrialized and new products were developed and marketed, the centuries-old, traditional way of doing things and making things fell into disuse. The decline of the craft traditions in America accelerated greatly in the decades after 1840, but the beginning of the end can be traced to conditions which existed prior to the Revolution.

Imported wares from Europe throughout the eighteenth and nineteenth centuries and the establishment of the factory system in potteries in this country in the mid-1800's were both important factors in the decline of the American folk pottery tradition. However, the major cause which led to the complete disappearance of the folk traditions was advance in technology and the evolution of an industrial society. This was not only true in the United States, but all over the world; as countries industrialized their folk traditions declined. In America, before the Revolution, technical advances were inhibited and slow in developing, but by 1860 the United States was well on the way to becoming a leading industrial nation.

The decline of the folk pottery tradition in this country can be fairly well traced and a definite inverse relationship to technological advances becomes apparent. It is only possible, of course, to generalize about the tradition as a whole because the closing of individual potteries may have come about for any number of reasons. Many small country shops in the nineteenth century were still operated by farmers as a sideline and slowly went out of business over a period of years, or were terminated suddenly by fire or the death of the potter.

The first earthenware potters in the colonies made a limited num-

ber of forms and no doubt each form served several functions. As the tradition developed, the number of items which the potter made increased and each object became more specialized. Potters competed with craftsmen, working in other media to meet all household requirements.

Clay, however, was the only natural material from which cooking pots could be made and until iron foundries began producing molded pots and pans in an area the earthenware potter often provided many of these items.

Before the Revolution, earthenware potters were producing utilitarian wares to meet every possible need, either as a production item or by special order. By the end of the eighteenth century stoneware replaced most of the earthenware items except in out-of-the-way places and on the frontiers. However, some forms and functions natural to the earthenware tradition, such as flower pots and vases, pie plates, baking dishes and porringers, continued to be made by those potters who had switched from earthenware to stoneware production. Earthenware was better for baking dishes and for those used to serve hot food because it withstood thermal shock much better than stoneware, and flower pots and vases were much more attractive when glazed with colorful lead glazes and slip decorations.

Allowing for slight modification, local style and individual interpretations, some forms continued to be used for more than two hundred years without change in either shape or function. The milk pan, churn, crock and lard pot are good examples of this continuation.

The local or colloquial name used for these and other pots varied in different areas and during different periods, but the functions remained the same. The milk pan was replaced in most areas after 1830 by tinware. The country wife gladly discarded her heavy pottery milk pans for the convenient, lightweight tin pans which were sold door to door by New England peddlers.

The dasher-type churn was used in many areas in the United States until well into the twentieth century. Many types of mechanical churns were invented in the nineteenth century but because of the lack of anything but hand power in farm kitchens they provided little advantage over the inexpensive, institutionalized dasher churn.

Stoneware crocks remain in use today. They provide a sturdy, easy-to-clean, noncontaminating container for preparing foods which require long periods of storage before use, such as sauerkraut, mincemeat and pickles.

The lard pot, which was one of the first shapes made in the colonies (see fig. 1, second from left), was finally replaced for that function in the 1870's by a mass-produced tin pail with a close-fitting lid and bale. The lard pot, or "common pot," was a general-purpose container—probably the most regularly produced vessel by earthenware potters. It was used for storing dye, soft soap and apple butter, as well as lard, and was adapted by the early colonist for baking beans and other foods.

The bean pot, as we know it today, evolved slowly. A lid was eventually added to keep the moisture in, thus requiring less of the cook's attention. By 1840, after the advent of the iron cooking stove, a small loop handle was added so that the bean pot could be easily pulled from the back corner of the oven with the hooked end of the stone poker.

The folk potter's response to the need for new types of containers for the modern method of sterilized canning developed by Nicholas Appert in France about 1810 was the corker (Page 125) and the airtight jar (Page 166). This market was soon lost to the factories which could produce the jars by the cheaper slip-casting method in great quantities. The screw-top glass "Mason jar" was patented in 1858 and glass factories soon dominated the market. The industrialized potters followed with a screw-top stoneware jar, but were unsuc-

FIG. 12. Keystone Pottery, Washington County, Tennessee, usually referred to as the Decker Pottery, *ca.* 1870–1910. *Left to right:* Son of Charles Decker; Duncan, a helper; Son of Charles Decker; Apprentices; Charles Decker, owner, at the wheel. Stoneware pots, *left to right:* funnel, yard flower pot on stand, flower vase, handled jar, crock, harvest water jug, small yard flower pot, chicken waterer, molasses jug, straight-sided crock, small crock, yard flower pot, crock, whiskey jug, pitcher, and churn with pot sitting on top. Note tools and large ring bottle hanging on the wall. Charles Decker was trained by his father in Germany. He immigrated to the United States in 1846 at the age of sixteen. Decker first settled in Pennsylvania. Sometime after the Civil War he moved to Tennessee and set up the Keystone Pottery; eventually his employees numbered twenty-five. From an article in the Johnson City (Tennessee) *Chronicle*, December 3, 1967, in which Dorothy Hamill recorded the story of the Keystone Pottery: "During the winter, while the kiln was fired, a dance was held in the pottery every Wednesday and Saturday night. Decker's son, Dick, was a fiddler—'the greatest in the world,' his nieces declared. He also played the banjo and guitar. The warm pottery then became a gathering place for the neighborhood, and there were square dances with refreshments of apples and cider and homemade grape wine." (Picture, courtesy of Paul M. Fink, Jonesboro, Tennessee.)

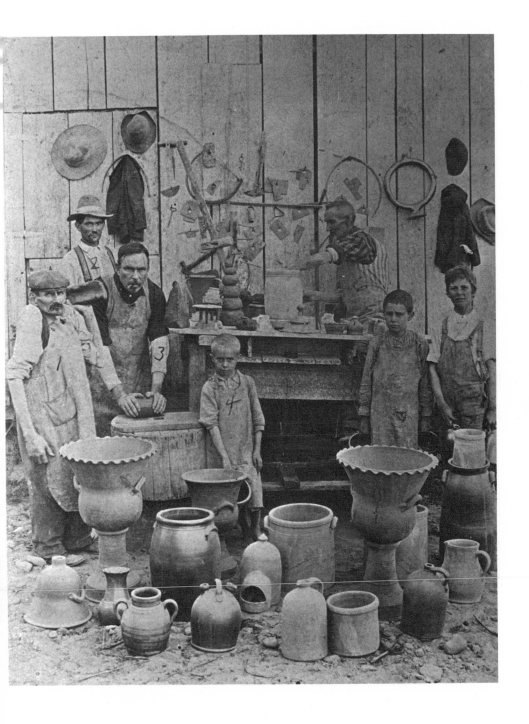

cessful in competing with Mason's glass jar. Food preserved in the glass jars could be checked for spoilage and at the first signs could be saved by immediate use.

The rubber ring seal in Mason's screw-top lid depended on the prior invention of vulcanized rubber by Charles Goodyear in 1839. Rubber seals were also used in the invention of the "lightening stopper" which was a porcelain plug with a rubber seal held in place by a wire clip. The lightening stopper was used to cork carbonated soda water and beer in stoneware bottles during the mid-1800's.

One of the changes brought about in the social habits of the American public by industrialization was the rise of "fashion" in the 1830's. The shapes and style of products which for two hundred years had been determined by tradition, were now set by factory designers and manufacturers. To absorb the tremendous increase in production of commodities brought about by the use of the factory method, manufacturers began to promote the idea of fashion and obsolescence. Before this time, people mended, patched and "made do" with the furnishings they were able to buy or which had been handed down by their families. However, with the introduction of inexpensive, mass-produced goods, people began to replace, rather than to repair, their old utensils. As the standard of living rose for the common man and his desire and ability to attain material status increased, it was a short step from replacing worn-out furnishings with new to the replacement of out-of-style articles with fashionable ones.

The commercialism that developed in the mid-1800's, brought about by the division of labor and the use of machinery, was a very positive social development because it increased the goods and opportunity for a large number of people. The effect on design, however, was generally disastrous, as commercial designers were more interested in designs for efficient production than in good forms.

Glass tableware, which for centuries had been a status symbol of the wealthy, came within the reach of the common man's economy about 1840. Glassware manufacturers were more in competition with mass producers of chinaware than folk potters but the glass tumbler soon replaced the stoneware mug on the table and in the tavern.

By 1850 the glass industry was rapidly expanding and was able to produce bottles and jugs much more cheaply than stoneware potters could. There was a growing demand for glass bottles from the manufacturers of whiskey, bitters and patented medicines. After the Civil War commercial food packers were also using great quantities of

glassware, rather than stoneware, because the customer could see what he was buying. Stoneware whiskey flasks disappeared early and the final blow to stoneware bottles came in 1892 with the invention of the modern crown top for sealing glass bottles.

After the Civil War most American households could supply their needs with factory-made goods. Metal pails and tubs, enameled cooking pots, and tinware kitchen utensils were available at every country store. Many people were still suspicious of commercially canned foods and put up hundreds of quarts of vegetables, fruits and meats in the new "glass cans." For the first time in history people were able to "banish the dull monotony of winter 'cellar' vegetables and salt rations." [30]

The use of refrigeration to preserve foods before 1800 was generally unknown. Ice was expensive and was used by those who could afford it only to cool drinks and make ice cream. In 1803, a Maryland farmer, Thomas Moore, invented and patented a refrigerator wagon to transport his milk to market. The idea spread slowly, but in 1827 Nathaniel Wyeth invented an ice cutter which revolutionized the ice industry. By 1838 the icebox refrigerator was considered a kitchen necessity, particularly in larger towns and cities. People were now able to keep meat and other perishables, use leftovers and purchase large amounts of food at a time.

About 1860, with the introduction of factory dairying and the growing use of the icebox, people in many areas began to depend on outside sources for their dairy products. Fewer people milked their own cows, churned butter and made cheese. These changes in social habits, as well as the introduction of new products, greatly affected the local potter's market.

Another major technical advance was the discovery and use of petroleum for lighting. Kerosene lamps were invented about 1859 and by 1865 were the most common means of producing artificial light. As candles and fat lamps fell into disuse, country potters had fewer calls for household lighting fixtures.

Other smaller inventions replaced many of the age-old functions met by vessels produced by traditional potters. In 1850, baking soda and cream of tartar were being used as a leavening agent for baking, replacing the saleratus crock and "emptin" pitchers. With the invention of the self-sealing envelope in 1850, the discovery of the process of the modern method of making paper from wood pulp in 1869, and the invention of the steel nib pen in the early 1800's, sand shakers for

blotting ink and other writing accessories were replaced. Changes in smoking habits with the introduction of the cigar and cigarette and manufacture of other styles of pipes led to the disappearance of the fragile clay pipe. Admittedly, these minor inventions are of small significance in the decline of the production of folk pottery in comparison to the effects of mass-produced wares which were placed on the market by both domestic and foreign manufacturers.

As the pottery industry in the United States developed in the years following the Civil War, the government passed tariffs which helped to protect local markets. These tariffs were, of course, of most advantage to large manufacturers, but no doubt traditional potteries still in operation received some benefit from them.

In 1883 the old tariff of 1862 of 20 percent on undecorated and 35 percent on glazed and decorated wares was raised to 25 percent and 50 percent, respectively. In 1890 the tariff on decorated wares was increased to 55 percent. After the national election of 1892, there was a severe depression and business suffered a rapid decline. "No one could sell anything and no one had any money to pay for what they did buy. And as this wasn't enough, the Society of American Florists about this time adopted a standard flower pot, and all members pledged themselves to use no other. The new pot involved a new and much more expensive method of manufacture, and then the next year [1894] the new administration passed the new tariff bill, which cut the duty on the cheaper grades of pottery more than one-half. It brought potters in this country into direct competition with those of Holland and Belgium, where the wages were more than 75% less than in this country." [31]

The great fairs such as the New York Exposition of 1853 and the Centennial Exposition of 1876 at Philadelphia were also factors which led to the breakdown in the traditional crafts. The fairs emphasized the technological advances and their advantages in the factory, on the farm, and in the home. At the Centennial Exhibition in 1876 a large collection of classical forms and Oriental art were shown for the first time. Many potters were greatly inspired and a trend toward art wares and knicknacks began to develop. Potters who had the benefit of some artistic training began to develop a greater variety of glazes, and to consciously create objects of art patterned after the ancient wares of China and Greece. Until this time, beauty in American pottery had been a spontaneous, subconscious expression in wares produced primarily for utilitarian purposes.

The earthenware tradition thrived for two hundred years and the stoneware for half that time. Changes happened rapidly at times and slowly at others. Only from our modern day perspective can we reconstruct the past and make sketchy generalizations about such vague subjects as traditions, which were a composite expression of thousands of people. It is hard to estimate the strength of the many forces which led to the decline of the folk pottery tradition in America: competition from imports, industrialization, technological advance, and social change.

Nevertheless, slowly, one by one, the folk potter's main production items fell into disuse. Some potters hung on by specializing or making sideline items for other industries. During the colonial period potters sometimes made bricks and tiles, water pipes, glass pots and iron kettle molds in order to supplement their incomes. In the nineteenth century, as industrialization spread and the markets grew smaller, the folk potter sometimes made thousands of flower pots to meet the growing demand from home owners and the commercial flower growers. Others made drain tile, "stone tubes," and flue tiles as well. In the 1870's some potters made emery wheels as a sideline, firing them among the flower pots. When the market for flower pots dropped off, many potters continued to specialize in making emery wheels and other refractory items for the growing metal industries.

Most small potteries in the northern and middle eastern states went out of operation by 1880 leaving only the southern highlands the stronghold of folk pottery (See Fig. 9). As roads and railroads penetrated the back country, only a few potteries continued in operation. The majority of these relied on stoneware whiskey jugs which they produced for local distilleries. When Congress passed the Prohibition Amendment in 1919 most of the surviving potteries closed their doors and the era of American folk pottery ended.

Design

American folk potters knew little about the history or origins of their craft. A few were well educated and familiar with classical forms but, for the most part, they had little education and knew nothing about the laws and theories of design which had been developed in ancient cultures. Forms and decorative motifs were passed on from generation to generation in the same way as was knowledge about methods and materials. John Ramsay in his *American Potters and Pottery* points out that, although early American potters lacked formal training in design, and in spite of the fact that their wares were limited by being severely practical, ". . . they not only obeyed those unknown laws of dynamic symmetry, but reproduced, with surprising fidelity and frequency, those Greek urns and early Chinese bottles of which they had never heard." [32]

This phenomenon was also noted by Jacques Busbee, a great admirer and promoter of North Carolina folk pottery, in a letter to his wife: "As the potter turns, the clay assumes various forms. . . . Almost all the shapes of antique Chinese pottery flicker before you in

the technique of hand turning. What I mean is that Chinese and Japanese shapes are structural in the sense that they are the forms almost automatically developed by the technique employed." [33]

In all probability Busbee is right in his assumption that there are certain prime shapes inherent in the process of forming clay on the wheel and that they will inevitably occur whenever and wherever potters reach a certain level of craftsmanship.

The mood of American folk pottery differs somewhat from earlier Oriental wares in that it expresses such an urgency for function. For example, the small, gracefully turned foot, found on Oriental wares was rarely used by American potters. American pieces invariably stood on a wide, stable foot, which was finished on the wheel during the original forming process.

Along with strict utility, durability was a second and equally important feature. Traditional American wares had relatively thick walls and were made to withstand hard daily use. Delicate, thin-walled pieces were sometimes produced by some earthenware potters for table services, but this was never a common characteristic of the American traditions.

American potters, unlike those of early China, were never patronized by the wealthy. There were no "palace wares" made only for the use of the court. The American folk potter's product was made to meet the needs of the common man. Yet, many pieces of American folk pottery reach the high plateau of quality and beauty which is so apparent in the wares of the Sung Dynasty of Twelfth Century China.

It is difficult to establish hard-and-fast rules with which the design the quality of pottery may be judged. In the case of American folk pottery a criterion for criticism is somewhat simplified because the wares were strictly utilitarian.

The form of the vessel is of first importance. In utilitarian pieces the form should be exactly appropriate for its use. If the vessel does not function properly for its intended use, it loses a great deal of aesthetic quality.

A pitcher is a good example of this. The form should be not only pleasant to look at but also light, because of the added weight of the contents. The handle should be placed to balance the weight of the pitcher and contents while being carried and poured. The spout ought to be adequate for pouring and should not drip. The mouth must be large enough for easy cleaning and the foot broad and stable to prevent spilling. Should any of these qualities be lacking in the

pitcher, it will not be used, for objects meant for use but which do not function are extremely frustrating.

In the case of decorative forms the emphasis is placed entirely on the pot's visual and tactile affects. Form is still of first importance, but strict utility is replaced by the ability of the piece to arouse an emotional response from the viewer.

Ornamentation, which is of secondary importance in utilitarian ware, is very important because color, texture and decorative motifs all enhance the form, thereby increasing the total effect of the piece. In either case, functional or decorative, bad form cannot be saved by good glazes or decorations.

Equally as important as the vessel's good form is its vitality, or "life." This subtle quality is an expression of the spirit of the maker and the culture in which he lives and works. Vitality is transmitted intuitively by the potter to the form and no matter how many design principles have been applied, if the pot lacks life it will not transcend the common.

In a day's production, some pots will, more or less, have this vitality, depending on the potter's ability to visualize and express the prime form of the object he is making. Occasionally the potter's intention or ideal is realized and the resulting pot is a true expression of beauty.

Besides the functional requirements and the spirit of the piece, there are several basic rules which apply to all good pots. The pot should reflect openly and honestly the materials and methods of construction used in its production. Low-fired, slip-cast ware with spiral rings imitating throwing marks and pseudostoneware glazes are completely dishonest in their conception and execution.

Techniques used in construction should be only a means to an end. The most simple, direct and practical methods of construction should always be used. If the end result is a beautiful pot, the techniques used in achieving that end have served their purpose and are of secondary importance.

The materials should be appropriate for the design. Coarse-grogged clay would not be appropriate for making thin, delicate shapes, just as a smooth porcelain body would not be suitable for heavy, sculptured pieces.

The pot should be in harmony with its surroundings. A highly decorated piece of Chinese porcelain would be out of place in a frontier log cabin, as would an austere brown whiskey jug in the sitting room of an imperial palace.

These rules or attitudes are necessary requirements in producing quality ware. They are a matter of integrity in craftsmanship which develop along with the potter's technical skill, aesthetic sensitivity, and artistic maturity.

To understand why a particular piece of pottery is or is not good, requires some understanding of the principles of design. However, it should be remembered that these principles are not inflexible, and even though one or more of them may be broken, the resulting object may be aesthetically superior.

The first principle to consider is *proportion*. Proportion is the comparative relationship in the size of the parts of the object or their division of space, both of which are basic to visual satisfaction. Proportion involves the size of the main mass or masses of the form, how these spaces are divided, and their relationship to added appendages such as handles, spouts, lids, knobs, and lugs. There are no set rules in how this harmony of parts is to be accomplished, although some ratios of size are universally accepted as being more pleasing to the eye than others.

Balance helps greatly to establish good proportion. The principle of *balance* implies the equality of weight on either side of a central axis producing an aesthetic equilibrium. Balance of interest may be accomplished in form, glaze color or decoration, or any combination of the three.

The principle of *symmetry*, in turn, helps to establish balance. Symmetry means the similarity of form or decoration on either side of a central axis. Symmetry in form evolves naturally in the technique of forming pottery on the wheel; both sides of a well-made pot reflecting exactly the same shape. *Asymmetry*, which is the placement of unequal elements at different distances from the central axis, may also be used to achieve balance.

Unity suggests a oneness of purpose with no division of interest in the parts of the piece in reference to form, glaze, decoration, and spirit. The principle of *unity* establishes continuity which leads to complete harmony of the whole. Unity requires that handles and sprouts must be in the appropriate style and applied in a fashion so that they appear to be a part of the whole.

The principle of *subordination* means that the character of the work is set by a single dominant element around which the lesser parts are organized. The dominant element could be the form as in early Oriental wares, the decoration found on Greek vases, or the radiating

crystals of certain glaze effects. The dominant feature of a pot usually makes the strongest impression.

The last principle, *harmony*, means the compatibility of all the design elements which include line, shape, space, mass, form, color, tone, and texture. Harmony is achieved by applying the appropriate design principles, either consciously or subconsciously, to obtain agreement among all the parts or elements which make up the whole object. Harmony, vitality and honesty are essential principles in creating beauty.

These major design principles are generalizations which help people to develop understanding and critical judgment with which to view art and craft objects. The appreciation of created objects may be further expanded by understanding the elements of design which are the variables that are governed by the design principles.

The element of line, as used in defining pottery, refers first to the contour line which forms the boundaries of the shape. Contour lines are either straight or curved; male or female; for strength or for beauty. They imply direction and speed of movement as the eye travels upward from the foot to the lip of the pot. Vertical lines for rapid growth, diagonal lines for movement and change; curved lines for slow movement and grace; horizontal lines for rest and repose. Lines are forces that call for emphasis where they change direction or cross. They should end with a certain definiteness at the foot and rim.

As well as defining the shape of a pot, lines are used to divide space into proportional areas and to apply decorations. Lines may be used to express any attitude or mood: bold, decisive, weak or delicate. Lines also directly reflect the skill, confidence and character of the maker, which may vary from strong and direct to nervous and uncertain to clumsy and frustrated.

It is impossible to separate line and shape. Line encloses shape, which is the two-dimensional aspect of the pot and defines its height and width. In pottery, shape and form are used interchangeably, but technically shape represents the cross section of the pot (as in a drawing), and separates it from space.

Space, when not limited to shape alone, is three-dimensional and refers to the defined area within the object as opposed to the limitless space around it. Both the positive space (the object) and the negative space (the area around the object) provide contrasting shapes of interest for the viewer to enjoy.

In pottery, spatial organization, which is the three-dimensional de-

sign of form, texture and color, is more important than shape or space division which is two-dimensional. A three-dimensional pot may be viewed from innumerable directions and should be pleasant to the eye from any angle.

Mass, like space, is three-dimensional and implies volume but refers only to the space contained in the form. The form of a pot may have any number of mass areas of indefinite shape and size.

Form is three-dimensional, including height, width, and depth, and represents the whole pot except for such surface effects as decoration, texture, glaze color and tone. Pottery forms are not found in nature; therefore they are abstractions of man's mind. Most pottery forms can be easily analyzed by reducing them to the simple geometric shapes from which they were derived, such as the square, rectangle, and circle. Some forms may involve more than one basic shape or a repetition of the same shape several times.

Color, in relation to pottery, is technically the light rays reflected to the eye from the glaze or clay body. In reference to design analysis, color may be described as having three qualities: hue, value and intensity. The hue determines what most people call color: red, green, or blue. Value refers to lightness, and darkness from white to black. Intensity, or saturation of color, determines the brightness of the hue in relation to the value. "Every Hue has its range from brilliant to neutral for each Value step from darkest to palest." [34]

The consideration of color is a vast subject and too lengthy to record in detail here, but a few major points will help in the criticism of pottery.

The color scheme in reference to glazes, decoration and exposed clay body is an essential part of the total pot and will greatly affect the outcome of the piece's aesthetic appeal. Color should not overpower the form. Strong hues and bright values should be used with care. The color scheme and other decorative effects, must be planned and should have an orderly purpose. Colors ought to be appropriate to the function of the pot. Equally important to color, and greatly affecting it are the elements of tone and texture.

Tone is the contrast of light and dark areas in a decoration, glaze color scheme, or pattern, and refers to the *quantity* of light reflected, as the color element refers to the *quality* of light reflected. Tone affects the sharpness of the design and greatly influences the mood of the whole piece.

Texture refers to the surface qualities of the form and affects both

the sense of sight and touch. Textured surfaces should be not only pleasant to look at, but also pleasant to hold and feel. Texture may be either impressions made in the plastic clay body or in the crystalline structure of the glaze. The number of textural effects that can be applied to the moist clay form are infinite, but they should always be appropriate to the form and function of the pot. The simplest, most direct, and often the most pleasing, textured surface is that which occurs naturally in the process of forming the piece. Throwing marks are a good example. They should be in scale to the form and should not appear as applied decoration, but occur naturally as a result of the technique.

Texture in the glaze may range from smooth to pebbly, and opaque to transparent. The first affects the sense of touch and the latter, the vision of the viewer. Glazes may function to enhance impressed textured patterns, add color, and in utilitarian wares they insure that the pot is watertight and easy to clean.

These design principles and design elements are the tools used by artists and craftsmen in their daily work, and are the bases for making aesthetic judgments of any object created by men. As presented here they apply mainly to pottery, but basically they apply to all the arts, crafts and trades. As understanding of these principles develops, aesthetic appreciation is greatly increased and confidence in one's taste becomes securely established.

In analyzing the designs of early American folk pottery one of the first things which becomes apparent is that beauty does not require a complicated structuring of design elements. The forms used are simple, as are the decorations and glaze effects, and harmony among the elements is achieved by the most fundamental and direct means.

The first impression is that the form dominates the other parts or elements of the piece (Page 3). Handles, spouts, lips and knobs are appropriately subordinated to create a pleasing unity of the whole. The domination of form is characteristic of both the stoneware and earthenware traditions, except in the highly decorated presentation pieces made by Pennsylvania-German potters (Page 269).

The mass arrangement of the form is usually simple, seldom divided into two or more areas.

The contour lines of the shape are either free-flowing, rising gracefully upward from the foot to the lip (Page 238), or straight and strong, sometimes angling sharply at the shoulder toward the neck (Page 136), or ending abruptly at a strong rim (Page 134). The lines

of growth are simple, yet invariably confident and strong. Reverse curves were occasionally used and were usually emphasized by an incised line or banding at the neutral area where they change directions (Page 198). Lines and bands were also used to divide the spaces in the main shape into pleasing proportional areas (Page 172), to emphasize a change in direction (Page 124), or to make a transition in the forces of opposing lines (Page 100).

Balance in form was always symmetrical and was often reinforced by an actual central axis rendered in the decoration (Page 262).

Symmetry was also the usual means of obtaining equilibrium in decorations (Page 212), although asymmetrical decorations were sometimes used (Page 257).

Interest was often heightened by the repetition of line in the form (Page 4), or the interaction of line in the shape and the decoration (Page 164). Rhythm sometimes appeared in the repetition as in alternating bands and spaces (Page 131), or in the patterns applied by coggle-wheel rollers.

There was usually a strong relationship between the foot and rim defining the borders within which the shape of the piece was framed. This relationship between the foot and rim was established either by size (Page 89) or similarity in shape (Page 167).

Color in reference to the fired clay body depended largely upon the amount of iron oxide and other natural colorants in the clay. The colors of earthenware bodies were mostly from the warm side of the spectrum, including yellow, orange, red, tan, brown, and white. Stoneware bodies were usually gray, but clay used at some potteries burned tan, brown, light yellow, orange, or off-white. The color value and intensity of both types of clay body were below medium, toward light and pale.

The varieties of earthenware glazes and effects were numerous even though early American potters had a limited number of coloring oxides at their disposal. The following hues were common: black, brown, red, orange, yellow and green. Sometimes the glaze was of a single hue, but more often it was polychrome or broken up by specks, splotches or mottling, either naturally or applied as decoration. The color value of earthenware glazes ranged from medium to light and the intensity covered the entire range from brilliant to neutral.

The element of color was an important factor in establishing harmony between the pot and its surroundings. The naturally warm, rich earthen colors of the clay body and the autumnal hues of nature in

the glazes blended unobtrusively into the simple interiors of the early American home. Quite often a pot was glazed only with a transparent coating of lead, reflecting its rich clay color in the smooth mirrorlike finish.

Most stoneware was salt glazed, which also produced a transparent surface. But unlike transparent lead glazes, salt glazing was hard to control, which resulted in a wide range of surface effects. A smooth, shiny surface, which enhanced the color of the clay body, was desirable, but as often as not the glaze had a broken, orange-peel effect (Page 16).

Gray-colored, salt-glazed stoneware was characteristic of the northern tradition because most of the potteries in the north used clay shipped in from deposits located in New Jersey. Sometimes local clay was added to make the expensive New Jersey clay body go further, changing the color of the fired body.

Albany slip was also used extensively in the northern potteries, usually on the inside of salt-glazed wares (Page 6), but occasionally all over, covering the whole surface of the ware with a smooth, rich brown glaze.

In the southern stoneware tradition, the color of salt-glazed wares varied considerably, depending on the amount of impurities in the local clay deposit. The most common hue was brown, ranging in intensity from very dark to light tan. Wood ash and lime base glazes were also developed in some areas of the South. The ash usually resulted in a variegated green glaze (Page 90), and the latter in a very hard-surfaced, camel-colored glaze, which was highly fluxed, and ran down the sides of the ware.

Engobes or slips, which were applied over the greenware to change the color of the body or as a ground for decorations, were used extensively by Pennsylvania-German potters on their earthenware. Engobe techniques were occasionally used in other locales in both the earthenware and stoneware traditions.

The element of tone used in the decorative effects on early American pottery varied from the lively contrast between the cobalt brushwork on the pale gray body of the northern stoneware tradition to the subtle transition of the color values on the plainer pieces of Pennsylvania-German wares.

The use of textural effects on the clay body was very limited, probably due to the emphasis on utility. Incised lines and decorations were common, but overall textural patterns were seldom, if ever, used.

Even the simple, rhythmic throwing marks were usually reduced to a smooth surface with a rib. Occasionally, combed bands gave a very formal and limited textural area, as did coggle-wheel patterns.

Early American folk pottery was extremely simple in design in comparison to wares of other cultures and the conscious efforts of the artist-craftsmen working in clay today. It was unsophisticated, and often plain; rightfully so, because it directly reflected the culture in which it was produced.

The words that best describe the character of the early colonial settlers, the frontiersmen and later the western pioneers, such as simple, strong, rugged, honest, independent, and vital could just as well be applied to the pottery they made and used.

Another important human characteristic, without which the hardships, the labor, the drabness, and the boredom of settling and surviving in the New World could not have been accomplished, was humor. Early American folk potters had a keen sense of humor which was often robust and rowdy, and which was expressed in a number of ways in their wares: form (Page 243), function (Page 136), decoration (Page 176), inscription (Page 231).

Dating unmarked pieces of American folk pottery is extremely difficult because there are no definite indicators, such as changes in shape, to judge when a particular pot was made.

Fig. 13. Four jug shapes illustrating the trend toward straight-sided forms between 1800 and 1880. (Drawn by Joe Vitek.)

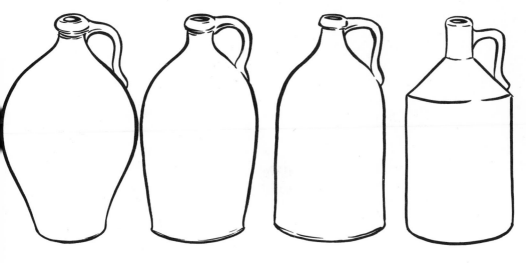

John Ramsay, in his *American Potters and Pottery*, points out that there was a tendency toward straight-sided forms as the tradition developed, particularly in the nineteenth century, but that old traditional forms continued to be made along with the newer shapes, and with such a dedicated exactness that one generation's work could not be told from another's.

The best indication of the period when a particular pot was made is found in its ornamentation, either in the glaze effect or in the style of the decoration. The following chronology may be somewhat redundant in repeating information found elsewhere in the text or captions, but it is necessary to coordinate these factors in relation to particular periods to help give some idea of how to judge the age of unmarked pots. It should be remembered, however, that these changes in decorations or glazes are merely indicators and are not reliable enough to form any concrete or final judgments of age.

During the early colonial period, from about 1640 to the 1720's, only earthenware was produced. This early ware was usually decorated with simple bands of finger impression, or lines incised with a sharp stick, or with throwing marks (fig. 1). Most pieces that were glazed had a thin coating of transparent lead on the interior only.

Stoneware was first made in the 1720's and no doubt was salt glazed, because the process had been used in England and Europe for a number of years. By 1750, engobes and coloring oxides were generally available to produce polychrome earthenware glazes which were washed or poured over the greenware before firing. The forming processes of press molding and slip casting were used in English potteries about this time and could have been introduced to the colonies at any time. By the mid-1700's, Pennsylvania German potters were decorating their presentation pieces with sgraffito and slip-trailed decoration. The method of slip trailing later spread northward through New Jersey and was used extensively by Connecticut earthenware potters. Simple banding and coggle-wheel decoration continued to be the predominant decorations used on earthenware made in New England throughout the tradition.

The first decorations used on stoneware were simple, stylized designs of flowers, birds, fish, animals and loops which were incised, untinted and rendered with great restraint (Page 113). Incised bands and coggle-wheel decorations were also used. Imported cobalt in the form of zaffera, or smalt, was at first imported and very expensive. It is doubtful that cobalt slips were used to any great extent before the

Revolution. Cobalt in the form of smalt, which was made by melting or calcining silica sand, potash and cobalt oxide and later grinding for use in coloring slips, was produced commercially at East Haddam, Connecticut, in 1787. The simple, stylized incised designs gradually gave way to more naturalistic rendering and were filled in with cobalt blue slip (Page 107).

About 1800 albany slip or "albany mud" which was mined at Albany, New York, began to be used by stoneware potters of the northern tradition to glaze the inside of their salt glazed wares. By 1840 albany slip was used throughout the country because it was an inexpensive and highly reliable glaze material.

During the period of hostilities between England and the United States which led to the War of 1812, incised patriotic symbols either plain or colored with "blues" became popular (Page 286). Incised decoration began to disappear about 1820 as the element of brushwork became more visible (Page 111).

The brushwork was quick and spontaneous, giving a freshness to the designs of delicate vines and flowers, realistic birds, animals and butterflies. Slip-trailed cobalt blue decoration also came into use in the mid-1800's and was occasionally used in combination with free-hand brushwork (Page 102).

By 1850 decoration on stoneware returned to a more formal style, and to offset the lack of interest in the straight-sided forms, became much more elaborate (Page 239). Flowers, birds, animals and winged insects were still the major decorative motifs along with figures of people and more homely objects such as houses, trees and chickens (Page 112).

After the Civil War, as competition increased, stenciled decorations were often used to save time. They were applied in either cobalt blue or brown manganese slips and quite often lacked the restraint found in earlier decorations (Page 217).

The traditions of early American folk pottery need a great deal of further study, both in reference to the evolution of forms and decorations as well as techniques. The quality of the American potter's work is apparent in the many pieces which are still in existence in private collections and museums.

American folk potters were severely limited not only in time and materials but also by the demand for strict utility in their wares. They did, however, in spite of these limitations, create wares of great strength, integrity and beauty.

Plates

*All illustrations in this
section are courtesy of the
National Gallery of Art,
Index of American Design.*

COVERED EARTHENWARE JAR with "smoke-splash"
decoration common to New England, *ca.* 182
The dark spots were probably made by daubin
manganese oxide on the glaze with the finger
H.12″ Conn. Cer. 61.

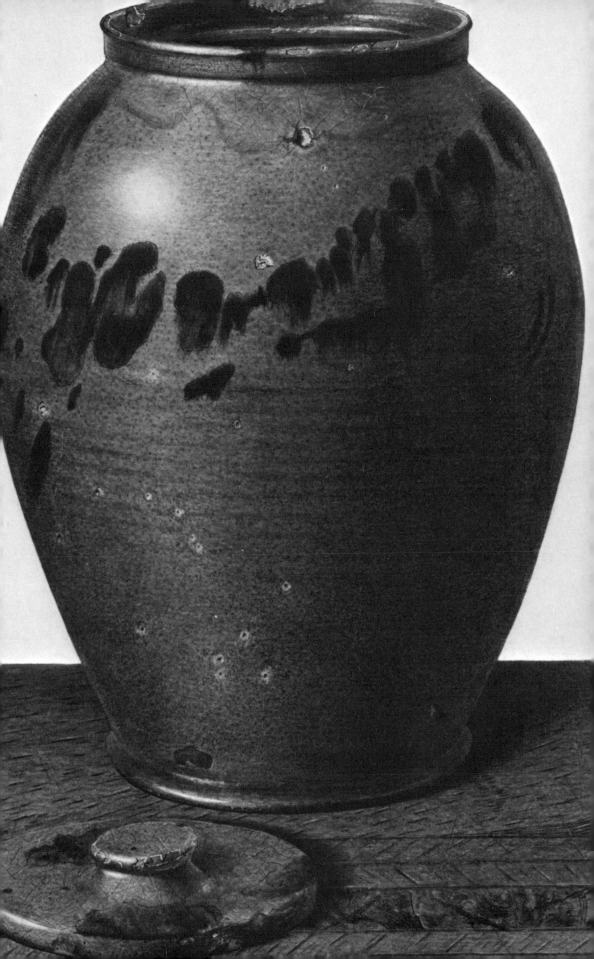

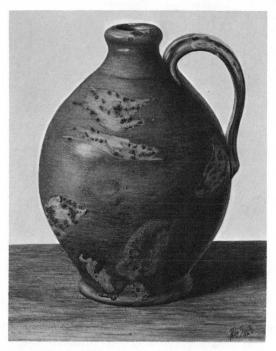

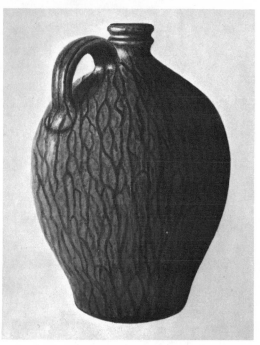

SMALL EARTHENWARE JUG made by Seth Goodwin at Hartford, Connecticut, about 1800. Green glazes and slips made from copper were expensive; consequently, they were used sparingly. H.6″ Conn. Cer. 49.

OLIVE GREEN JUG made at Meader's Pottery near Cleveland, Georgia, in the late 1800's. Glazed with "Shanghai" ash glaze consisting of wood ashes from the kiln, local red clay and ground glass. Fla. Cer. 49.

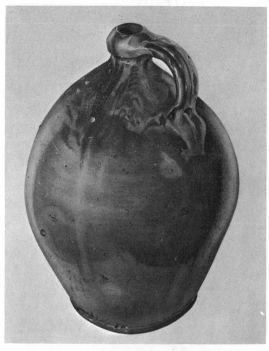

JUG made at Galena, Illinois, 1850–1888, known locally as the "Galena Big Jug." H.13¾″ W.10″ Ill. Cer. 19.[35]

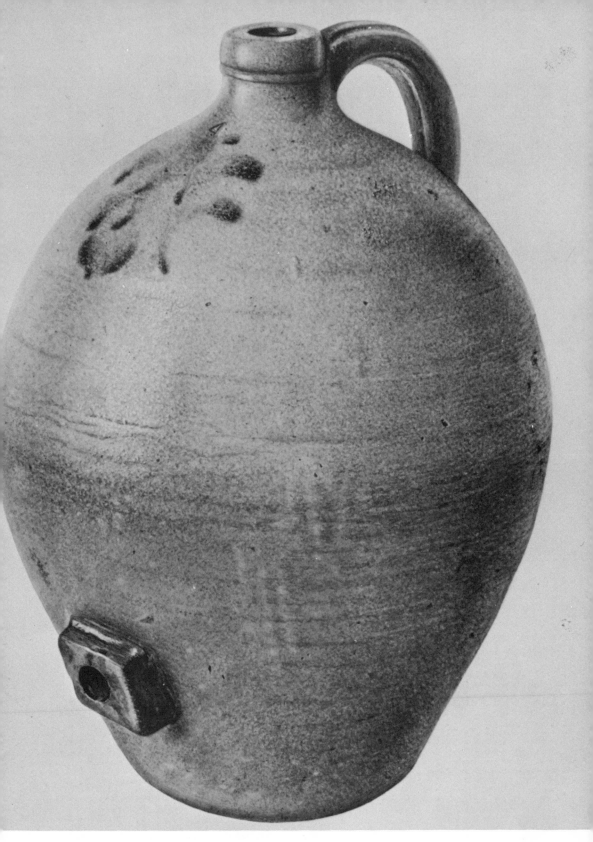

SALT GLAZED GRAY STONEWARE CIDER JUG made in the early 1800's. These jugs or coolers were commonly used in taverns for storing drinks behind the bar. They were convenient containers for carrying small amounts of cider or wine from barrels stored in the basement or back room. The bungs were often placed a little above the base to allow sediment to settle below the spigot. H.16½" N. Y. C. Cer. St. 48.

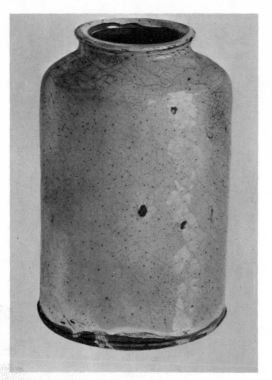

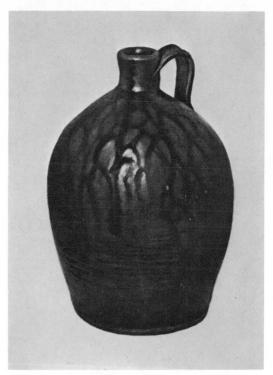

YELLOW SLIPWARE JAR covered inside and out with crackled transparent lead glaze. Made in Pennsylvania. Antimony oxide was probably used to obtain the bright yellow-colored slip on this jar. Other coloring oxides used by early American potters were: cobalt for blue, copper for green, iron for red and manganese for brown. H.6¾″ B.4¾″ M.3¼″ N. Y. C. Cer. 68.

19TH CENTURY JUG made in southern Virginia. The dribbled glaze effect on this jug was achieved by placing a piece of broken glass on the neck as it was set in the kiln. H.8¼″ B.4½″ N. Y. C. Cer. St. 246.

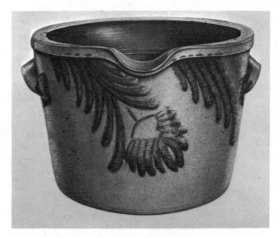

SALT GLAZED GRAY STONEWARE MILK PAN probably made in Pennsylvania or Ohio after 1800. Boldly brushed cobalt blue floral decoration, albany slip interior. To strain the milk, a thin cloth was laid over the flared rim and tied in place. The crock was then placed in a cool cellar or pantry to allow the cream to rise. H.7″ T.12″ B.9½″ N. Y. C. Cer. St. 295.*

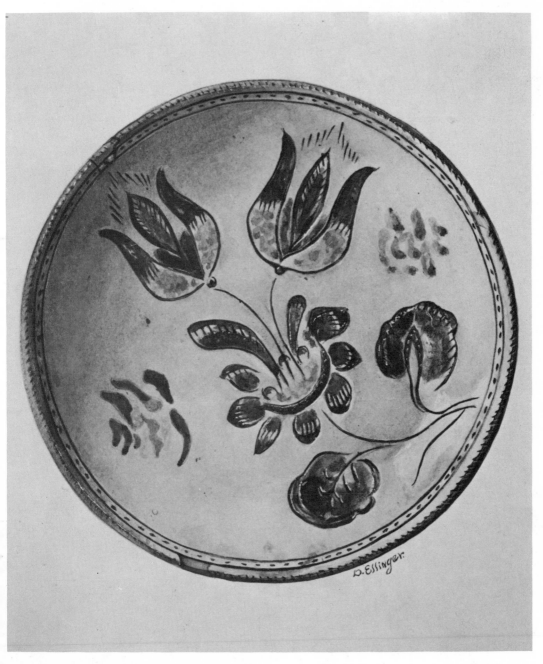

EARTHENWARE PIE PLATE with sgraffito and slip decoration made in Montgomery County, Pennsylvania. The white slip ground of many Pennsylvania-German pie plates appears to be yellow because of the tinted raw lead glaze finish. W.8⅝″ Pa. Cer. 107b.

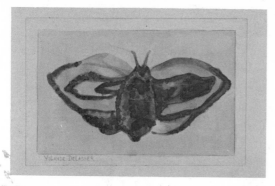

DETAIL OF JUG: Brushed moth, stamped "Julius Norton, Bennington, Vt." 1841–1845. H.12½" N. Y. C. Cer. St. 55d.

DETAIL OF JUG: Brushed carrousel horse. 1825– 1850. H.17" N. Y. C. Cer. St. 16c.

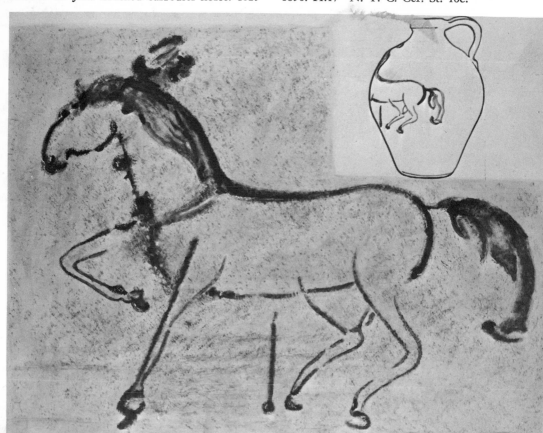

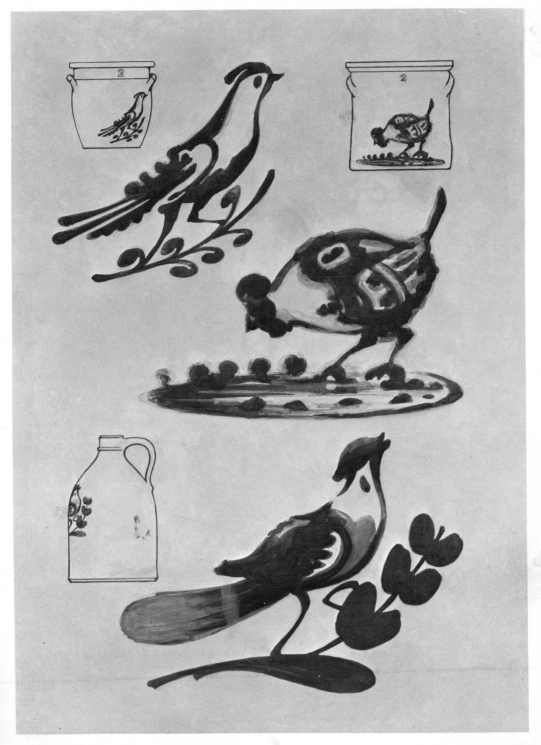

DETAIL: Top: White and Wood, Binghamton, N. Y. 1850–1860. H.9¾". Middle: Maker unknown, mid-19th century. Bottom: White and Wood, Binghamton, N. Y. H.14½". N. Y. C. Cer. 008.

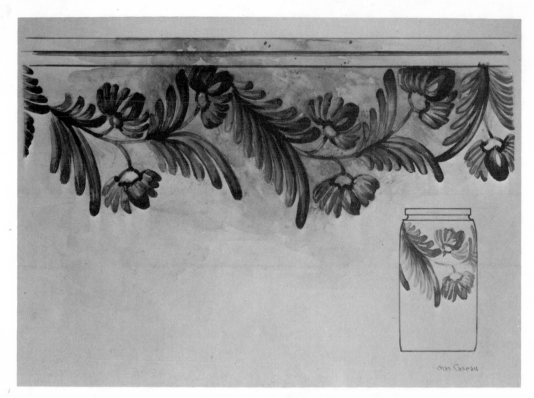

DETAIL OF JAR: Brushwork, J. Fisher, Lyons,
New York, *ca.* 1878. H.10″ N. Y. C. Cer. St.
53d.

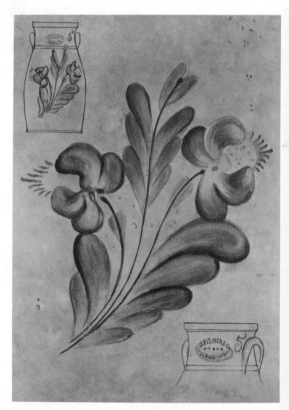

DETAIL OF CHURN: Brushed. Stamped with mak-
er's name, *ca.* 1850. H.18½″ N. Y. C. Cer. St.
42d.

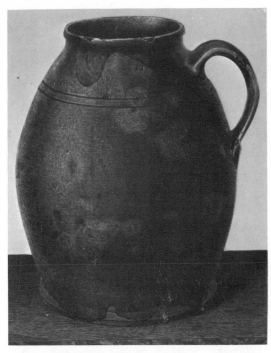

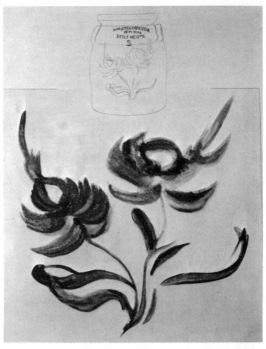

SMALL EARTHENWARE JUG. Before 1800. The shape and glaze are associated with eastern Massachusetts. Conn. Cer. 68.

DETAIL OF JAR: Brushwork. 1864–1870. H.11¼″ N. Y. C. Cer. St. 8c, d.

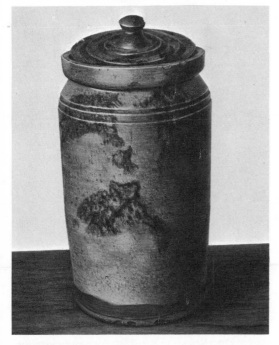

EARTHENWARE PRESERVE JAR probably made in Connecticut about 1825. These jars often were used for exporting preserves, pickled oysters and other foodstuffs from New England to the South and to the Caribbean. The lids were sealed for shipping with a mixture of beeswax and rosin or plaster of paris. H.7″ W.4½″ Conn. Cer. 29.

97

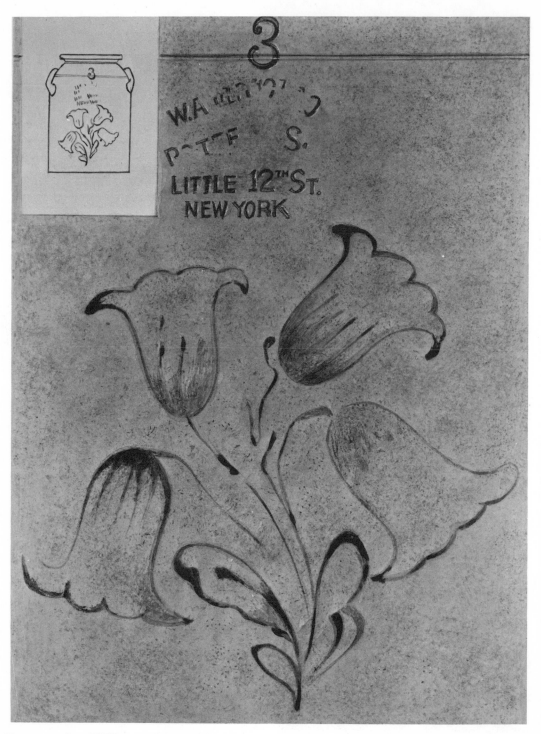

DETAIL OF JAR: William A. Macquoid and Co., Pottery Works, Little 12th Street, New York, 1864–1870, delicately brushed flowers suggesting Canterbury Bells. H.13⅛″ N. Y. C. Cer. St. 89d.

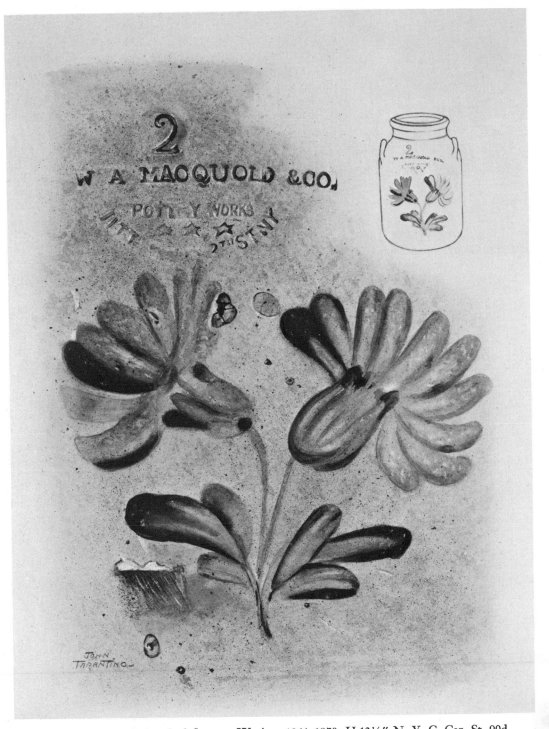

DETAIL OF JAR: Loosely brushed flowers, W. A. 1864–1870. H.12¼″ N. Y. C. Cer. St. 90d.
Macquoid and Co., Little West St., New York,

DETAIL OF CROCK: Brushwork, stamped "A. E.
Smith and Sons, Manufacturers, 38 Peck Slip,
New York." H.10½″ N. Y. C. Cer. St. 31d.

100

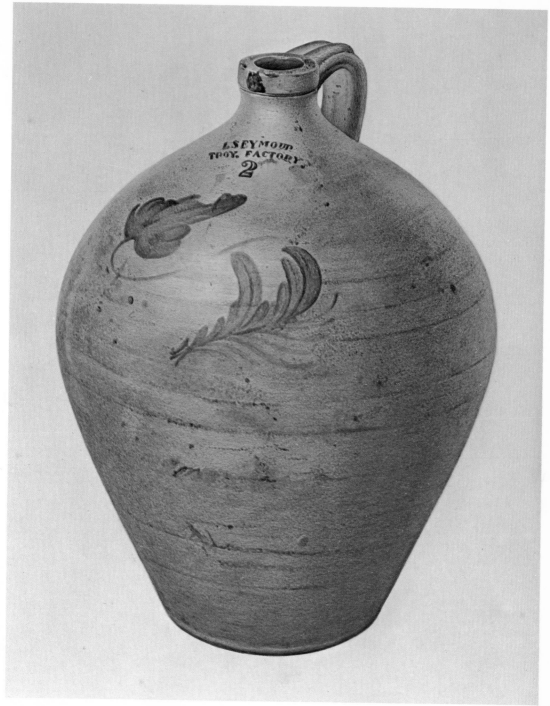

SALT GLAZED STONEWARE JUG showing circular rib marks. Made by Israel Seymour at Troy, New York, about 1820. H.13½″ W.10½″ B.4⅜″ N. Y. C. Cer. St. 348.

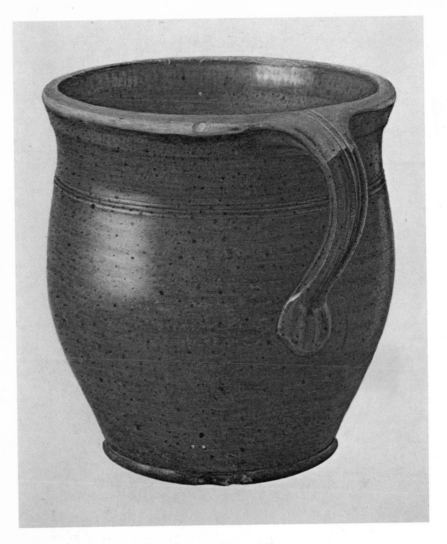

RED EARTHENWARE APPLE BUTTER POT with complementary incised lines on handle and shoulder. Apple butter pots used for storage were handleless. No doubt this pot was made for use on the table. H.7⅜" T.7¼" B.4⅞" N. Y. C. Cer. 72.†

SALT GLAZED STONEWARE BATTER JUG stamped "Cowden and Wilcox, Harrisburg." Pennsylvania, *ca*. 1860. Cobalt blue decoration. H.10" B.6½" N. Y. C. Cer. St. 226a, b.*

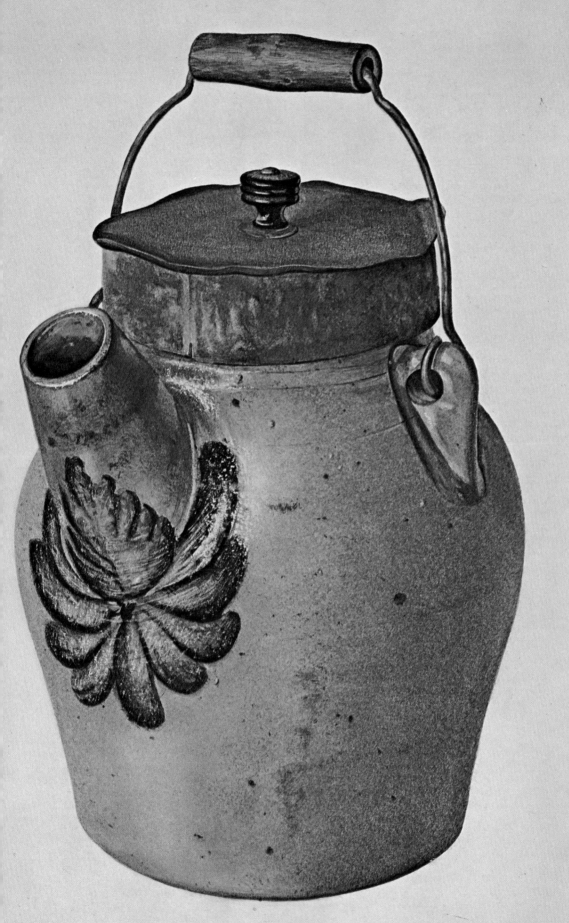

J. TARANTINO

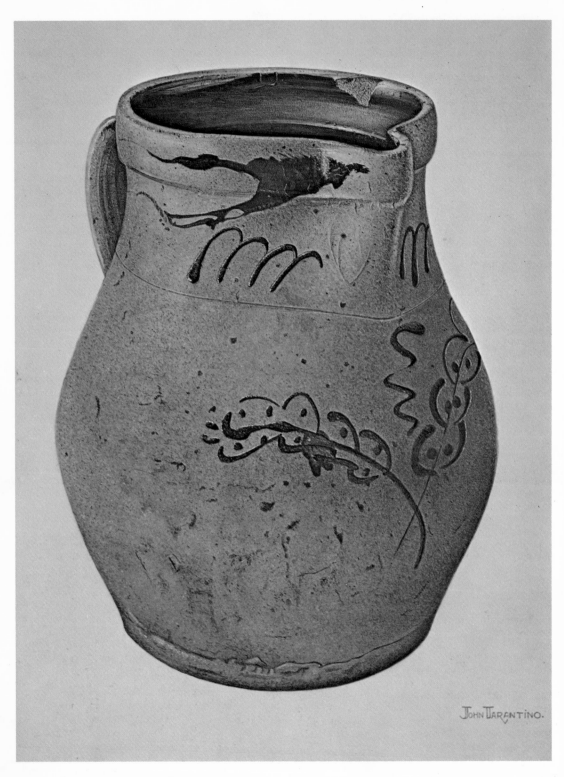

JOHN TARANTINO.

LATE 19TH CENTURY STONEWARE PITCHER covered with gray slip and salt glazed. The slip splashed on the rim of this pitcher could have been an accident; it was probably not meant to be decorative at all, but the potter did not feel that its removal was necessary. The color of interior glazes varied depending on the materials used and the effects of the fire. Albany slip, leftover glazes and low-firing red clays were all used as interior glazes for stoneware. H.8⅝" B.5½" N. Y. C. Cer. St. 319.*

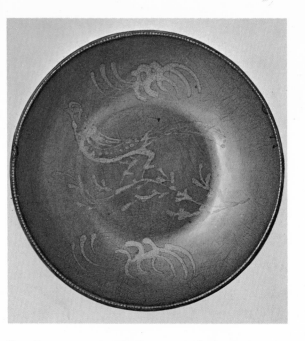

RED EARTHENWARE PIE PLATE with slip trailed decoration covered by transparent lead glaze. Pie plates were produced in large numbers in eastern Pennsylvania and were also made in New Jersey, New York, Connecticut, Massachusetts, Maryland, and Ohio. Pie plates were decorated and glazed only on the inside. The continuous curve allowed the pie to be easily slipped from the plate. Pies could not be cut in the plate because the knife would damage the glazed surface. W.12″ N. Y. C. Cer. 87a.*

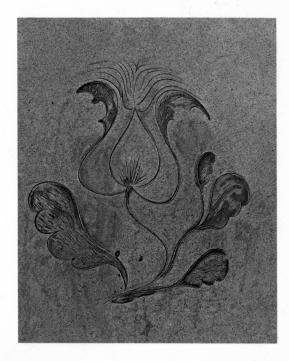

DETAIL OF WINE OR CIDER JUG probably made by Louis Lehman and Co., 31 West 12th St., New York City, 1859–1861. H.18″ N. Y. C. Cer. St. 341d.

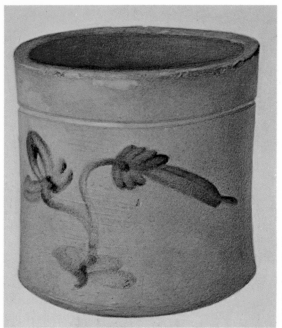

SMALL SALT GLAZED BUTTER CROCK probably made by Brown Bros., Huntington, Long Island, New York, about 1863. Grayish-tan stoneware, slip glazed interior. The simple brushed flower on this crock is typical of the color produced by cobalt oxide. H.5¾″ T.6½″ B.6¼″ N. Y. C. Cer. St. 243.*

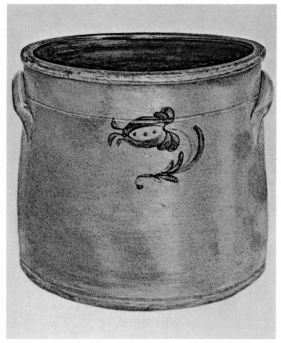

GRAY STONEWARE SALT GLAZED BUTTER CROCK decorated with simple fuchsia-like blue flowers. Butter crocks and jars were usually slip glazed inside and stacked mouth to mouth in the kiln. Late 1800's. H.5¾″ T.7⅛″ B.7¼″ N. Y. C. Cer. St. 124c, d.

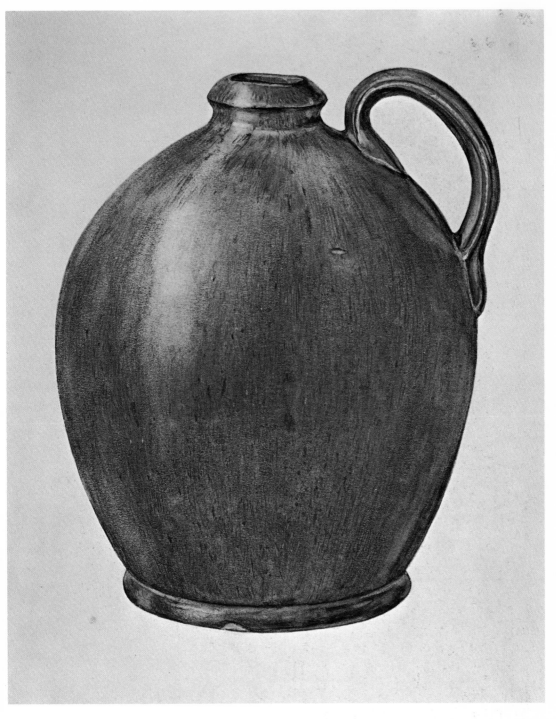

SLIP GLAZED VINEGAR JUG probably made at Haddonfield, New Jersey, about 1780. Vinegar was more commonly used in colonial cookery than it is today. It was made from wine, raisins, malt, sugar, fruit, and wood. H.7″ N. J. Cer. 105.

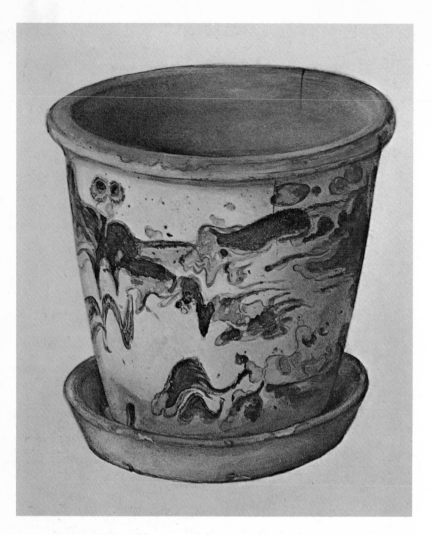

EARTHENWARE FLOWER POT with slip decoration produced at the Solomon and Samuel Bell Pottery, Strasburg, Virginia, about 1845. H.6″ W.6½″ Pa. Cer. 112.

YELLOW STONEWARE PITCHER, salt glazed, probably made in the mid-1800's. Stoneware clay was often very expensive because it had to be transported long distances by barge or wagon. To make the clay go further, potters sometimes added local clays to their stoneware bodies which gave them rich, earthen colors. H.10⅜″ M.5″ B.5⁹⁄₁₆″ N. Y. C. Cer. St. 289.

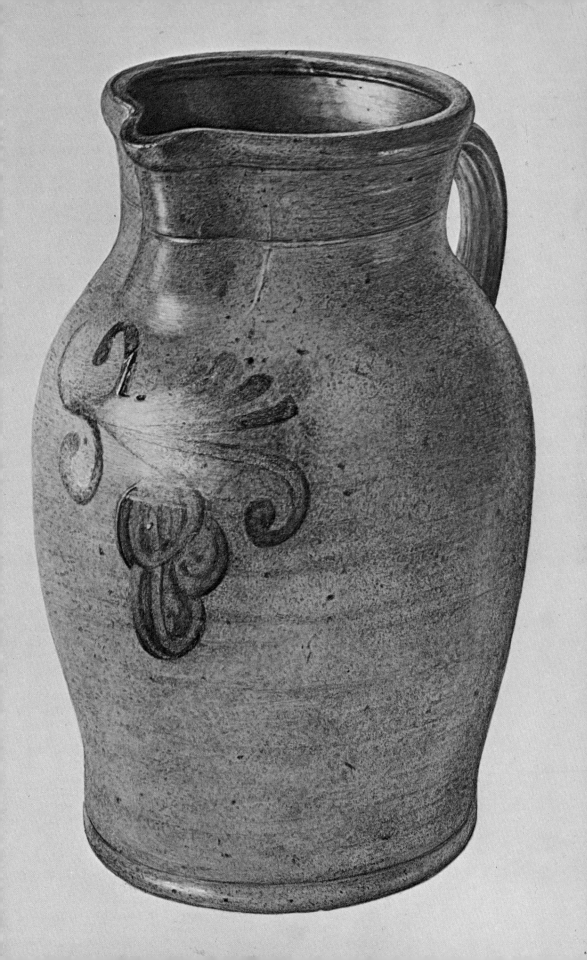

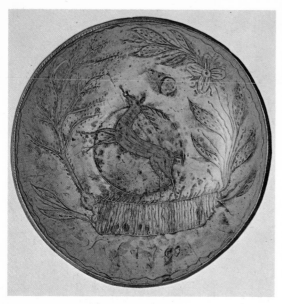

DECORATIVE PIE PLATE made by Isaac Stout, Bucks County, Pennsylvania, in 1790. Earthenware with sgraffito and slip decoration. The design was pricked through paper patterns with a pin to mark outlines on the white slip ground. The symbolic meaning of the deer to the Pennsylvania Germans can be understood from the following poetic analogy:

Like as a hart groans
and pants for water,
when it is hunted,
so also [does] my mind
[pant] Lord for thy gifts
Because it is tormented.

"Most sgraffito ware was made for gifts; potters made them for their sweethearts, wives, children and friends. Anniversaries, birthdays and weddings were marked by the presentation of such pieces." W.14" N. Y. C. Cer. 89a, b.[36]

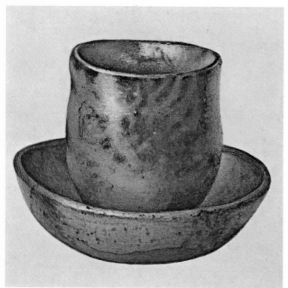

EARLY 19TH CENTURY CUP AND SAUCER made of red earthenware. Glaze colors often varied because of unrefined materials used in their composition and the irregularity of early wood-fired kilns. Overall H.3⅝" Saucer W.5" Cup W.3¼" N. Y. C. Cer. 108.

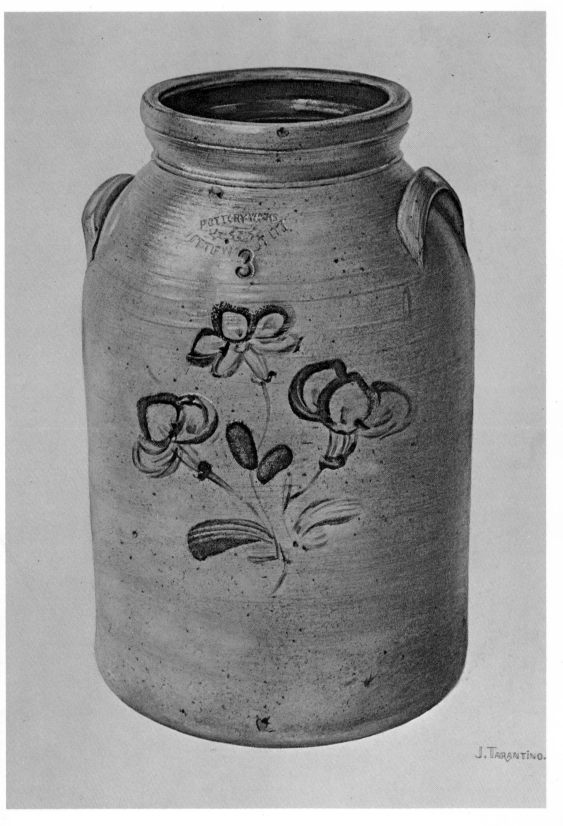

STONEWARE JAR made by Wm. A. Macquoid and Co., stamped "Pottery Works, Little W. 12th St., N. Y." Lid missing. H.14⅞" T.7" B.9" N. Y. C. Cer. St. 78c, d.*

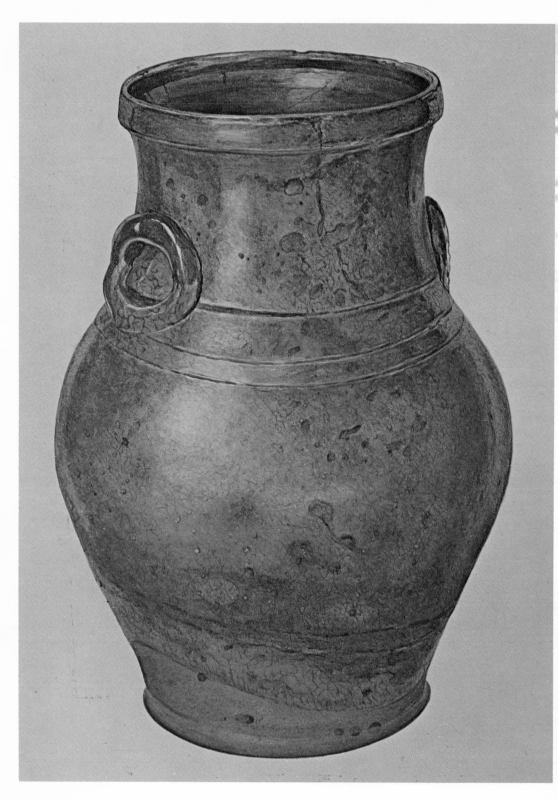

EARTHENWARE FLOWER VASE made in Pennsylvania. Bough pots listed as "Bow pots" in early pottery advertisements were used to arrange sprays of fruit tree blossoms or bunches of long-stemmed flowers. The pot was partially filled with sand or gravel to hold the stems in place and keep the pot upright. H.8½" T.4⅜" B.3⅞" N. Y. C. Cer. 17.

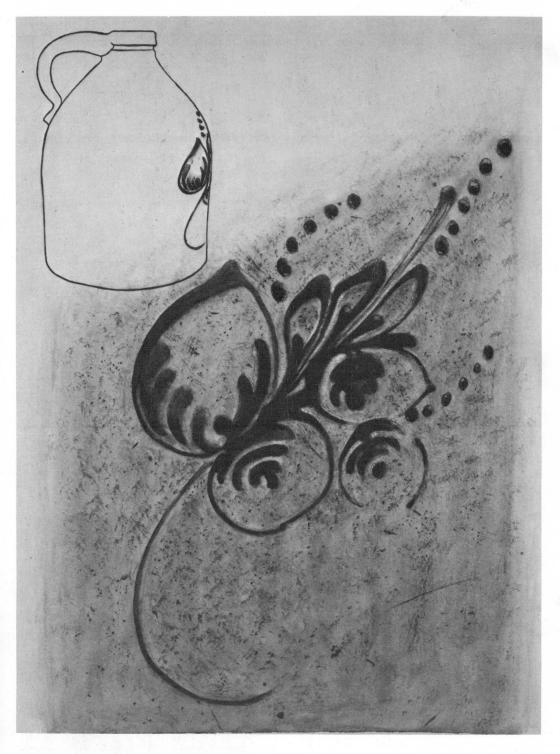

DETAIL OF JUG: Late 19th century, slip trailed stylized floral decoration. H.14″ N. Y. C. Cer. St. 114d.

DECORATIVE FIREPLACE TILE made at Zoar, Ohio, between 1819 and 1850. Tiles were also used on roofs, stove fronts, and for paving floors and sidewalks. W.12″ L.18″ Ohio Cer. 48.

DETAIL OF CROCK: Bird and leaf spray decoration with brushed ground, embellished by slip trailed lines, marked, 1866–1870. H.11″ N. Y. C. Cer. St. 335a, b.

DETAIL OF CROCK: Brushwork, William A. Macquoid & Co., Little West 12th Street, New York. H.12″ N. Y. C. Cer. St. 45d.

DETAIL OF CROCK: Brushwork decoration suggesting a tulip bent in the wind, stamped "Evan R. Jones, Pittston, Pa.," *ca.* 1800. H.8½″ N. Y. C. Cer. St. 62d.

DETAIL OF JUG: Brushed, Thompson Harrington, Lyons, New York, mid-19th century. N. Y. C. Cer. St. 92d.

DETAIL OF JUG: Slip trailed floral decoration, White's Pottery, Utica, New York, 1865–1870. H.19″ N. Y. S. Cer. 4.

DETAIL OF JUG: Heavy slip trailed decoration, late 19th century. H.11½″ N. Y. C. Cer. St. 127d.

DETAIL OF CROCK: Slip trailed pigeon. Maker unknown. Late 19th century. H.9¼″ N. Y. C. Cer. St. 326d.

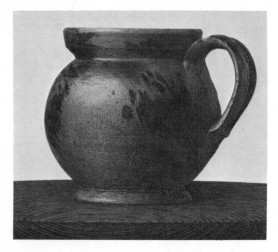

EARTHENWARE BEAN POT made in Connecticut between 1800 and 1825. Lid missing. Bean pots were made in both earthenware and stoneware and ranged in size from 2 to 4½ quarts. Early bean pots, "old style," were deep, cylindrical earthenware shapes which were used to bake beans in beds of hot coals. Later "stone" bean pots for oven use were low-handled forms with a lid. Potters sometimes advertised that they would bake beans while firing. This was probably done by placing the bean pots in hot coals near the fire mouth of the kiln during the early part of the firing cycle. A Connecticut potter placed the following in the *Norwich Packet*, November 21, 1788: "Baking done as usual and the smallest favors gratefully acknowledged." Conn. Cer. 35.

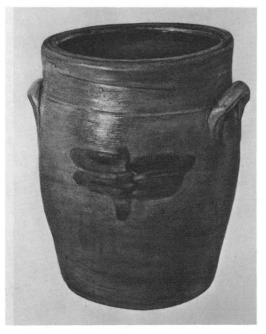

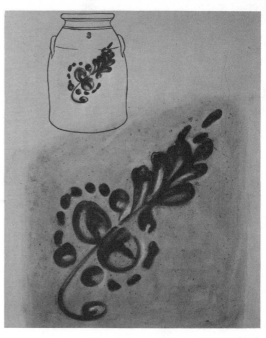

MID-19TH CENTURY CROCK made of stoneware covered with light coat of orange slip and transparent glaze. Simple dragonfly-like decoration brushed in blue slip. H.7⅜″ T.6″ N. Y. C. Cer. St. 275.*

DETAIL OF JAR: Late 19th century, slip trailed stylized floral decoration. N. Y. C. Cer. St. 107d.

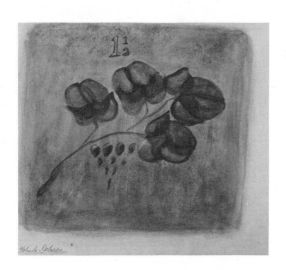

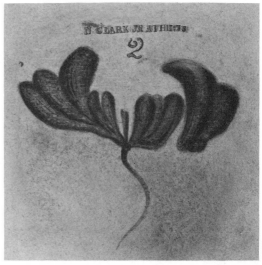

DETAIL OF CROCK: Brown Bros., Huntington, Long Island, New York, 1813–1875, brushed decoration suggesting ground cherries. H.10″ N. Y. C. Cer. St. 122d.

DETAIL OF JUG: Brushed blossom-like decorations, stamped "N. Clark Jr., Athens, New York," ca. 1850. H.13″ N. Y. C. Cer. St. 64d.

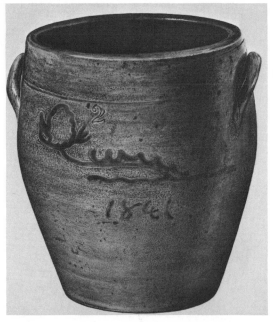

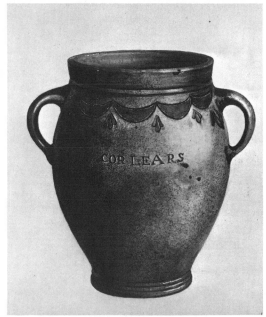

STONEWARE CROCK with blue thistle decoration, brown slip glazed interior. Potted meats such as cooked cuts of beef and venison, small fowl, fish and other seafood were preserved for future use by packing them into jars or crocks and covering them with clarified butter. The meat was "potted" whole if small enough. Otherwise it was ground to a paste, but in either case it was well spiced. Ham, bacon, and sausages were "potted" and covered with lard. Sometimes the pots were stored top down on a clean shelf in the basement or springhouse. If stored right side up a dust cover of thin leather or a wetted bladder was tied over the mouth. H.10″ W.8½″ N. J. Cer. 121.

STONEWARE CROCK made between 1802 and 1820 at Commeraw's pottery, Corlears Hook, New York. Early American potters rarely trimmed the foot of a pot but often used a rib profile at the base to give it a finished look. H.10⅛″ T.6⅞″ B.5″ N. Y. C. Cer. 50c.

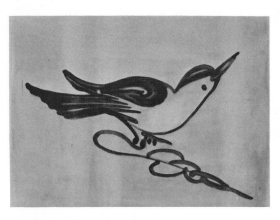

DETAIL OF BUTTER CROCK: Brushed bird suggests white-breasted nuthatch. After 1860. H.8¾″ N. Y. C. Cer. St. 14c, d.

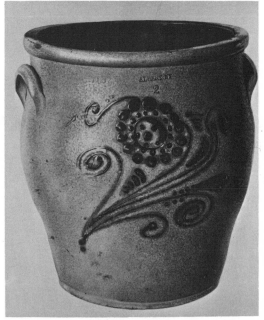

SALT GLAZED GRAY STONEWARE CROCK probably made in the mid-1800's. Cobalt blue slip decoration of conventionalized flower; Albany slip interior. H.10¾″ T.9 11/16″ B.7¼″ N. Y. C. Cer. St. 75c, d.

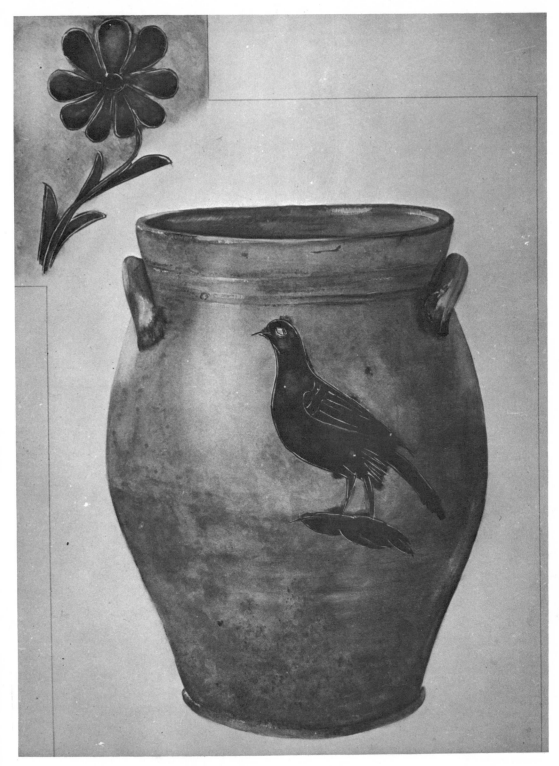

STONEWARE CROCK probably made at the Crolius pottery in New York City about 1800. Incised bird and flower filled in with cobalt blue slip. H.14⅓" T.9" B.6¾" N. Y. C. Cer. St. 7c.

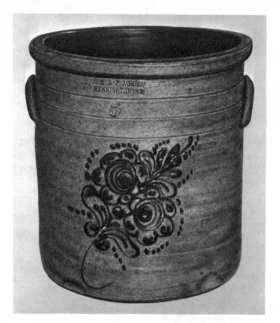

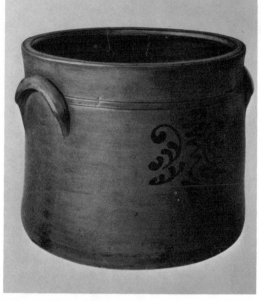

TAN STONEWARE SALT GLAZED BUTTER CROCK produced at the Norton pottery between 1861 and 1881. Elaborate blue slip decoration, brown interior. In the late 1800's larger potteries sometimes furnished round wooden lids for sealing butter crocks for shipping. The lids were fastened to the crock with wire and tacks. A circle of wire somewhat larger than the crock was placed just under the rim. Pendants were twisted in the circle equidistant at four points until the circle closed tightly on the crock. The pendants were then bent up and over the top edge of the lid. A flatheaded tack was driven through the eye of the pendant holding the wooden lid securely to the crock. H.12⅛" B.11¾" N. Y. C. Cer. St. 237.

LATE 19TH CENTURY CROCK, stoneware, with stylized blue decoration on both sides. Albany slip interior. Storage crocks were also called tubs or jars. Occasionally crocks were made that held as much as fifty gallons. H.7½" T.8⅝" N. Y. C. Cer. St. 214c.

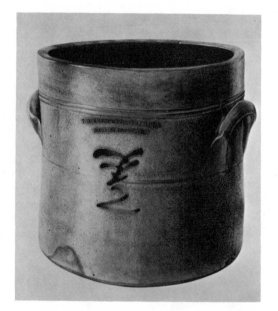

STONEWARE BUTTER CROCK produced by Boone Pottery, Brooklyn, New York, between 1841 and 1843. Cobalt blue brushed decoration. The incised lines made just before the pot was removed from the wheel add interest to this plain, cylindrical crock in addition to marking the height at which the handles should be applied. H.9" T.9½" N. Y. C. Cer. St. 217.

108

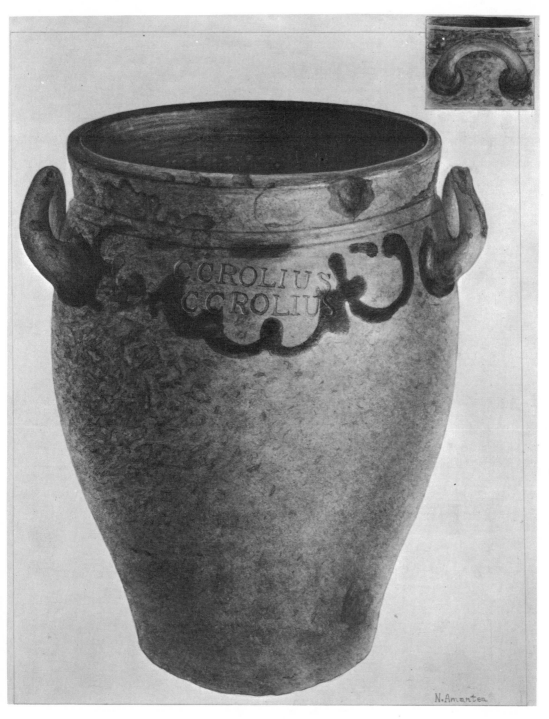

TAN STONEWARE CROCK made by C. Crolius at New York City between 1800 and 1825. Irregularly brushed festoon decoration in cobalt blue slip. White spots on inside of crock may be residue of water-glass solution used for preserving eggs. An earlier and more common method of egg preservation was to completely seal the egg shells with lard or bacon grease and pack them in sawdust or ashes. H.11″ T.8″ B.5¾″ N. Y. C. Cer. St. 22c, d.

109

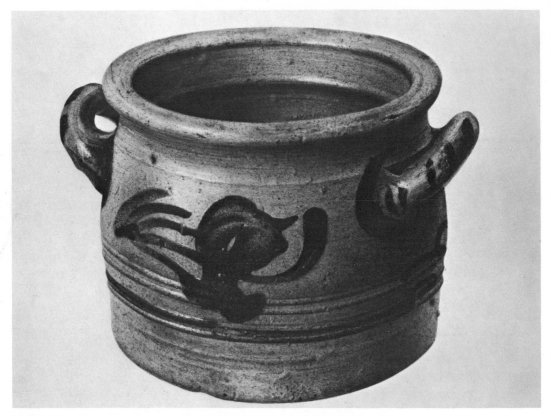

SALT GLAZED STONEWARE CROCK probably used for cooking or storing household butter supply, cobalt blue flower decoration, *ca.* 1850. Cover missing. H.4⅜″ T.5⅞″ B.5½″ N. Y. C. Cer. St. 303.*

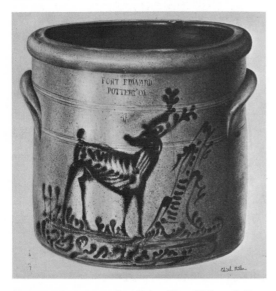

BUTTER CROCK produced by Fort Edward Pottery Co., Washington County, New York. Cobalt blue decoration. Butter for household use was sometimes "put down" in crocks without lids by placing a cloth sack partially filled with salt on top of the butter. H.11¾″ W.12″ N. J. Cer. 20.

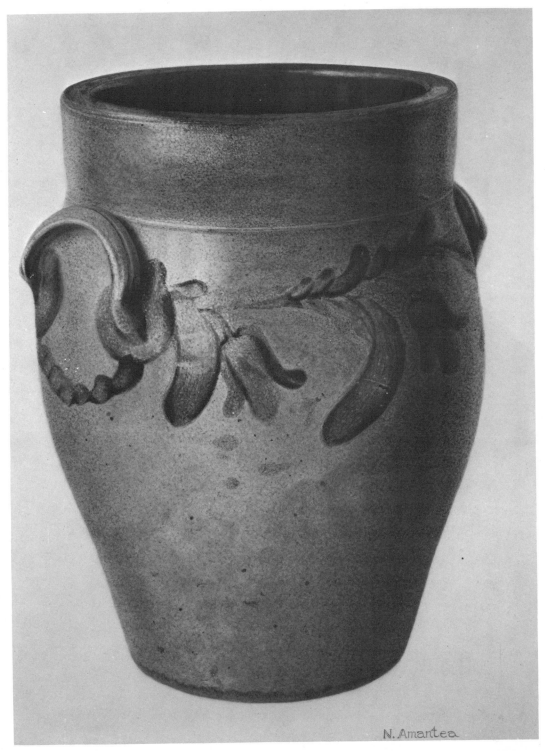

N. Amantea

STONEWARE STORAGE CROCK decorated with entwined leaves and bell-shaped flowers was probably made at Richard Clinton Remmey's Pottery in Philadelphia, Pennsylvania, between 1854 and 1869. The curved handles are repeated in the cobalt blue brushwork. H.12″ T.8⅜″ B.6⅜″ N. Y. C. Cer. St. 101c.*

111

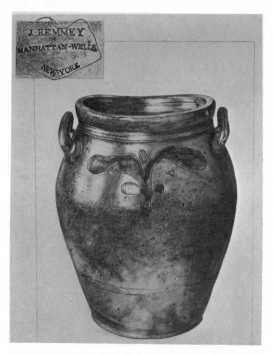

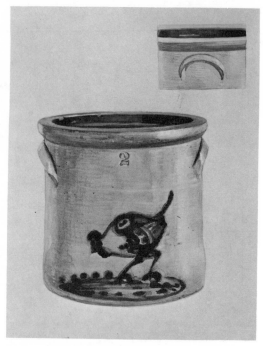

STONEWARE CROCK made by John Remmey III about 1800, incised conventionalized design filled in with blue slip. N. Y. C. Cer. St. 36c.

LATE 19TH CENTURY BUTTER POT, gray stoneware, salt glazed, cobalt blue decoration. The unusual placement and the motion implied in the decoration add interest to this otherwise austere crock. N. Y. C. Cer. St. 206.

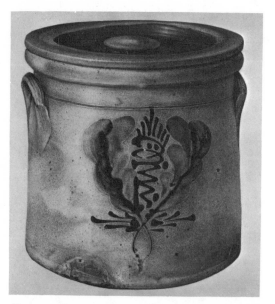

COVERED BUTTER CROCK of tan stoneware. Salt glazed, with conventionalized decoration in blue; lined with brown slip. After 1850. Straight-sided butter crocks differed little from "cake pots," which were used for storing cake, bread, biscuits, cookies, and other baked goods. Butter crocks were deeper and usually glazed on the inside for easy cleaning. Overall H.7⅝″ T.8¼″ B.8″ N. Y. C. Cer. St. 330.*

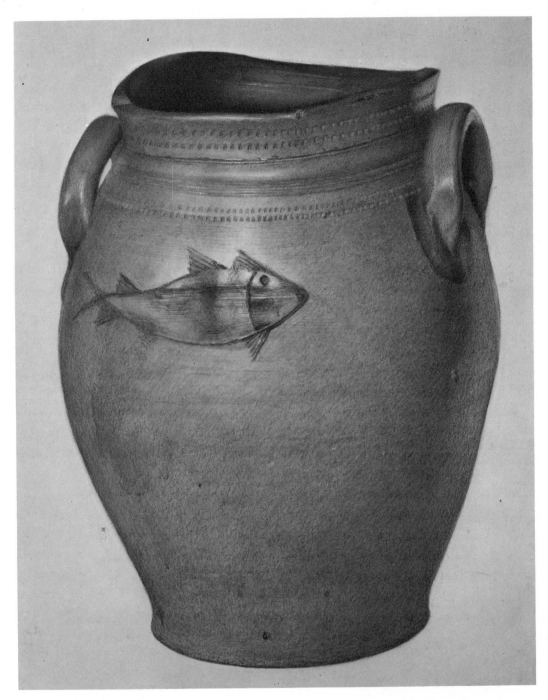

CROCK made by Warne and Letts, South Amboy, New Jersey. Salt glazed gray stoneware decorated with incised fish, tinted blue. Bands of indentations around shoulder and neck were made with a coggle wheel. H.12¼" T.7⅞" x 8⅞" B.9¼" N. Y. C. Cer. St. 239.*

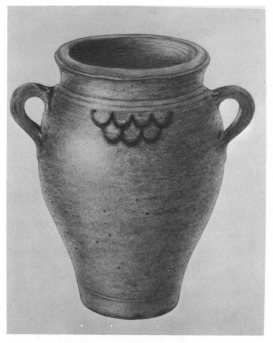

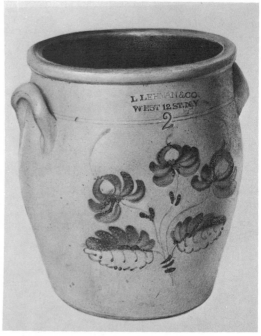

STONEWARE CROCK, salt glazed, cobalt decoration. Possibly made by Lewis and Gardiner, Huntington, Long Island, New York, *ca.* 1827. H.8½" T.5⅜" B.3⅝" N. Y. C. Cer. St. 148.

SALT GLAZED GRAY STONEWARE CROCK produced by the Lehman Pottery Co. in New York City between 1858 and 1861. Elaborate decoration of flowers in blue slip, dark brown glaze inside. Potters favored small- to medium-sized storage crocks because they were easy to make. They were also a good size for the housewife to handle. H.10¾" T.9¼" B.7⅜" N. Y. C. Cer. St. 266.

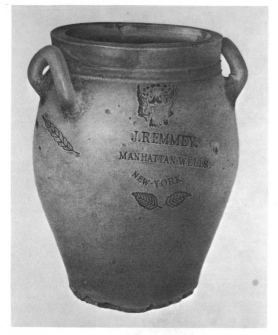

EARLY 19TH CENTURY SALT GLAZED CROCK with maker's name and decoration stamped and filled with blue slip. H.11¾₁₆" W.8" N. Y. C. Cer. St. 309.

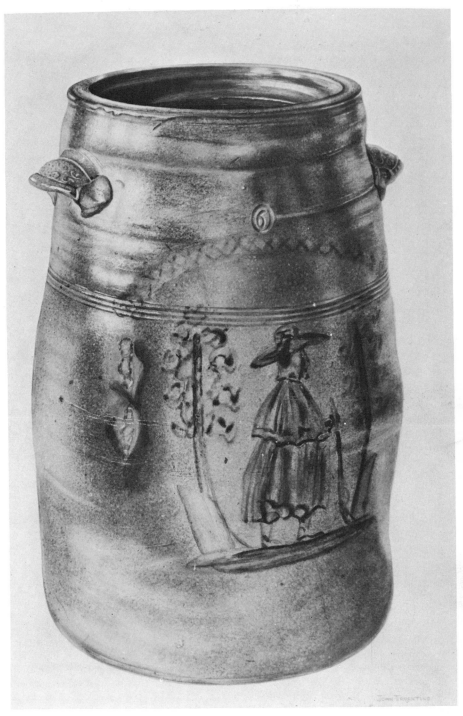

STONEWARE CHURN possibly from Pennsylvania. Blue slip decoration of Puritan hunter with gun between two trees. Molded handles. Lid and dasher missing. Capacity of large churns, jars and crocks often varied a great deal. Pots marked "6" sometimes held seven or eight gallons. H.18″ Warped T.8½″ x 9¾″ B.10¼″ N. Y. C. Cer. St. 210c.

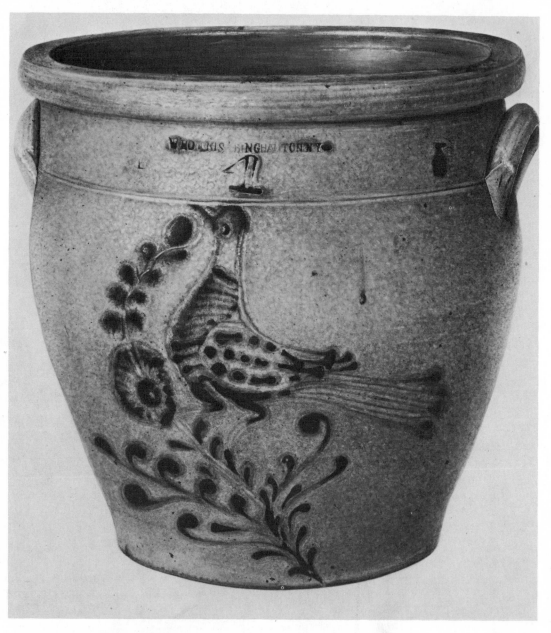

GRAY STONEWARE SALT GLAZED CROCK stamped
"W. Roberts, Binghamton, N. Y." 1859–1872.
Decoration of a bird on a branch in blue slip
with incised outline. Reddish-brown slip inside.
The basic lines of a decoration were sometimes
scratched in the leather-hard pot to insure good
composition. These scratched lines could be eas-
ily changed, whereas cobalt slip was extremely
hard to remove or alter, once applied. H.12"
T.11⅞" B.8" N. Y. C. Cer. St. 339.

116

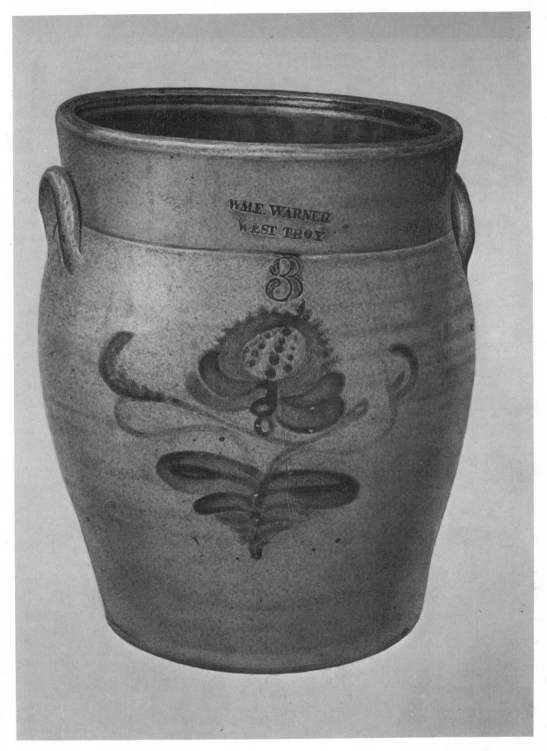

STONEWARE CROCK, salt glazed, stamped with maker's name, 1850–1870. Blue slip decoration suggests cross-section of strawberry fruit and runners. H.11⅝″ T.9½″ B.7½″ N. Y. C. Cer. St. 324.

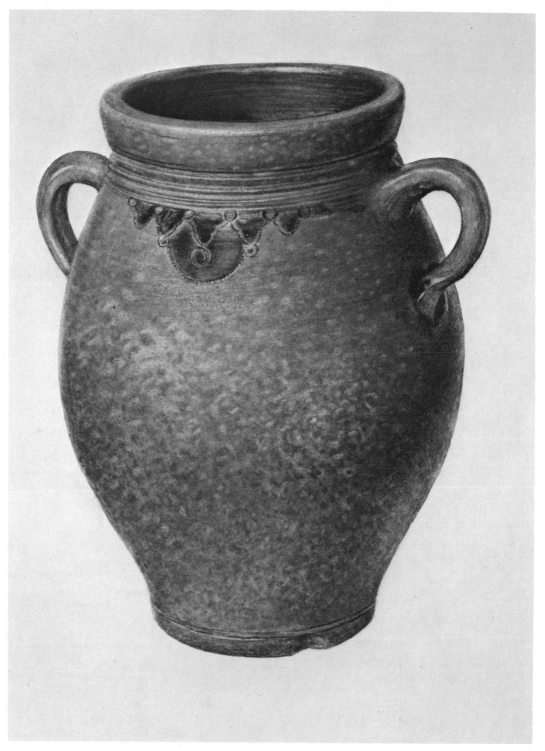

Red Stoneware Crock covered with mottled gray slip and salt glazed. Blue pendants and circles outlined with small indentations decorate both sides. Probably made at Huntington, Long Island, about 1800. H.8″ T.5″ B.3⅞″ N. Y. C. Cer. St. 283.

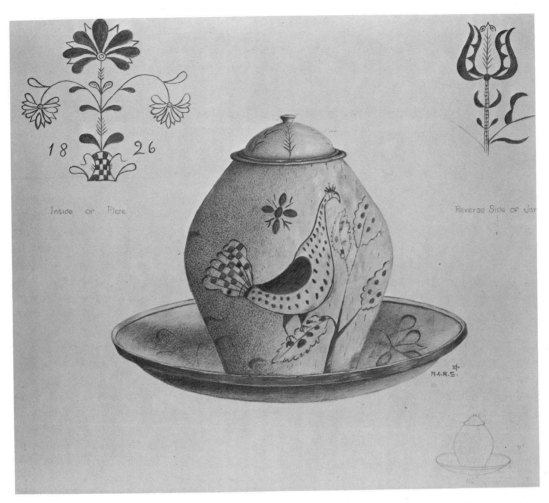

EARTHENWARE PLATE AND JAR, possibly made by Samuel Troxel, Montgomery County, Pennsylvania. Sgraffito design with yellow and green slip covered by transparent lead glaze. Rural Pennsylvania-Germans believed that the peacock was a weather prophet, "its discordant cry . . . [indicating] approach of rain." Jar H.7″ Dish W.10″ D. C. Cer. 11.[37]

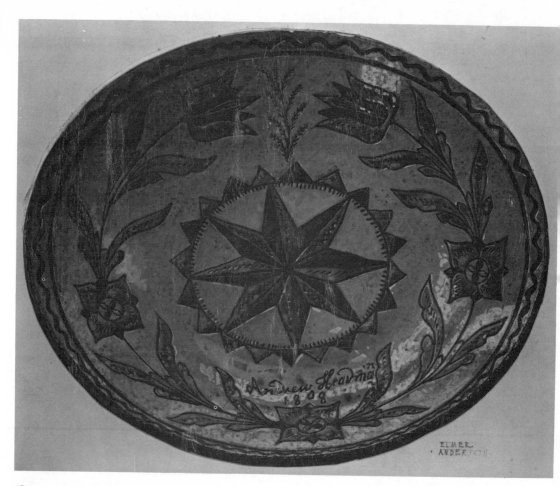

ORNAMENTAL PIE PLATE made in Bucks County, Pennsylvania, decorated with sgraffito design: green, red and brown slip. Although many of the decorations used by the Pennsylvania-German potters had religious significance, it is doubtful that the potters intended to use them for anything but decorative purposes. The star in the center of this dish symbolizes "the Christ." The maker's name did not quite fit between the leaves in the decoration. W.13⅜" Pa. Cer. 100.*

120

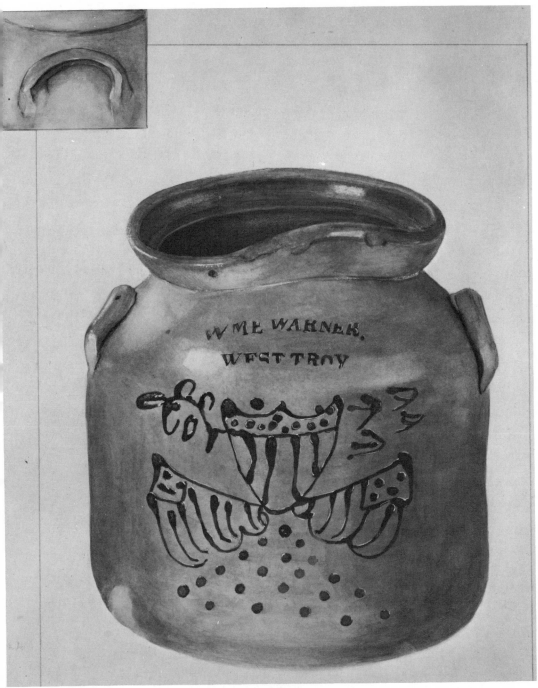

Low STONEWARE JAR made by William E. Warner, West Troy, New York, 1860–1865. Decoration of a shield and draped flags in blue slip. Salt glazed. Brown slip interior. Lid missing. Early potters suffered from a high percentage of damaged pots which were warped or cracked in the firing. Potters' records in the late 1800's sometimes list sales of this second- and third-quality ware. Pots which were slightly warped or badly blemished but completely functional were called "seconds" and were sold with a small reduction in price. "Thirds" were badly warped or otherwise damaged and were usually sold locally at greatly reduced prices. "Lump ware" was the name given to pots which were so badly warped that they were not worth trying to sell. These "wasters" were usually thrown in the dump behind the pottery. H.8″ T.6⅜″ B.12½″ N. Y. C. Cer. St. 171.

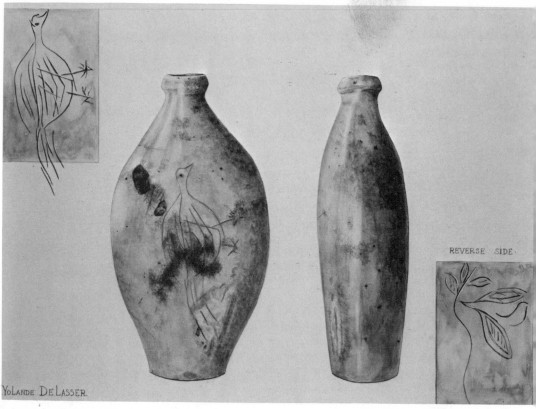

GLAZED STONEWARE FLASK decorated with crudely scratched bird and leaf spray decoration, *ca.* 1800. Flasks with flattened sides were convenient containers for carrying small amounts of liquor in the pocket or saddlebag. They could be filled at stores, taverns, inns and at almost any farmhouse. Distilling liquors was a common farm activity. It has been noted by early travelers that no matter where one went in the country, smoke from a still could be seen at any point. H.8¼″ W.4¼″ N. Y. C. Cer. St. 193.

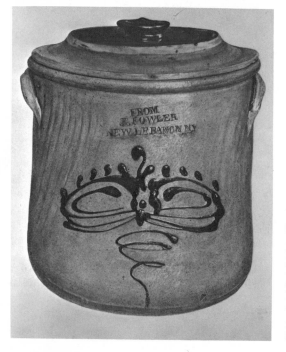

SALT GLAZED TAN STONEWARE BUTTER CROCK decorated with trailed cobalt blue slip. Dark brown slip glaze on cover and interior of crock. Butter for household use was packed in small, covered crocks and stored in the cellar or springhouse. If the butter was carefully prepared and well salted it could be used for six months or more. Overall H.8¾″ B.8″ T.8½″ N. Y. C. Cer. St. 231.*

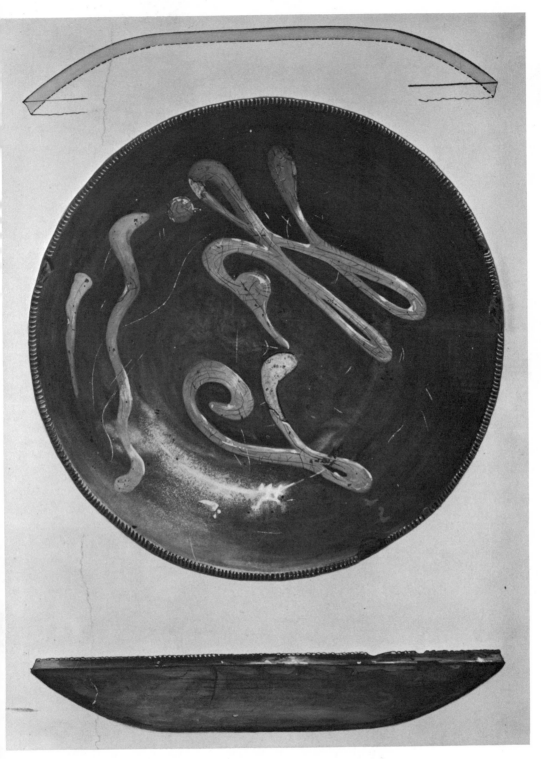

EARTHENWARE PIE PLATE decorated with initials "S. C. S." in yellow slip. Made in Connecticut about 1800. Pie plates were formed by rolling out a clay slab to the proper thickness, cutting it in a circle and letting it partially dry. The slip decoration was then applied and rolled into the surface of the slab for the pie plate intended for baking. The slab was again set aside to dry and when leather hard it was shaped over a drape-mold and trimmed. The plate was removed and the edge was finished with a coggle wheel. When completely dry the inside of the plate was given a coat of transparent lead glaze with a brush. H.1¼″ W.9″ Mich. Cer. 87.

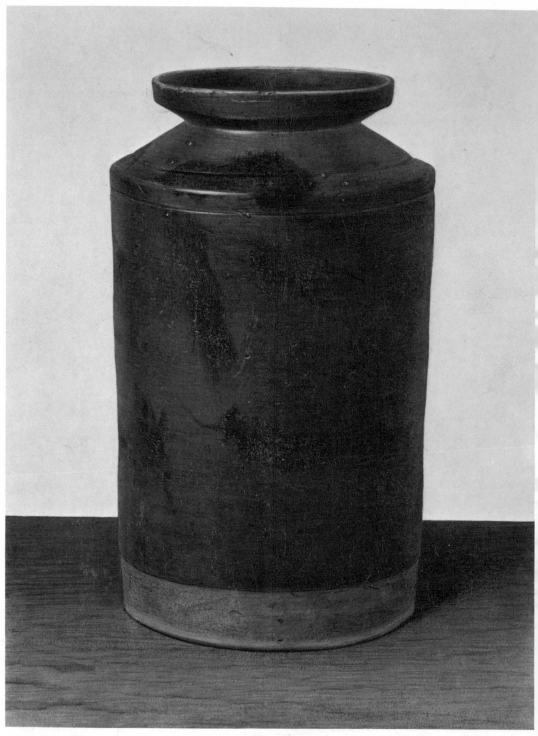

EARTHENWARE PRESERVE JAR, possibly made by Sidney Risley, Norwich, Connecticut, *ca. 1825.* Red glaze with dark splashes, lid missing. Preserve jars were also used in New England for pickling oysters. The oysters were boiled and packed in the jars with liberal sprinklings of spice and covered with apple cider. If prepared properly, they would keep for several months. H.10¾" Conn. Cer. 59.

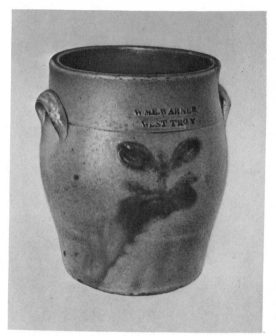

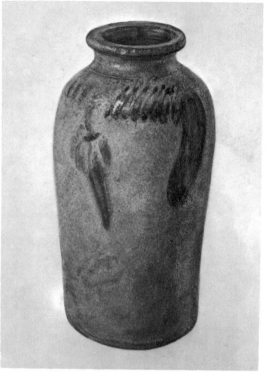

GRAY STONEWARE CROCK stamped with maker's name, 1850–1864. Salt glazed, insect-like blue decoration. Crocks of this shape were listed in early broadside price sheets as cream pots. They ranged in size from one-half to six gallons. Crocks of various shapes and sizes were also used as containers for storing dye, soap, bleach, grease, lye, oil, tallow, lard, pickles, sugar, flour, eggs, butter, salt meat and fish, sauerkraut, mincemeat, corned beef, fresh fruit and vegetables. H.8½″ T.7″ B.5¾″ N. Y. C. Cer. St. 244.*

EARLY AIRTIGHT JARS called "corkers" were probably the first type of pottery vessels used in America for canning foods by modern methods of sterilization and hermetic sealing. The main principles of canning were to sterilize the jar and its contents and expel all the air in sealing. To accomplish this the jar was filled nearly to the top. Two pieces of packing string were placed at right angles across the mouth. The cork was inserted in the mouth on top of the string. As the cork was forced down into the jar the air came out along the strings between the neck and the cork. When the cord was home the strings were cut off even with the mouth of the jar. Another string was tied around the neck and up over the cork holding it securely in place. The jar was then inverted and plunged into melted wax to the shoulder several times at half-minute intervals to finish the sealing. This salt-glazed stoneware jar is stamped "Solomon Bell, Strasburg, Va." H.8⅞″ T.3⅛″ B.4″ N. Y. C. Cer. St. 285.

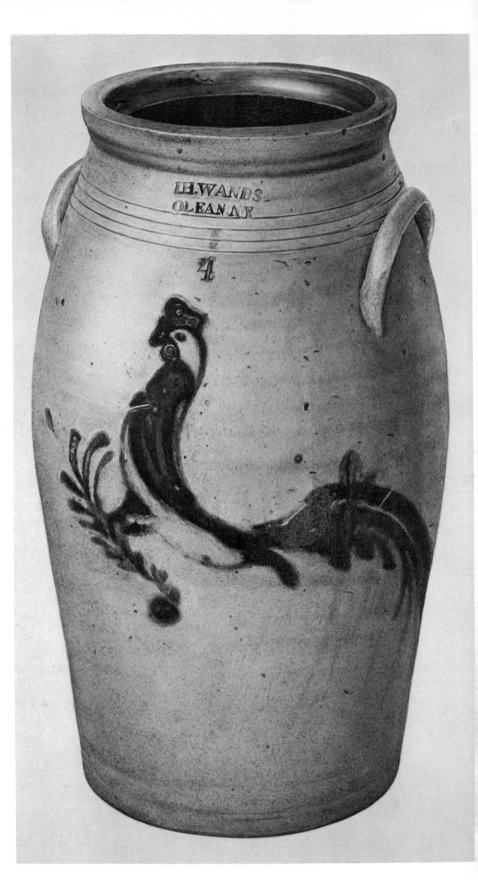

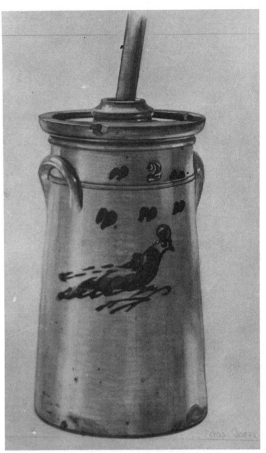

STONEWARE JAR, salt glazed, brushed cobalt blue decoration. Wingender Bros. Pottery, Haddonfield, New Jersey, 1805–1825. Pickling was a common method of preserving vegetables for winter use. Vinegar was the basic brine for pickling such vegetables as Indian corn, cucumbers, artichokes, mushrooms, asparagus, onions, cabbage, beans, beets, and cauliflower. Pickle jars and crocks were sealed by first pouring oil, melted butter, or mutton fat over the brine to keep it from evaporating. The pot was then covered with a lid or a dust cover made of leather, saturated bladder or cloth tied over the rim. H.10″ T.5½″ N. J. Cer. 30.

MID-19TH CENTURY STONEWARE CHURN made in New York State decorated with dark cobalt blue. Churning was a constant household chore because cream was hard to keep. The butter when churned often spoiled because of lack of cleanliness and attention in preparation. There is an old saying that, "Butter commends the housewife, good cheese the cow." H.13⅞″ T.7¾″ B.8½″ N. Y. C. Cer. St. 145.*

STONEWARE JAR made by I. H. Wands, Olean, New York. Tall jars were used for both storage containers and butter churns. Lid missing. N. Y. C. Cer. 58.

127

SALT GLAZED STONEWARE JUG stamped "C. Cro-
lius, Manufacturer, Manhattan Wells, New
York." 1795–1815. Jugs to be salt glazed were
sometimes stacked in tiers one above the other
by using "jug collars." These collars were bisque
cylinders placed on the shoulder of each jug.
A notch was cut out of the side to receive the
handle. The cylinder stood slightly above the
neck and handle supporting the jug above. Clay
wads called "chucks" were forced between some
of the jugs in the tier to keep them apart. This
method of stacking was very economical. Cus-
tomers, interested only in function, were not
bothered by the circular mark left in the glaze
on the shoulder or by an occasional chuck mark.
N. Y. C. Cer. St. 116c.

EARTHENWARE INKWELL made for Dr. Levi A.
Ward Jr. by Clark and Co. Pottery at Roches-
ter, New York, about 1814. Cream-colored
glaze. The center funnel-shaped hole was used
for dipping the quills and for filling the reser-
voir which was about half the width of the ink-
well. The outer circle of holes were dry wells
used for penholders. H.4″ W.10″ N. Y. S. Cer.
19.

STONEWARE JAR, small dome lid missing. Warne
and Letts, South Amboy, New Jersey, 1807. The
patriotic sentiment "Liberty Forev[er]" incised
on this jar may have been one of the many
sayings proposed for the state slogan of New
Jersey before the phrase "Liberty and Pros-
perity" was accepted in 1821. Another possibil-
ity is that the saying was a social protest made
by the potters in response to Britain's seizures
of American goods and seamen during the Na-
poleonic Wars in the early part of the 19th
century. H.11 7/16″ W.7 11/16″ N. J. Cer. 14.

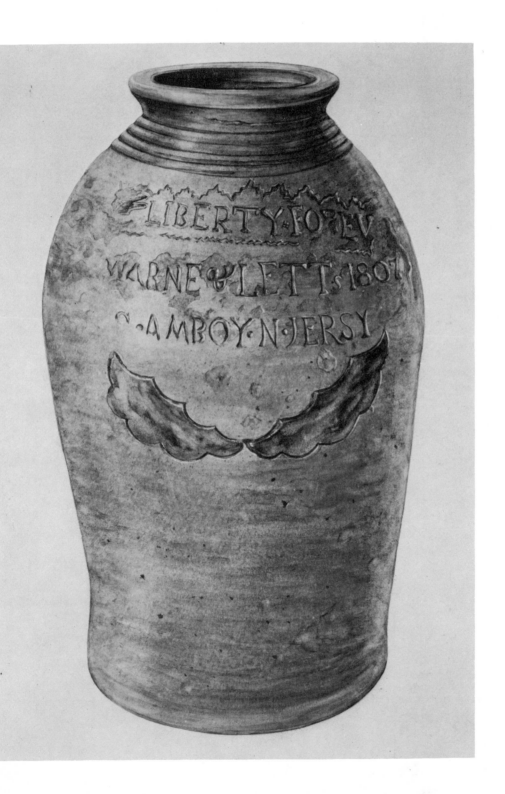

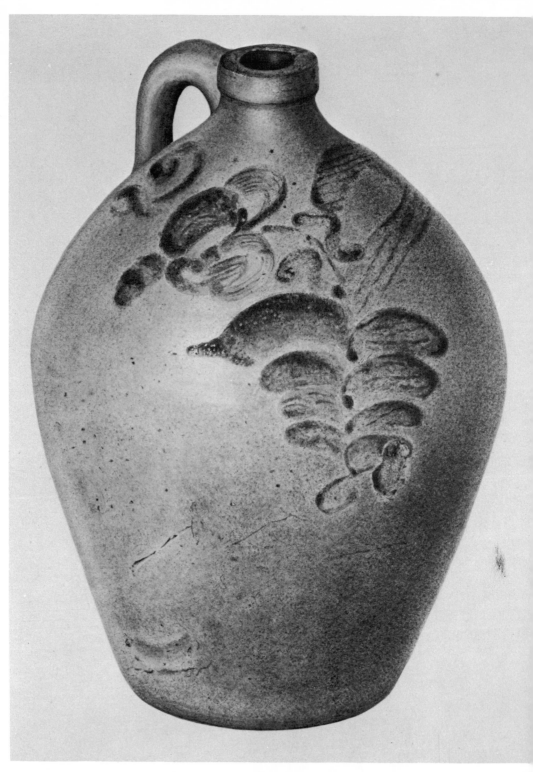

GRAY STONEWARE SALT GLAZED JUG with brushed flower and leaf decoration in blue slip. Capacity marks were often included in brush-work decoration. H.13″ B.6″ N. Y. C. Cer. S 308.*

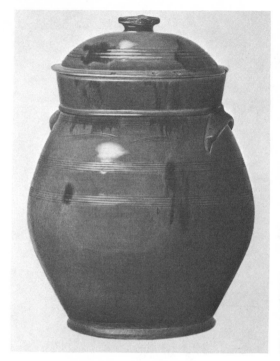

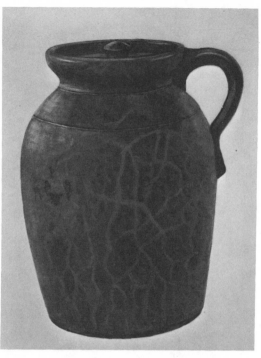

EARTHENWARE STORAGE JAR typical of Connecticut, Long Island, and New Jersey in the early 1800's. Reddish-brown lead glaze. H.13½" N. Y. C. Cer. 51.

HANDLED PRESERVE JAR from northern New York State. Red earthenware with mustard-colored slip covered by transparent lead glaze, *ca.* 1850. Lids were often made with inadequate knobs to facilitate stacking the jar with the lid on in the kiln. H.8¼" B.5" N. Y. C. Cer. 85.

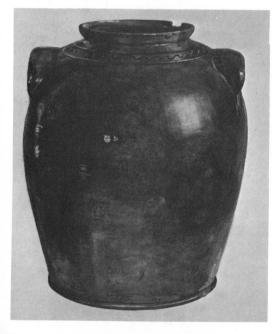

EARTHENWARE STORAGE JAR with mottled reddish-brown and green glaze, *ca.* 1825. Lid missing. H.10⅜" T.4¾" B.6⅞" N. Y. C. Cer. 81.

131

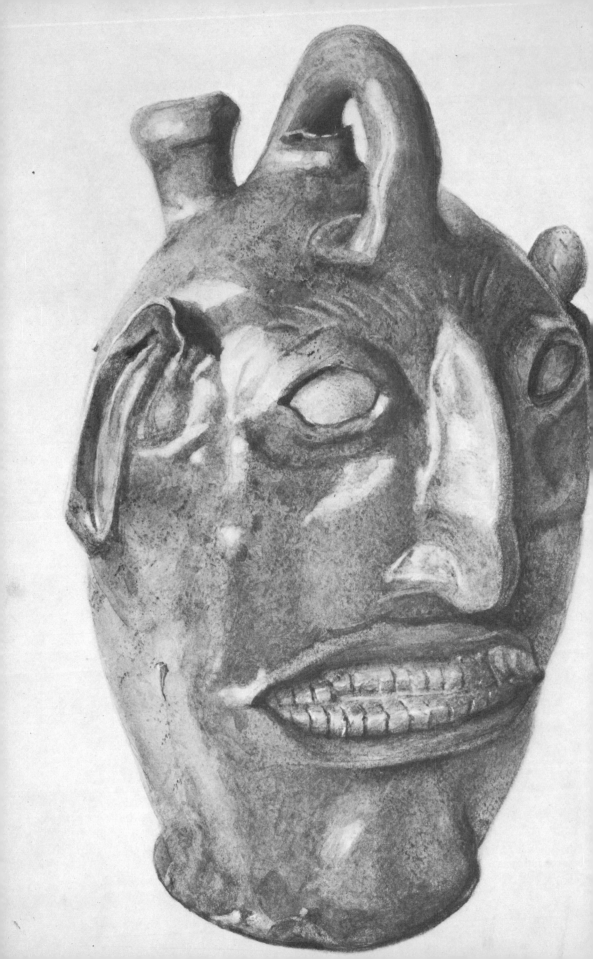

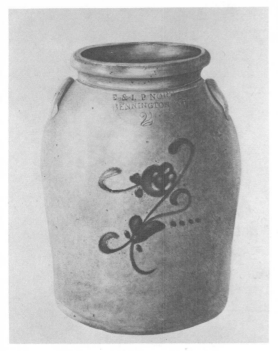 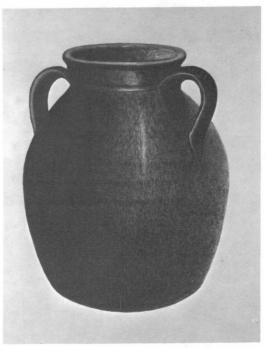

SALT GLAZED STONEWARE JAR stamped "E. &
L. P. Norton, Bennington, Vt." 1861–1881.
Trailed flower design in cobalt blue slip. H.11″
T.6⅜″ N. Y. C. Cer. St. 13c, d.

JAR made by J. B. Long, Long's Pottery, Byron,
Georgia, about 1800. Stoneware with dark
brown mottled glaze. The letters "J. B. L." are
stamped on one handle. H.11½″ W.9″ Fla. Cer.
43.

GROTESQUE JUG, probably made in Connecticut
in the early 1800's. Gray stoneware with olive
green glaze, white eyes and teeth. These whim-
sical jugs, sometimes called "monkey jugs" were
made in potteries throughout the East. Grotesque
jugs were probably made to order in most pot-
teries. No doubt they were also made occa-
sionally as a humorous relief at the end of a hard
day's work or to make use of a jug damaged
while throwing. Overall H.8¾″ B.4¼″ N. Y. C.
Cer. St. 250.

133

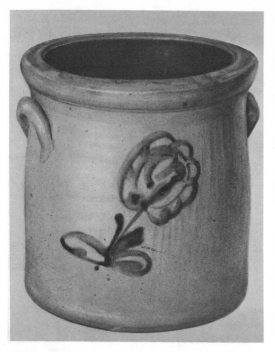

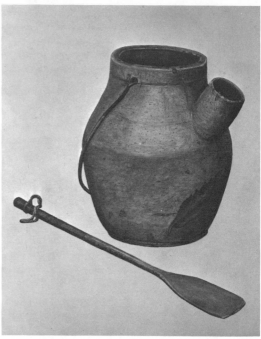

BUTTER CROCK made of gray stoneware, salt glazed, with tinted blue flower decoration. After 1850. Lid missing. Straight-sided butter crocks ranged in sizes from one quart to six gallons. The larger sizes, called tubs, were used for shipping butter to market. H.9″ T.8⅜″ B.8¼″ N. Y. C. Cer. St. 248.*

GRAY STONEWARE BATTER JUG with stirring paddle. Batter jugs were used for incubating buckwheat cake batter. The batter was never completely used which allowed the growth of yeast in batch after batch. Cover missing. H.8¾″ T.5″ B.6½″ W.7½″ Spout. 2½″ Del. Cer. 33.

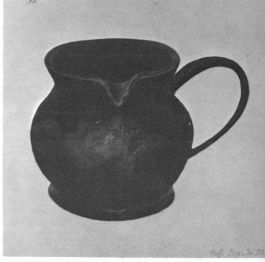

DETAIL OF JAR: Brushed leaf spray, stamped "C. Bykeepers and Sons, Fulton St., Brooklyn," New York, 1894–1897. N. Y. C. Cer. St. 272c, d.

EARTHENWARE CREAM PITCHER with unusual side handle, made at the Bell Pottery at Strasburg, Virginia, in the late 1800's. Mottled red-yellow glaze with green spots. H.3½″ B.3⅜″ T.3⅛″ Del. Cer. 29.

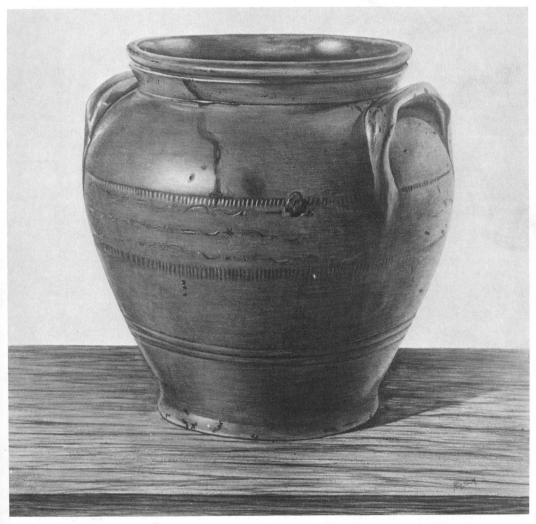

STONEWARE JAR made by Jeremiah Burpee at Boscawen, New Hampshire, about 1804. Dull brown glaze, coggle-wheel and scratched decoration. H.10″ Conn. Cer. 74.

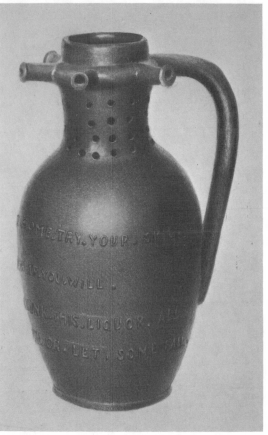

EARTHENWARE SPICE JAR, orange glaze with black splashes. In the early 19th century spice was purchased in small paper bags at the store. At home the spice was removed from the bag and stored in small covered spice jars. Spices were expensive but considered a necessity in the early American household. They were used for flavoring a stew when vegetables were lacking and quite often to cover the flavor of overripe meat or left over dishes. The number "29" trailed in yellow slip on the jar was made to coincide with the number on the lid to insure a matching set for a close fit. This jar was probably made in Connecticut in the early 19th century. Lid missing. H.6¼" Conn. Cer. 48.

EARTHENWARE PUZZLE JUG made at the Hare Pottery, New Castle, Delaware, about 1800. Inscribed:

"Hear.gentlemen.come.try.your.skil.
I'll.hold.a.wager.if.you.will.
that.you.don't.drink.this.liquor.all.
without.you.spill.or.let.some.fall."

Puzzle jugs were trick drinking vessels made to provide amusement for the initiated, and embarrassment for the naive. They usually had perforated necks and small spouts arranged around the rim. The spouts were connected by a tube which continued down through the handle to the bottom of the jug. The trick was to close off all the spouts but one which was used to draw out the contents. Some puzzle jugs also had a hole in the under side of the handle to further complicate the process. H.10" W.5" T.2¼" B.3¾" Del. Cer. 2a.

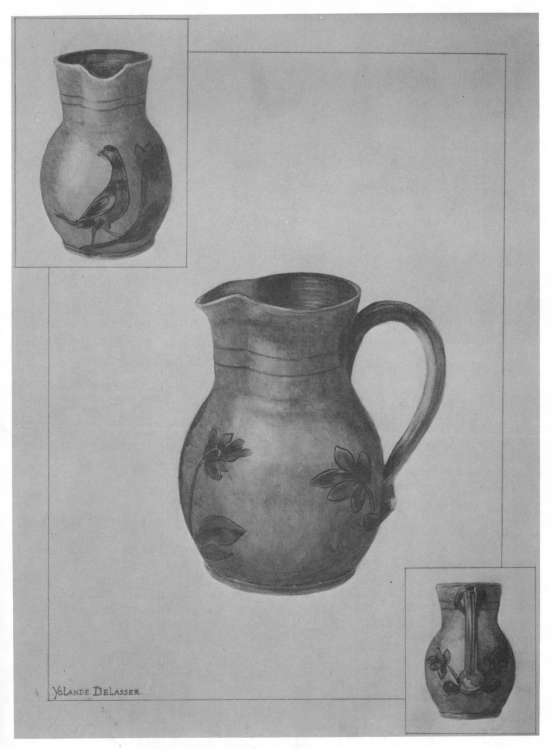

Yolande DeLasser

SMALL STONEWARE PITCHER probably made in Pennsylvania in the early 1800's. Although most American folk pottery was designed for use in the kitchen, dairy, pantry, cellar, or springhouse, pieces that were highly decorated or nicely glazed were probably used on the dinner table. Small pitchers were used for serving cream, molasses and syrup. H.5¾" B.3" N. Y. C. Cer. St. 155.

137

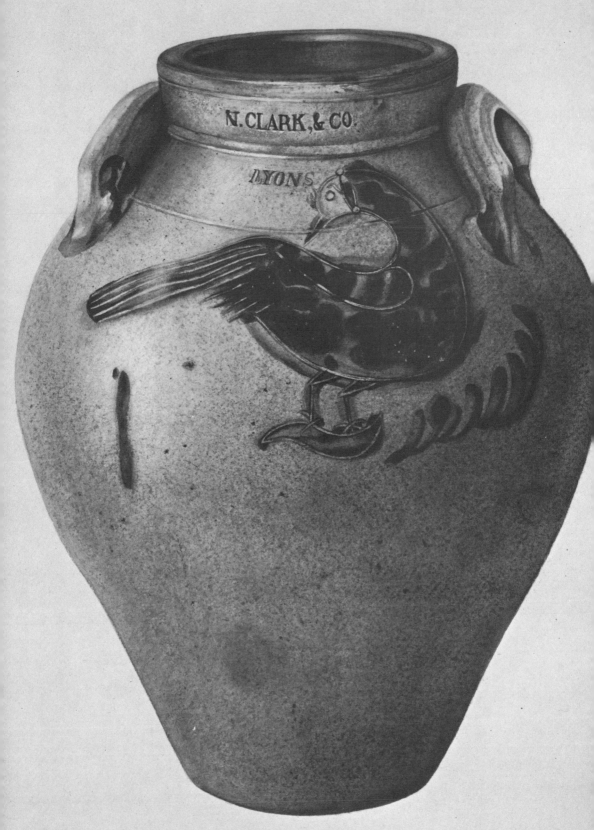

N. CLARK, & CO.

LYONS

JOHN
TARANTINO.

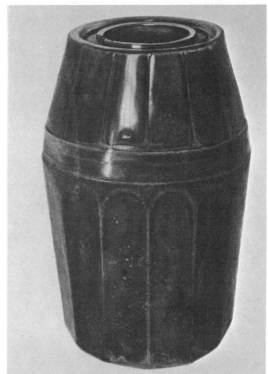

PLUMB PRESERVE JAR marked "C. Crolius Manufacturers, Manhattan-Wells, New York." 1794–1815. Impressions filled with blue slip. Conventionalized flower decoration on reverse side. H.9″ T.4″ B.4⅜″ N. Y. C. Cer. St. 38c, d.

AIRTIGHT JAR made in Peoria, Illinois. Brown glaze, metal lid missing. This jar appears to have been slip cast in a two-piece mold that came apart at the circular band, *ca.* 1840. Mo. Cer. 10.

GRAY STONEWARE JAR, salt glazed, stamped "N. Clark & Co., Lyons" New York. Bird decoration with incised outline filled in with brushed blue slip. The bird's bare head, long, straight tail and mottled feathers suggest a wild turkey. N. Y. C. Cer. St. 111c, d.

139

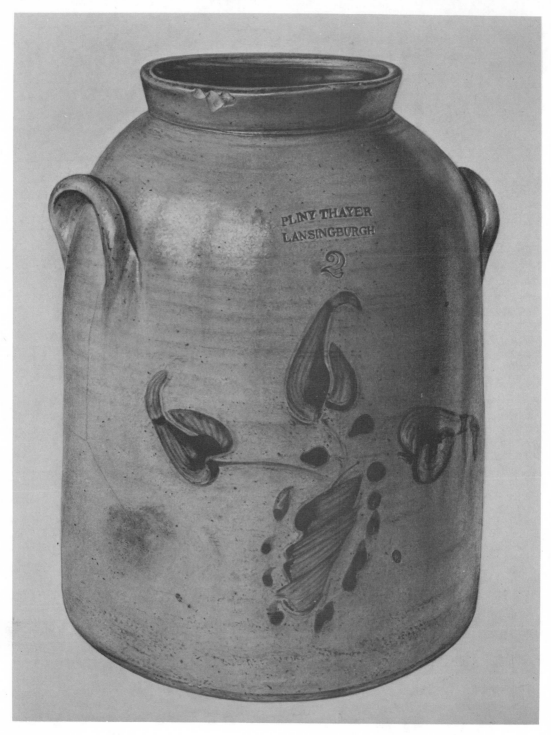

STONEWARE JAR made by Pliny Thayer, Lansing-burgh, New York, *ca.* 1850. Salt glazed, grayish-tan body with simple blue floral decoration. H.12″ T.6″ N. Y. C. Cer. St. 97c.

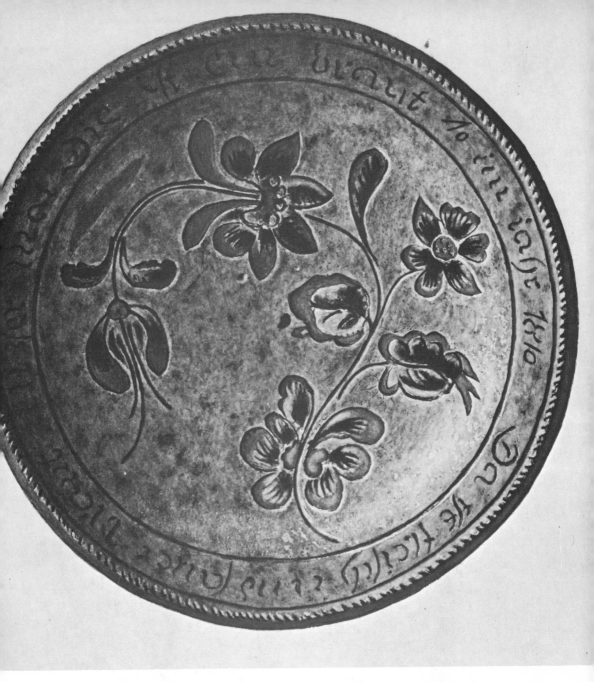

RED EARTHENWARE PIE PLATE covered with olive green slip made by David Spinner, Bucks County, Pennsylvania. Sgraffitto decoration. Inscription reads: "There is meat and sauerkraut. Our girl is a bride in the year 1810." W.10" N. Y. C. Cer. 115.

141

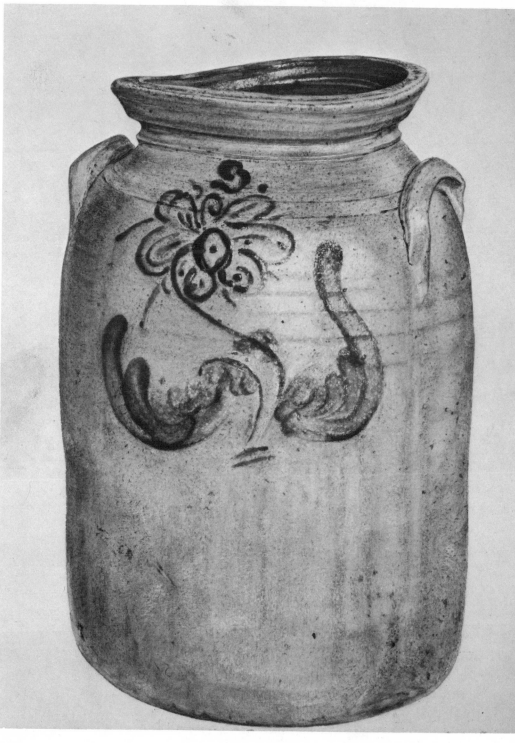

THREE-GALLON STONEWARE JAR possibly made by William A. Macquoid and Co. of New York City between 1864 and 1876. Lid missing. The jar is salt glazed outside with an albany slip interior. The cobalt blue design is a combination of slip trailing and brushwork. The flower suggests stonecrops or live-forevers. H.13½″ N. Y. C. Cer. St. 100.

EARTHENWARE PIE PLATE probably made in New England between 1800 and 1825. Green slip decoration covered by clear lead glaze. Common pie plates actually used for baking, made in New England and New Jersey, were indistinguishable from those made in Pennsylvania. They were decorated with wavy lines, letters and expressions like: "Mince Pie," "Oysters and Clams," "A.B.C.," "Good and Cheap," "Money Wanted," "Mary's Dish," and "Shoo Fly."

Decorative pie plates known as "presentation pieces" were made only by potters of German origin who usually settled in Pennsylvania or central North Carolina. These plates were cherished as ornaments to decorate fireplace mantles and cabinets. Their sgraffito and raised slip trailed decorations rendered them impractical for use. The triple-line decoration "painted" on this plate was called "knotty waves." Conn. Cer. 70.*

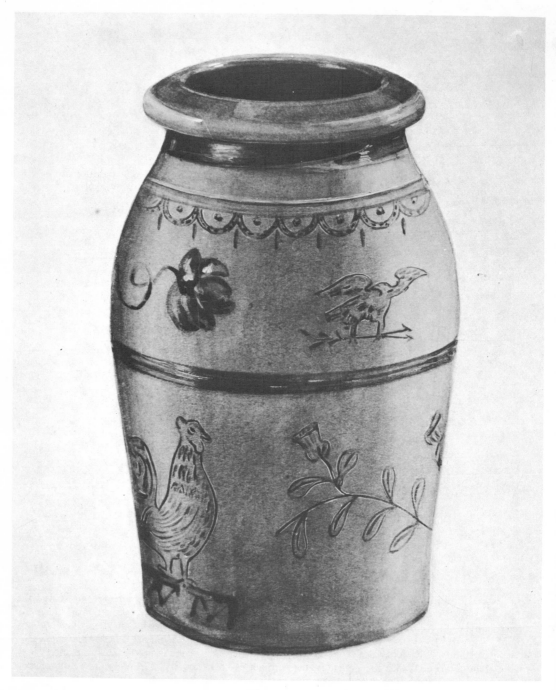

GRAY STONEWARE JAR decorated with bands, flowers, leaves, roosters, festoons, a spread eagle holding arrows, and the initials "W. M." filled in with blue slip. Probably made in Pennsylvania. H.8¼" B.4¼" M.3" N. Y. C. Cer. St. 142.

144

SALT GLAZED STONEWARE JAR with the word "plumbs" lettered on the front in blue slip and "E. C. 1799 No. 2" scratched on the back. Crolius ware, 1799. H.10″ B.5½″ N. Y. C. Cer. St. 189.

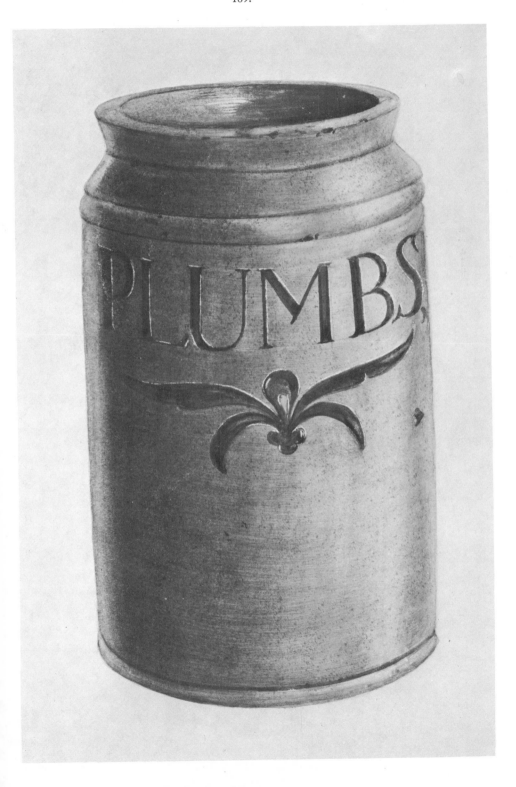

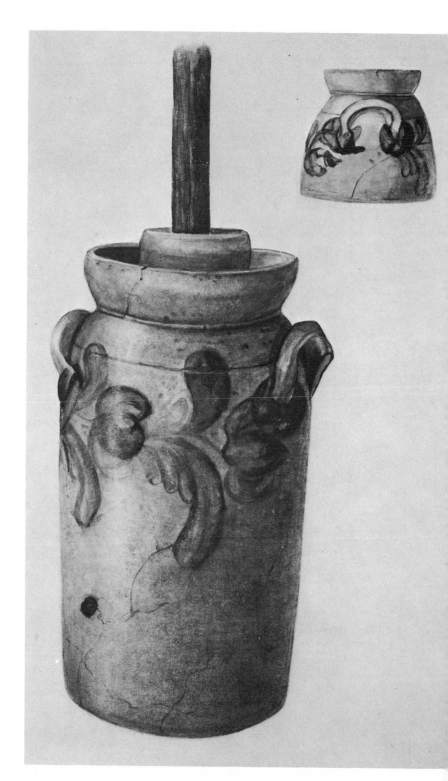

146

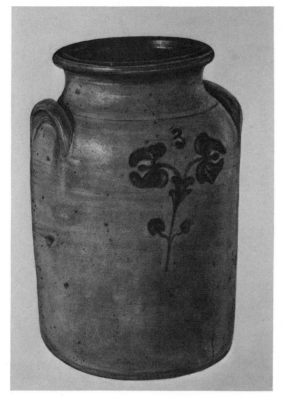 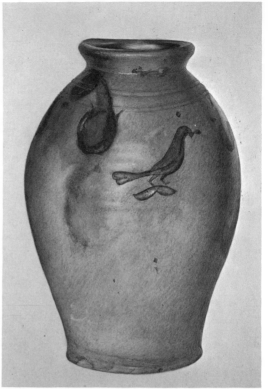

Late 19th Century Jar. Gray stoneware, salt glazed. Simple cobalt blue decoration. H.11⅛″ T.7⅛″ N. Y. C. Cer. St. 282.

Tan Stoneware Jar which appears to have been damaged in the firing, *ca.* 1820. Bird incised on front and the initials "J. D." on back, both filled in with blue slip. Simple bird designs were favorite decoration of stoneware potters in all locales during the 19th century. H.13″ T.4¾″ B.5½″ N. Y. C. Cer. St. 238.

Gray Stoneware Salt Glazed Churn made by Clarkson Crolius, New York City, 1817–1837. Blue floral decoration. "Milk was set in heavy earthen pans, skimmed inadequately and churned with a 'dasher' and the united curses of the family. 'Butter won't come,' accounted for every domestic hiatus. Mother churned— and all the larger children. The men took a whack at the work as they came in from the field, they even sang to it." H.10¾″ B.5″ N. Y. C. Cer. St. 188.

147

LATE 19TH CENTURY STONEWARE JAR covered
with brown glaze. Brushed cobalt blue flower
decoration. The name "J. Miller" is stamped
on the left side of the jar. H.10¼" T.5½"
N. Y. C. Cer. St. 318.*

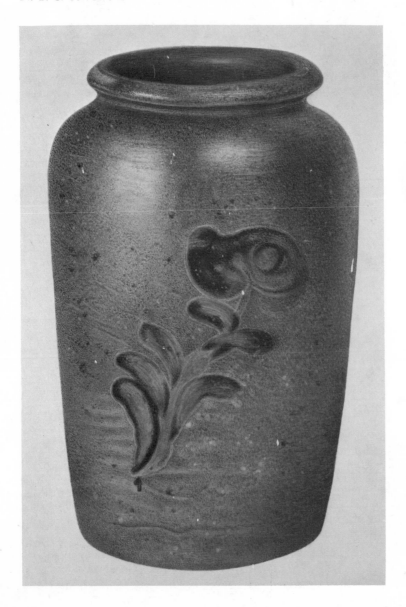

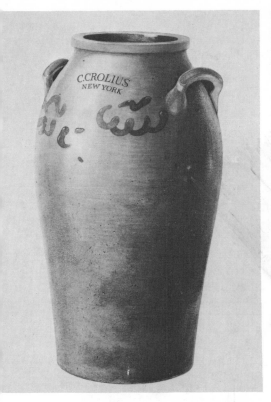

TALL SALT GLAZED STONEWARE JAR produced at the Crolius pottery in New York City between 1815 and 1848. Cobalt decoration. H.15½″ N. Y. C. Cer. St. 300.

SALT GLAZED TAN STONEWARE PRESERVE JAR, *ca.* 1880. Stylized blue slip decoration on front and the figure "1½" stamped on back. Preserve jars were also used as containers for storing butter, lard, flour, sugar, salt and other household necessities. H.10¼″ T.5⅞″ B.7¾″ N. Y. C. Cer. St. 245.

MELON SHAPED JAR made in New England about 1825. N. C. N.

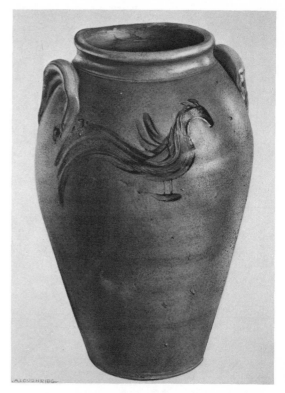

SNUFF JAR made at Portland, Maine, between 1800 and 1825. Dark brown glaze flecked with deeper tones. There were two kinds of snuff or ground tobacco used by early Americans. Upper-class gentlemen preferred the dry form which was finely ground and was inhaled through the nostrils. It was made from the finest part of the leaves, sometimes scented and sold under various names, such as Irish, Scotch, and Sweet Snuff. The common man usually "chewed" his snuff by placing a large pinch of it under his lower lip or in his cheek. This moist snuff for chewing was called "rappee" and was made by allowing the leaves to ferment which gave it strength and aroma. After the fermentation process, which took many months, the leaves were ground and stored in jars or other airtight containers. Another kind of "chaw" tobacco was made by removing the large veins from the leaf and forcing it down a hole bored in a piece of black birch. The leaves were rammed down the hole one on top of the other with a few drops of molasses in between. When the hole was full it was fitted with a tight-fitting plug. The green piece of wood was then put away to dry. The longer it aged the better. The "plug" of tobacco was removed by splitting open the piece of wood. H.5″ Conn. Cer. 56.

TALL STONEWARE JAR made from blue-gray clay, salt glazed, brown slip interior. Bird decoration in blue slip may have been finger painted. H.15″ T.7½″ B.7½″ N. Y. C. Cer. St. 216.

STONEWARE JAR made at Commeraw's pottery at Corlears Hook, New York, about 1820. The letters "S" and "N" are reversed in the potter's stamp. H.15″ B.7⅜″ T.6½″ N. Y. C. Cer. St. 23.

151

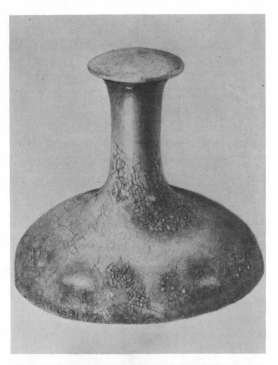

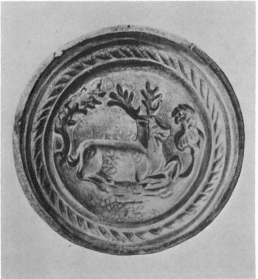

LATE 19TH CENTURY BUTTER STAMP made of Ironstone china covered with a transparent glaze. Intaglio design of reclining deer framed by two trees with a rope border. Butter stamps were the dairyman's trademark. They were used throughout Pennsylvania, New York, and New England until the late 1800's. Stamps were made in different sizes and usually would mark a one- or two-pound butter pat. Patterns varied according to individual taste; the most common included flowers, animals, birds and initials. The designs were either carved freehand in the clay when it was leather hard, or impressed in the stamp with clay, wood or plaster of Paris dies. H.3½" W.3⅞" N. Y. C. Cer. 100a, 100b.

SALT GLAZED TAN STONEWARE CHURN with dark brown slip glazed interior. Rooster decoration and capacity mark stenciled in cobalt blue slip. Made after 1850. Butter churns were tall jar-like vessels in which cream was agitated to break down the small globules of butterfat so they would cluster together and float to the top. The agitation or churning action was accomplished by steadily plunging the dasher up and down in the cream. The cream went through three stages in the churning process called "swell, break, and gather." When the churning began the cream frothed like whipped cream or "swelled." Consequently the churn could not be filled too full. Next the cream "broke" and small pieces of butter began floating to the surface. These small pieces of butter "gathered" or adhered to each other forming larger lumps as the churning continued. When the churning was finished the buttermilk was strained off and a small amount of cool water was added to the butter remaining in the churn. The cool water helped to consolidate the butter and wash out the remaining buttermilk. The buttermilk had to be removed or the butter would spoil; to avoid this the butter was usually washed two or three times. Finally, butter was scooped from the churn with a curved wooden paddle or with the hands cooled in cold water, which was easier and faster. The butter was placed in a bowl where it was salted and all the water worked out with a paddle. H.17½" T.9¼" N. Y. C. Cer. St 280.

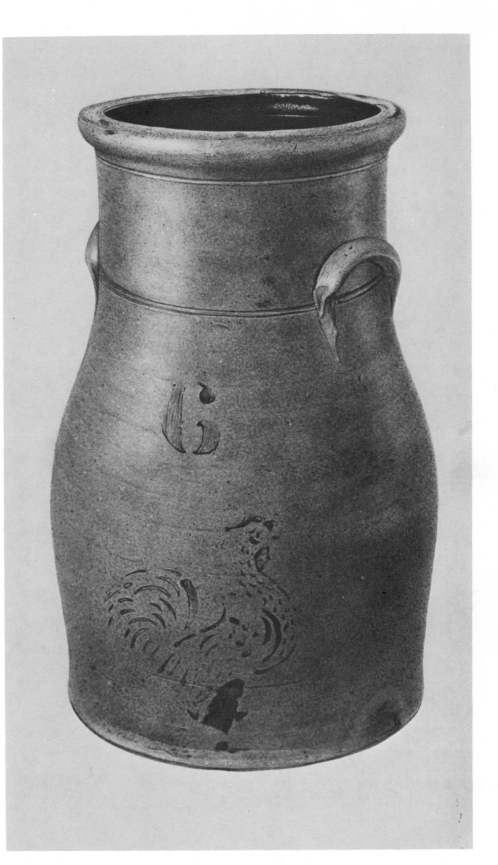

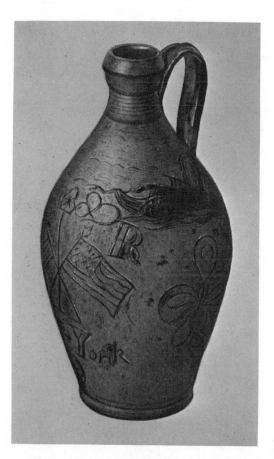

Small Tan Stoneware Salt Glazed Jug probably made by Bill Howard at the Crolius or Remmey Pottery in New York City, between 1806 and 1810. H.6⁵⁄₁₆″ B.5″ N. Y. C. Cer. St. 328, 57d.

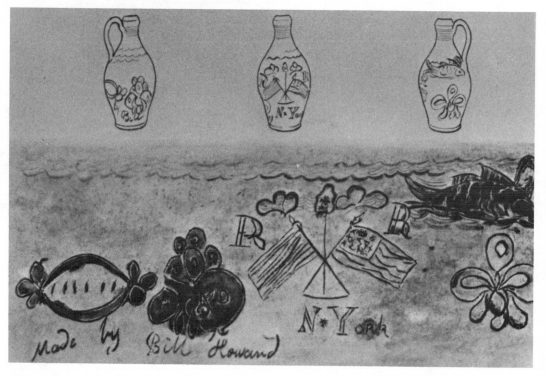

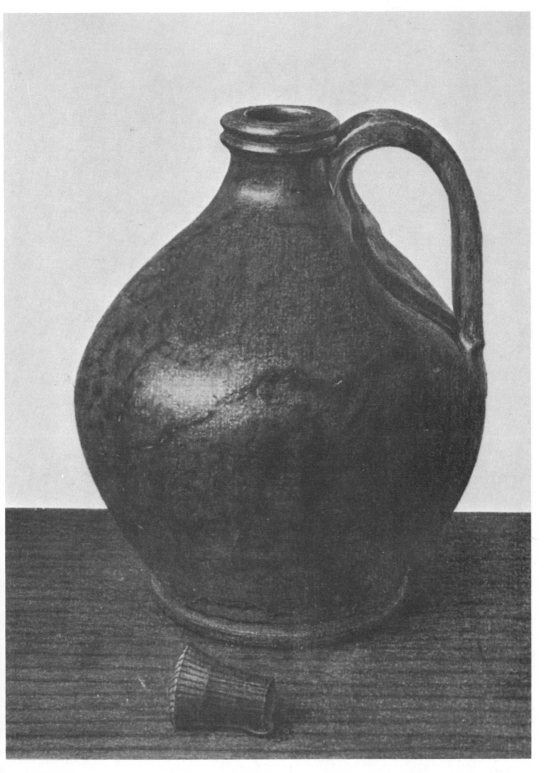

LATE 18TH CENTURY EARTHENWARE JUG from New England. Green glaze with red splashes. In Massachusetts in the mid-1700's a gallon of corn, wheat and rye whiskey sold for twenty-five cents. The price included the cost of the jug. Conn. Cer. 30.

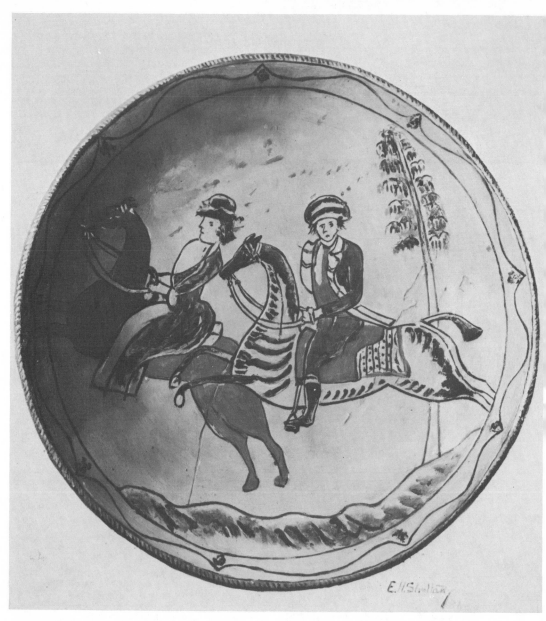

PAIR OF EARTHENWARE PIE PLATES called "Deer Chase," made by David Spinner, Bucks County, Pennsylvania. Sgraffito design of officer and lady on horseback chasing a deer with dogs. Yellow, green and red slip. It is doubtful that these plates are an exact pair. The slip grounds are different colors, the borders do not match, and the missing lower legs of the horse on the right plate reappear as the front half of a horse on the left plate. Although the two plates are mismatched, they are a good indicator that Spinner did make pairs of decorative pie plates on which the decorations continued from one plate to the other. Both plates: W.11½″ Pa. Cer. 7b—Pa. Cer. 77.

156

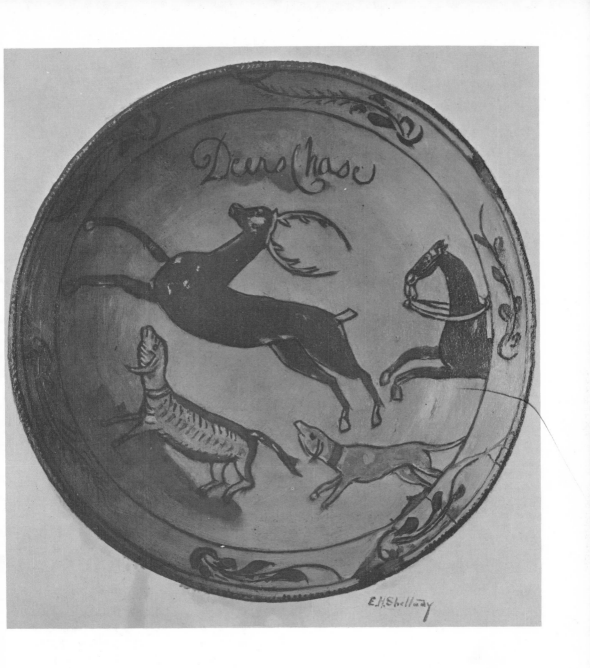

157

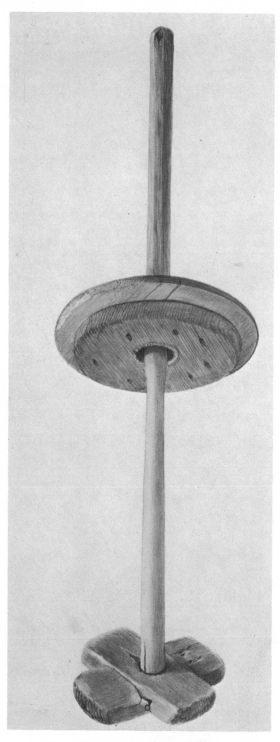

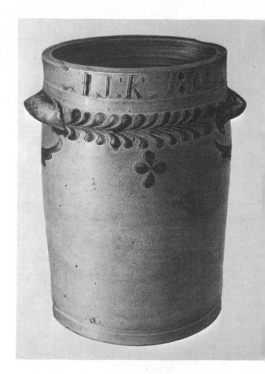

STRAIGHT-SIDED JAR incised "I. J. K. 1802. N. Y. March 4th." Gray stoneware, salt glazed. Incised letters and decoration filled in with cobalt blue slip. N. Y. C. Cer. St. 321.

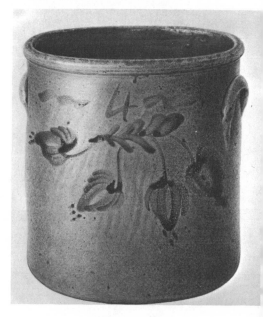

WOODEN DASHER FOR BUTTER CHURN. Sold at John Eardley's Pottery, St. George, Utah, in the 1860's. Pottery lids were generally furnished with churns. They were, however, easily broken so some potters supplied wooden lids along with the dasher. The potters probably didn't make these items themselves but purchased them from some local woodworker. Utah Cer. 23.

LATE 19TH CENTURY BUTTER CROCK probably made in Pennsylvania. Gray stoneware, salt glazed, with reddish slip inside. Fuchsia-like flower design brushed in blue. In Pennsylvania German folklore the fuchsia was considered sacred because it was one of the first signs of returning life in the spring. H.11⅞" T.11 B.10⅝" N. Y. C. Cer. St. 233.*

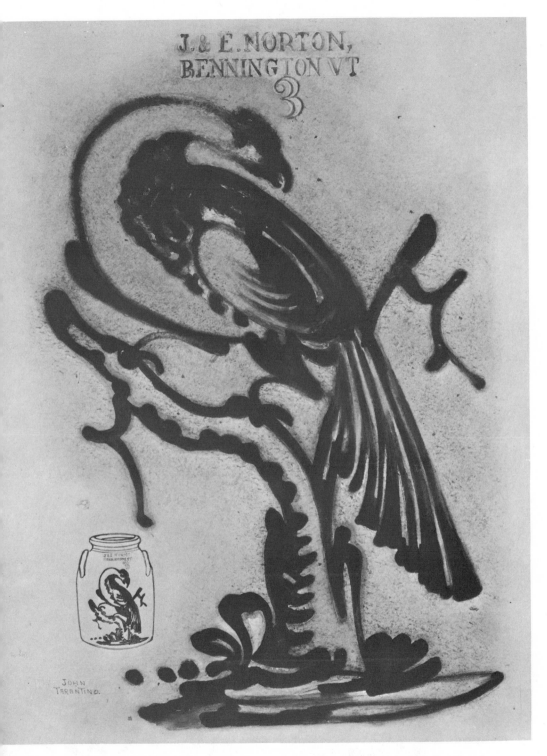

DETAIL OF JAR: Elaborate slip trailed decoration of bird on stump, possibly a peacock, 1850– 1859. H.13¾" N. Y. C. Cer. St. 87c, d.

AIRTIGHT JAR, used for canning pickles in t
Tuscarawas River District, Holmes Count
Ohio, mid-19th century. Mottled red and yello
slip glaze. Metal lid missing. The airtight ca
ning jar was a contemporary of the corke
They were used much like the glass canning j
is used today, and sealed with a circular, co
cave metal lid. The jar and contents were heate
in a boiling kettle of water for the prescribe
time. The jars were then removed from t
kettle and sealed. A piece of cloth soaked i
melted beeswax was placed over the mouth
the jar. The metal lid was immediately presse
firmly down over the cloth, sealing the mout
of the jar. Wax was poured over the lid to hol
it in place. The thin sheet metal lid was the
protected inside and out from corrosion. Ohi
Cer. 42.

YELLOW EARTHENWARE JAR made by unknown
Ohio potter. Five-gallon capacity. Ohio Cer. 19.

LATE 19TH CENTURY STONEWARE JAR with alban
slip interior. Probably made in New York State
Cobalt decoration, lid missing. H.10¾″ B.8
N. Y. C. Cer. St. 230.*

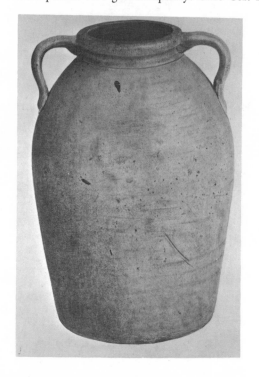

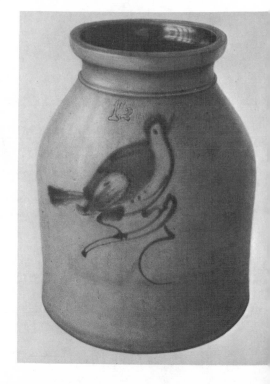

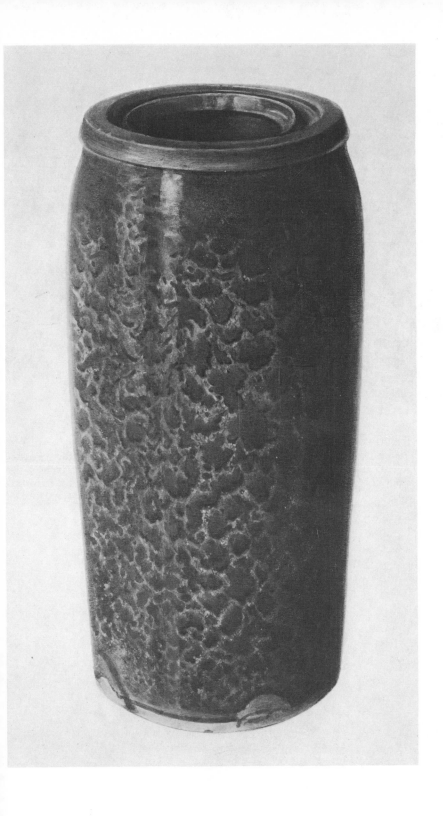

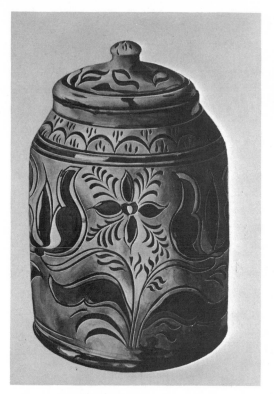 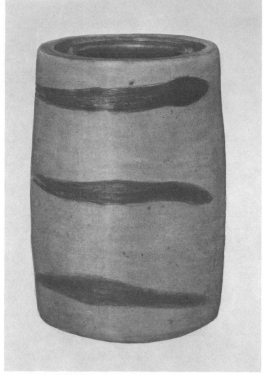

Sgraffito Decorated Jar from southeastern Pennsylvania. Conventionalized tulip and leaf design executed in yellow, red and green slip, *ca.* 1830. H.7¾″ W.5″ Pa. Cer. 131b.

Salt Glazed Stoneware Airtight Jar or "can" used for preserving fruits and tomatoes. Possibly made by Dillon Bros. Pottery, Irontown, Ohio. Cobalt blue decoration. Metal lid missing. H.6″ W.4⅜″ M.2½″ Ohio Cer. 6.

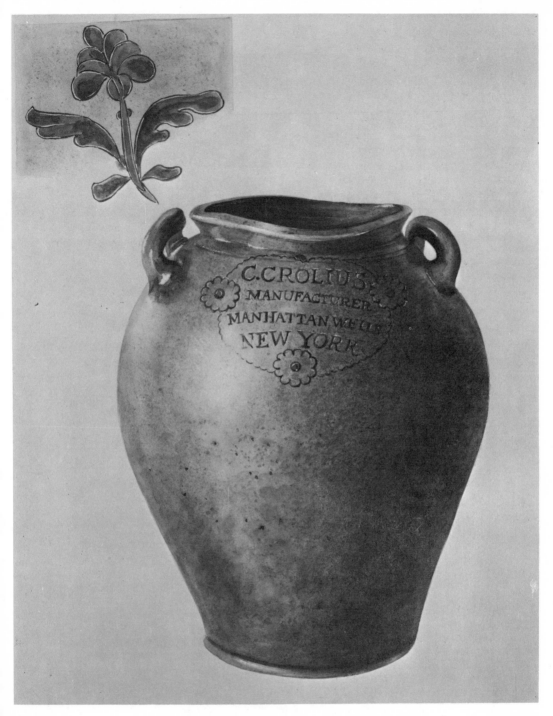

GRAY STONEWARE JAR. Maker's name enclosed by daisies and scalloped line. Outlined blue flower on reverse side. Rim probably warped during firing. H.12¼" T.5⅝" B.5½" N. Y. C. Cer. St. 174c, d.

163

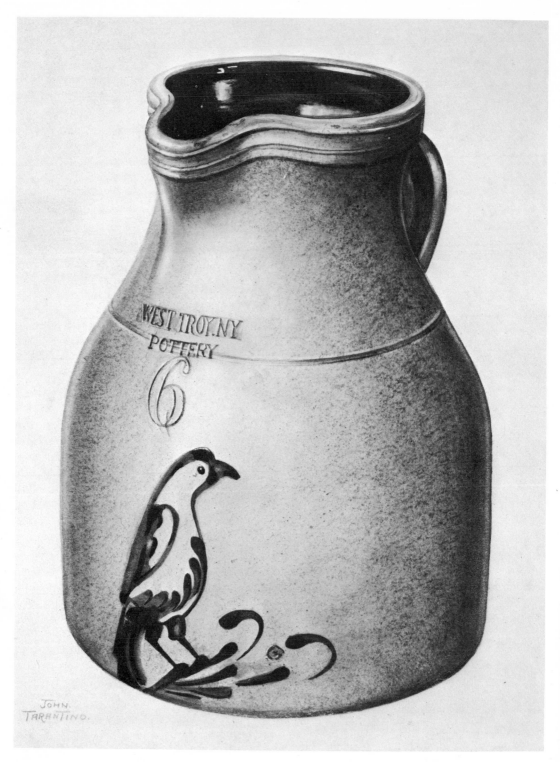

LATE 19TH CENTURY STONEWARE PITCHER with
interesting, low placement of a slip trailed deco-
ration of a bird. The decoration relates well to
the form by repeating its curves. Six-quart ca-
pacity. H.11″ N. Y. C. Cer. St. 108.

164

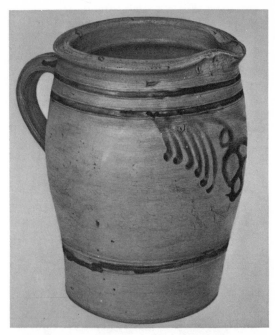

GRAY STONEWARE SALT GLAZED PITCHER with blue decoration, probably made in Pennsylvania. Pitchers made during the mid-1800's were often no more than handled cylinders with hastily pulled "pours." H.8¼" B.4½" N. Y. C. Cer. St. 286.

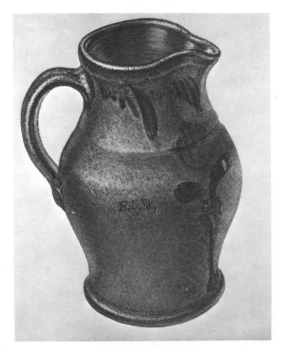

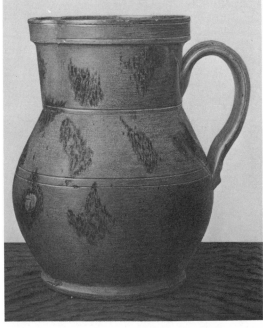

GRAY STONEWARE SALT GLAZED PITCHER, marked "R. C. R., Phila." made by Richard Clinton Remmey of Philadelphia, Pennsylvania. The stamp is casually placed beside the freely brushed cobalt leaf and flower decoration. H.7¼" W.4½" B.4⅛" N. Y. C. Cer. St. 179.

EARTHENWARE WATER PITCHER from the New London-Norwich, Connecticut area. Mahogany-colored glaze with dark splashes. Except for the glaze this pitcher is identical to 16th century earthenware pitchers found in England. H.9¼" Conn. Cer. 10.

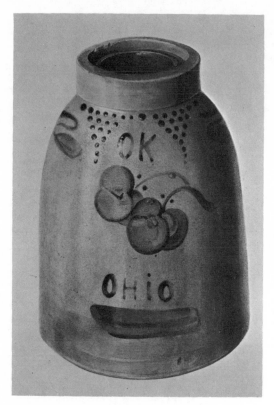

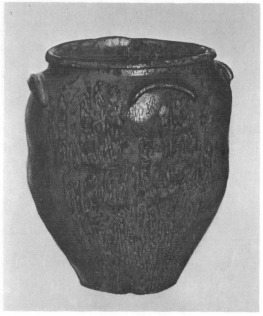

AIRTIGHT JAR, made either by John Hopkins or Daniel Wyant, both of Seneca County, Ohio. 1850–1875. Salt glazed stoneware with brushed cobalt decoration. Metal lid missing. "O. K." is the abbreviation of "Oll Korrect," a colloquial term often used in Seneca County. Ohio. Cer. 38.

LARGE FOUR-HANDLED JAR for preserving salt meat or lard, covered with mottled green glaze. The names of two Negro potters, "Dave and Baddler, 1859" are scratched on the jar. They worked at the Louis Miles Pottery at Stoney Bluff in Aikens County, South Carolina. Records do not indicate whether the potters were free or slave laborers. A southern planter occasionally hired a journeyman craftsman in some trade to work full time on his plantation with the idea that both he and the craftsman would profit from the products made from raw materials located on his property. The agreement sometimes lasted only long enough for the slave apprentice to learn the trade. H.27½″ M.18¾″ S. C. Cer. 1.

SALT GLAZED STONEWARE PITCHER probably made by Richard Clinton Remmey at Philadelphia, Pennsylvania, about 1859. Garlands of flowers and leaves in blue slip. N. Y. C. Cer. St. 288.

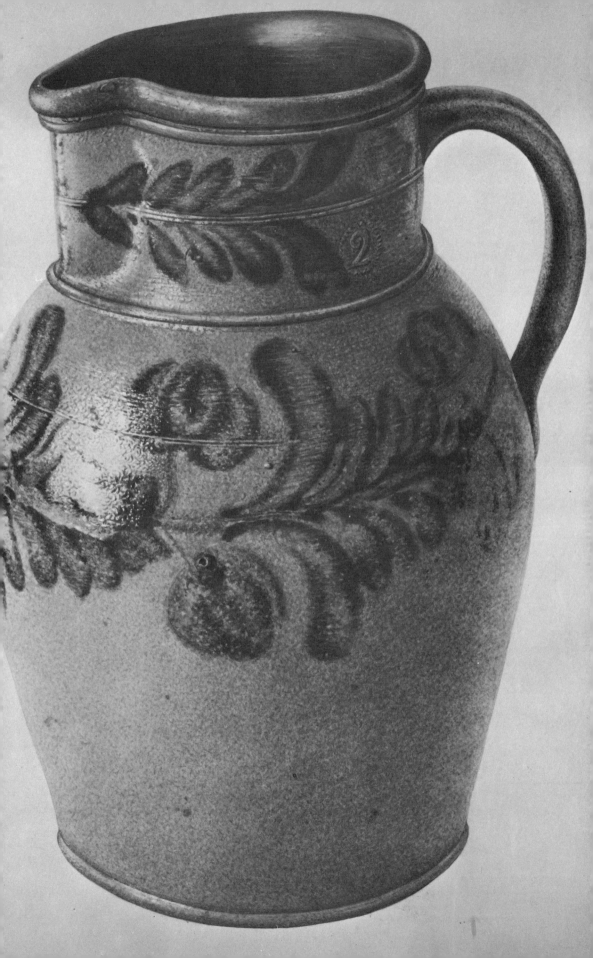

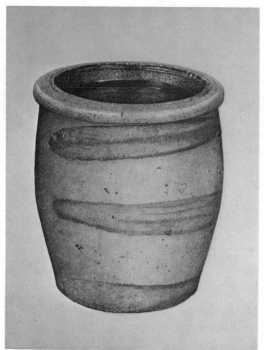

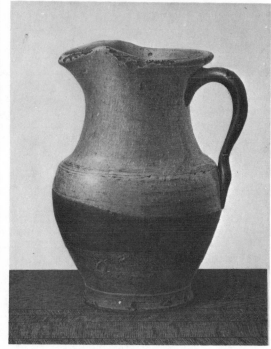

SALT GLAZED STONEWARE JAR made in Philadelphia, Pennsylvania, about 1860. Casually brushed cobalt blue stripe decoration. Wide-rimmed jars were used for "putting-up" apple butter, preserves, and fruits preserved in honey. A round of brandied paper was sometimes placed directly on the fruit to inhibit the growth of mold. A dust cover was either tied over the mouth or sealed to the wide rim with wax or egg white. H.6½" W.6⅛" Iowa Cer. 3.*

UNUSUAL SMALL EARTHENWARE CREAM PITCHER, *ca.* 1800. The combination of cream and brown glaze is thought to be typical of pottery made on the outskirts of New Haven, Connecticut, in the Quinnipiac district. H.5½" Conn. Cer. 60.

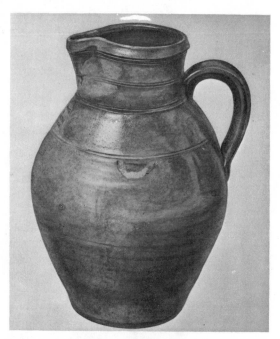

SALT GLAZED STONEWARE PITCHER stamped "Armstrong and Wentworth, Norwich," Connecticut, 1814–1834. Large pitchers, holding as much as five gallons, were used to serve cider, beer, and ale. N. Y. C. Cer. St. 225.

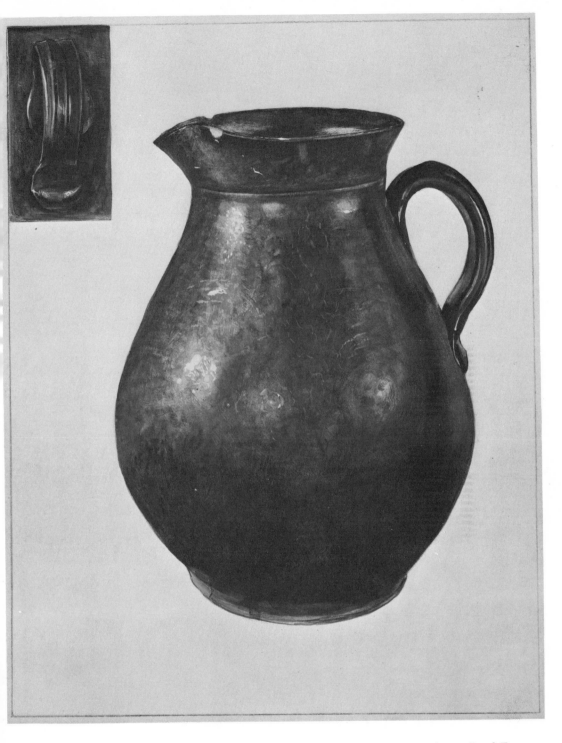

LATE 18TH CENTURY EARTHENWARE PITCHER probably made in Pennsylvania. Black glaze. A very old design originating in medieval Europe. H.9″ T.4½″ B.3⅞″ N. Y. C. Cer. 67.

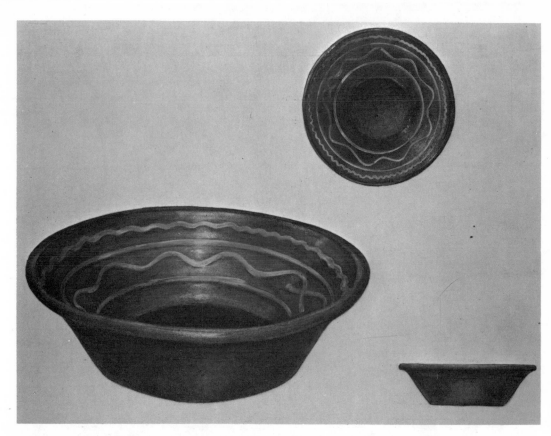

EARTHENWARE PUDDING PAN made in Pennsylvania in the late 1700's. Slip trailed decoration, transparent glaze. Puddings were a favorite dessert along with pies, cakes, and custards. They were either baked in a buttered pan or wrapped in a floured cloth sack and boiled. There were numerous recipes and methods for making these "puddins"—as they were called in earlier times. The most common ingredients were flour, eggs, milk, butter, sugar, suet, marrow, and raisins. Some recipes also called for meat, blood, fruit, vegetables, and molasses. W.7" N. Y. C. Cer. 3.

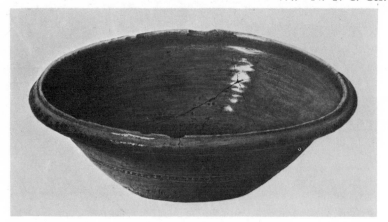

EARTHENWARE RIM PAN with transparent glaze. Rim pans were all-purpose vessels used in the kitchen for food preparation. They were used to carry vegetables and fruit from the garden, to collect eggs, and to store food temporarily in the house. They were made as large as eighteen inches in diameter. Their wide rims doubled as handles. Utah Cer. 6.

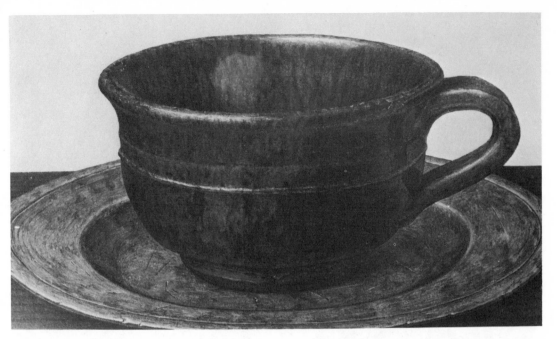

LATE COLONIAL PORRINGER made in New England. Red earthenware with dark green glaze. Porringers looked like large-handled cups but were actually bowls used for serving foods which were eaten with a spoon. Conn. Cer. 31.

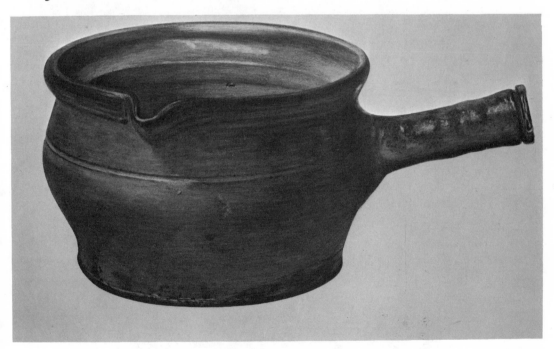

SMALL EARTHENWARE PIPKIN made at the Langenberg Pottery, Franklin, Wisconsin. Lid missing. Pipkins were small-handled cooking pots used much like saucepans are today. They were sometimes glazed only on the inside to insure easy cleaning. Pipkins and other cooking utensils were usually cleaned by scouring them with sand or, if they were greasy, with wood ashes. H.4¼″ W.6¹¹⁄₁₆″ B.5⁷⁄₁₆″ Handle L.3⁵⁄₁₆″ Wis. Cer. 2.

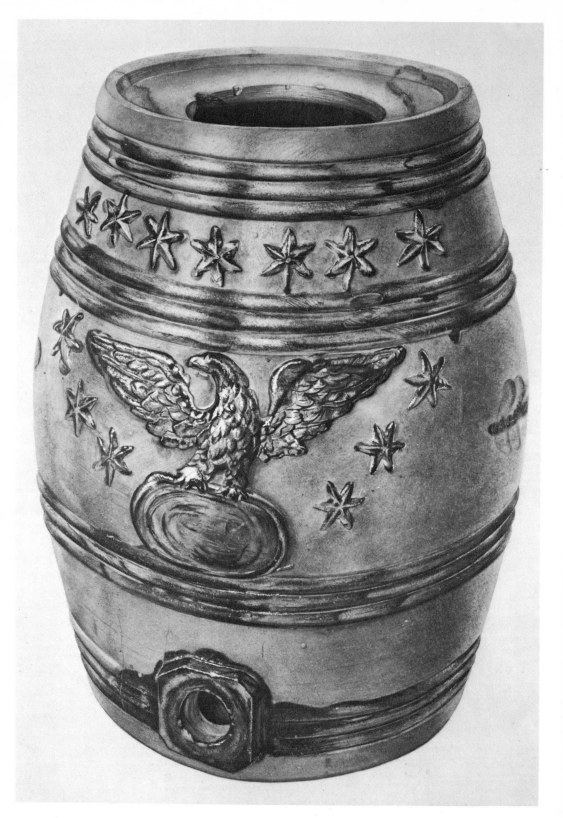

172

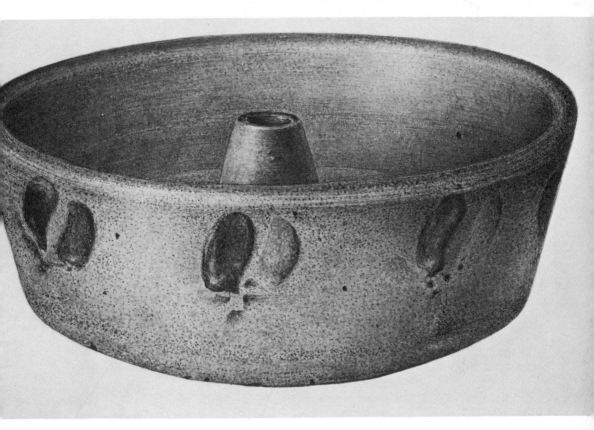

SALT GLAZED STONEWARE CAKE MOLD or "Tube Pan" for baking sponge cake, 1800–1850. Simple blue decoration. Pottery cake molds were more popular than those made of tin and cast iron. They were inexpensive, light in weight, easy to clean, and did not rust. Cake molds were made in many styles, and usually were six inches to twelve inches wide and two inches to four inches high. The center cone of a cake mold was usually open at the top to allow hot air to circulate through the mold in order to bake the inside of the cake. H.3″ T.9⅓″ B.7¼″ N. Y. C. Cer. St. 313.

GRAY STONEWARE SALT GLAZED WATER COOLER probably made during the Civil War. Modeled relief decorations and bands painted with cobalt blue slip. Lid missing. H.14″ T.7⅝″ B.7¼″ N. Y. C. Cer. St. 279.

173

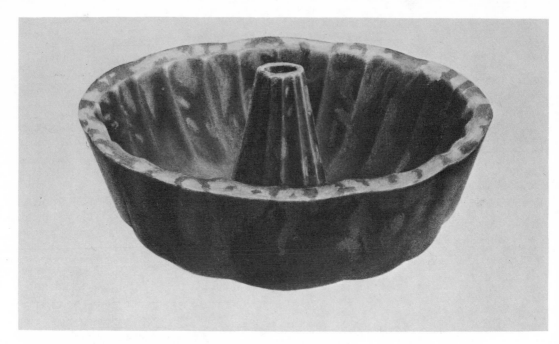

"Turks-Head" Baking Dish which was formed on a mold. Marbled clay body. Ribbed baking dishes were usually formed on molds, but some were thrown and fluted by hand. Rim H.2¼" Cone H.3⅛" W.7¼" Del. Cer. 19.

Jar made by Odon and Turnlee, Knox Hill Pottery, Knox Hill, Florida, in 1859. Stoneware with light olive spots. H.14½" W.9" Fla. Cer. 31.

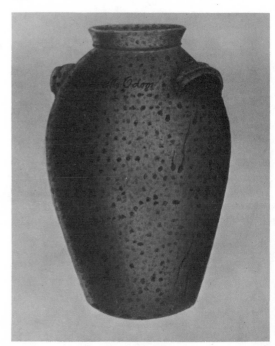

174

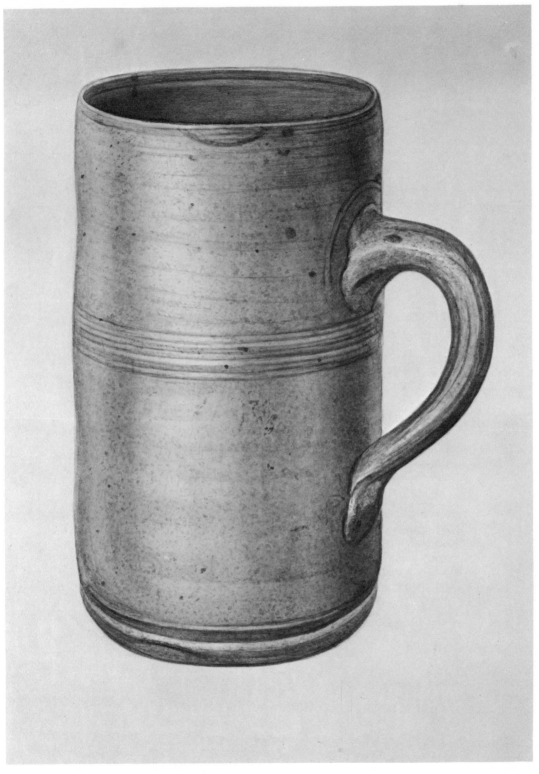

THIN STONEWARE MUG probably made in the late 1700's. Cider, ale, and beer mugs or "drinking cans," as they were sometimes referred to, were usually made in half-pint, pint and quart sizes. Occasionally, "pottle-size" or two-quart mugs were made in some New England potteries. H.6½″ W.4″ N. Y. C. Cer. St. 322.

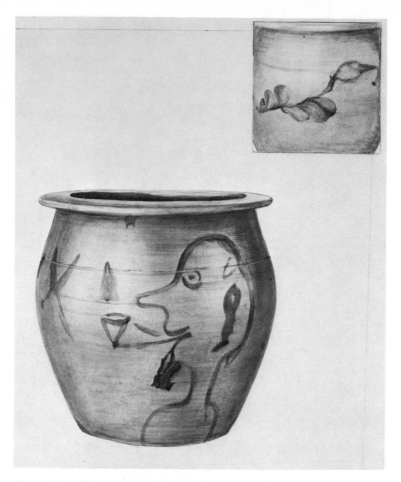

Small Salt Glazed Apple Butter Pot made of grayish-tan stoneware, with cobalt blue slip decoration. Probably made in Pennsylvania, 19th century. This shape was made in several sizes and was commonly used in the middle eastern and southern states for storing apple butter. Apple butter is a natural preservative which required only a dust cover over the jar. The common lard pot had a similar shape with a somewhat narrower rim. H.4¼″ T.4⅜″ B.2⅞″ N. Y. C. Cer. St. 34c.

RED EARTHENWARE MEASURE WITH GLAZED IN-
TERIOR probably made in Pennsylvania about
1800. In England measuring cups used by mer-
chants were checked by officials and stamped
to indicate that they held at least the amount
marked. In this country standard measure sizes
were never strictly enforced. Many merchants
were completely unscrupulous and gave short
measure and light weights whenever possible.
Adulteration of foodstuffs was also quite com-
mon: white sand in sugar, dust in pepper, wa-
tered-down liquors, flour in ginger, chicory in
coffee and lard in butter. But since almost all
trade was by barter it was often hard to tell
where along the line the food was stretched.
Both farmer and merchant operated on the
principle of "let the buyer beware." Hence the
only sure way to get good products was to pay
premium prices. H.4½" N. Y. C. Cer. 25.

KEG-SHAPED STONEWARE WATER COOLER stamped "Paul Cushman," Albany, N. Y., *ca.* 1809. Incised fish and bird decorations filled with blue slip. Lid missing. Running water was a luxury in the 19th century, even in the larger cities. River and spring water was considered superior to well water by most people although they contained impurities, especially after a rain. Drinking water for use in business establishments as well as in the home was often stored and settled in stoneware coolers. If the water was extremely dirty, it was strained through a cloth as it was poured from the bucket into the cooler. Finer particles were then allowed to settle below the faucet placed near the bottom of the cooler. The water supply was stored in a warm place, usually the kitchen, during the winter so that the water wouldn't freeze and break the cooler on cold nights. Stoneware water coolers ranged in sizes from two to twenty gallons. In the mid-1800's they sold for forty cents a gallon. H.15″ N. Y. C. Cer. St. 257.

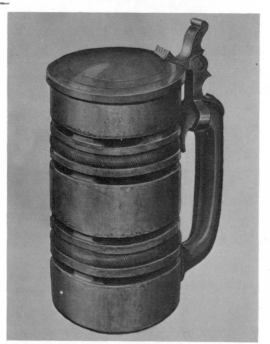

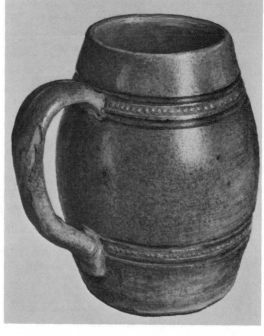

STONEWARE BEER MUG with pewter lid made by N. A. White and Sons, Utica, New York, about 1865. Covered stoneware tankards and steins for ale or beer were never as common in America as in Europe. H.5″ W.3″ N. Y. S. Cer. 3.

BROWN STONEWARE MUG produced by Carl and William Wingender, Haddonfield, New Jersey, in 1894. Barrel-shaped drinking mugs were popular throughout the 19th century. H.5½″ W.4″ N. J. Cer. 15.

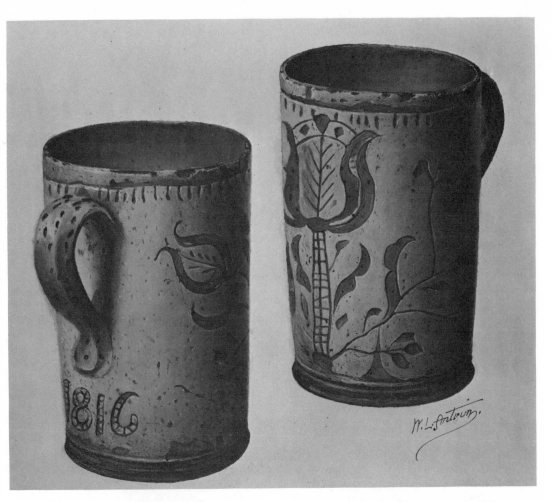

SGRAFFITO DECORATED DRINKING MUG covered with light tan slip and lead glaze. Made in Pennsylvania, date marked. Potters sometimes showed a sense of humor by fastening realistically modeled frogs in the bottoms of beer mugs. H.6⅛″ W.5¾″ Pa. Cer. 169.

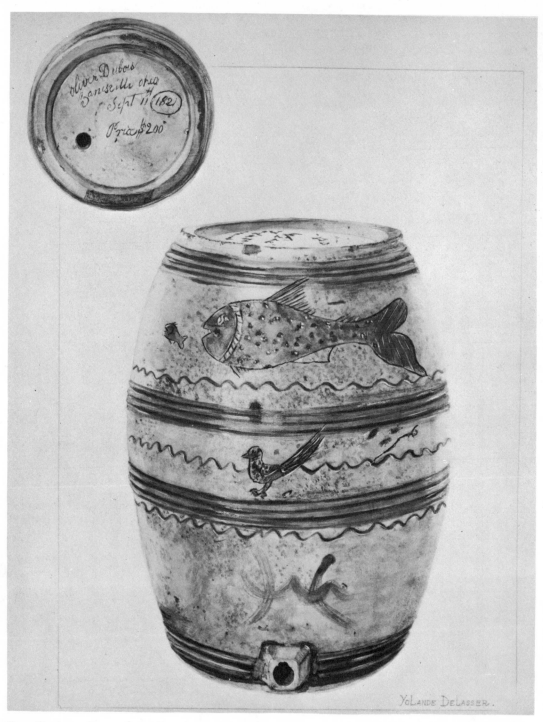

FIVE-GALLON STONEWARE WINE CASK with maker's name, location, date and the price scratched on top. Incised decorations filled in with blue slip. Unlike water kegs and coolers, containers for dispensing cider and wine were made so that they could be securely corked to keep the contents' natural flavor and effervescence. H.17″ T.8″ N. Y. C. Cer. St. 164.

180

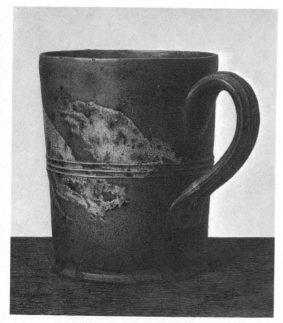

EARLY 19TH CENTURY EARTHENWARE MUG probably made in Eastern Connecticut. Orange-brown glaze splashed with green slip. "Small drink" in the colonies was the name for fermented beverages such as beer, wine, ale and hard cider. They were considered a superior drink to water and were often served three meals a day. In New England apple cider was the common small drink because of the lack of grain for brewing. "Water cider," which was made by soaking apple pulp from the first pressing overnight in water and repressing, was considered an appropriate drink for women and children. Respectable women and children did not drink alcoholic beverages. H.4½" W.3⅓" Conn. Cer. 44.

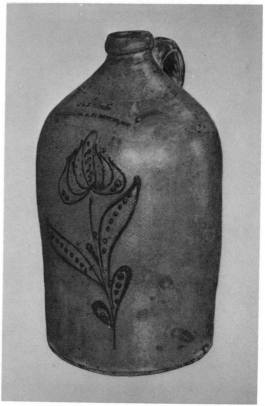

TAN STONEWARE SALT-GLAZED DRUGGIST JUG stamped "J. and J. F. Tripp, Druggist, 90 and 92 Maiden Lane," probably made by Hudson River Pottery in New York City between 1830 and 1855. Dark cobalt blue slip-trailed tulip decoration. The line in the glaze around the shoulder was left by the jug collar used in stacking. Stoneware druggist jugs probably first made in the early 1800's, have changed very little in shape and are still used today. In the 19th century druggists were wholesale suppliers. They sold crude drugs, herbs, roots and gums to apothecaries and doctors. H.12¼" B.6¾" N. Y. C. Cer. St. 221.

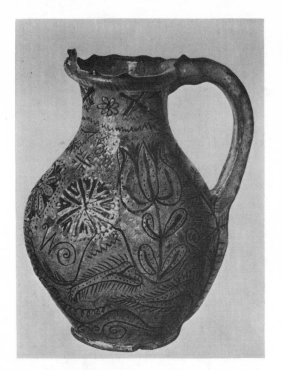

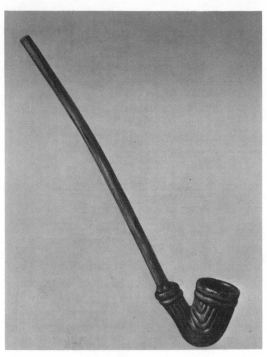

RED EARTHENWARE PUZZLE JUG made in Pennsylvania, dated 1775. Sgraffito design through yellow-green slip ground covered by transparent lead glaze. The initials "S. W." and the inscription "This and the giver are thine forever" are included in the decoration. H.8" N. Y. C.

GRAY CLAY PIPE known as a "reed-stemmed clay" made about 1856. Pipe bowls were usually formed in molds and were unglazed. The stems were cut from cornstalks, grapevines, river cane, willow, and elderberry bushes. W.1" L.1½" Cane Stem L.6½" Fla. Cer. 27.

SALT GLAZED STONEWARE WATER FOUNTAIN made at Zanesville, Ohio, about 1840. Incised decoration tinted blue. Faucet and cover missing. H.22" T.7¼" W.12½" B.9⅞" Ohio Cer. 29.

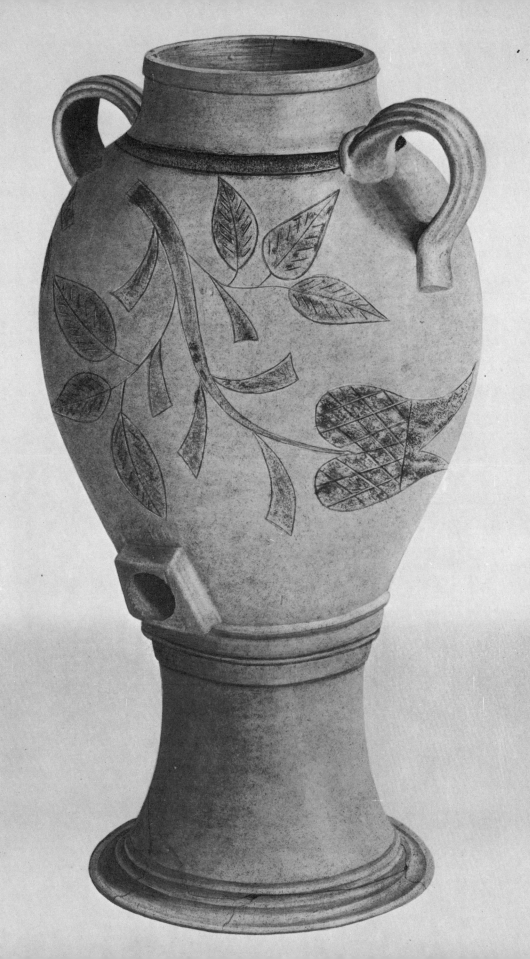

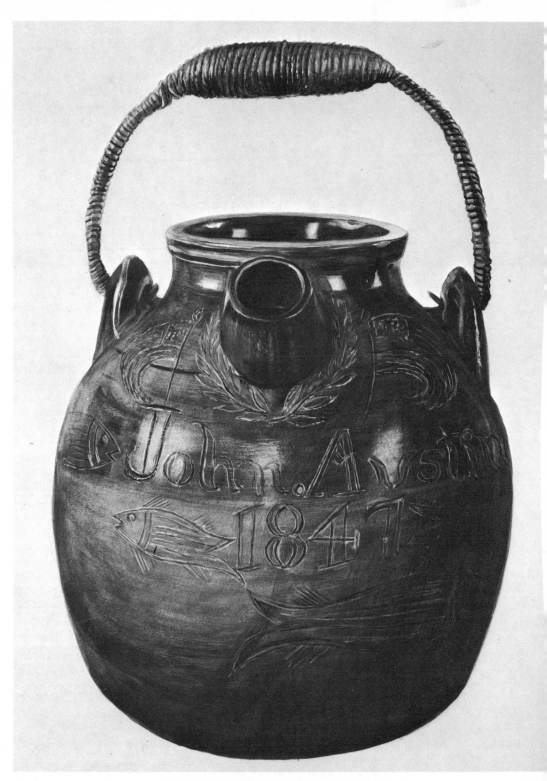

EARTHENWARE BATTER JUG with dark brown glaze probably made to order for "John Austin." Batter jugs were usually made in three-quarter, gallon, and gallon-and-a-half sizes. They sold for twenty-eight dollars, thirty dollars and forty dollars a hundred in Ohio in the late 1800's. H.9″ T.4½″ B.7″ N. Y. C. Cer. 53.

LARGE CLAY PIPE marked "Paul Bunyan 1862" made at Ladysmith, Wisconsin. Pipes with both pottery bowls and stems were called "clays." When these clay pipes became stopped up with tar they were easily cleaned by laying them on hot coals in the fire place for a few minutes. This "Paul Bunyan" pipe is aptly named because of its large dimensions. W.2" H.2½" Stem L.5¼" Wis. Cer. 5.

UNGLAZED CLAY PIPE with reed stem commonly found in the South; made about 1869. In the "back country" both men and women smoked. Clay pipes were in constant demand because they were very fragile and easily broken. W.⅞" L.1½" Stem L.4⅛" Fla. Cer. 28.

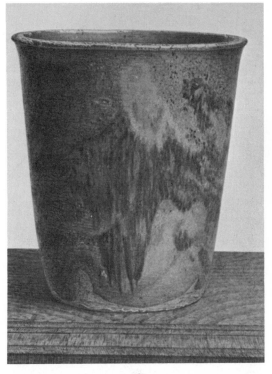

EARLY 19TH CENTURY DEEP PAN made in New London County, Connecticut. Earthenware with rich mahogany glaze and dark brown splashes. Separated cream was usually churned immediately. It not, it was stored in a cream pot in a cool place until the next churning. In some locales of New England these deep pan-shaped containers were used for storing cream. H.13" Conn. Cer. 9.

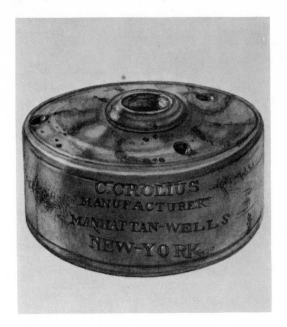

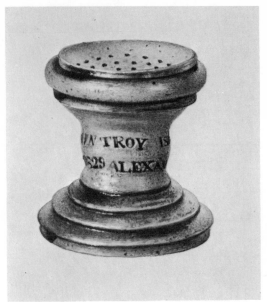

SALT GLAZED STONEWARE INKWELL stamped with maker's name *ca.* 1800. Light blue brushed crescent decoration. Ink used by early Americans was usually homemade. There were numerous formulas and methods of preparation. Where materials were available and cost was not a factor three pints of "Excellent black ink" could be made from the following: 3 oz. Aleppo gallnuts; 3 oz. copperas; 1 oz. gum arabic; 6 oz. logwood. The ingredients were boiled together, strained and added to a water base to make the proper amount. A much simpler formula called for saw filings to be dissolved in vinegar and a little white maple bark added for tannic acid which made the ink more permanent. This ink was black when first applied to paper but with age turned a light brown. H.2¼″ W.3¾″ N. Y. C. Cer. St. 158.

GRAY STONEWARE SANDER produced at the Israel Seymour Pottery at Troy, New York. "Alexander Coplin, Troy, 1829," is stamped around the stem below the maker's name. Sand shakers were used to blot ink on a newly written page with a light sprinkling of fine, black sand. H.2⅞″ T.2¼″ B.2⅞″ N. Y. C. Cer. St. 265.

CLAY PIPE marked "Shakers, Pleasant Hill, Ky." found in the East family residence erected in 1817. Shaker pipe bowls were made of both red and white clay bodies and the stems were cut in two lengths: ten and fifteen inches. In 1814 pipe bowls, sometimes listed "boals," sold for a penny each in quantity; the stems sold for three cents each. Ky. Cer. 29.

EARTHENWARE GELATIN MOLD with black glaze made about 1860. Jelly molds were used for making decorative desserts which employed a congealing agent to hold their shape. Fruit and fruit juice jellies were common along with blancmange and flummery made from cream, wine, and sugar. There were three main jelling agents used in making desserts. Isinglass, the purest and most expensive, was made from boiling "sounds" or swimming bladders of fish, usually sturgeon. Hartshorn was made from the white part of deer horns which were finely shaved and boiled. The most common gelatin used in this country was made from cleaned and boiled calves feet. It was said to have a fine consistency and flavor if properly prepared. Blancmange and flummery were sometimes tinted different colors, green was made by adding spinach juice, yellow from egg yolk, brown from chocolate and white from cream. H.1½″ W.4½″ Pa. Cer. 326.

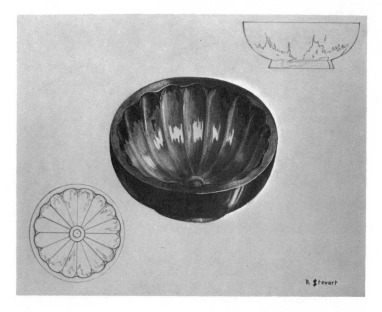

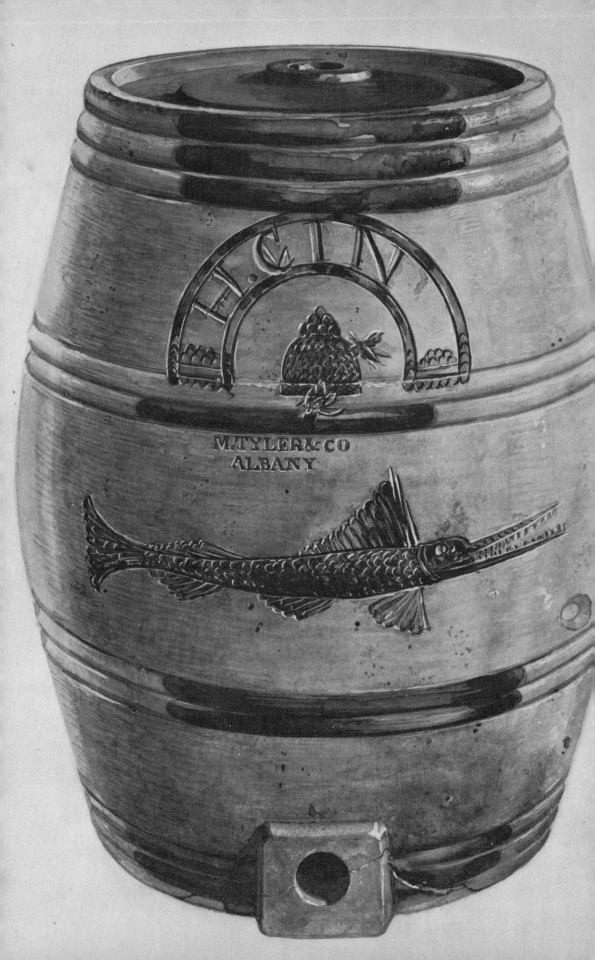

SMALL INK BOTTLE used by schoolchildren, made at East Liverpool, Ohio. Dark blue glaze, wooden stopper. H.1¾″ W.1″sq. Ohio Cer. 1.

SALT GLAZED GRAY STONEWARE HOLLAND GIN KEG produced by M. Tyler and Co., Albany, N. Y. Incised decorations of a swordfish and beehive painted with blue slip. Gin, or "Geneva," was first made in Europe in the 17th century by a Leyden professor named Sylvius who was trying to discover an agreeable flavor for spirits distilled from grain. Juniper berries were found not only to give an agreeable flavor to the spirits but to "likewise communicate valuable medical qualities." The liquor was consequently sold as a diuretic medicine in apothecary shops but was so avidly drunk that it soon became an article of trade. The best quality gin was exported to America from Schiedam, Holland, under the name of Holland or Dutch Geneva. Pottery kegs, in coolers, were used to store and dispense liquors in drinking establishments. A spigot placed in the bottom hole of the keg was used to draw the liquor. The decorations on this keg possibly symbolize the high quality of Holland gin which had the "bite" of a swordfish or the "sting" of a swarm of angry bees. H.15½″ T.9⅜″ B.9⅜″ N. Y. C. Cer. St. 47c.

189

GRAVE POST made at the Kohler Pottery, Pensacola, Florida. Light yellow clay. Stoneware grave markers were occasionally used in the southern part of the country in the 19th century. They were usually made by the potter on special order and varied in size and shape according to the wishes of the buyer. H.35" W.5½" sq. Fla. Cer. 55.

SALT GLAZED GRAY STONEWARE INKWELL in the form of a book. Probably made in Pennsylvania in the mid-1800's. Incised line decoration filled with blue slip. Steel pen nibs were invented around 1810, but the goose quill continued to be used until the latter part of the century. When the steel point became popular, potters began to omit the quill holders from their inkwells. H.1¼" x 1½" W.1⅞" L.2¾" N. Y. C. Cer. St. 263.

BROWN STONEWARE PRESERVE JAR, salt glazed. The shoulder is decorated with incised half circles filled in with blue slip. Stamped, "Commeraw's—Stoneware New York City." Lid missing. Preserve jars ranged in size from one pint to six gallons. 1802–1820. H.8½" T.4" B.5" N. Y. C. Cer. St. 19c, d.

STONEWARE INK BOTTLE with dull red glaze. 1815–1848. When ink began to be made commercially it was first sold and shipped in beer bottles and whiskey jugs. Later on, potters began to produce bottles solely for storing ink. They varied a great deal in shape and style at first, but by the mid-1800's most ink containers had a heavy-collared neck with a pouring spout. They ranged in size from ten ounces to a gallon. H.8¼" W.3⅞" N. Y. C. Cer. St. 208.

GRAY STONEWARE INKWELL, salt glazed, made for George Crawford by Clark and Fox, Athens, New York, in 1828. Maker's name and date stamped on the bottom. Elaborate ribbing and coggle-wheel decoration tinted with cobalt blue. H.2 3/16″ W.5½″ N. Y. C. Cer. St. 264.

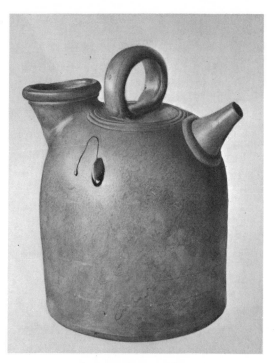

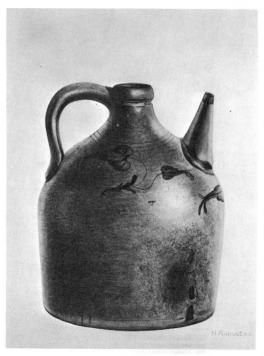

EARLY 19TH CENTURY HARVEST JUG made in Vermont. Large dark drop of glaze on the side probably fell from a melting arch brick. Harvest jugs were used to carry water to the fields. They were filled through the large spout and emptied through the smaller. The jug was held high in the air and tilted so the water would squirt out into the mouth. This type of water jug was used in several European countries long before they were made here. H.11″ N. Y. C. Cer. St. 235.

UNUSUAL STONEWARE JUG with small spout, probably made in Pennsylvania by Thomas Cottrell about 1839. Decorated with blue flower sprays around the shoulder. H.13″ B.9¾″ N. Y. C. Cer. St. 157.

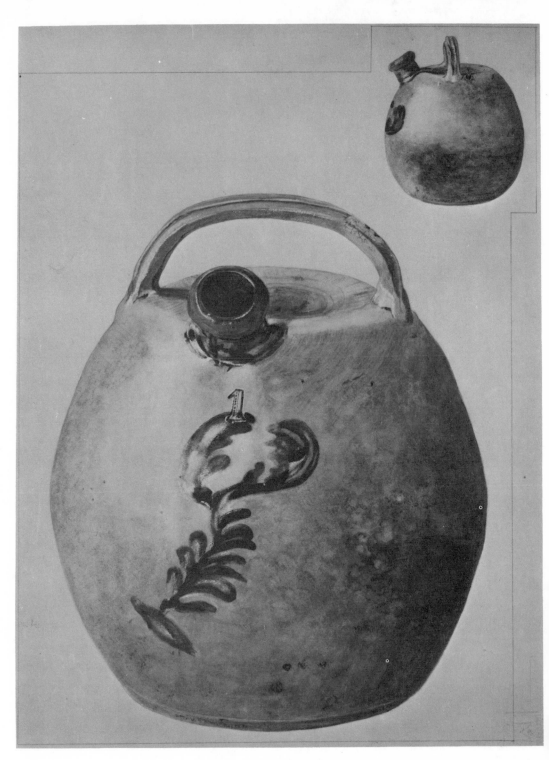

GRAY STONEWARE HARVEST JUG made by Lewis and Gardiner at Huntington, Long Island, New York, about 1827. Cobalt blue decoration. Water jugs were sometimes fitted with a heavy cloth cover which was saturated before being carried to the field. As the day warmed, the water evaporating from the cloth cover kept the jug and its contents cool. H.9½″ N. Y. C. Cer. St. 153.

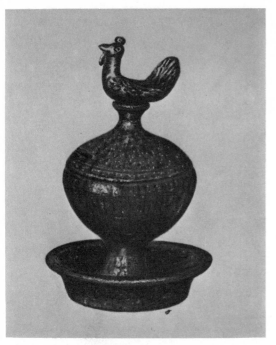

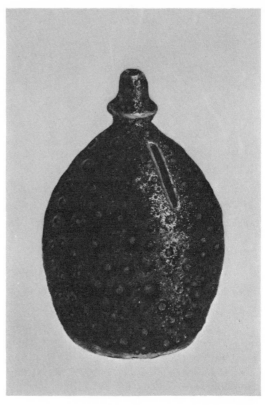

EARTHENWARE MONEY BANK with dark brown glaze made at Old Zionsville, Lehigh County, Pennsylvania. Children's coin banks were usually made to order. Pa. Cer. 140.

STONEWARE MONEY BANK probably made in Pennsylvania in the early 1800's. Pock-marked mottled red-brown glaze. Toy banks were made in many shapes and styles. Often they were made in whimsical shapes such as fruits, animals or log cabins, but sometimes the potter simply sealed an ordinary small jug or jar and cut a slot in it. H.4½" N. Y. C. Cer. St. 240.

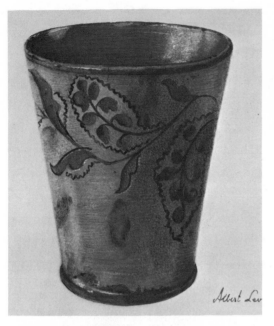

EARTHENWARE BEAKER made in Pennsylvania about 1850. Lead glazed, sgraffito designs incised with buff-colored ground with red-brown, brown and green shading. Beakers were not a common pottery item. Pa. Cer. 116.

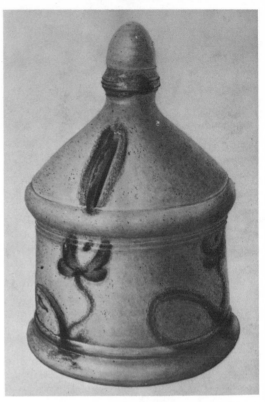

SALT GLAZED TAN STONEWARE MONEY BANK probably made by Hastings and Belding at South Ashfield, Massachusetts, about 1850. Cobalt blue decoration. "During the long months of the child's year, the toy bank accumulated it's hoard of pennies—gifts, rewards, and payments. At Christmas time it disgorged its treasure, but only by a tedious process of shaking and tilting and twisting, until the coins slipped, one by one, out of prison. . . ." H.6″ B.3½″ N. Y. C. Cer St. 236.[38]

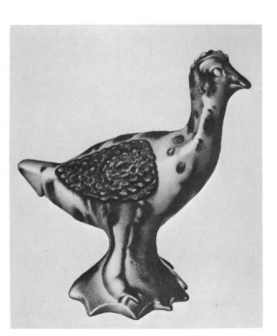

PENNY BANK modeled from red clay decorated with splashes of purple covered by transparent lead glaze. Probably made in Pennsylvania in the early 1800's. H.8½″ N. Y. C. Cer. 101.

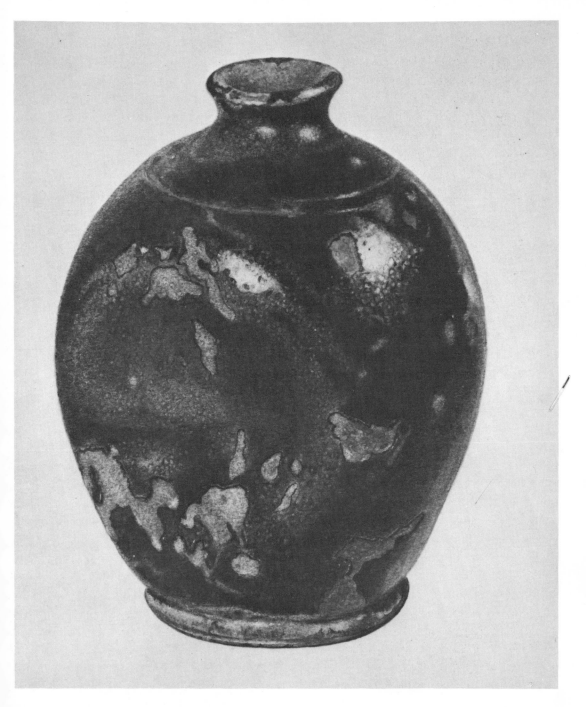

RED EARTHENWARE BOTTLE made at unknown pottery in Fairport, Iowa, 1878–1885. Pots that were left around before firing long enough for the glaze to flake off were called "shop rotten." H.5½″ W.3¼″ Iowa Cer. 8.

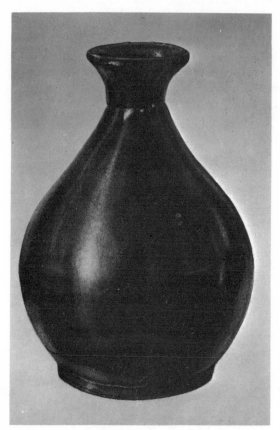

SMALL BLACK BOTTLE unearthed near a pottery at Mount Holly, New Jersey. These bottles were made at many potteries throughout the country. Its form is the same as the early rice wine bottles imported from China. H.6⅝″ N. J. Cer. 21.

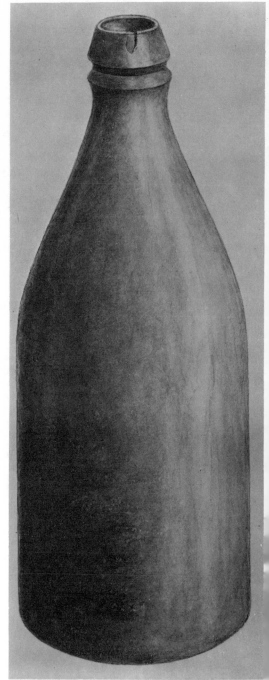

STONEWARE BOTTLE made in Chicago, Illinois before 1860. Brewing began in the colonies soon after they were settled. Beer was considered a necessity for good health and well being. Where grain for brewing was lacking, substitutes from the woods and gardens were used. Beer was made from apples, pumpkins, parsnips, the bark from spruce, birch and sassafras trees, and walnut tree chips. Makeshift substitutes for sugar included molasses, honey, maple syrup and beet tops. Few breweries did their own bottling in the early part of the 19th century. They sold kegs to "small beer bottlers" who filled, corked and distributed the beer. H.8½″ Utah Cer. 12.

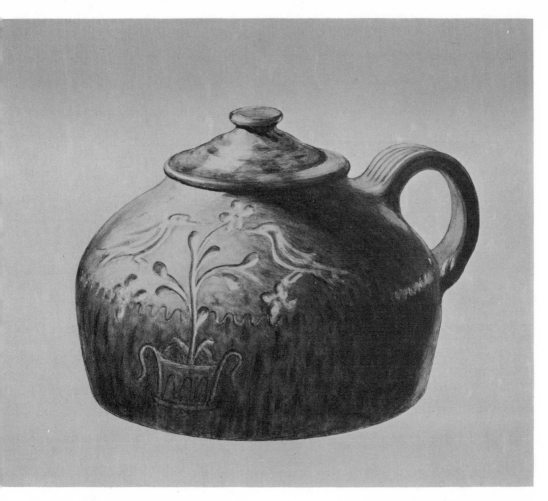

EARTHENWARE BEAN POT made in Pennsylvania about 1800. Early colonists probably learned how to bake beans from the Indians as well as how to use corn, Irish and sweet potatoes, pumpkins, several varieties of squash, tomatoes, peppers, watermelons, strawberries, American grapes, raspberries, blackberries, gooseberries, peanuts, walnuts, pecans, butternuts, hickory nuts, chinquapins, pinon nuts, tobacco and native cottons. Overall H.5¾" W.8" Pa. Cer. 252.

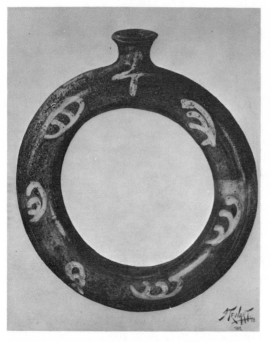

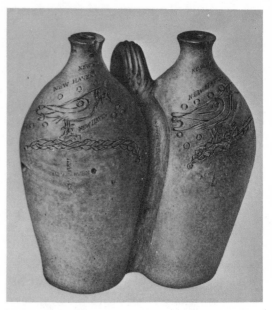

RING BOTTLE made by C. Potts and Son, Norwich, Connecticut, about 1800. Brown glaze with yellow decoration. Ring bottles were a standard production item at Potts' Bean Hill Pottery at the turn of the century. They were made in all locales but were usually not a production item. Ring bottles were also called harvest bottles and mowers' bottles. H.8½" Iowa Cer. 10.

TAN STONEWARE GEMEL BOTTLE stamped "New Haven," Connecticut, in several places, *ca.* 1800. Gemel or twin bottles were used for storing oil and vinegar or two kinds of wine. H.8" N. Y. C. Cer. St. 305.

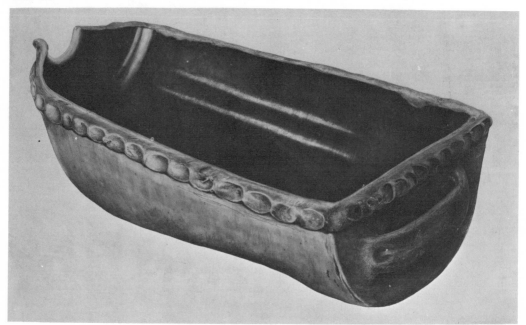

EARTHENWARE BATTER BOWL made by Stoeckert City Pottery Co., New Ulm, Minnesota, about 1870. Unglazed buff exterior, dark slip inside. The bowl was made from a jug shape cut in half. Batter was mixed in the bowl and poured on the griddle through the small circular spout. H.4" W.10½" Overall L.15½" Minn. Cer. 4.

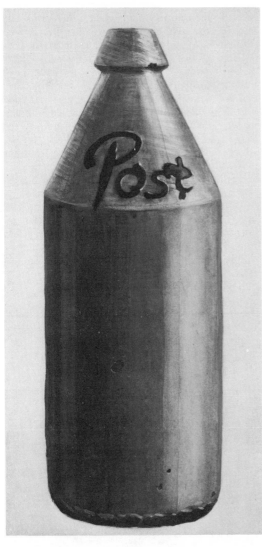

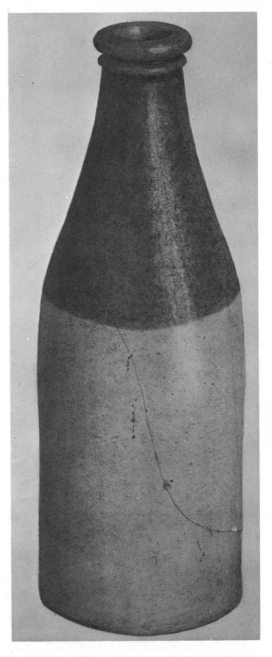

BROWN STONEWARE ROOT BEER BOTTLE produced at the Caire Pottery, Poughkeepsie, New York, after 1850. The word "Post" painted in green slip. Root beer and carbonated soft drinks were very appropriately nicknamed "pops" in earlier times because pop went the cork when it was drawn. These stoneware bottles continued to be used for root beer long after breweries had switched to glass. H.10³⁄₁₆″ B.3¹¹⁄₁₆″ N. Y. C. Cer. St. 190.

SALT GLAZED STONEWARE INK OR CATSUP BOTTLE probably made in Connecticut about 1840. H.8¼″ W.3″ Ohio Cer. 28.

EARLY 19TH CENTURY RING BOTTLE, salt glazed, incised decoration filled with blue slip. The initials are probably those of the buyer who requested the potter to include them in the decoration. "These bottles, commonly called haymakers' bottles, are often said to have been intended primarily for use in the fields by haymakers, who carried them on the arm. Anyone who has ever used a scythe or watched a skilled mower use one, will be likely to smile at the suggestion. Anything more unlikely to be adopted it would be hard to imagine. It is far more likely that such bottles of this type . . . were intended for the purpose for which such bottles have been made in many lands; namely, to be carried over the arm when riding or driving. The man who set out for a long ride on horseback, perhaps in cold and wet weather, found it a convenient way to carry a moderate supply of stimulant. He could refresh himself from such a bottle without dismounting." [39] H.6½" W.5¼" B.2½" N. Y. C. Cer. St. 167.

GLAZED BOWL, possibly a wash bowl, made at Eardley Bros. Pottery in St. George, Utah, about 1855. "Basons" listed in early broadside price lists were not wash bowls but mixing bowls. Utah Cer. N. N.

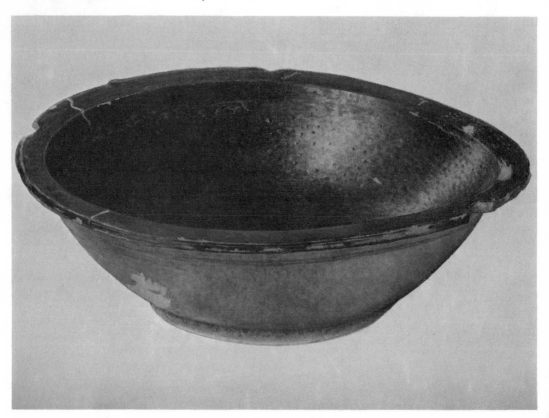

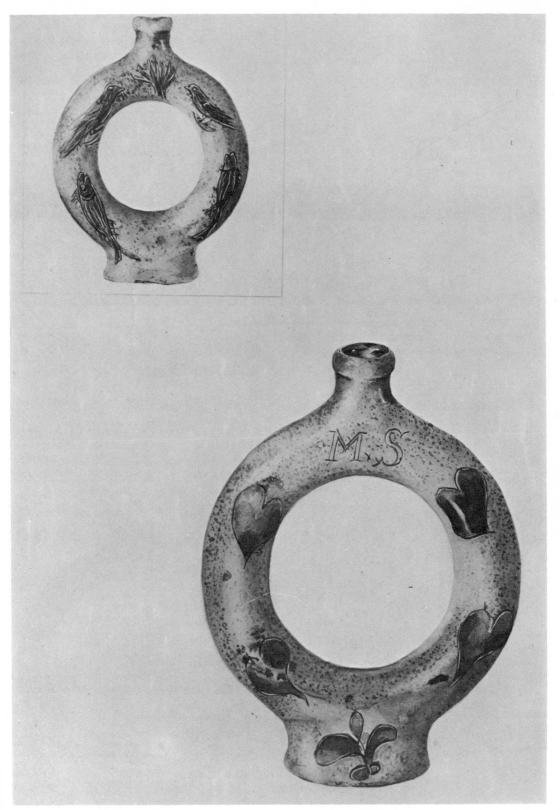

203

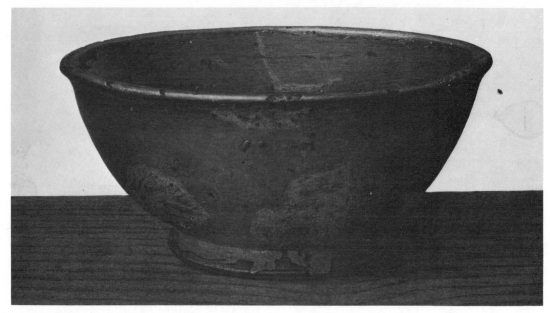

LATE 18TH CENTURY RED EARTHENWARE BOWL, probably made in Connecticut. Clear lead glaze with green splashes. Potteries listed bowls in sizes from one-half to several gallons. Some price lists simply referred to bowls in small, "middlin'," large and great sizes. Conn. Cer. 32.

STONEWARE JUG stamped with maker's name and two-gallon capacity mark. The number recurs twice in the cobalt blue decoration. Ill. Cer. 10.

EARTHENWARE HORN used to call field workers to assemble at Zoarite Community, Tuscarawas County, Ohio. Made at Zoar Pottery, *ca.* 1818. Red-brown body with transparent glaze. W.13″ Ohio Cer. 10.

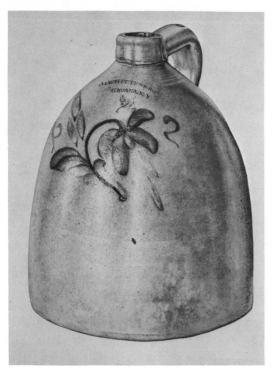

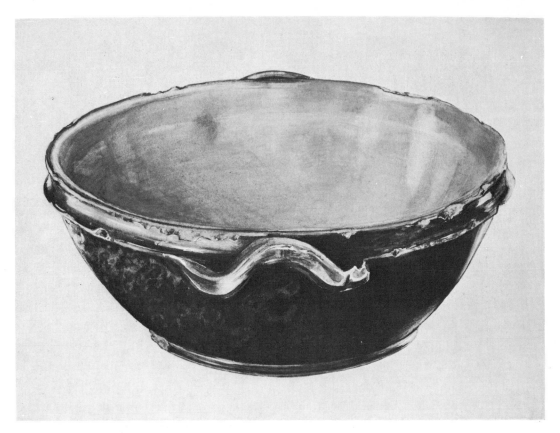

Red Earthenware Bowl with pulled handles made at Economy, Pennsylvania, between 1834 and 1880. Transparent glaze inside, mottled green outside. H.3½″ Overall W.12½″ B.7″ Pa. Cer. 321.

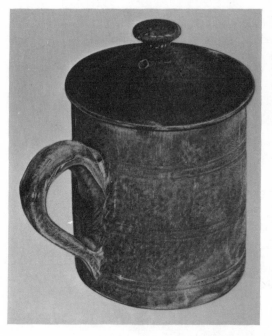

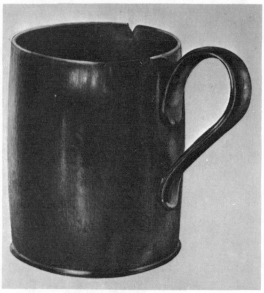

SALT GLAZED CUP for hot coffee or cider, made at Zoar, Ohio, between 1819 and 1852. There are no records indicating when hot drinks were first used in the colonies. Some 17th century diarists mention coffee, tea and chocolate but these new imports were probably very expensive and could only be afforded by the rich. Peter Kalm, a Swedish scientist traveling on the eastern seaboard in 1747, recorded in his diary "tea, coffee and chocolate, at present constitute even the country people's daily breakfast" an indication that their use was quite widespread by the mid-1700's. Hot drinks may have been commonly used by people along the coast but on the frontiers they continued to be a luxury for quite some time. In the early part of the 19th century lists of commodities shipped to Pittsburgh priced tea from a dollar to a dollar and a half a pound and thirty-eight to forty cents a pound for coffee. These prices were more than most common people could pay. Tea and coffee were often cut with local herbs to make them go farther, until their flavor was hardly recognizable. Substitutes for tea and coffee were used in many households. Tea was made from thyme, sage, pennyroyal, and catnip, and coffee from sassafras, roasted chestnuts, and barley, rye, and wheat which was boiled and roasted. Lip H.3¼″ W.3⁵⁄₁₆″ Ohio Cer. 26.

EARTHENWARE LOVING CUP probably made by Brother Aust in the Moravian Pottery at Bethabara, North Carolina. Dark brown glaze. Excerpt from Bethabara Church diary: "Sept. 10, 1756. Brother Aust burned pottery today for the second time; the glazing did well, and so the great need is at last relieved. Each living room now has the ware it needs, and the kitchen is furnished. There is also a set of mugs of uniform size for a love feast." H.3⅝″ W.3″ Ill. Cer. 16.

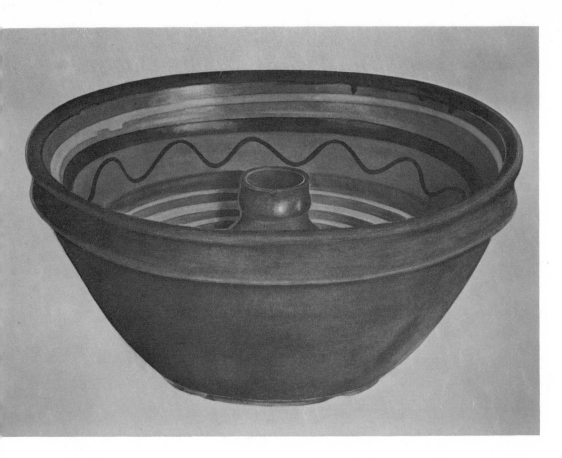

COMBINATION BOWL AND CAKE MOLD made by Economite Potters at Economy, Beaver County, Pennsylvania, between 1834 and 1880. Red earthenware body decorated inside with yellow, green and black trailed slip. Removable funnel in center of mixing bowl could be taken out and used for filling fruit and preserve jars; with funnel in place, the bowl served as a cake mold. H.5″ W.12⅜″ Pa. Cer. 322.

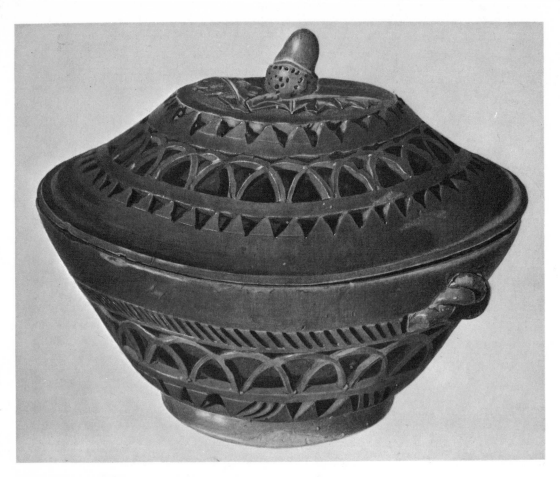

EARTHENWARE TOBACCO BOWL with carved outer wall and solid inside liner. Probably made by David Waring, Bucks County, Pennsylvania, about 1835. Inns and taverns usually sold tobacco which could be smoked in long-stemmed clay pipes called "church wardens." A customer selected a pipe from the rack, broke an inch or so off the stem and filled the pipe with a penny's worth of tobacco at the bar. H.7″ W.10½″ N. Y. C. Cer. 20.

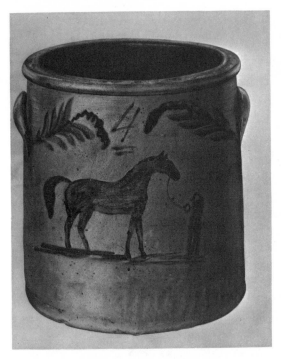

EARTHENWARE CUP with mottled olive-green and orange glaze made on Long Island, New York, about 1800. The only time country potters made any amount of tableware or "dirt dishes" as they were called was during the Civil War. The Union blocade of the South and general lack of foreign trade in domestic articles in the North caused a severe shortage of cups, saucers, plates, teapots and other tablewares. H.2⅞" T.3⅞" B.2½" N. Y. C. Cer. 88.

LATE 19TH CENTURY BUTTER CROCK. Salt glazed, gray stoneware, with cobalt blue decoration. The farmer's wife usually considered the "butter and egg money" her own because it came from the barnyard, which was part of her domain. In actuality, farm produce was seldom exchanged for hard cash but was generally accepted at stores as "country pay" in exchange for the necessities of life or some feminine luxury such as a horn comb, a piece of ribbon or colored cloth. H.12" T.10⅛" B.10⅜" N. Y. C. Cer. St. 207.

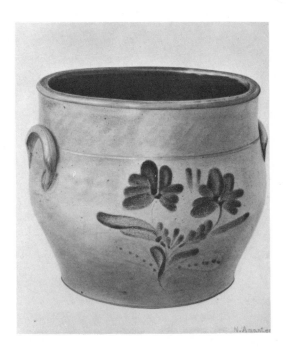

TAN STONEWARE CROCK, salt glazed, probably made by Riedenger and Caire at Poughkeepsie, New York, between 1829 and 1863. Brown slip glazed interior. Brushed cobalt blue flower decoration. H.9" T.10" B.7½" N. Y. C. Cer. St. 232.

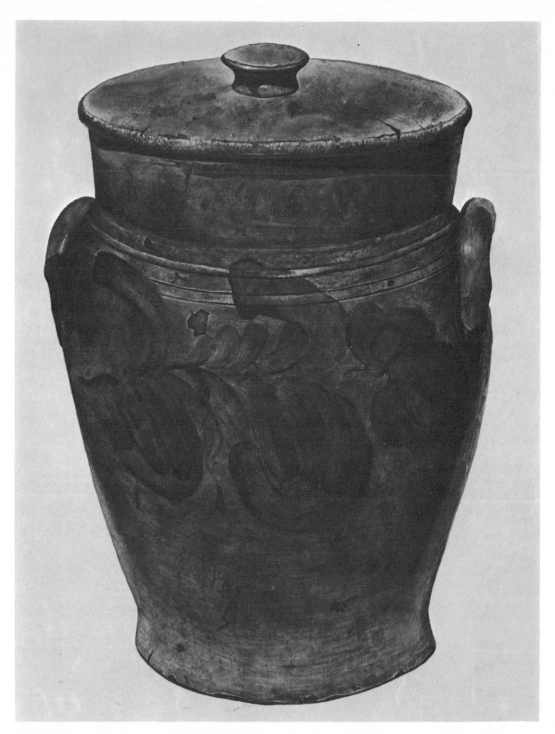

GRAY STONEWARE CROCK with flat lid found in Philadelphia. Probably made about 1840. Blue decoration. Pottery lids were generally available for all sizes of crocks. Lids were handled frequently which caused a high rate of breakage. It was a common practice to replace these broken lids with a board lid held in place by a rock. Lids were usually not made for any particular pot. They were made in standard sizes and stacked in the kiln, one above the other in high tiers. They were sold separately and were listed in late 19th century catalogues in the following manner: "Covers 2 to 6 gallons inclusive count one gallon each." This referred to the cost per gallon price of the container. H.8½" T.6" B.4⅝" Del. Cer. 37.

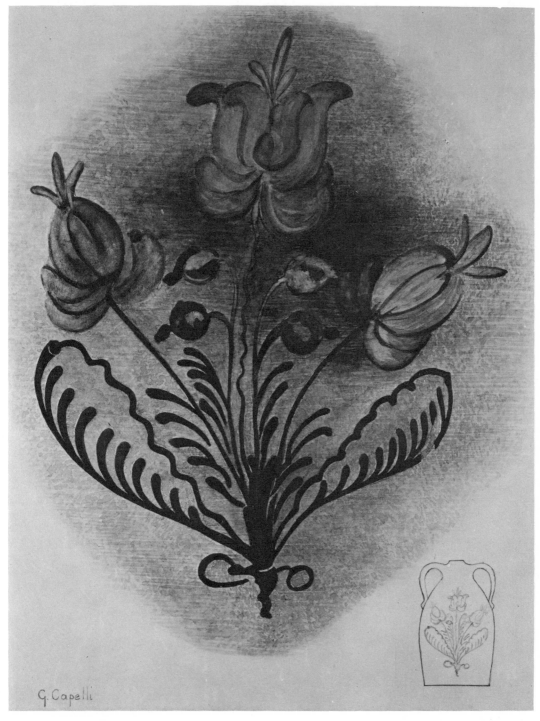

G. Capelli

DETAIL OF WATER OR CIDER JUG. Brushed and slip trailed decoration. "Hubbell and Ceseboro, Geddes, N. Y." 1868. H.20½″ N. Y. C. Cer. St. 269.

211

Book Bottle with brown-yellow-green flint enamel glaze made at Bennington, Vermont, about 1851. Book bottles came in pint, quart and gallon sizes. They were used as flasks for carrying liquor. They invariably had humorous titles: "Ladies Companion," "Hermit's Delight," "Departing Spirits," "History of Bourbon" and "Indian's Lament." The title on this bottle, "Life of Kossuth," refers to Lajos Kossuth the Hungarian patriot and hero in exile who toured the United States in 1851 to raise money for his cause. His tour aroused great popular enthusiasm but brought in very little money. Opportunist advertisers, looking for any topical subject to put before the public, soon placed a number of products on the market bearing the name Kossuth, including such items as Kossuth coats, Kossuth oysters and Kossuth cigars. H.5¾" W.3⅜" x 2" N. Y. C. Cer. 75

Rockingham Coachman Wine Bottle made at Bennington, Vermont, about 1840. Mottled yellow-tan glaze. H.10¼" La. Cer. 4.

212

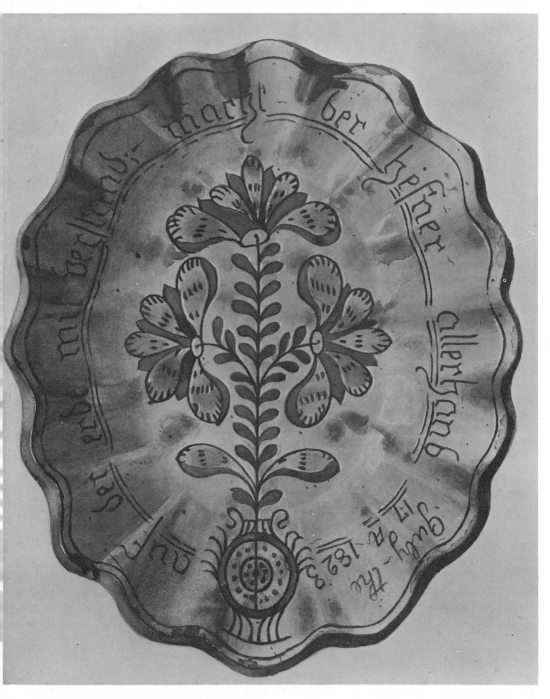

MOLDED EARTHENWARE DISH with scalloped edge made by Samuel Troxel, Montgomery County, Pennsylvania. Sgraffito "Tree of Life" design decorated with green and yellow slip. German inscription reads: "Out of the earth with understanding, the potter makes everything." L.9½" Pa. Cer. 55.

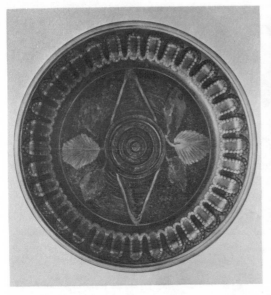

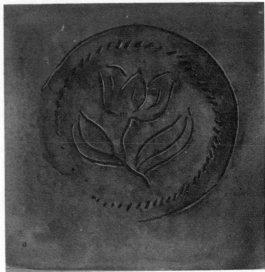

EARTHENWARE DEEP DISH possibly made by Peter Schmidt, a potter from Switzerland. Schmidt was one of three frontier potters working in the vicinity of Winesburg [Shanesville], Ohio, on the Holmes-Tuscarawas County line between 1795 and 1838. The dish is decorated with yellow, green and black slip covered by transparent lead glaze. Red and yellow slips were very popular among early German and Swiss potters of the Tuscarawas Valley. W.16″ Ohio Cer. 40.*

DETAIL OF STORAGE CROCK: Scratched medallion tinted blue. Xerxes Price, South Amboy, New Jersey, *ca.* 1810. H.9″ N. Y. C. Cer. St. 20d.

SLIP DECORATED EARTHENWARE BREAD TRAY made at Norwalk Pottery, Norwalk, Connecticut. Orange-brown glaze, yellow slip. Flatware, lids and other articles which could not be measured in gallons of capacity usually were listed in early catalogues by size: 1st size, 2nd size, 3rd size and so on, without any indication of diameter in inches. Oblong meat dishes and bread trays were formed over drape molds the same as round pie plates. W.7¾″ L.11¾″ Conn. Cer. 45.*

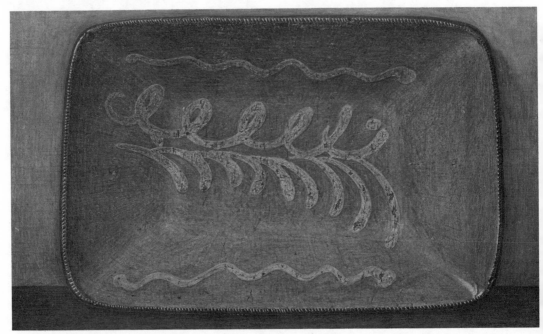

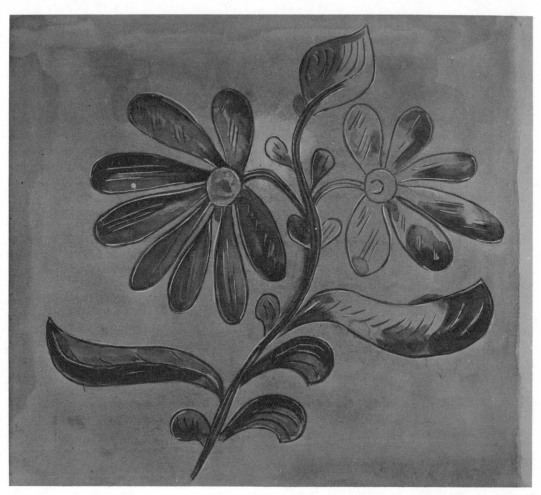

DETAIL OF JUG: Daisy-like flower with scratched outline; tinted blue, *ca.* 1800. H.15″ N. Y. C. Cer. St. 4c, d.

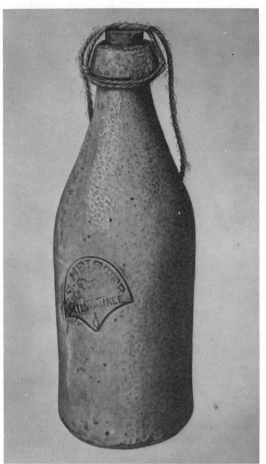

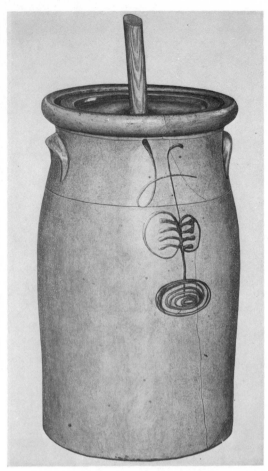

STONEWARE BEER BOTTLE stamped with brewer's trademark. Made by Herman's Pottery, Milwaukee, Wisconsin. Light gray glaze. Beer and ale bottles were corked and tied with pack thread to avoid popping. To prevent "leakers," it was important to use new and sound corks. "Velvet tapers" were the best. They were soaked in water to make them soft and pliable before inserting. The corks were then driven home with a bottle corker or a wooden mallet. If the cork could be forced in even with the neck, it was too small. Bottles were usually stored on their sides to keep the cork swelled and pliant. If properly corked it was said that beer would keep eight to ten years. Beer bottles had an interesting secondary use. In the winter they often were used as hot-water bottles. The water, still warm the next morning, was used for washing. H.8″ W.2¾″ Wis. Cer. 11.

FOUR-GALLON SALT GLAZED STONEWARE CHURN with capacity mark incorporated in the blue slip trailed decoration. Lid glazed brown. This churn owned by the Watterstrom family was carried in a covered wagon from the East to Fort Dodge, Iowa, in the early 1880's. During the trip the churn was used as a deposit box for the family's savings. H.16″ W.9″ Iowa Cer. 27.

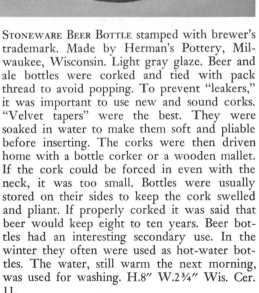

SALT GLAZED STONEWARE JAR with stenciled decoration made by James Hamilton and Co., Greensboro, Pennsylvania, about 1860. H.15⅛″ T.7⅛″ N. Y. C. Cer. St. 222.

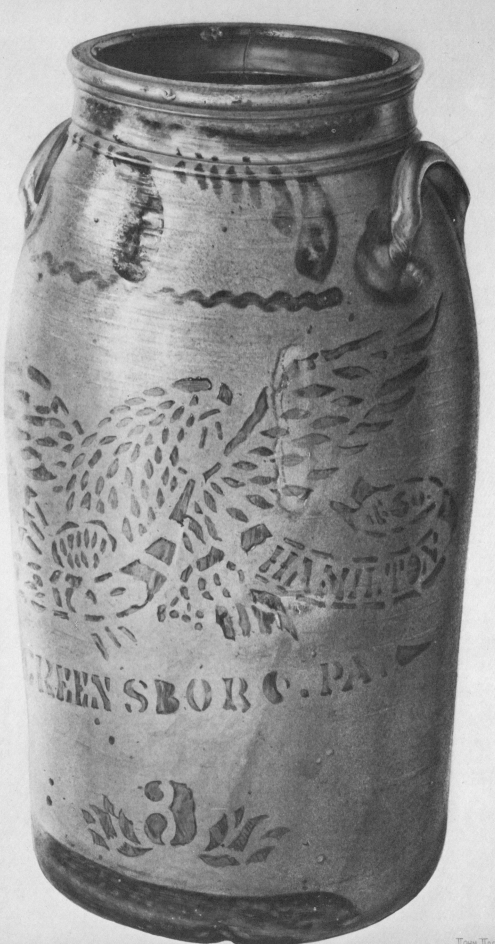

JOHN TARANTINO.

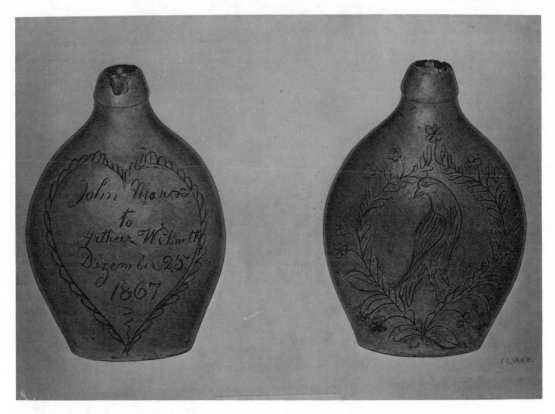

Brown Stoneware Flask, salt glazed with Albany slip interior. Incised line decoration filled with blue slip. This flask was probably ordered from a Pennsylvania German potter for a Christmas present. H.7″ W.4¾″ x 2½″ Mich. Cer. 89.

Earthenware Grease Lamp probably made in Pennsylvania. Fat lamps burned grease, scraps of fat, fish oil and whale oil. They smoked and smelled considerably when fish oil was burned. Although these lamps were inexpensive to use and were popular in rural areas, the tallow candle was the most common source of lighting in early America. H.5″ T.3½″ B.4¾″ Mo. Cer. 3.

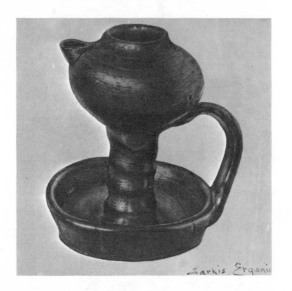

Earthenware Fat Lamp with double spouts made either by Curtiss Houghton, Dalton, Wayne County, Ohio, 1824–1864, or by S. Routson, Boylestown, Wayne County, Ohio, 1835–1870. Black-brown slip glaze. Grease lamps were called *Fet Licht* for fat light, by the Pennsylvania-Germans and "slut lamps" by the Scotch-Irish in the back country. Oil or grease was poured into the center hole of the reservoir, which was closed together to prevent spilling. Rag wicks placed in the spouts at either end drew the oil up to the flame. H.6½″ Ohio Cer. 31.

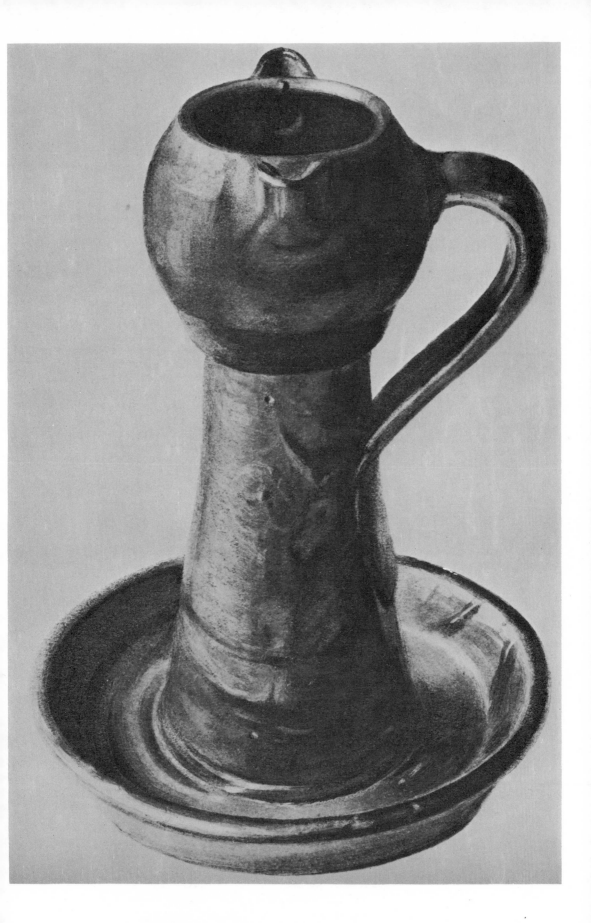

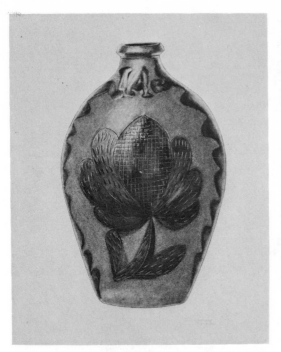

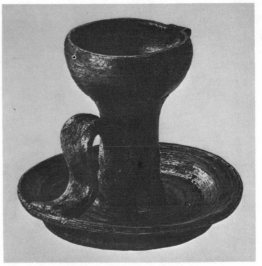

19TH CENTURY BROWN STONEWARE FLASK, salt glazed, with incised decoration. Painted blue. The letters "JA" brushed on the neck are probably those of the original owner. When this flask was found in an attic at Roatstown, Ohio, it contained blackberry brandy. H.8″ W.3″ x 5″ Mich. Cer. 90.

RED EARTHENWARE GREASE LAMP with maker's name, "Justus Blaney, Cookstown, Pennsylvania," stamped on the bottom. 1825–1854. Coarse black slip glaze. Fat lamps made in America differed little from those used in northwestern Europe. The European lamps sometimes had a pouring spout in the saucer for removing excess oil that had dripped from the wick. Fat lamps probably were introduced to this country by immigrating German potters in the mid-1700's and were used quite extensively by the common people throughout Pennsylvania, Ohio and the South until 1860. H.5⅝″ N. Y. C. Cer. 91.

PRIMITIVE-STYLE EARTHENWARE FAT LAMP made at Zoar Pottery at Zoar, Ohio, about 1820. Fat lamps usually had a wide saucer base to catch dripping oil because most oils used for fuel were drawn up the wick faster than they could be burned. H.1½″ W.4⅝″ L.7¼″ Ohio Cer. 15.

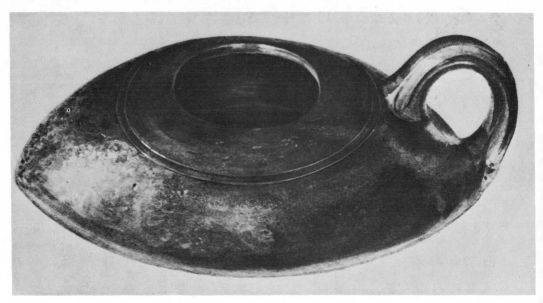

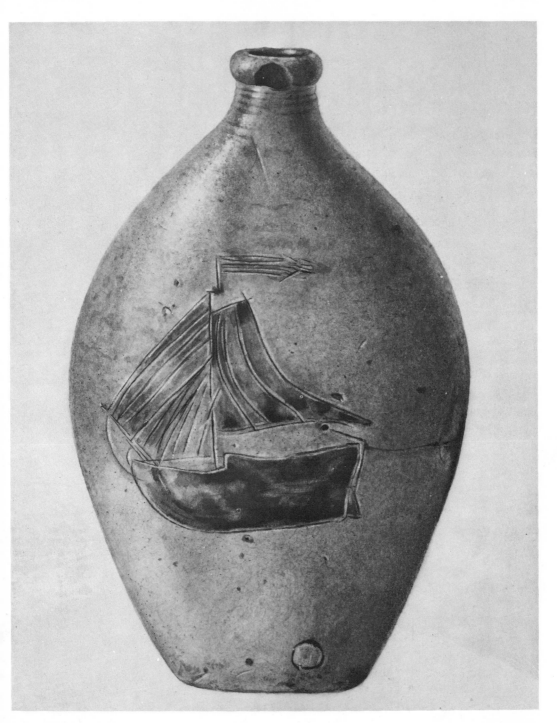

SALT GLAZED GRAY STONEWARE FLASK with incised and blue slip decoration of two boats. Late 18th century. The larger boat, with two sails and pennant, is attached by a towline to the smaller boat on the opposite side of the flask. These pint-sized liquor flasks were sometimes referred to as "ticklers." H.7″ N. Y. C. Cer. St. 255a, b, c.

221

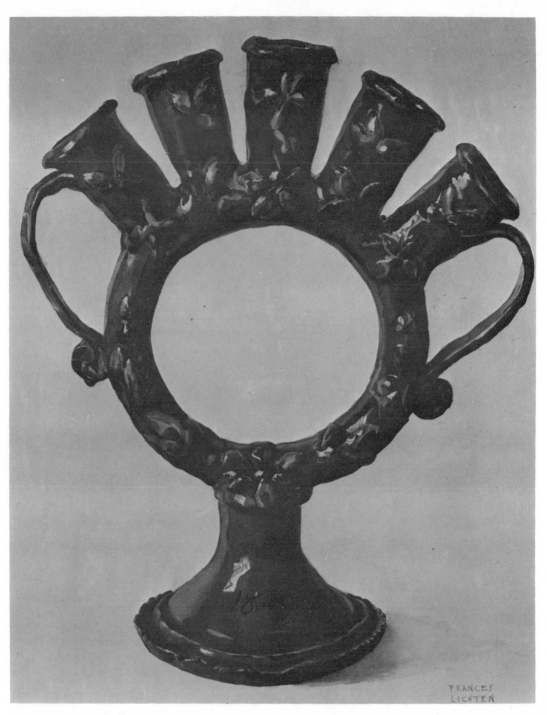

EARTHENWARE FLOWER HOLDER decorated with red, green, yellow slip covered by transparent lead glaze. Made by a Pennsylvania-German potter, dated 1849. "Five-fingered posy holders" were used for arranging flowers in a fan-shaped bouquet. Colonial housewives liked to use them to grace small wall niches and fireplace mantels. H.10¾″ W.9¾″ Pa. Cer. 44.

HANGING FLOWER BASKET with scalloped edge. Glazed, earthenware. Decorated hanging flower baskets and pots were very popular household ornaments just after the Civil War. N. C. N.

BARREL-SHAPED FLASK with mottled brown-orange glaze. Probably made in Connecticut in the 19th century. Small wooden kegs contemporary to this one were called "swiglers." As the name implies they were liquor flasks and held just enough for a good "swig." Barrel flasks were no doubt very popular in 1840 during William Henry Harrison's "log cabin and hard cider" campaign for the presidency. Hard cider barrels appeared on campaign buttons, posters and Whig speaker platforms all over the nation. In the presidential campaign of 1888, Benjamin Harrison, the earlier Harrison's grandson, also used the cider barrel as a campaign insignia. H.3¾" T.3" Conn. Cer. 36.

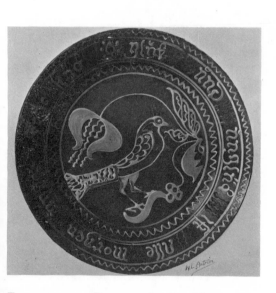

EARTHENWARE DISH made in Montgomery County, Pennsylvania, about 1796. Yellow and green slip trailed on red ground, covered by transparent lead glaze. Pennsylvania-German inscription around border reads: "Good and bad luck are our daily breakfast fare." W.14" Pa. Cer. 144.*

223

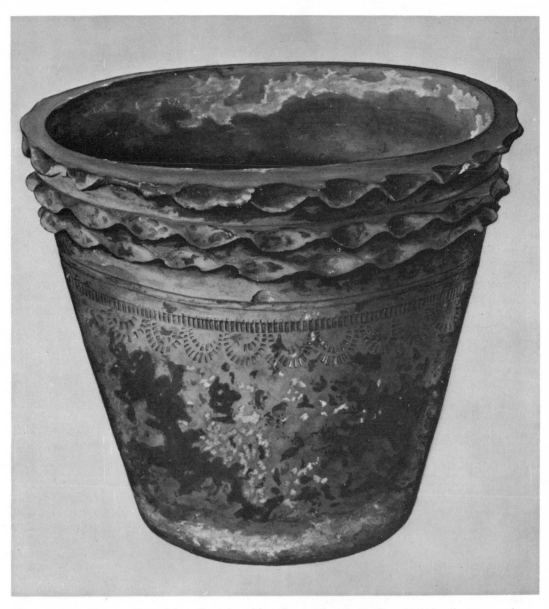

EARTHENWARE FLOWER POT with scalloped molding and coggle-wheel decoration. Made at Galena, Illinois, between 1850 and 1888. Flower pots varied greatly in design and ranged in size from "thumb pots" an inch in diameter to large yard pots twenty-four inches across. H.7½″ Ill. Cer. 21.

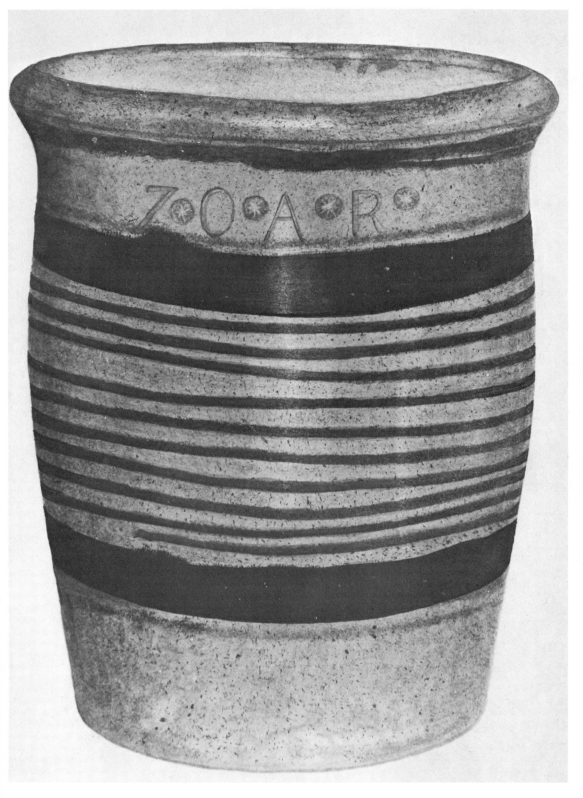

EARTHENWARE FLOWER POT made at Zoarite Community Pottery, Zoar, Ohio, in 1836. Orange-brown clay body decorated with brown stripes. Zoar pottery was rarely marked. H.7⅝″ W.6⅛″ Ohio Cer. 13.

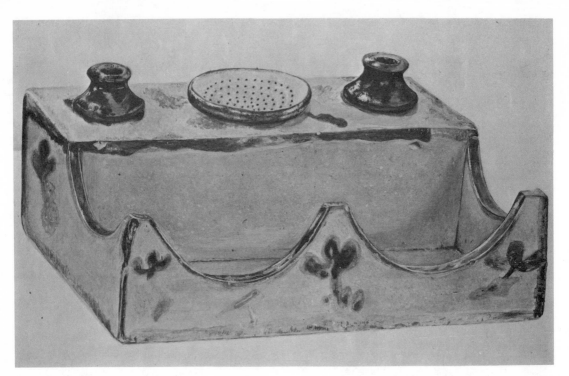

INK STAND with two ink bottles, sand shaker and tray for pens. Made at Cincinnati, Ohio, about 1825. "Standish" was the 18th century term for ink stand, which was derived from "stand" and "dish." Ink stands were sometimes equipped with ponce shakers used to sprinkle gum sandric over the rough paper to prepare it for writing, wafer dishes for holding flour wafers, which were used for sealing letters, a bell for calling servants, quill cutters, seals, and sealing wax. H.3½" L.7⅛" W.5½" Ohio Cer. 2.

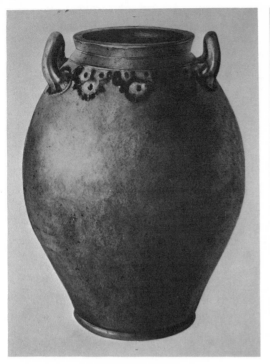

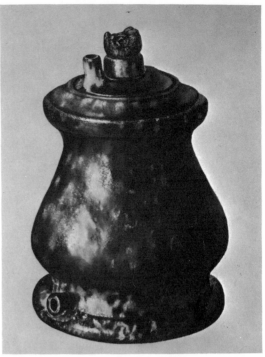

GRAY STONEWARE JAR made by Lewis and Gardiner at Huntington, Long Island, New York, *ca.* 1827. Brushed blue decoration, salt glazed. H.12½″ T.5½″ B.5½″ N. Y. C. Cer. St. 28c, d.

ROCKINGHAM INHALER or "croup kettle" with mottled cream and brown glaze made by the United States Pottery, Bennington, Vermont, *ca.* 1850. H.7¼″ N. Y. C. Cer. 33.

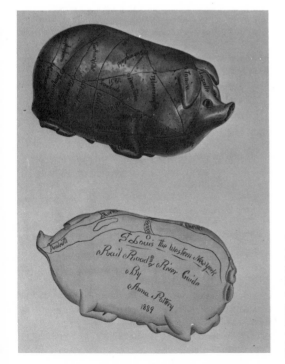

"BOTTOMS-UP" PIG BOTTLE made by Wallace V. Kirkpatrick at Anna, Illinois, in 1889. Gray-colored body; railroad lines' and towns' names brushed in cobalt blue slip. Wallace and Cornwal Kirkpatrick were famous for pottery animals of every description which they made in large numbers in the late 1800's. This pottery pig bottle, filled with whiskey, was probably given out as a convention favor. Ill. Cer. 11.

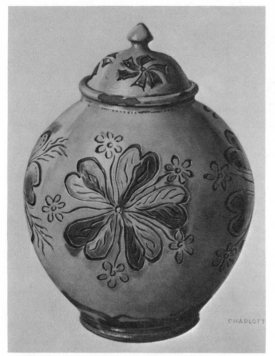
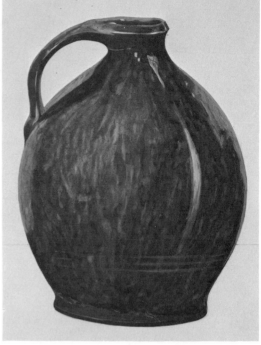

EARTHENWARE JAR with sgraffito decoration made by Jacob Scholl about 1830. Highly decorated small jars with lids were sometimes used for storing "potpourri," a fragrant mixture of dried flowers and spices. On special occasions the lid was removed to allow the scent to fill the house. Pa. Cer. 93.

LEAD GLAZED EARTHENWARE JUG covered by glossy green mottled glaze, *ca.* 1800. Incised decoration in low relief on earthenware was often not effective because lead glazes filled the impressions. H.8¾" N. Y. C. Cer. 30.

SALT GLAZED EARTHENWARE CURAÇAO BOTTLE. Originally owned by the Applegate family of Toms River, New Jersey, *ca.* 1800. This shape is still used for bottling Curaçao liqueur. Long-necked bottles and jugs were sealed with corks called "long straights." The corks were forced into the neck and secured with a piece of string or sealing wax. If the cork was to be secured with wax it was cut off flush with the neck. The bottle was then inverted and dipped in a mixture of melted pine rosin and beeswax, or the cheapest sealing wax available. Another method was to drip the wax in a puddle on top of the cork and the bottleneck. H.9¼" N. J. Cer. 115.

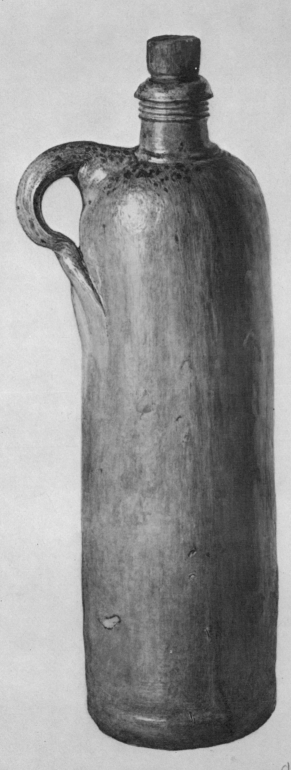

Carl Buergerniss

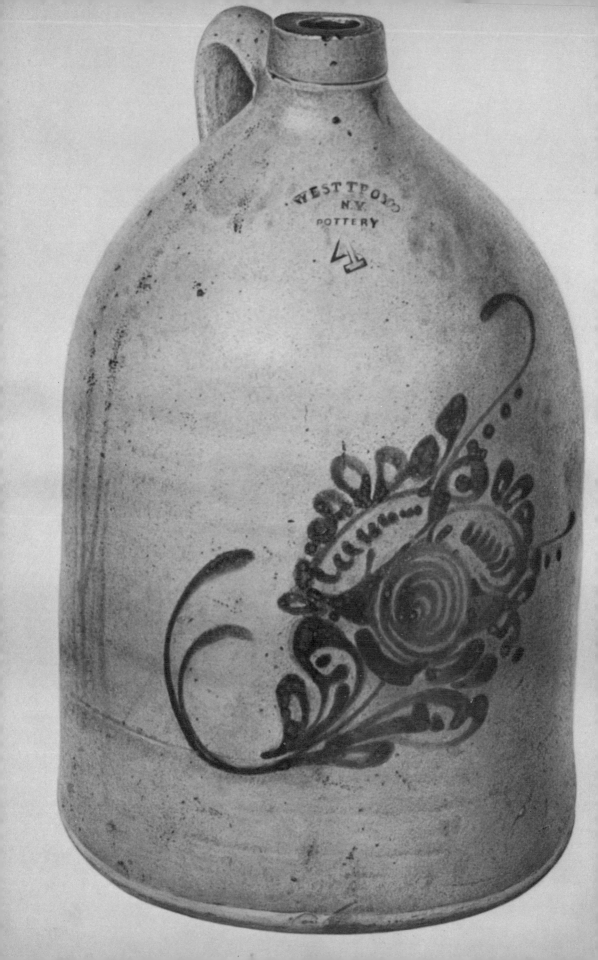

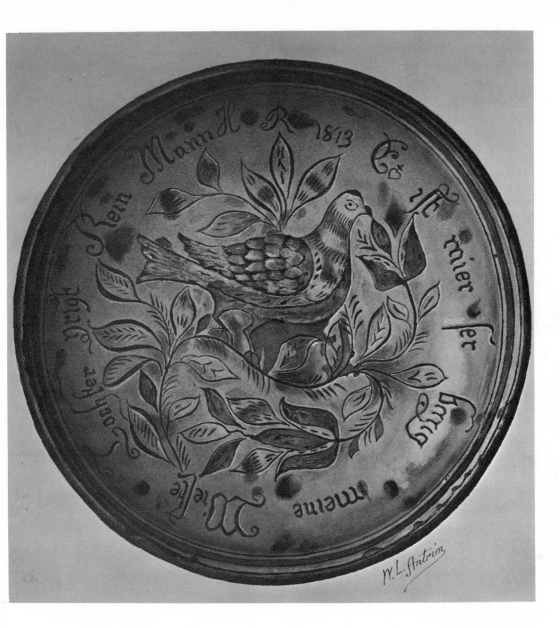

EARTHENWARE PIE PLATE with sgraffito decoration. Bird and floral design, in red, yellow, and green slip with initials and date "H. R. 1813." Covered by transparent lead glaze. German inscription reads: "I am very much afraid my naughty daughter will get no man." W.10⅛" Pa. Cer. 105b.

LATE SALT GLAZED STONEWARE JUG with elaborate floral decoration in cobalt blue. H.16⅝" B.10⅜" N. Y. C. Cer. St. 349.*

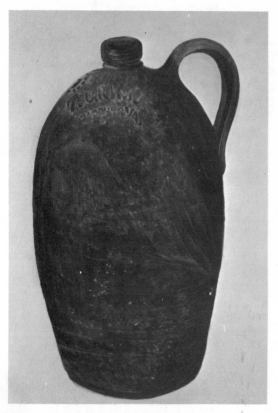

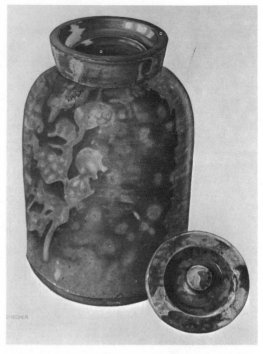

SALT GLAZED JUG, probably for brandy, made by T. Grim at Strasburg, Virginia, between 1866 and 1890. This jug is a piece of "end of day" ware made from different clays left over from the day's production. Mottled pink-brown-gray body. H.12″ B.5¾″ Va. Cer. 1.

PRESERVE JAR. Galena, Illinois, 1850–1888. Salmon-colored body with mottled green glaze over light gray slip. Even though glass jars were widely available by the mid-1800's, the clay preserve jar continued to be used in remote areas. Glass jars were expensive because the store owners passed on to the customer the high freight costs and loss due to breakage. Galena quart preserve jars in 1870 sold for ten cents. H.8½″ W.6″ Ill. Cer. 24.

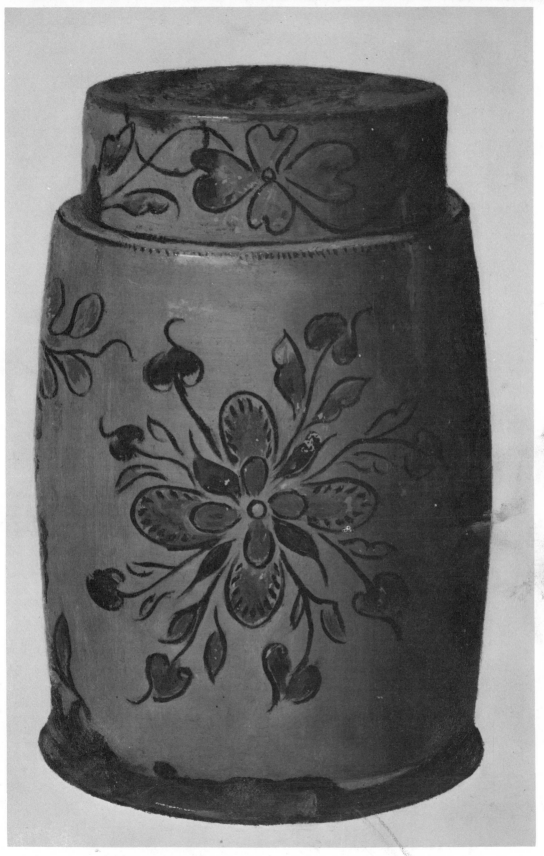

SGRAFFITO JAR made by Jacob Scholl, Tylersport, Montgomery County, Pennsylvania, about 1830. Delicate floral design on yellow ground tinted with blue and green slip. Cap-style lid. H.9″ Pa. Cer. 48.*

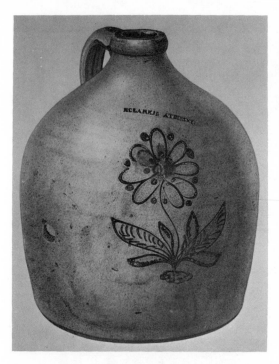

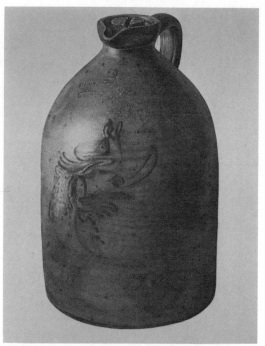

GRAY STONEWARE JUG made at Clark and Fox Pottery about 1830. Blue slip-trailed flower resembling a buttercup. H.11½″ B.9½″ N. Y. C. Cer. St. 338.

SALT GLAZED STONEWARE MOLASSES JUG marked "Riedinger and Caire, Poughkeepsie, N. Y." 1856–1878. Conventionalized bird perched on leaf spray in blue-green slip. Jugs for storing molasses and heavy syrups usually had pouring spouts. H.13⅝″ N. Y. C. Cer. St. 293.

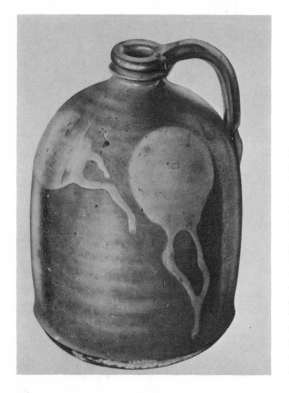

LEAD GLAZED JUG made between 1850 and 1880 at Galena, Illinois. Medium brown glaze with "full-moon" decoration, in tan slip. Potters were often sick with lead poisoning, or stomach rheumatism as they called it, from the continual grinding, mixing and application of lead glazes. They sometimes had nausea and stomach cramps for only a few days before returning to work, but occasionally a potter would be off for weeks, or he might even have been stricken with paralysis. The poisonous effects of lead oxide could have been greatly reduced if, after working with lead glazes, potters had washed their hands with soap and water. Unfortunately, most potters believed in the "superior efficacy of ardent spirits" in warding off stomach rheumatism. H.9¾″ W.7″ Ill. Cer. 15.

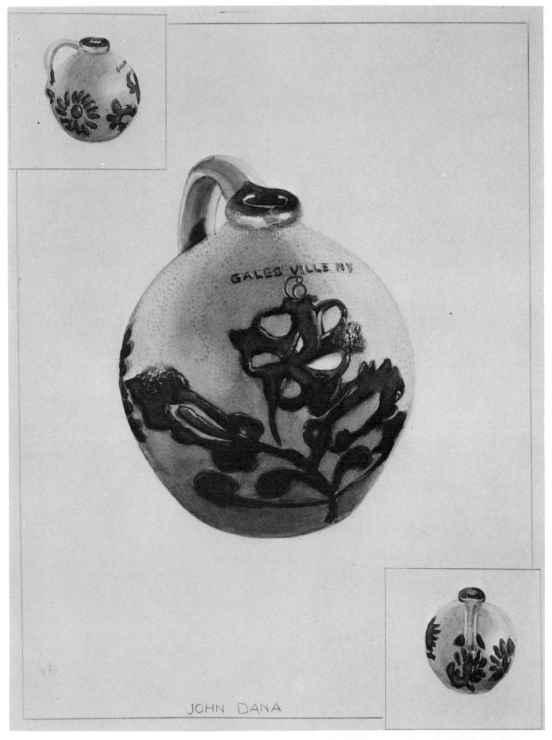

JOHN DANA

SMALL TAN STONEWARE SALT GLAZED JUG made in Galesville, Washington County, New York. Freely trailed flower and sunburst decoration in cobalt blue slip. During the late 1800's some potteries made a series of small jugs, both plain and highly decorated, which sold for six dollars to ten dollars a hundred. The "6" on this quarter-gallon jug is probably the "style number" for catalogue identification. H.5" N. Y. C. Cer. St. 141.

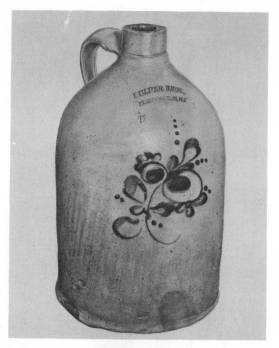

LATE GRAY STONEWARE SALT GLAZED JUG stamped "Fulper Bros. Flemington, N. J." Blue slip trailed decoration. H.10¾" W.7" N. Y. C. Cer. St. 228c.

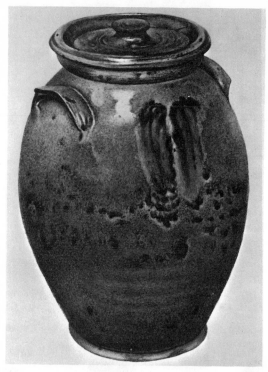

EARLY 19TH CENTURY EARTHENWARE JAR made at Portland, Maine. Salt glazed earthenware was not common and was never very successful. Cobalt blue, the traditional decoration on salt glazed stoneware, could not be used on earthenware because it combined with the iron in the body and turned a dull black. H.10" W.6½" N. Y. C. Cer. 106.

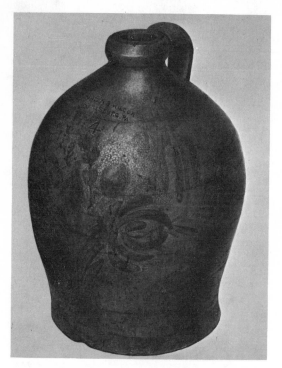

GRAY STONEWARE JUG with maker's name impressed on shoulder, *ca.* 1840. Blue floral design. It took eight gallons of salt or about one hundred pounds, to salt glaze one thousand gallons of pots. H.17" W.12" B.10" Del. Cer. 35.

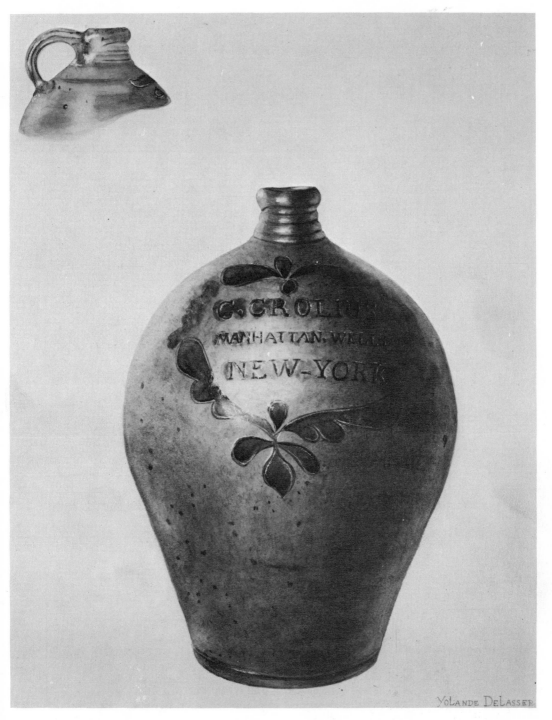

GRAY STONEWARE JUG with maker's name bordered by floral pattern, incised and filled in with blue slip. 1794–1815. "Literally tons of Crolius stoneware were made, and it was an honest boast of this factory that for one hundred years you could not sail to any port of the world without finding there some stone mug or jug bearing the Crolius stamp." H.10¾″ B.4¼″ N. Y. C. Cer. St. 173.[42]

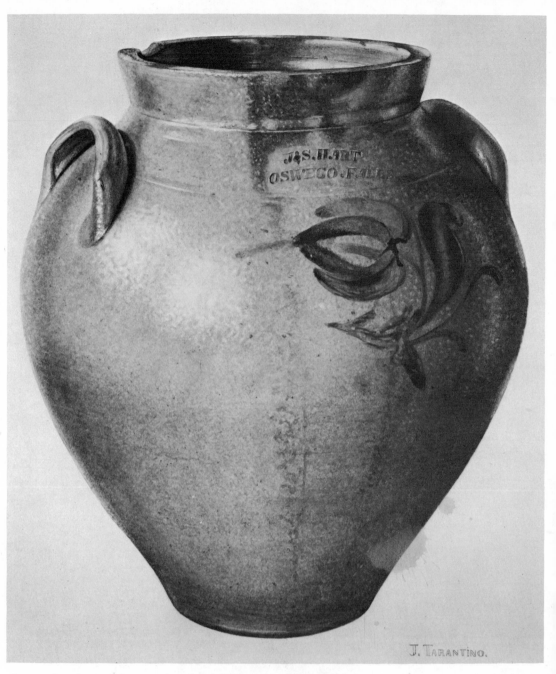

J. TARANTINO.

LARGE STONEWARE JAR produced by J. & S. Hart, Oswego Falls, New York, between 1832 and 1840. Salt glazed, brown slip interior, brushed cobalt blue flower decoration. H.14½″ T.9″ B.6½″ N. Y. C. Cer. St. 224.

238

TAN STONEWARE SALT GLAZED JUG produced by J. Norton and Co. between 1859 and 1861. By the mid-1800's straight-sided shapes were common in most potteries. Design emphasis had shifted from form to elaborate decorations. H.18″ W.10½″ N. Y. C. Cer. St. 126.

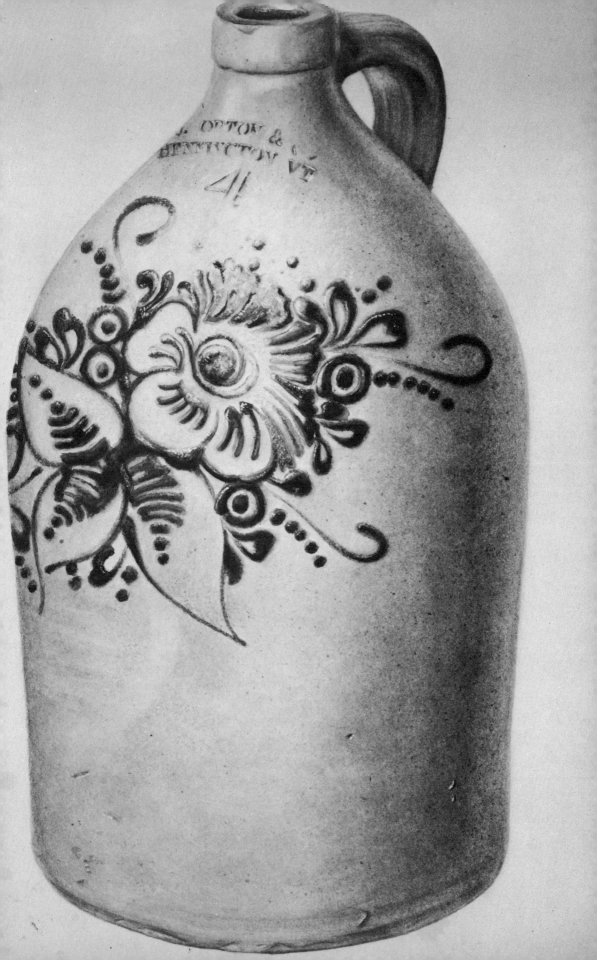

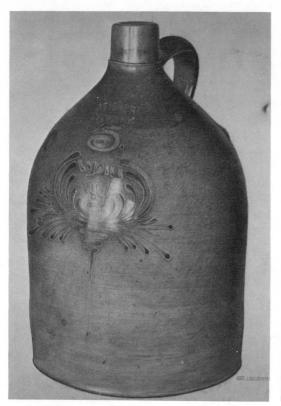 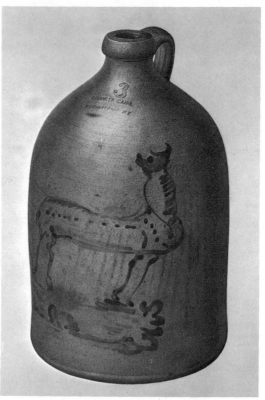

Large Stoneware Jug stamped with maker's name, *ca.* 1878. Brown and tan mottled body, salt glazed with formalized blue decoration. H.18½″ N. Y. C. Cer. St. 83c, d.*

Stoneware Jug, salt glazed, decorated with strange dog-like animal in blue slip, 1856. H.17″ B.9½″ N. Y. C. Cer. St. 347.*

Late Stoneware Brandy Jug, salt glazed, with conventionalized flower spray decoration trailed in blue slip. A "¾" gallon capacity mark is stamped on the back near the handle. Alcoholic beverages were considered a necessity rather than a luxury by early Americans. Liquor was used not only for its good cheer but also was administered liberally "for what ailed you." It was used as an anesthetic, an antidote for snake-bite and for protection against the cold. Spirits were drunk on all occasions: at meals, house and barn raisings, quilting bees, ordinations, weddings, funerals, political rallies, elections, trials, and militia trainings. Liquor was considered "a source of courage for the soldier, endurance for the traveler, foresight for the statesman, and inspiration for the preacher." H.14½″ W.5½″ N. Y. C. Cer. St. 294.[40]

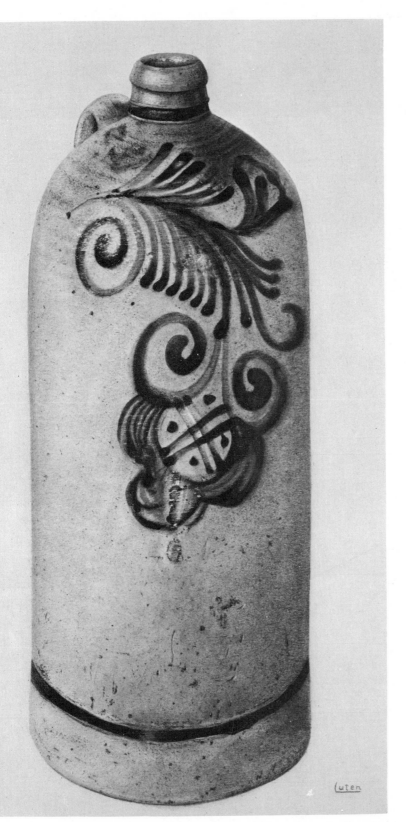

Luten

241

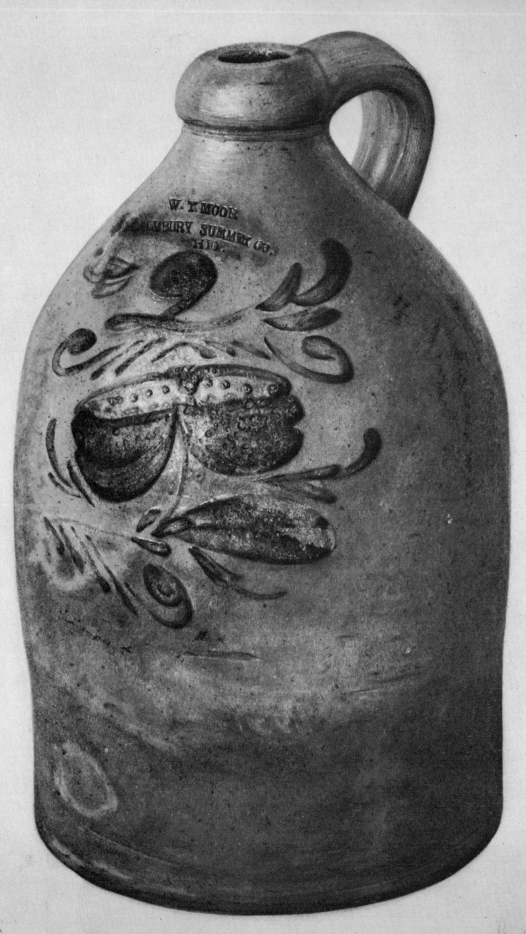

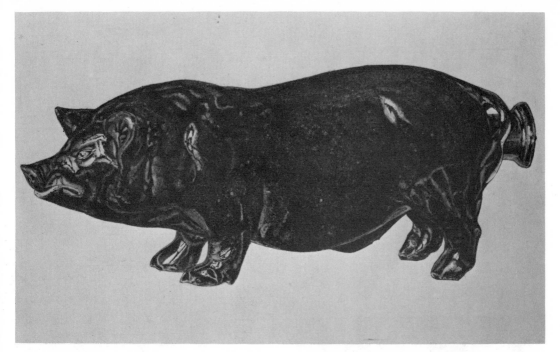

EARTHENWARE PIG BOTTLE covered by red-brown-yellow glaze with white spots. 1860– 1880. H.3½″ L.8″ Mo. Cer. A.

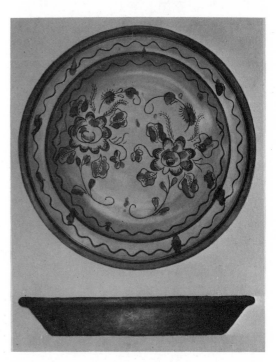

EARTHENWARE DISH made in Pennsylvania prior to 1800. Sgraffito decoration on yellow ground with splashes of green. Early earthenware table plates were fairly deep and shaped like milk pans. They were "turned" on the wheel and usually had very simple decorations. "Slip decorated dishes were the poor man's china in the 18th century." H.1⅞″ W.13⅜″ N. Y. C. Cer. 4.⁴⁴

SALT GLAZED TAN STONEWARE JUG stamped "W. T. Moor[e], Middleburg, Summit Co., Ohio." 1850–1870. The "H10" under the stamp is probably a catalogue identification number. Floral decoration and the figure "2" in dark blue slip. H.14″ N. Y. C. Cer. St. 291.*

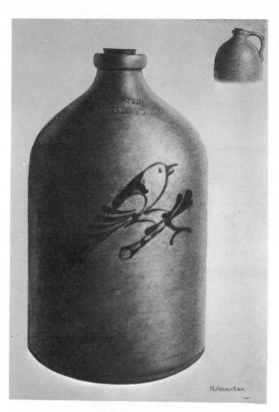

N. Amanten

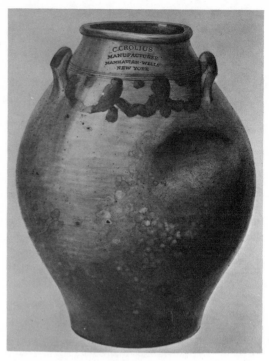

LARGE TAN STONEWARE JAR, salt glazed, made at the Crolius Pottery between 1794 and 1815. Brown slip glazed interior. N. Y. C. Cer. St. 98c.

TAN STONEWARE JUG with hollow wooden stopper, 1850–1859. Brushed bird in blue slip. This jug was probably used for storing a chemical solution. Salt glazed stoneware, which is impervious to acid, was in large demand due to the expanding industries of the mid-1800's. N. Y. C. Cer. St. 5c.*

244

UNUSUAL GRAY STONEWARE JUG made by Clarkson Crolius in New York City. Conventionalized daisy-and-leaf decoration tinted blue covered by greenish glaze. The exact function of this famous jug is unknown but in all probability it was used for serving some kind of drink. The elaborate decoration indicates that it may have been made as a gift, and possibly for use on the table. The small spout could only pour a thin liquid and its height above the rim indicates that the pot was made to be filled. The handles appear to be more decorative than functional. They are high above center which would make pouring awkward even if a person stood directly behind the jug and used both hands. It is likely that pouring was aided by a leather thong, cord or wire bail looped between the small holes in the top of each handle. The jug could then have been held aloft with one hand while the other gripped the bottom to tip the jug to pour out the contents. A bail might also have served to hang the jug on a peg or allow it to be lowered into a well to cool the contents. H.11¼″ T.4⅛″ B.4⅞″ N. Y. C. Cer. St. 159.

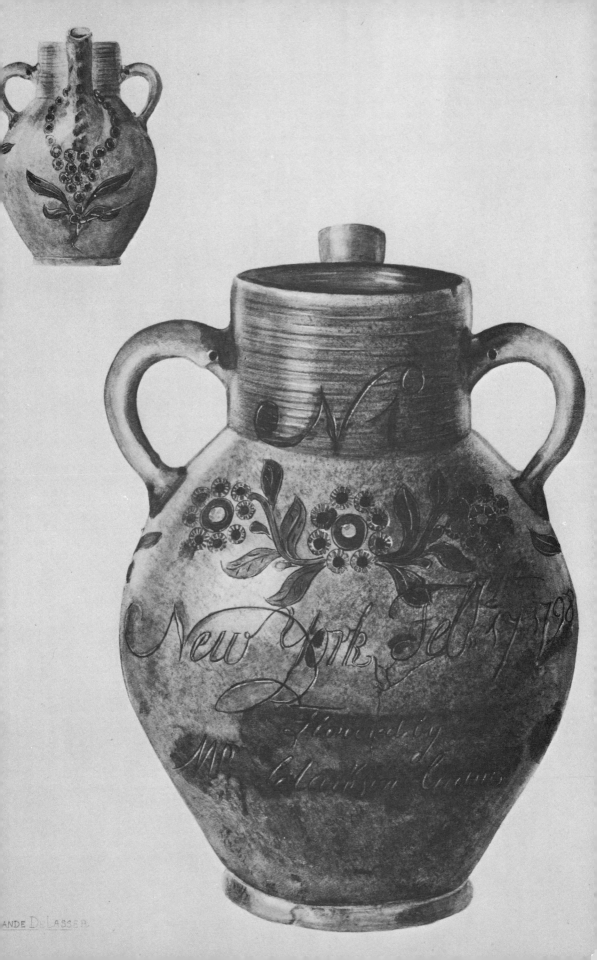

ANDE D. LASSER

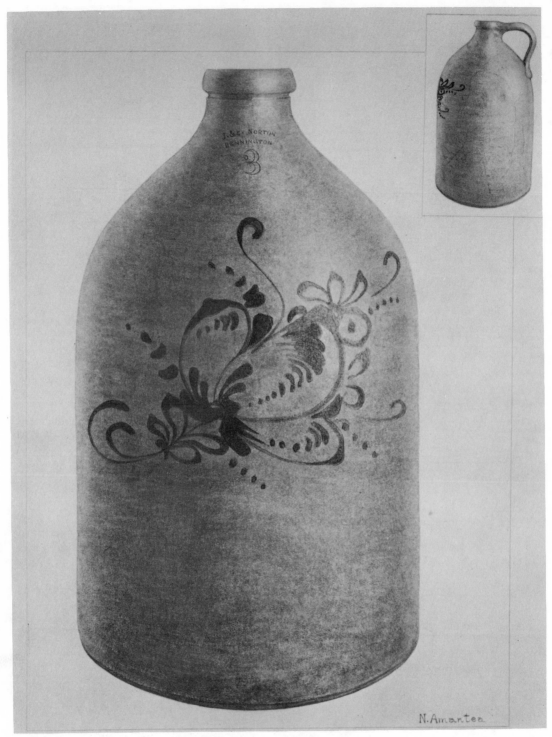

N. Amantea

Tan Stoneware Jug with intricate floral design in dark blue slip. Produced at the Norton Pottery at Bennington, Vermont, between 1850 and 1859. Amounts of clay, prices, and wages were all figured by the gallon. An average day's work "turning" was a hundred gallons. H.16″ B.9½″ N. Y. C. Cer. St. 2.

246

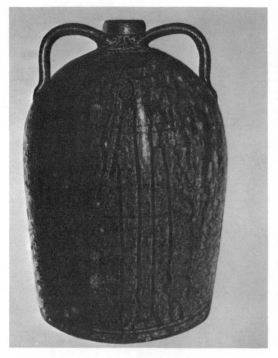

OLIVE GREEN JUG made at the Meaders' Pottery at Cleveland, Georgia, in the late 1800's. Five-gallon capacity. Large jugs which were quite heavy when filled could be conveniently carried by the double handles between two people. H.17½″ W.11″ Fla. Cer. 47.

EARLY 19TH CENTURY EARTHENWARE JAR with black-brown glaze. The exact function of this vessel is unknown; it could quite possibly be a flower vase. H.10″ T.4⅝″ B.4⅝″ N. Y. C. Cer. 66.

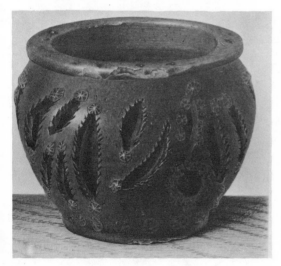

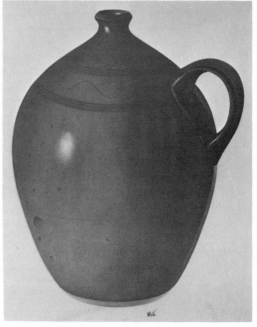

SMALL EARTHENWARE BOWL OR JARDINERE with dark brown glaze. "A jardinere is a large flower pot, tray, stand or box of more or less decorative character, for growing plants, or holding cut flowers." [48] This pot was found in New England but it is doubtful that it was made there. New England potters never decorated their ware with carved-out patterns or stamped rosettes. It probably was made by a potter of German origin somewhere in Pennsylvania. Conn. Cer. 75.

RED EARTHENWARE JUG made at Economy Pottery, Economy, Beaver County, Pennsylvania, between 1834 and 1880. H.18″ W.12″ Pa. Cer. 299.

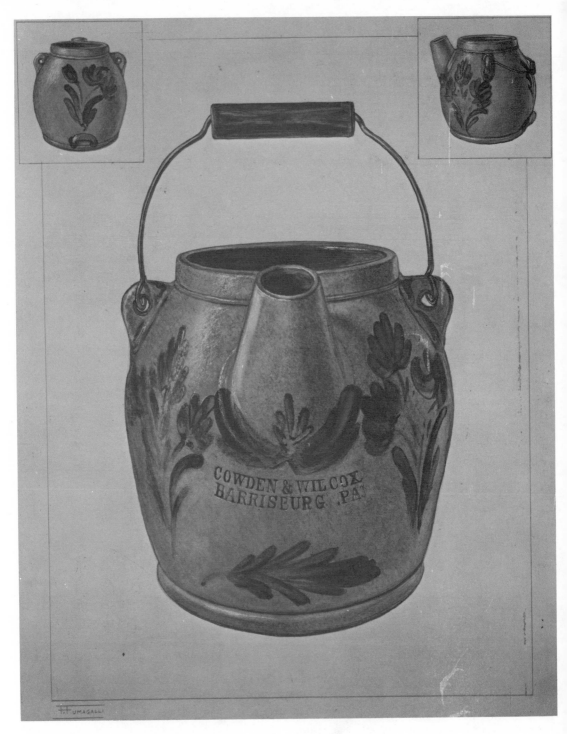

GRAY STONEWARE BATTER JUG, salt glazed, made by Cowden and Wilcox, Harrisburg, Pennsylvania, about 1860. Batter jugs were fitted with bail and "lift" handles for ease in pouring. The mouth and spout were usually covered by a cap-type metal lid. H.8¼″ T.5½″ B.6½″ N. Y. C. Cer. St. 25.

248

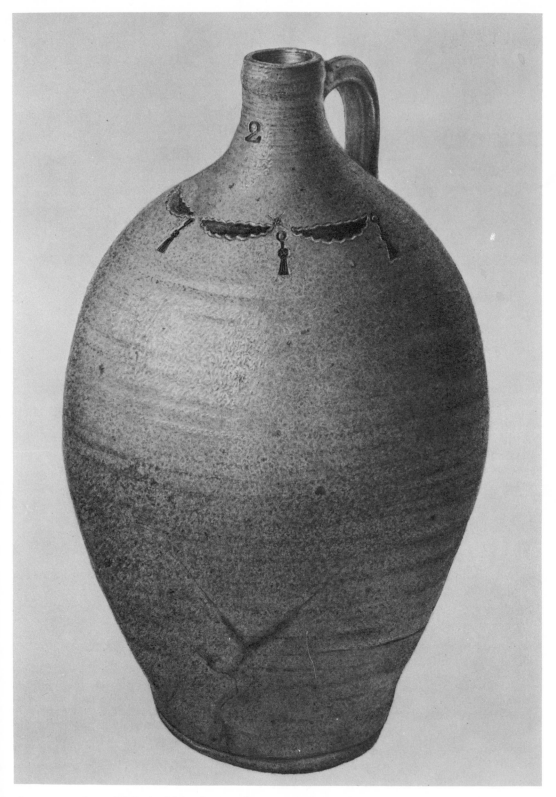

STONEWARE JUG with incised blue festoon decoration. Possibly made at Thomas Commeraw's pottery at Corlears Hook, New York City, *ca.* 1800. H.15¾″ N. Y. C. Cer. St. 274.

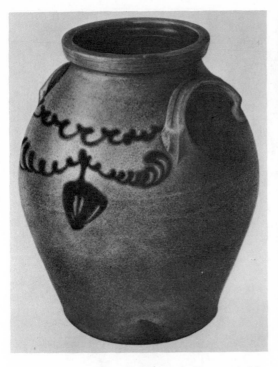

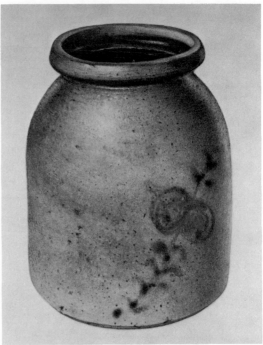

SALT GLAZED GRAY STONEWARE JAR probably made in New York State after 1825. Decorated with trailed cobalt blue slip; black interior. Lid missing. H.9″ T.4″ N. Y. C. Cer. St. 227.*

STONEWARE SALT GLAZED JAR possibly made in New York State about 1875. Decorated with faint blue formalized spray; brown interior. Lid missing. H.8¾″ B.6¾″ N. Y. C. Cer. St. 241.

EARTHENWARE PIE PLATE with sgraffito decoration on yellow slip ground covered by transparent lead glaze. Dated 1808. Tulips filled with green slip. Pennsylvania-German pie plates were made with both smooth and serrated edges. N. Y. C. Cer. 120.*

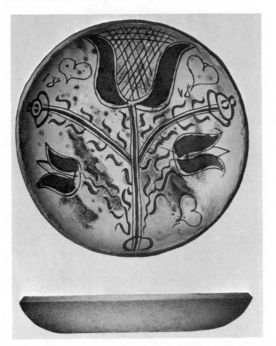

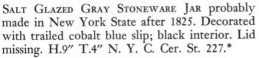

STONEWARE JUG probably made by a Pennsylvania potter, stamped 1844. This decoration, sometimes referred to as the "gaudy dove of paradise," is inspired by the "Song of Songs" in the Old Testament: "Beloved with dove's eyes who feeds among the lilies." H.16″ B.10¼″ N. Y. C. Cer. 51c, d.*

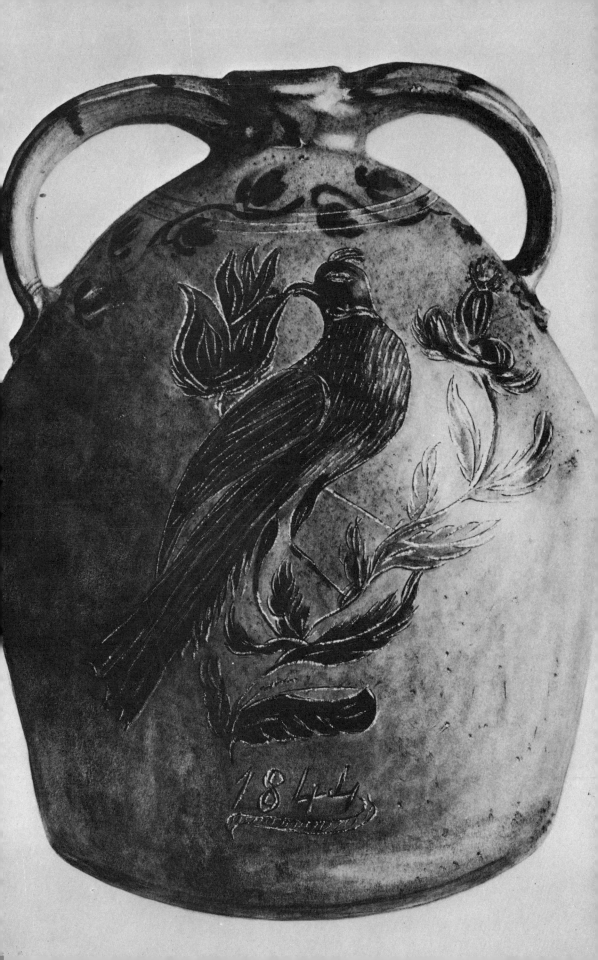

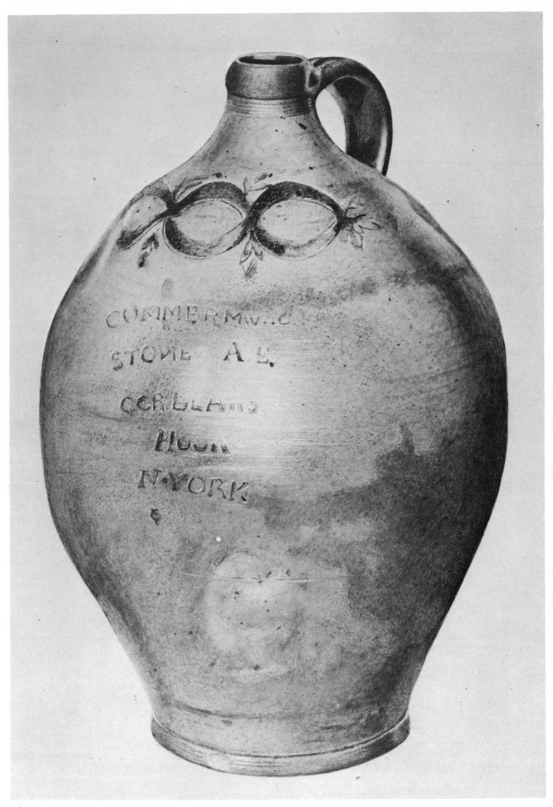

SALT GLAZED JUG stamped "Commeraws Stone-
ware, Corlears Hook, N. York." 1802–1820. In-
cised chain of double crescents embellished with
clusters of leaves. H.16″ N. Y. C. Cer. St. 219.*

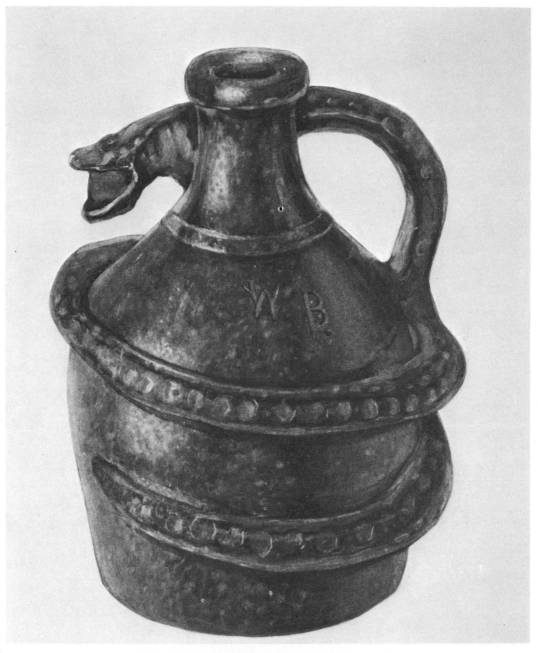

SMALL LIQUOR JUG produced by the Missouri
branch of the Boonville Pottery. "California,
Mo." is scratched on the bottom. Dull blue
glaze marked with numerous fine pinholes.
Drinks and drinking habits of early Americans
varied a great deal from place to place but they
generally reflected the temperament of the peo-
ple. In colonial New England the drinking of
intoxicating beverages was usually associated
with a useful activity or a special occasion. Rum
and hard cider were the most common drinks.
Drinking probably gave relief for the lack of
other social outlets, humdrum work, and the
austerity of New England Calvinism. In the
South the planter class took pleasure more for
its own sake. These men followed the pattern
set by English gentlemen and drank liberally of
imported liquors and local brandies. Pioneers on
the frontiers were mostly of Scotch-Irish and
German descent and were brought up from
early childhood on corn, wheat and rye whis-
key. Whiskey became the national drink in the
19th century because it was cheap and widely
available. Drinking habits remained unchallenged
until the first organized prohibition movement
was formed in the 1830's. H.6⅛" W.4⅜" B.3⅝"
M.1⅜" Mo. Cer. 4.⁴¹

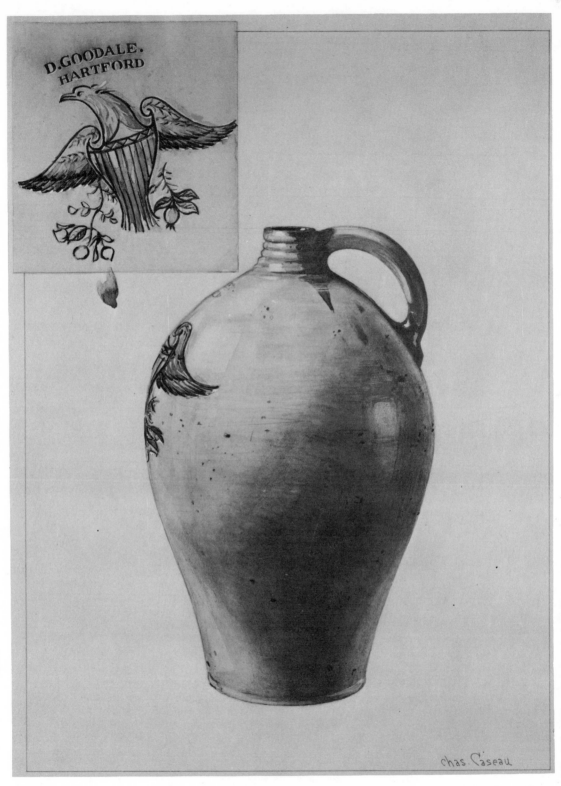

chas. Caseau

STONEWARE JUG made by Daniel Goodale, 38 Front St., Hartford, Connecticut. 1818–1830. In-cised eagle decoration tinted with blue slip. H.15¼" B.5¾" N. Y. C. Cer. St. 139.

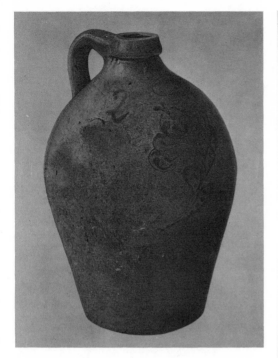

STONEWARE JUG used for molasses, produced by the C. Hermann Co., Milwaukee, Wisconsin, *ca.* 1855. Probably the most common stopper used for sealing a jug was a corncob wrapped in a small piece of old cloth. Potatoes were sometimes fashioned by store clerks as a temporary seal. Whittled wooden plugs tied to the jug handle to avoid loss were also used. H.13¾" W.9¾" B.7" Wis. Cer. 14.*

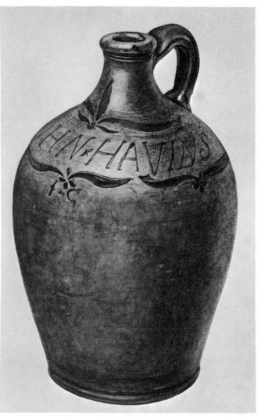

GRAY STONEWARE JUG incised "1775" made by John Crolius in New York City. Incised ribbon decoration and inscription reading, "John Havins, 1775, July 18, N. York," filled in with blue slip. The initials "I. C." are the potter's mark. H. 10" B.4¼" N. Y. C. Cer. St. 133a.

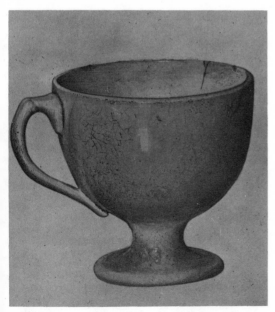

LATE 19TH CENTURY EGG CUP made of white earthenware called Ironstone China, covered with transparent glaze. H.3⅞" T.2¾" B.1¾" N. Y. C. Cer. 111.

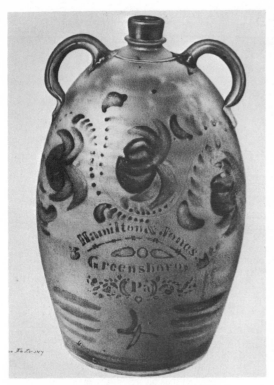 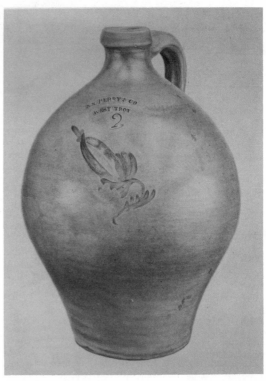

LATE STONEWARE JUG stenciled "Hamilton and Jones, Greensboro, Pa." Brushed floral decoration. Use of stencils for applying firm names and decorations began in the mid-1800's. They were used extensively after the Civil War when potteries began to industrialize in earnest. H.17⅝" B.8¼" N. Y. C. Cer. St. 254.

GLAZED EARTHENWARE JUG with traditional stoneware shape and decoration. H.15" W.10" N. J. Cer. 103.

SALT GLAZED STONEWARE WINE JUG probably made by G. Baird, Huron County, Ohio. Elaborately incised grapevine and stamped grape clusters tinted with blue slip. The groove in the neck was used for securing the cork with string. Wine jugs were a standard production item of the two potteries operating in the Huron Co. grape district between 1850 and 1870. Ohio Cer. 41.

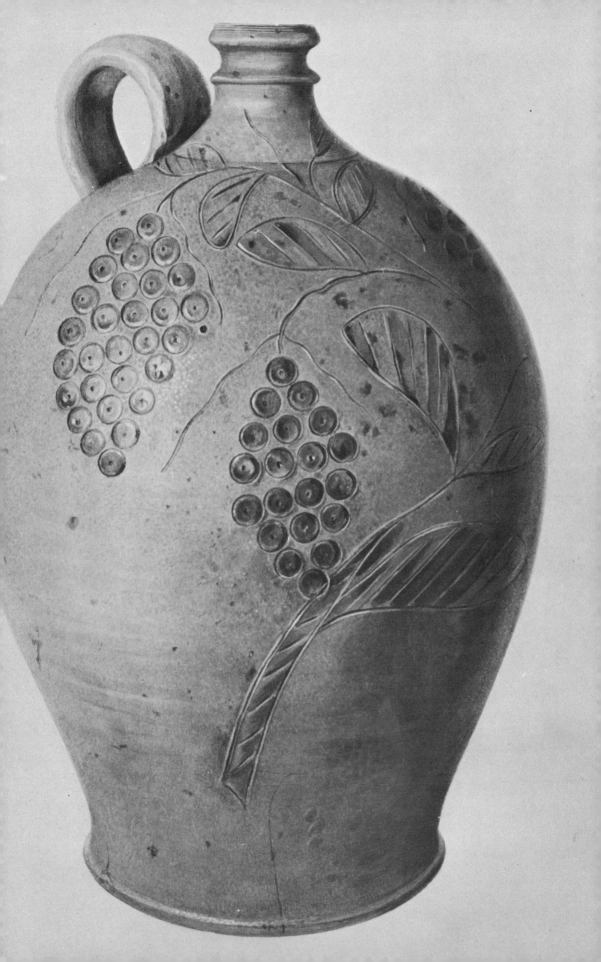

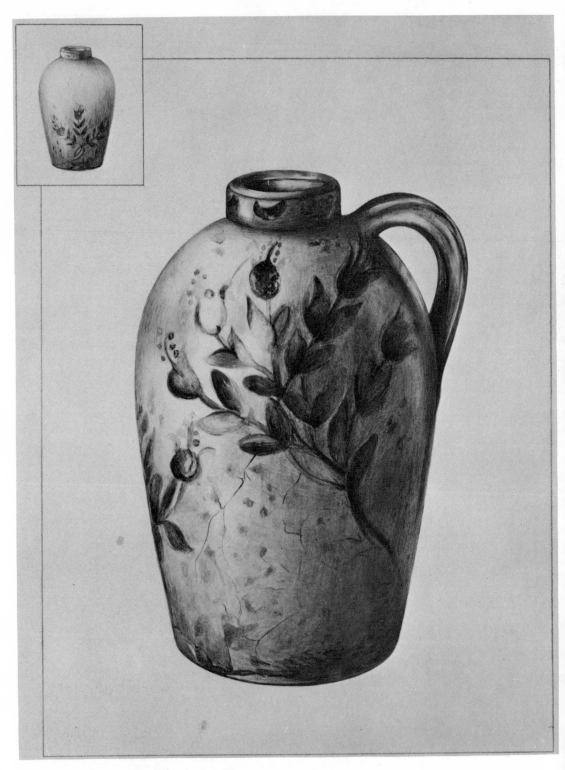

EARTHENWARE JUG made by Charley Bell at John Bell's Pottery, Waynesboro, Pennsylvania, in 1865. Cream-colored slip ground. Blue flower decoration covered with transparent glaze. Wide-mouthed jugs were used for wine and porter and for preserving small fruits such as gooseberries, raspberries, cherries and currants in syrup. H.8″ B.3½″ N. Y. C. Cer. 59.

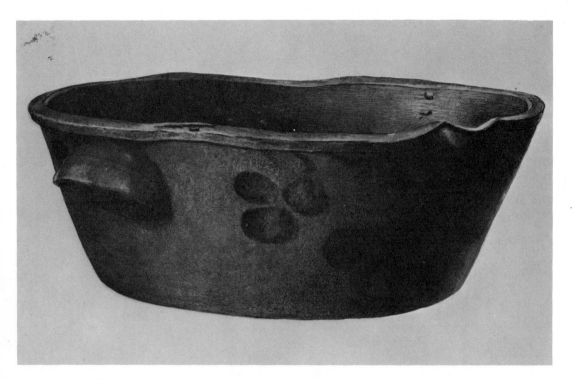

STONEWARE MILK PAN probably made near Glasgow, Delaware, about 1790. Simple blue decoration, brown slip interior. In many locales shallow vessels (three or four inches deep) were considered the best for separating cream. Temperature was also an important factor. Cream would "rise" quickest at about 50° F. H.4″ T.12″ B.8″ Del. Cer. 28.

SALT GLAZED GRAY STONEWARE WINE COOLER made by E. Hall at the W. P. Harris Factory, Newton Township, Muskingum County, Ohio. Dated 1856. Elaborate relief decoration tinted with blue slip. Spigot hole stopped with a cork is in the center of the heart just above the base. Modeled clay stopper. Capacity: 5 gallons. N. Y. C. Cer. St. 138.

EARTHENWARE PITCHER for "emptins" probably made at Haddonfield, New Jersey, in the 18th century. Mottled orange-brown glaze; lid missing. A constant problem of the early housewife was keeping a supply of yeast to "set the sponge" in her next baking. One method was to bury a handful of dough in flour which was stored in a small, covered pitcher. N. J. Cer. 24.

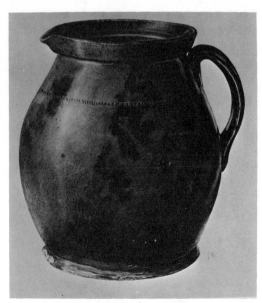

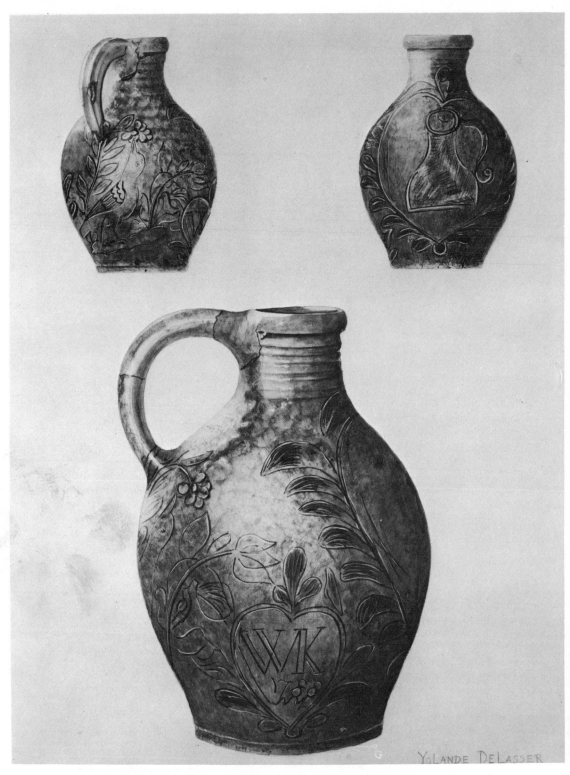

SMALL GRAY STONEWARE JUG with "W. K., 1788, N. Y." incised inside heart-shaped medallion, covered with transparent glaze. This personalized jug probably was ordered as a gift. It was common practice to order special inscriptions and decorations on gift items. H.8″ B.3¾″ N. Y. C. Cer. St. 187.

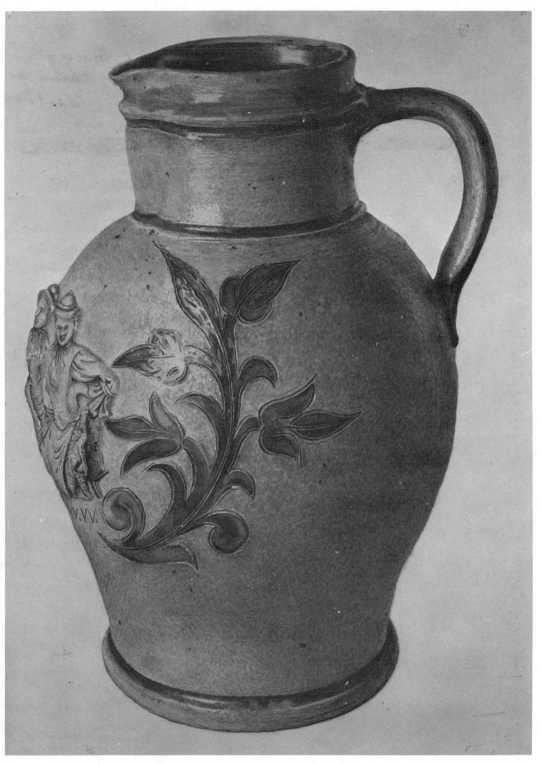

GRAY STONEWARE BEER PITCHER made by William Wingender at Haddonfield, New Jersey, about 1850. Modeled relief and sprigged decorations were rarely used except by a few potters of German, Dutch, and Swiss origins. H.11¼″ N. J. Cer. 111.

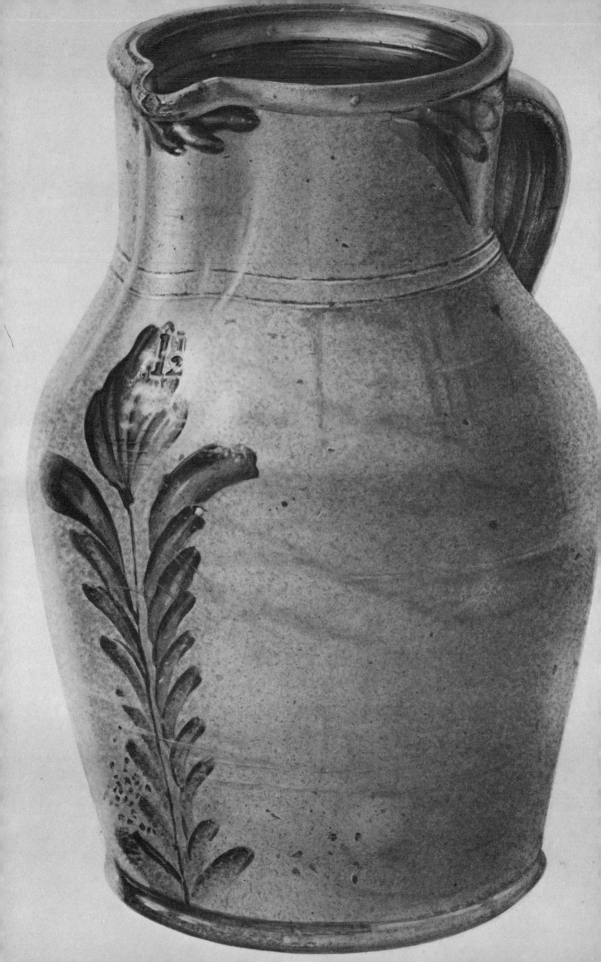

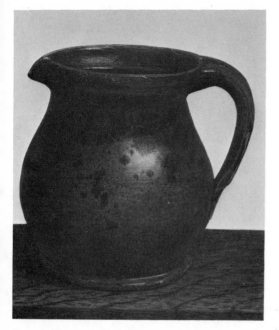

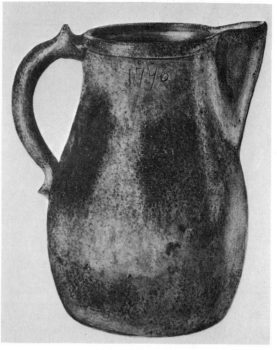

SMALL EARTHENWARE PITCHER used to pasteurize milk possibly to be used in a glass or pottery "sucking bottle." Probably made in Pennsylvania between 1840 and 1850. Red glaze with black specks. Lid missing. H.4½″ W.4⅛″ B.3¼″ Conn. Cer. 72.

STONEWARE PITCHER with red-brown glaze copied from early pewter design. Craftsmen working in wood, tin, pewter, copper, glass, iron, silver and clay were all competing to fill the needs of the community. Designs were sometimes adapted from one medium to another. H.10″ B.6″ N. Y. C. Cer. St. 163.

GRAY STONEWARE PITCHER with stylized blue slip leaf and flower decoration which appears to grow from the foot rim. Potters also painted horizontal lines under floral designs to represent the ground. H.12″ N. Y. C. Cer. St. 218.*

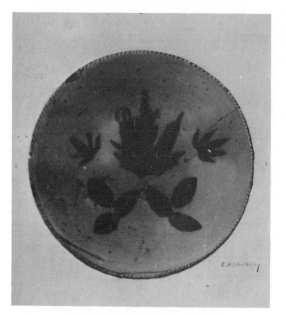

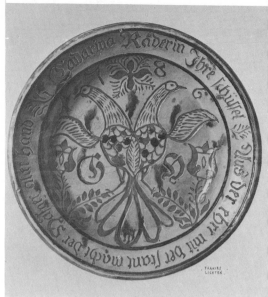

PIE PLATE made by David Haring, Bucks County, Pennsylvania, in 1831. Earthenware with yellow-colored slip ground. Natural leaves were sometimes used for decorations on pie plates. They were pressed into the damp clay before the slip was applied. The leaves were later removed, leaving their likeness in the raw clay. Transparent lead glaze was then applied over the interior of the plate. H.1½″ W.10¾″ Pa. Cer. 49.

EARTHENWARE DISH made by George Hubener, Montgomery County, Pennsylvania, in 1786. Sgraffito design on buff-colored ground decorated with red and black slip. This dish was, no doubt, made for a wedding present. The dove was a symbol of love in the Pennsylvania-German culture. Two doves united in a heart symbolized the joining of a betrothed couple in the union of love and marriage. German inscription reads: "Katharine Raeder—her dish. Out of the clay, with understanding, the potter makes everything." W.12½″ Pa. Cer. 128.

THREE-QUART BEER PITCHER with pewter lid made by Carl Wingender at Haddonfield, New Jersey, between 1820 and 1850. Incised decoration filled in with cobalt blue slip. H.12″ W.6¾″ B.4″ M.3½″ N. J. Cer. 113.

264

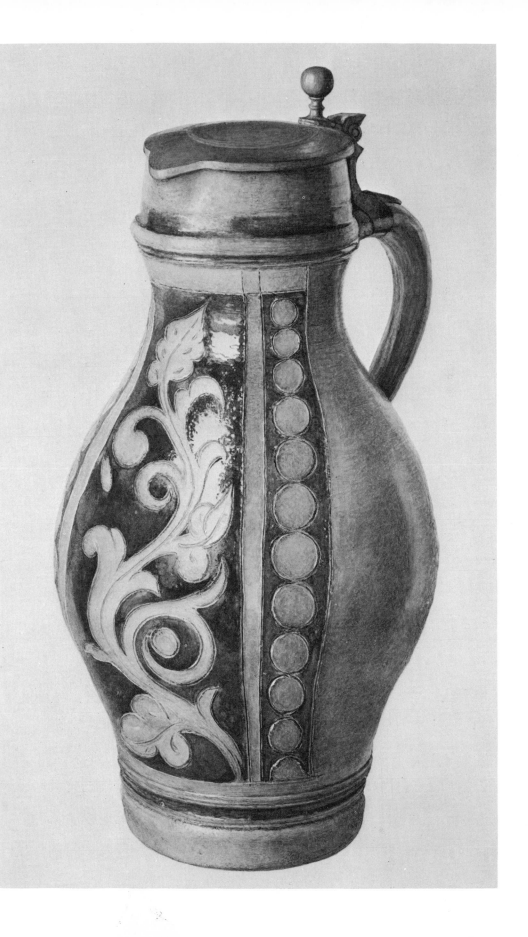

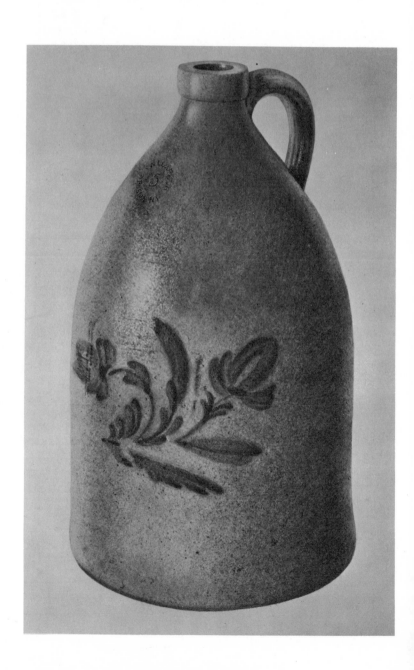

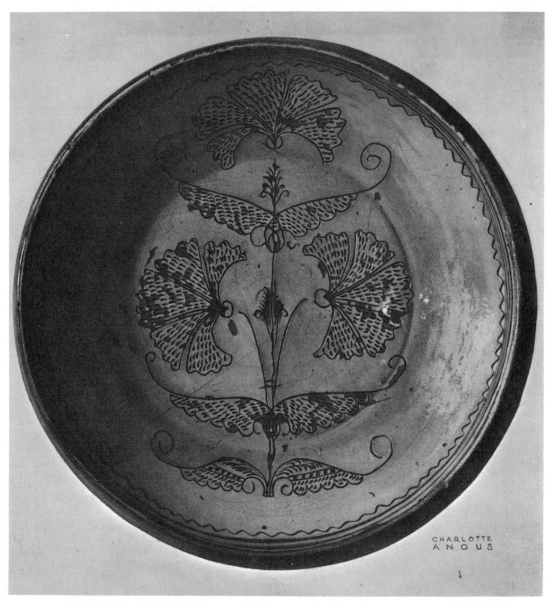

CHARLOTTE
ANGUS

EARTHENWARE PIE PLATE with "tree of life" sgraffito decoration on pale yellow slip. "Four meals a day, and a pie at every meal, could soon dispose of fifty pies, which was the number a young girl boasted she had made at harvest time in the 1860's." H.2¼″ W.13¾″ Pa. Cer. 15c.[43]

LATE 19TH CENTURY JUG stamped with potter's name. Salt glazed stoneware with brushed blue flower and leaf decoration. Potter's trademarks stamped on stoneware came into general use in the early 1800's. H.19½″ N. Y. C. Cer. St. 271.

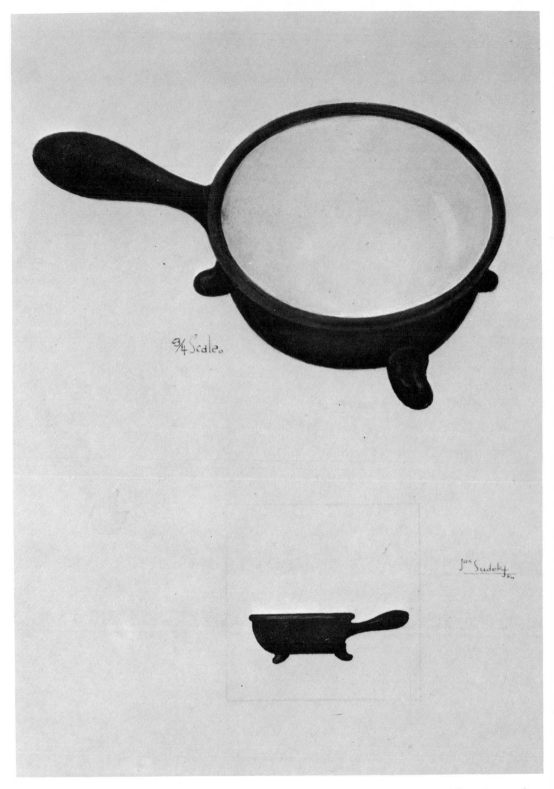

SERVING DISH produced by International Pottery Co., Trenton, New Jersey, about 1890. H.3¾″ W.7⅝″ Overall length 11⅛″ New Jersey Cer. 32.

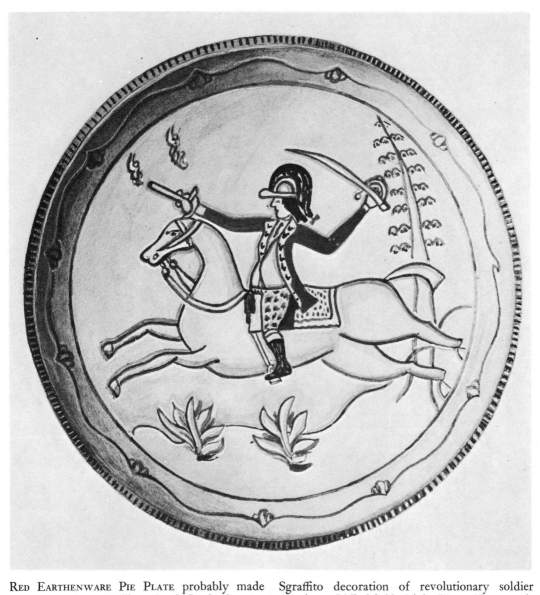

RED EARTHENWARE PIE PLATE probably made by David Spinner, Willow Creek, Bucks County, Pennsylvania, between 1800 and 1811. Spinner was fond of equestrian and hunting scenes. Sgraffito decoration of revolutionary soldier wearing a Philadelphia Light Horse Troop uniform of 1774. Brown coat trimmed with white; bucktail hat. H.2⅛″ W.11¾″ N. Y. C. Cer. 31.

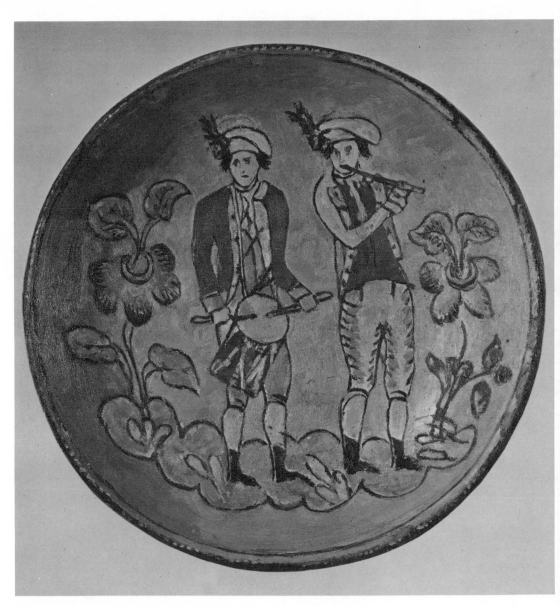

DECORATIVE PIE PLATE made by David Spinner, Bucks County, Pennsylvania, about 1810. Lead glazed earthenware with sgraffito design of Continental fifer and drummer. Red, green and yellow slip. Pa. Cer. 20.

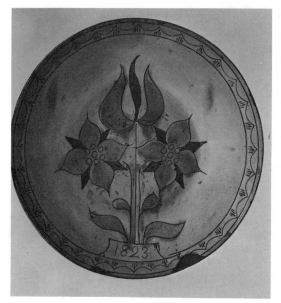

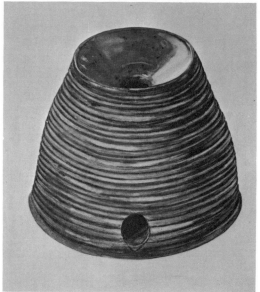

EARTHENWARE PLATE with sgraffito-outlined tulips painted red and green on yellow slip ground. The tulip, or "lily" as it was known to the Pennsylvania-Germans, was a very popular decorative motif. Its precise symbolic meaning is not clear. Among many symbolic meanings of the tulip are the following: "the Christ," "all believers," "new age or spiritual time," "spiritual growth," "humility," and "purity." H.1¾" W.11¼" N. Y. C. Cer. 97.

EARTHENWARE ROACH TRAP made in Pennsylvania about 1840. The bottom hole was corked and the trap was partially filled with a mixture of molasses and water used as bait. The insects attracted by the scent would climb the unglazed, ribbed outside wall up to the funnel-shaped well, which was glazed, and upon reaching the top they would slide into the well and be trapped. H.4¼" T.3" B.5⅛" N. Y. C. Cer. 50.

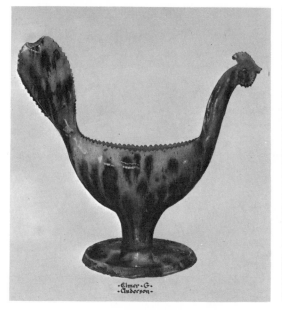

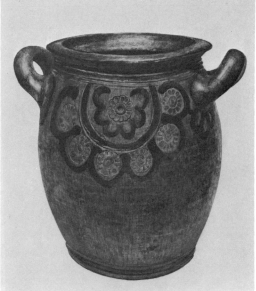

EARTHENWARE WATER WHISTLE made in Pennsylvania about 1830. Yellow glaze with dark brown splashes. The user blew in the beak, causing a warbling whistle-sound to come from the bowl, which was partially filled with water. Pa. Cer. 141.

MID-19TH CENTURY STONEWARE JAR covered by brown glaze and decorated with stamped rosettes and brushwork scallops in bluish-black and brown slip. The shape of this jar is very similar to those made by German potters in the Rhine valley in the mid-1700's. Del. Cer. 31.

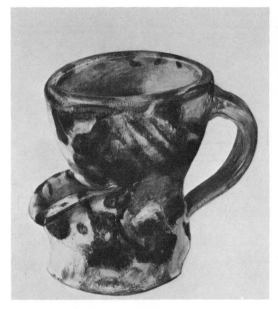

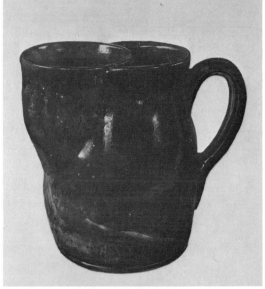

EARTHENWARE SHAVING MUG made at S. Bell and Sons Pottery in Strasburg, Virginia, in 1882. Mottled cream-green-brown glaze. Shaving mugs were used to hold soap and hot water for lathering the face before shaving. The brush was dipped in the hot water and vigorously rubbed on the soap in the small cup to form the lather. H.4⅛″ N. Y. C. Cer. 62.

RED EARTHENWARE SHAVING MUG with mottled yellow-green-brown glaze. Made in New Jersey in the late 18th century. Early shaving mugs were regular drinking mugs with a small cup added to the rim for soap. H.4½″ B.3¼″ N. Y. C. Cer. 57.

STONEWARE BOWL showing the trend in design of ware made by the industrialized potteries of the late 19th century. *Ca.* 1870, this bowl was made in a mold with the maker's name on the bottom in raised letters, "U. S. Stone Co.,

Akron, Ohio." The blue and white mottle glaze was applied with a sponge. The top and bottom of the rim are unglazed so that the bowls could be meshed when stacked in the kiln. H.2½″ W.8 1/16″ Mich. Cer. 88.

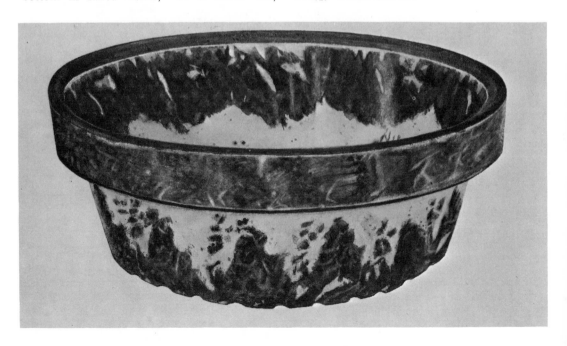

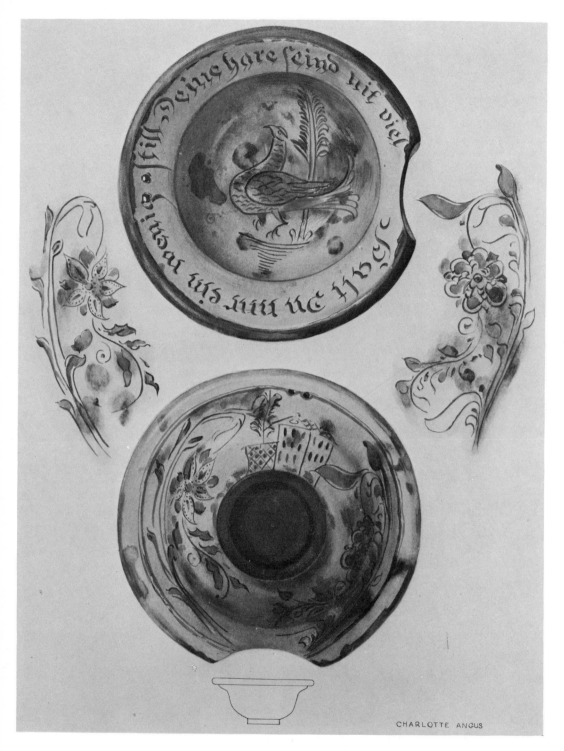

CHARLOTTE ANGUS

EARTHENWARE BARBER'S BOWL with turned foot made in Pennsylvania in 1790. Red and green slip decoration on yellow ground, covered by transparent lead glaze. The notch in the bowl was placed at the neck to protect clothing while the face was being lathered. As late as 1830 these basins were also used by barber-surgeons to hold against an arm or leg of a patient who was being bled. The two holes in the rim opposite the notch were for a string loop to hang the bowl on the wall. H.3" W.7" Pa. Cer. 121.

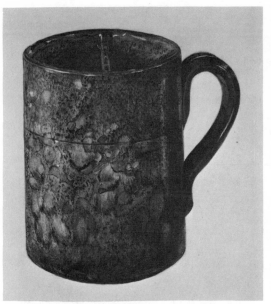

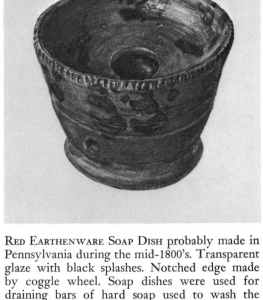

EARTHENWARE SHAVING MUG with brilliant green and tan mottled glaze marked "Conn-glass" on the base. A center divider separating hot water and soap was an early 19th century innovation. H.4¾" N. Y. C. Cer. 162.

RED EARTHENWARE SOAP DISH probably made in Pennsylvania during the mid-1800's. Transparent glaze with black splashes. Notched edge made by coggle wheel. Soap dishes were used for draining bars of hard soap used to wash the hands and face. This kept the bar from melting into a soupy mess. Hard soap for the hands and soft soap used for laundering clothes were usually made from the same ingredients: lye leached from wood ashes and animal fat or tallow. The only difference between the two kinds of soap was that the hard soap required more lye of a higher quality than did soft soap. H.2¾" T.3½" N. Y. C. Cer. 105a, b.

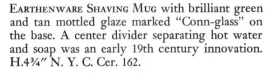

HAND-MODELED EARTHENWARE STATUETTE made in Pennsylvania about 1825. Mottled red-black glaze. H.6¾" B.6½" x 3" N. Y. C. Cer. N. C. N.

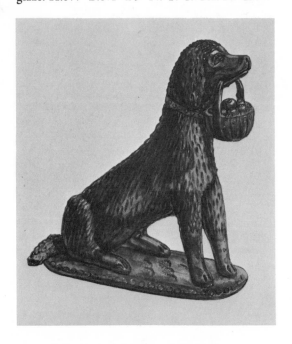

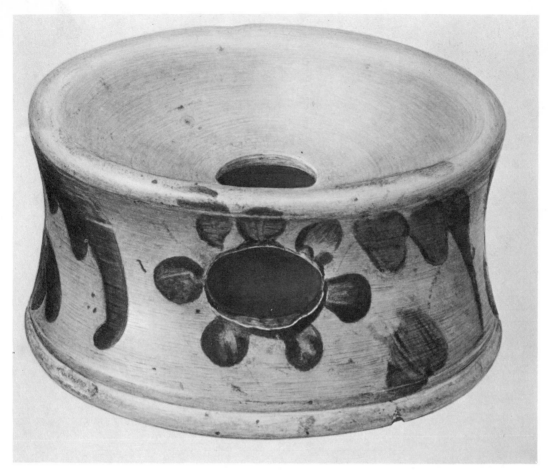

EARLY 19TH CENTURY STONEWARE SPITTOON, salt glazed with simple cobalt blue decoration. Spittoons were a standard production item made in both earthenware and stoneware. They often are mistakenly called cuspidors, which are distinguished by a high, open, funnel-shaped top. Late 19th century stoneware potters made spittoons in half a dozen different sizes ranging from six inches to fifteen inches in diameter. "The large or first size, called professional, added dignity to law offices and barrooms," while smaller spittoons "graced the household." [45] H.4″ W.3⅜″ N. Y. C. Cer. St. 311.

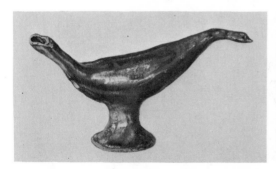

STONEWARE WHISTLE covered with greenish-brown glaze made in Pennsylvania between 1820 and 1850. Children's whistles called "blow birds" were simple to operate. The user blew into the tail or beak and the sound came out a vent in the back or bottom. H.2¼″ B.1½″ L.5″ N. Y. C. Cer. St. 268.

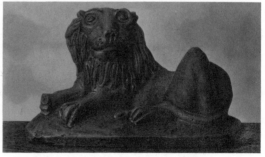

EARTHENWARE LION with the name John Sanders scratched on the bottom. Red glaze. Possibly made in Connecticut, dated 1817. Modeled and molded dogs, deer, lambs, lions, horses, cows, birds and human figures were the usual subjects for shelf ornaments, paperweights and doorstops. Approx. H.3½″ W.4½″ L.7½″ Conn. Cer. 38.

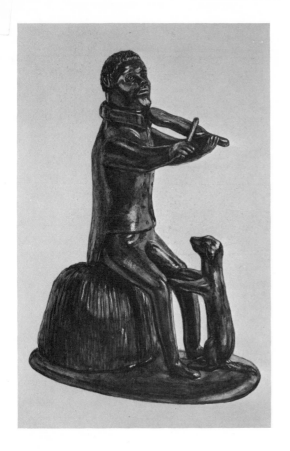

HAND-MODELED EARTHENWARE STATUETTE of Negro violinist made in Pennsylvania during the early part of the 19th century. Greenish-brown glaze. H.7¼″ B.5½″ x 3⅛″ N. Y. C. Cer. 41.

EARTHENWARE STRAINER with brown glaze interior, *ca.* 1800. Earthenware colanders and strainers were made in many shapes and sizes and usually were glazed only on the inside. H.4″ T.11½″ B.7″ N. Y. C. Cer. 69.

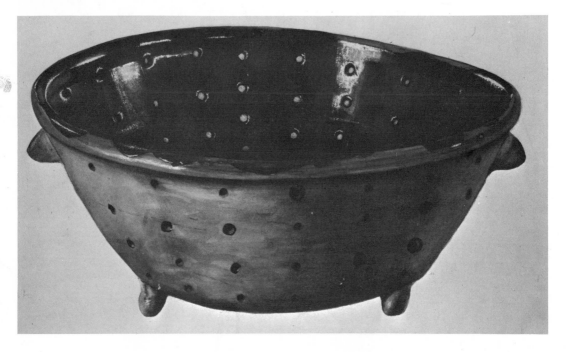

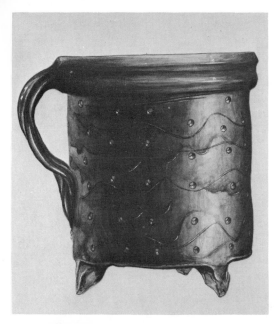

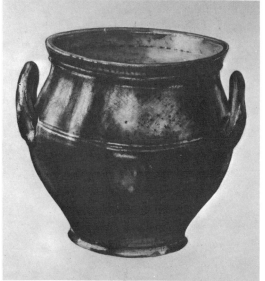

EARTHENWARE CHEESE STRAINER made at Bethlehem, Pennsylvania, about 1860. Black glaze. Cheese curds removed from the whey in the cheese tub were cut in small blocks and placed in the strainer lined with cheese cloth. When the strainer was almost filled the cloth was folded over the curd and a round board or trencher weighted with a stone was placed on top. Some soft cheeses were allowed to cure in this fashion for ten to fourteen days and then were used. Other methods of preparation called for allowing the cheese to stay in the strainer under weight only until all the whey had been removed. Then it was placed in a round wooden box and pressed until it was solid. H.7″ W.7¼″ Pa. Cer. 329.

SUGAR BOWL made in Pennsylvania in the early 1800's. Red earthenware with speckled brown- and cream-colored glaze outside, cream-colored interior. Lid missing. In colonial times white cane sugar was imported from the Caribbean. It was called "loaf sugar" because it was shipped in slender, conical loaves weighing about six pounds each. It was wrapped in dark purple paper, which thrifty wives used for dye. Loaf sugar, which was quite hard, had to be broken into small lumps for use in sweetening liquids and ground in a mortar if it was to be added to a dry recipe. Sugar to be used on the table was broken into lumps and stored in covered sugar bowls. Granulated sugar did not come into popular use until after the Civil War. Although loaf sugar was generally available it was not commonly used because it was very expensive. Molasses and honey were the primary sweeteners used in most households. H.4½″ T.4⅞″ N. Y. C. Cer. 46.

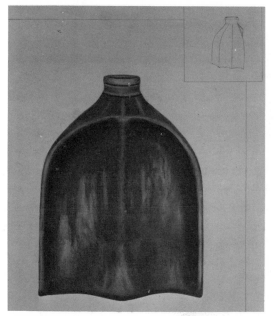

STONEWARE FOOT WARMER made at Bennington, Vermont, in 1864. Reddish-brown glaze. Foot warmers filled with hot water were placed on the floorboards of buggies or under church pews to keep the feet warm on cold winter days. H.9¾″ W.7¾″ Fla. Cer. 26.

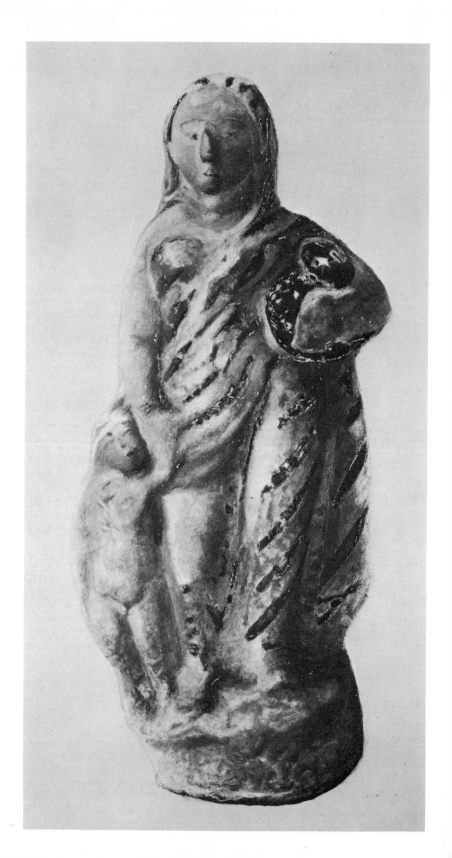

278

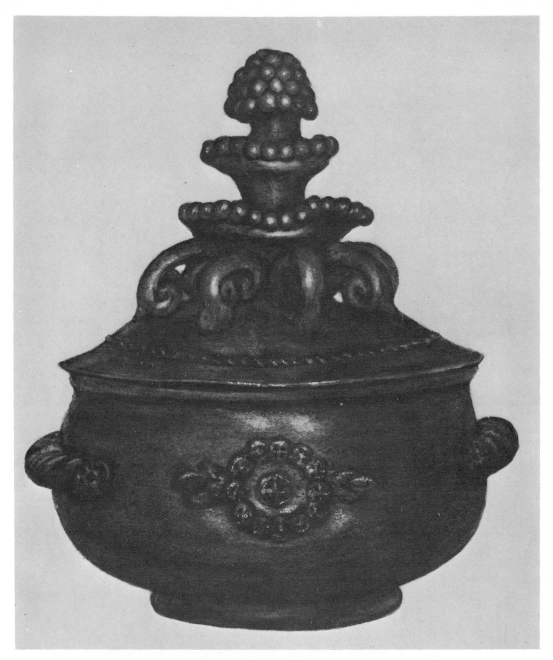

GLAZED RED EARTHENWARE SUGAR BOWL made by a Swiss potter in Pennsylvania during the late 1700's. Modeled decoration. Sugar bowls were also called "sugar boxes," "sugars," and "sugar pots." Overall H.5¾" and W.4¾" N. Y. C. Cer. 27.

MODELED EARTHENWARE STATUETTE of a woman and child, *ca.* 1800. White glaze decorated with yellow, green, black and red slip. Modeling of this type was occasionally done by German potters in eastern Pennsylvania and North Carolina. H.8⅜" Pa. Cer. 428.

279

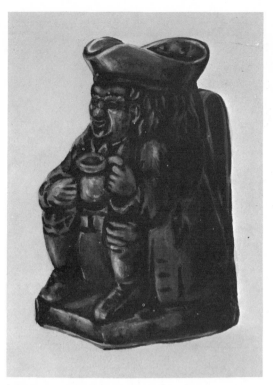

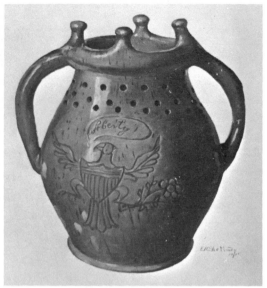

EARTHENWARE PUZZLE JUG made by Philip Kline, Bucks County, Pennsylvania, about 1809. Puzzle jugs usually had an inscription which challenged the drinker's skill: "From mother earth I claim by birth, I'm made a joke for man; but now I'm here, filled with good cheer, can taste me if you can." "In this jug there is good liquor, fit for either priest or vicar, but to drink and not to spill, will try the utmost of your skill." "What though I'm common and well known to almost everyone in town, my purse to sixpence if you will, that, if you drink, you some do spill." H.9″ Overall W.9⅛″ Pa. Cer. 69.

AMERICAN TOBY JUG, probably copied from imported English ware, with brown glaze, made about 1847. It is thought that the first English Toby drinking jugs were inspired by an engraving of Toby Fillpot, who was the subject of Francis Fawkes' ballad published in 1761. "This [engraving] pictures Toby as a happy, laughing, baldheaded fellow of immense girth with his three-cornered hat set none too securely on the back of his large head. He is seated in a low chair with turned legs in a beautiful arbor-like setting, smoking a long clay 'churchwarden' pipe and holding a huge jug of foaming ale in his right hand." H.6″ Mich. Cer. 85.[46]

CURTAIN TIEBACK made at Bennington, Vermont, about 1850. Molded earthenware with rockingham glaze. N. Y. C. Cer. 87.

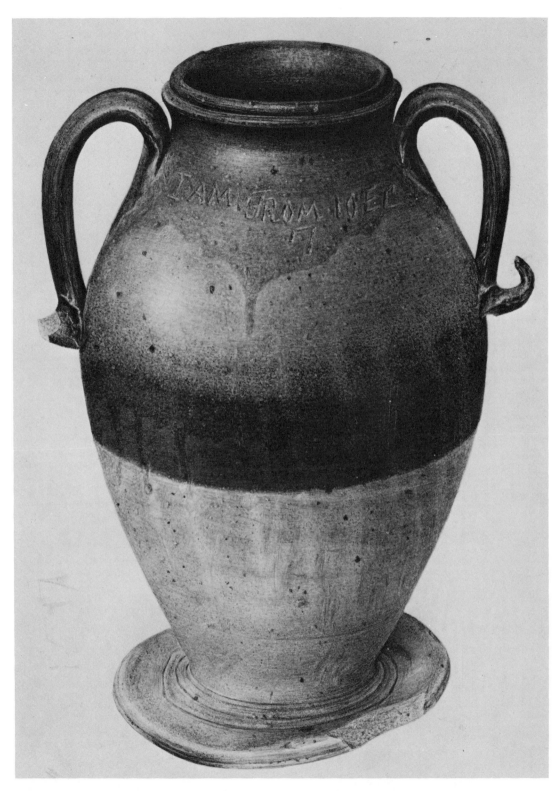

GRAY STONEWARE FLOWER URN of classic shape, glazed with dark brown slip. "I am from IOEC" is scratched around the neck. "IOEC" was probably the potter's homespun abbreviation for Tennessee. It was possibly used so that the inscription would fit between the handles, or the potter may simply not have known how to spell Tennessee. H.11½" N. Y. C. Cer. St. 290.

SALT GLAZED STONEWARE FLASK possibly made at the Crolius Pottery in New York City, 1775–1800. Incised flower filled with blue slip. Flasks were made in both earthenware and stoneware but usually were not a regular production item. They were "turned" on the wheel and gently flattened when leather hard. H.8″ N. Y. C. Cer. St. 258a, b.

EARTHENWARE VASE with mottled red-brown glaze. In the late 1700's there were no frogs or needlepoint holders for cut flowers. Flowers were arranged by clumping them tightly together in a vase for mutual support. Arrangements in large-mouthed containers were made by partially filling the container with sand or gravel to hold the flowers in place. H.5½″ T.4″ B.3⅜″ N. Y. C. Cer. 23.

TOY BEAN POT made as a present for Miss Mamie Koehler by a South Jersey potter in 1839. Toys made for girls were usually miniatures of standard production items such as bean pots, crocks, jugs, jars, pitchers, pipkins and teapots. Occasionally a potter modeled dolls' heads, chairs and other toy furniture. Pottery and toys for boys were marbles, banks, and whistles. H.2¾″ W.2¾″ N. J. Cer. 46.

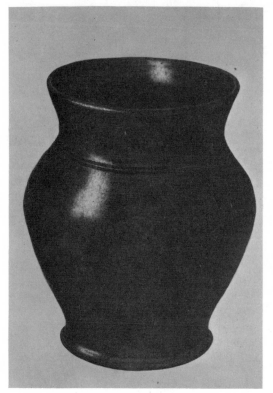

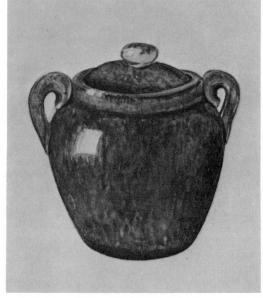

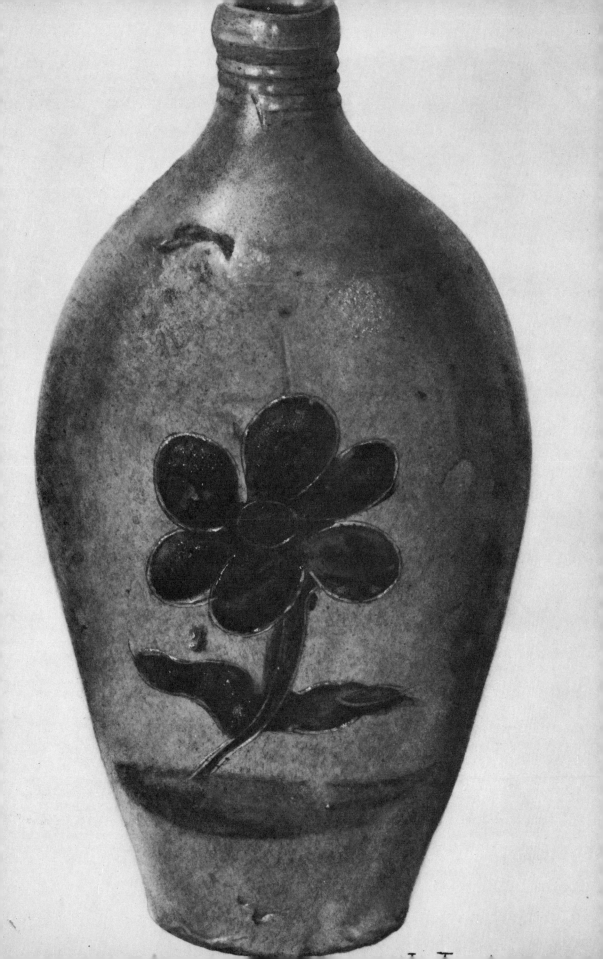

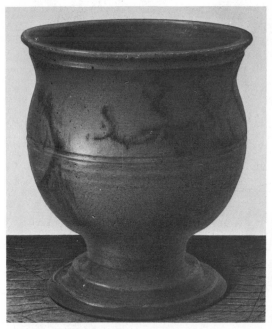

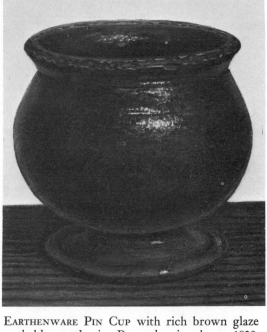

EARTHENWARE FLOWER POT covered by red glaze with black splashes. Probably made in Pennsylvania-German pottery about 1840. H.6¼" T.5¼" B.4⅝" Conn. Cer. 62.

EARTHENWARE PIN CUP with rich brown glaze probably made in Pennsylvania about 1820. Small goblet-shaped cups were used in Pennsylvania for vases, pin cups, spice holders, egg cups and saffron cups as well as for containers to hold various other small household items. H.3½" Conn. Cer. 64.

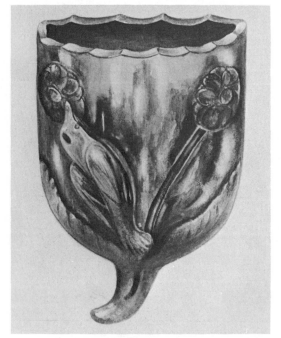

EARTHENWARE WALL POCKET for cut flowers made by S. Bell and Son, Strasburg, Virginia, about 1880. Cream and brown glaze over modeled relief decoration of bird and flowers. Although wall pockets were made to hold small bouquets of flowers, they quite often became recepticals for matches and other small objects. H.6½" T.4½" x 3⅜" N. Y. C. Cer. 7.

THREE-GALLON STONEWARE WINE OR CIDER JUG stamped "New York City," probably made by Louis Lehman and Co., 31 West 12th St., between 1859 and 1861. The name "Uri Doolittle Esqr. Paris" is inscribed above the incised decoration of kissing doves. Salt glazed brown body, cobalt blue brushwork. H.18" B.6" N. Y. C. Cer. St. 346.

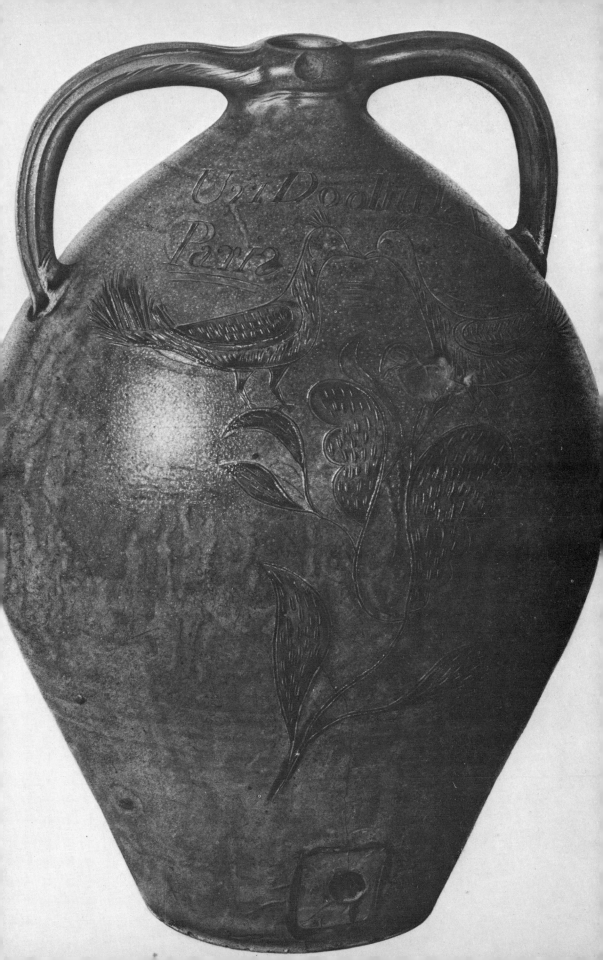

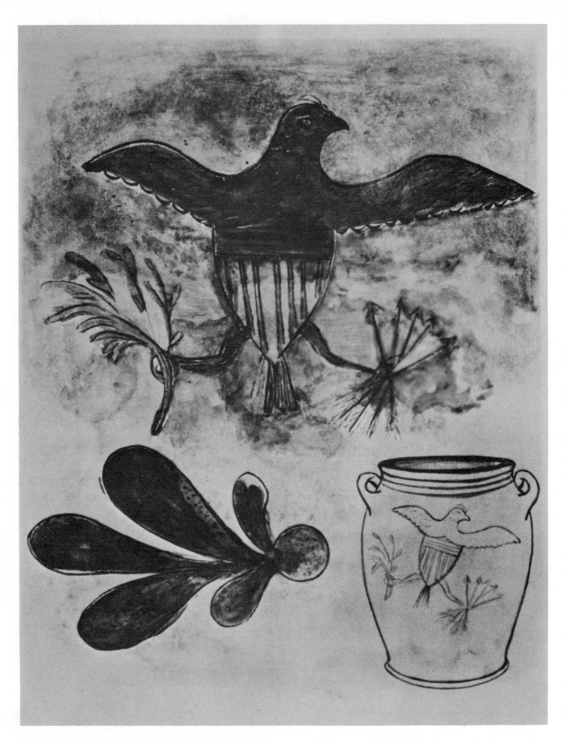

DETAIL OF CROCK: John Remmey, New York City. 1794–1815. Incised eagle decoration tinted with blue slip. Patriotic symbols such as eagles, flags, shields and cannons were favorite stoneware decorations. They were especially popular during times of political fervor and national crises. H.9⅝″ N. Y. C. Cer. St. 39.

286

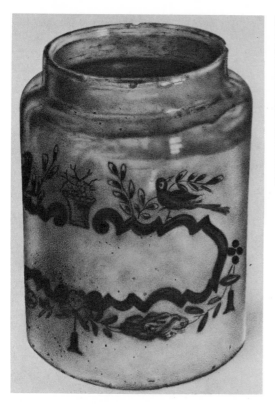

WIDE-MOUTHED WHITE STONEWARE DRUG JAR
used for storing dry materials. Drug jars were
used by apothecaries for storing their balsams,
barks, extracts, flowers, oils, roots, seeds, salts,
and elixirs. The apothecary, like the doctor,
mixed and prescribed syrups, ointments and
other medicines which were the common reme-
dies of the day. They also sold paint and brushes,
varnish, linseed oil and window glass. H.6¾″
W.5⅞″ Ill. Cer. 13.

EARTHENWARE SLIP CUP made by Judak Teanes
with "10th month 27th 1827" inscribed on the
base. Brown slip glaze, decorated with incised
vines, flowers and a female head. "The slip was
prepared by mixing white clay with water until
it was the consistency of thick cream." Most
slip cups were: ". . . about the size of a coffee
cup, usually with depressions on either side to fit
the fingers and thumb of the operator. Near the
lower part of one side of the cup were perfora-
tions in which goose quills were inserted, through
which the liquid slip was made to trickle over
the surface of the ware. . . . Grasping the slip
cup between the thumb and fingers of the right
hand, the decorator drew the quills over the
surface of the clay in waving or zigzag lines,
the slip being made to flow out by the power
of attraction, very much in the same way as
ink is drawn from a fountain pen by contact
with the paper. There were generally three
quills or pipes in the cups used for this charac-
ter of work on ordinary commercial wares,
though the number varied, sometimes reaching
five or seven. For fine work, such as lettering
or outlining figures, a single quill was used."
H.3¼″ W.2⅜″ L.4¼″ N. Y. C. Cer. 42.[47]

DETAIL OF JUG. Clarkson Crolius I, 1773–1843,
and Clarkson Crolius II, 1806–1887, both marked
their ware C. Crolius, New York. Crolius I was
recorded as a potter in New York City from
1794 to 1837 and stamped his ware, "C. Crolius,
Manhattan Wells, N. Y." Clarkson Crolius II
used "C. Crolius, Manufacturer, N. Y." ca. 1825
to 1870. N. Y. C. Cer. St. 79d.

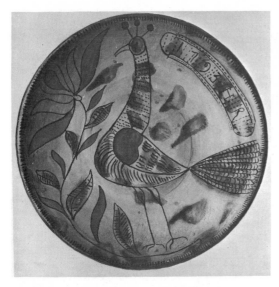

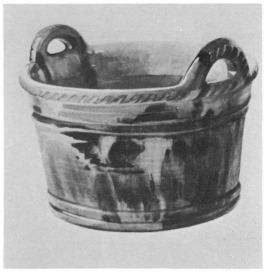

EARTHENWARE PIE PLATE with sgraffito design of a peacock probably made by Henry Roudebuth, Montgomery County, Pennsylvania. The peacock had no specific meaning in Pennsylvania-German symbolism. In early primitive Christian art it symbolized immortality and later, the Resurrection. H.1⅞″ W.12¼″ N. Y. C. Cer. 125.

EARTHENWARE TUB probably made at the Bell Pottery in Strasburg, Virginia, *ca.* 1840. Yellow glaze with brown splashes. H.4¼″ T.7½″ B.6″ Pa. Cer. 102.

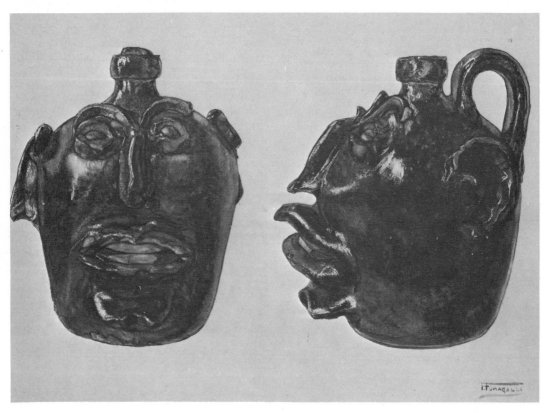

STONEWARE GROTESQUE JUG with face modeled in high relief covered by green glaze, *ca.* 1800. Pieces of broken china were sometimes used for the eyes and teeth. H.7″ B.3¾″ N. Y. C. Cer. St. 183.

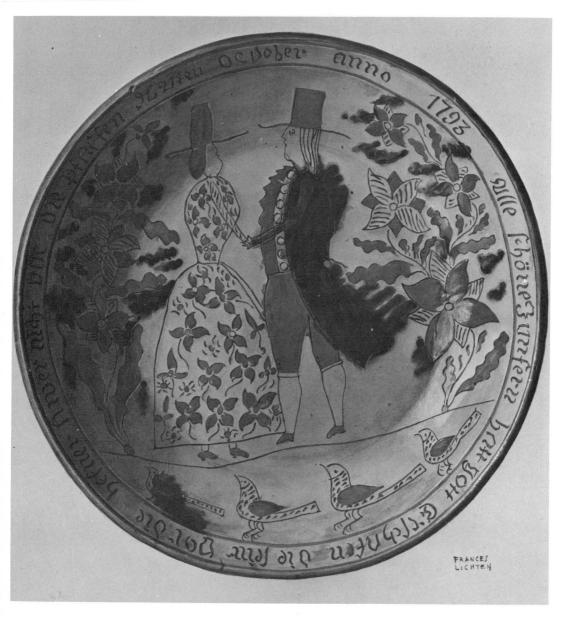

PENNSYLVANIA-GERMAN PIE PLATE with sgraffito design on yellow slip ground. Detail in red and green slip. Inscription reads: "All beautiful maidens hath God created; they are for the potter but not for the priest." W.12" Pa. Cer. 126.

289

Notes

1. Charles McLean Andrews, *Colonial Folkways* (New Haven: Yale University Press, 1921), p. 85.
2. Edith Elliott Swank, *The Story of Food Preservation* (Pittsburgh: H. J. Heinz Co., 1942), p. 185.
3. Andrews, p. 64.
4. Henry Bamford Parkes, *The United States of America* (New York: Alfred A. Knopf, Inc., 1963), p. 28.
5. Andrews, p. 63.
6. Edwin Tunis, *Colonial Craftsmen* (Cleveland: World Publishing Company, 1965), p. 17.
7. Lura Woodside Watkins, *Early New England Potters and Their Wares* (Cambridge: Harvard University Press, 1950), p. 2.
8. Victor Selden Clark, *History of Manufactures in the United States*, Vol. I. (New York: McGraw–Hill, Inc., 1929), p. 156.
9. *Ibid.*, p. 135.
10. Alvin H. Rice and John Baer Stoudt, *The Shenandoah Pottery* (Strasbury, Virginia: Shenandoah Publishing House, Inc., 1929), p. 272.
11. Eliza Meteyard, *Life of Josiah Wedgwood*, Vol. I. (London: Hurst and Blackett Publishers, 1865), p. 366.
12. Clark, Vol. I., p. 216.
13. Edwin Atlee Barber, "The Earliest Decorative Pottery of the White Settlers in America," *House and Garden* XI (June, 1902), 239.
14. Watkins, p. 80.
15. Clark, Vol. I, p. 27.

16. Arthur W. Clement, "Ceramics in the South", *Antiques* LIX (February, 1951), 136.
17. Meteyard, Vol. I, p. 367.
18. Clement, p. 137.
19. Rice and Stoudt, pp. 272–274.
20. Janet R. MacFarlane, "Nathan Clark, Potter," *Antiques* LX (July, 1951), 42.
21. Clark, Vol. I, p. 391.
22. Carl Bridenbaugh, *Colonial Craftsman* (New York: New York University Press, 1950), p. 63.
23. John Ramsay, *American Potters and Pottery* (New York: Tudor Publishing Co., 1947), p. 68.
24. Watkins, p. 212.
25. *Ibid.*, pp. 214–216.
26. "William H. Bloor," *Bulletin of the American Ceramic Society* XVI (January, 1937), 27.
27. Watkins, p. 211.
28. *Ibid.*, p. 165.
29. Rice and Stoudt, p. 49.
30. Gerald Carson, *The Old Country Store* (New York: Oxford University Press, Inc., 1954), p. 196.
31. Edwin H. Coolidge, "The Pottery Business in Sterling, Massachusetts", *Old Time New England* XXIII (July, 1932), 21.
32. Ramsay, p. 27.
33. J. J. Breese, "Jugtown Pottery", *Country Life* XLII (October, 1922), 64.
34. Janet K. Smith, *Design: An Introduction* (Chicago: Ziff–Davis Publishing Company, 1946), p. 104.
35. National Gallery of Art, "Records" *Index of American Design*, Illinois Division. (Washington, D.C.: 1935–1941).
36. *Ibid.*, Iowa Division.
37. Edwin Atlee Barber, *Tulip Ware of the Pennsylvania-German Potters* (Philadelphia: The Pennsylvania Museum, 1903), p. 85.
38. Willard Emerson Keyes, "Toy Banks", *Antiques* X (October, 1926), 290.
39. John Spargo, *Early American Pottery and China* (New York: The Century Company, 1926), p. 108.
40. Herman Frederick Wilkie, *Beverage Spirits in America* (New York: Newcomen Society of England, American Branch, 1947), p. 13.
41. Gerald Carson, *The Social History of Bourbon* (New York: Dodd, Mead & Co., 1963), p. 7.
42. John E. Stillwell, "Crolius Ware and Its Maker" *New York Historical Society Quarterly Bulletin* X (July, 1926), 54.
43. Frances Lichten, *Folk Art of Rural Pennsylvania* (New York: Charles Scribner's Sons, 1963), p. 12.
44. Watkins, p. 57.
45. Andrew L. Winton and Kate Barber, "Norwalk Potteries", *Old Time New England* XXIV (April, 1934), 125.
46. Edward Wenham, "Toby Jugs," *Antiques* LI (May, 1947), 323.
47. Barber, *Tulip Ware of the Pennsylvania German Potters*, p. 53.
48. Edwin Atlee Barber, *The Ceramic Collectors Glossary* (New York: The Walpole Society, 1914), p. 66.

Bibliography

AMERICAN FOLK POTTERY

Barber, Edwin Atlee. *Catalogue of American Potteries and Porcelains.* Philadelphia, Pa.: Pennsylvania Museum, 1893.

——. *The Ceramic Collectors Glossary.* New York, N.Y.: The Walpole Society, 1914.

——. *General Guide to the Collection of the Pennsylvania Museum.* Philadelphia, Pa.: The Pennsylvania Museum, 1907.

——. *Lead Glazed Pottery.* Philadelphia, Pa.: Pennsylvania Museum, 1907.

——. *The Pottery and Porcelain of the United States.* New York, N.Y.: G. P. Putnam's Sons, 1893.

——. *Salt Glazed Stoneware: Germany, Flanders, England and the United States.* Philadelphia, Pa.: The Pennsylvania Museum, 1903.

——. *Tulip Ware of the Pennsylvania-German Potters.* Philadelphia, Pa.: The Pennsylvania Museum, 1903.

Blair, C. Dean. *The Potters and Potteries of Summit County, 1828–1915.* Akron, O.: Summit County Historical Society, 1965.

Catalogue of the Collection of Pottery. New York, N.Y.: New York Metropolitan Museum of Art, 1911.

Chamberlain, Samuel. *Old Sturbridge Village.* New York, N.Y.: Hastings House, Publishers, Inc., 1951.

Clarke, John Mason. *The Swiss Influence on the Early Pennsylvania Slip Decorated Majolica.* Albany, N.Y.: J. B. Lyon Co., 1908.

Clement, Arthur W. *Our Pioneer Potters.* New York, N.Y.: Private Publication, 1947.

——. *Notes on American Ceramics, 1607–1943.* Brooklyn, N.Y.: Brooklyn Museum, 1944.

Crawford, Jean. *Jugtown Pottery: History and Design.* Winston-Salem, N.C.: John F. Blair, Publisher, 1964.

Dodd, Arthur Edward. *Dictionary of Ceramics.* New York, N.Y.: Philosophical Library, 1964.

Earle, Alice Morse, *China Collecting in America*. New York, N.Y.: Charles Scribner's Sons, 1892.

Hopkins, Thomas Cramer. *Clays and Clay Industries of Pennsylvania*. Harrisburg, Pa.: W. S. Ray, State Printer, 1900.

Horney, Wayne B. *Pottery of the Galena Area*. East Dubuque, Ill.: 1965.

Hough, Walter, *An Early West Virginia Pottery*. Washington, D.C.: Annual Report of the Smithsonian Institution, 1899.

James, Arthur E. *The Potters and Potteries of Chester County*. Chester, Pa.: Chester County Historical Society, 1945.

Jervis, William P. (comp.) *The Encyclopedia of Ceramics*. New York, N.Y.: Blanchard, 1902.

Ketchum, William C. Jr. *Early Potters and Potteries of New York State*. New York, N.Y.: Funk & Wagnalls, 1970.

Moses, John. *American Potteries*. New York, N.Y.: 1895.

Noel-Hume, Ivor. *Pottery and Porcelain in Colonial Williamsburg's Archaeological Collections*. Williamsburg, Va.: Colonial Williamsburg, 1969.

Pitkin, Alber Hastings. *Early American Folk Pottery*. Hartford, Conn., 1918.

Porter, George R. *A Treatise on the Origin, Progressive Improvement, and Present State of the Manufacture of Porcelain and Glass*. Philadelphia, Pa.: Carey and Lea, 1832.

Pottery and Porcelain. New York, N.Y.: Metropolitan Museum of Art, 1875.

The Pottery and Porcelain of New Jersey 1688–1900. Newark, N.J.: Newark Museum, 1947.

Ramsay, John. *American Potters and Pottery*. New York, N.Y.: Tudor Publishing Co., 1947.

Rice, Alvin H. and Stoudt, John Baer. *The Shenandoah Pottery*. Strasburg, Va.: Shenandoah Publishing House, Inc., 1929.

Shoemaker, Henry Wharton. *Early Potters of Clinton County*. Altoona, Pa.: The Altoona Tribune Publishing Co., 1916.

Spargo, John. *The ABC of Bennington Wares: A Manual for Collectors and Dealers*. Bennington, Vt.: Bennington Historical Museum, 1948.

——. *Early American Pottery and China*. New York, N.Y.: The Century Co., 1926.

——. *The Potters and Potteries of Bennington*. Boston, Mass.: Houghton Mifflin Company, 1926.

Stiles, Helen E. *Pottery in the United States*. New York, N.Y.: E. P. Dutton & Co., Inc., 1941.

Van Winkle, William Mitchell. *The Brooks Pottery, Goshen, Connecticut*. New York, N.Y.: 1937.

Watkins, C. Malcolm and Noel-Hume, Ivor. *The "Poor Potter" of Yorktown*. Washington, D.C.: Smithsonian Institution Press, 1967.

Watkins, Lura Woodside. *Early New England Potters and Their Wares*. Cambridge, Mass.: Harvard University Press, 1950.

Watkins, Lura Woodside. *Early New England Pottery*. Sturbridge, Mass.: Old Sturbridge Village, 1959.

Young, Jennie J. *The Ceramic Art*. New York, N.Y.: Harper, 1878.

AMERICAN HISTORY: SOCIAL

Andrews, Charles McLean. *Colonial Folkways*. New Haven, Conn.: Yale University Press, 1921.

Apprenticeship, Past and Present. Washington, D.C.: U.S. Government Printing Office, 1950.

Bridenbaugh, Carl. *Cities in the Wilderness: The First Century of Urban Life in America, 1625–1742*. New York, N.Y.: Alfred A. Knopf, Inc.; 1955.

Calhoun, Arthur Wallace. *A Social*

History of the American Family. New York, N.Y.: Barnes & Noble, Inc., 1945.

Carrier, Lyman. *The Beginnings of Agriculture in America*. New York, N.Y.: McGraw–Hill, Inc., 1923.

Carson, Gerald. *The Old Country Store*. New York, N.Y.: Oxford University Press, Inc., 1954.

——. *The Social History of Bourbon*. New York, N.Y.: Dodd, Mead & Co., 1963.

——. *Country Stores in Early New England*. Sturbridge, Mass.: Old Sturbridge Village, 1955.

——. *Rum and Reform in Old New England*. Sturbridge, Mass.: Old Sturbridge Village, 1966.

Carvalho, David Nunes. *Forty Centuries of Ink*. New York, N.Y.: The Bankslow Publishing Co., 1904.

Crow, Carl. *The Great American Customer*. New York, N.Y.: Harper and Brothers Publishing Co., 1943.

Dolan, J. R. *The Yankee Peddlers of Early America*. New York, N.Y.: Clarkson N. Potter, Inc. 1964.

Earle, Alice Morse. *Home Life in Colonial Days*. New York, N.Y.: The Macmillian Company, 1899.

Indentures of Apprentices. New York, N.Y.: New York Historical Society, 1910.

Kalm, Pehr. *Travels in North America*. 2 vols. New York, N.Y.: Wilson–Erickson, 1937.

Parkes, Henry Bamford. *The United States of America*. New York, N.Y.: Alfred A. Knopf, Inc., 1963.

Riznik, Barnes. *Medicine in New England 1790–1840*. Sturbridge, Mass.: Old Sturbridge Village, 1965.

Smith, Helen Evertson. *Colonial Days and Ways*. New York, N.Y.: F. Ungar, 1966.

Tunis, Edwin. *Colonial Living*. Cleveland, O.: World Publishing Company, 1957.

Wright, Richardson Little. *Hawkers and Walkers in Early America*. New York, N.Y.: Frederick Ungar Publishing Co., Inc., 1965.

AMERICAN HISTORY: INDUSTRIAL

Abbott, Edith. *Women in Industry*. New York, N.Y.: Arno Press, Inc., 1969.

Bishop, John Leander. *A History of American Manufactures, from 1608 to 1860*. Philadelphia, Pa.: E. Young and Co., 1864.

Bolles, Albert S. *Industrial History of the United States*. Norwich, Conn.: Henry Bill Publishing Company, 1879.

Bramson, Roy T. *Highlights in the History of American Mass Production*. Detroit, Mich.: The Bramson Publishing Company, 1945.

Clark, Victor Selden. *History of Manufactures in the United States*. 2 vols. New York, N.Y.: McGraw-Hill, Inc., 1929.

Documents Relative to the Manufactures in the United States: 1832. New York, N.Y.: Burt Franklin, 1969.

Frey, John. *Craft Unions of Ancient and Modern Times*. Washington, D.C., 1945.

Hamilton, Alice. *Lead Poisoning in Potteries*. Washington, D.C.: U.S. Government Printing Office, 1912.

Loughlin, Gerald Francis. *The Clays and Clay Industries of Connecticut*. Hartford, Conn.: Case, Lockwood & Brainard Co., 1905.

McCabe, David Aloysius. *National Collective Bargaining in the Pottery Industry*. Baltimore, Md.: The Johns Hopkins Press, 1932.

Ries, Heinrich and Leighton, Henry. *History of the Clay-Working Industry in the United States*. New York, N.Y.: John Wiley and Sons, 1909.

——. *The Pottery Industry of the United States*. Washington, D.C.: U.S. Government Printing Office, 1896.

Romaine, Lawrence B. *Guide to American Trade Catalogues*. New York, N.Y.: R. R. Bowker Co., 1960.

Shall the Pottery Industry of the United States Be Destroyed? Washington, D.C.: U.S. Potters Association, 1888.

Tariff Acts from 1789 to 1909. Washington, D.C.: U.S. Government Printing Office, 1909.

Tryron, Rolla Milton. *Household Manfactures in the United States 1640–1860*. Chicago, Ill.: University of Chicago Press, 1917.

United States Bureau of Labor Statistics. Bulletin 404–414. Washington, D.C.: U.S. Government Printing Office, 1926.

Wages, Hours and Productivity in the Pottery Industry. Washington, D.C.: U.S. Government Printing Office, 1926.

Wage Scale and Agreements. East Liverpool: U.S. Potters Association, Jos. Betz Printing Company, 1911.

Wallis, George. *Report on Porcelain and Ceramic Manufacture in General Report of the British Commissioners on the New York Industrial Exhibition*. London: T. Harrison: 1854.

AMERICAN HISTORY: REGIONAL

Andrews, Edward Deming. *The Community Industries of the Shakers*. Albany, N.Y.: The University of the State of New York, 1932.

Aurand, Ammon Monroe. *Historical Account of Ephrata*. Harrisburg, Pa.: published by the author, 1940.

——. *Home Life of the Pennsylvania Germans*. Harrisburg, Pa.: Privately Printed, 1947.

Buck, Solon Justus. *Frontier Economy in Southwestern Pennsylvania*. Reprinted from *Agricultural History* Vol. X. 1 (January, 1936).

Faust, Albert Bernhardt. *The German Element in the United States*. New York, N.Y.: Arno Press Inc., 1969.

Hanna, Charles Augustus. *The Scotch-Irish; or the Scot in North Britain, North Ireland and North America*. Baltimore, Md.: Genealogical Publishing Co., Inc., 1968.

Raine, James Watt. *Saddlebag Folk: The Way of Life in the Kentucky Mountains*. Evanston, Ill.: Row, Peterson, 1942.

Sim, Robert J. *Pages From the Past of Rural New Jersey*. Trenton, N.J.: Jersey Agricultural Society, 1949.

——. *Some Vanishing Phases of Rural Life in New Jersey*. Trenton, N.J.: Department of Agriculture, 1941.

Valentine, David T. *History of the City of New York 1841–1870*. New York, N.Y.: G. P. Putnam & Co., 1853.

Wayland, John Walter. *The German Element of the Shenandoah Valley of Virginia*. Charlottesville, Va.: The Author, 1907.

Weygandt, Cornelius. *The Red Hills*. Philadelphia, Pa.: University of Pennsylvania Press, 1929.

——. *The White Hills*. New York, N.Y.: H. Holt & Co., 1934.

Whyte, Bertha Kitchell. *Wisconsin Heritage*. Boston, Mass.: Charles T. Branford Co., 1954.

ANTIQUES, FOLK ARTS AND CRAFTS

Antiques Book. New York, N.Y.: Wyn Co., 1950.

Arnold, James. *Country Crafts*. London: John Baker, 1968.

Belknap, Henry Wyckoff. *Artists and Craftsmen of Essex County, Massachusetts*. Salem, Mass.: The Essex Institute, 1927.

——. *Trades and Tradesmen of Essex County, Massachusetts, Chiefly of the Seventeenth Century*. Salem, Mass.: The Essex Institute, 1929.

Bridenbaugh, Carl. *Colonial Crafts-*

man. New York, N.Y.: New York University Press, 1950.

Brown, Clark W. *Salt Dishes*. Ashland, Mass.: C. W. Brown, 1937.

Buller, Joseph T. *Candleholders in America 1650–1900*. New York, N.Y.: Crown Publishers, Inc., 1967.

Burton, Thomas G., ed. *A Collection of Folklore by Undergraduate Students of East Tennessee State University*. Johnson City, Tenn.: Institute of Regional Studies, East Tennessee State University, 1967.

Cahill, Holger. *American Folk Art*. New York, N.Y.: Museum of Modern Art, 1932.

Chaptal, M. J. A. *Chemistry Applied to Arts and Manufactures*. London: R. Phillips, 1807.

Christensen, Erwin Ottomar. *American Crafts and Folk Arts*. Washington, D.C.: Robert B. Luce, Inc., 1964.

——. *Index of American Design*. New York, N.Y.: The Macmillan Company, 1950.

Comstock, Helen, ed. *The Concise Encyclopedia of American Antiques*. 2 vols. New York, N.Y.: Hawthorn Books, Inc., 1958.

Cotter, John L. and Hudson, J. Paul. *New Discoveries at Jamestown*. Washington, D.C.: U.S. Government Printing Office, 1957.

Creekmore, Betsey Beeler. *Traditional American Crafts*. New York, N.Y.: Hearthside Press, 1968.

Darmstadt, Jo Ragnes, comp. *Craftsmen and Artists of Norwich*. Stonington, Conn.: Pequot Press, Inc., 1965.

Davidson, Marshall B. *The American Heritage History of American Antiques from the Revolution to the Civil War*. New York, N.Y.: American Heritage Publishing Company, Inc., 1968.

——. *The American Heritage History of Colonial Antiques*. New York, N.Y.: American Heritage Publishing Company, Inc., 1967.

Dorson, Richard Mercer. *American Folklore*. Chicago, Ill.: University of Chicago Press, 1959.

Dow, George Francis. *The Arts and Crafts in New England 1704–1775*. New York, N.Y.: DaCapo Press, 1967.

Drepperd, Carl William. *A Dictionary of American Antiques*. Garden City, N.Y.: Doubleday & Company, Inc., 1952.

——. *The Primer of American Antiques*. New York, N.Y.: Doubleday Doran & Co. Inc., 1944.

Dunhill, Alfred. *The Pipe Book*. New York, N.Y.: The Macmillan Company, 1969.

Eaten, Allen Hendershott. *Handicrafts of the Southern Highlands*. New York, N.Y.: Russell Sage Foundation, 1937.

——. *Immigrant Gifts to American Life*. New York, N.Y.: Russell Sage Foundation, 1932.

——. *Rural Handicrafts in the United States*. Washington, D.C.: U.S. Government Printing Office, 1946.

Freeman, Graydon La Verne. *Bitters Bottles*. Watkins Glen, N.Y.: Century House, Inc., 1947.

A General Description of All Trades. London: T. Waller, 1747.

Glassie, Henry H. *Pattern in the Material Folk Culture of the Eastern United States*. Philadelphia, Pa.: University of Pennsylvania Press, 1968.

Gould, Mary Earle. *Early American Wooden Ware and Other Kitchen Utensils*. Springfield, Mass.: Pond-Ekberg, 1942.

Harper, George W. *Antique Collectors Guide*. New York, N.Y.: G. W. Harper, 1939.

Hayward, Arthur H. *Colonial Lighting*. New York, N.Y.: Dover Publications, Inc., 1962.

Hayward, Halena, ed. *Antique Collecting*. London: The Connoisseur, 1960.

Hindle, Brooke. *Technology in Early*

America. Chapel Hill, N.C.: University of North Carolina Press for the Institute of Early American Life and Culture at Williamsburg, Va., 1966.

Hough, Walter. *Heating and Lighting Utensils in the U.S.* Washington, D.C.: U.S. Government Printing Office, 1928.

Kauffman, Henry J. *Pennsylvania Dutch American Folk Art*. New York, N.Y.: Dover Publications, Inc., 1964.

Kouwenhoven, John Atlee. *Made in America*. Garden City, N.Y.: Doubleday & Company, Inc., 1948.

Langdon, William Chauncy. *Everyday Things in American Life*. New York, N.Y.: Charles Scribner's Sons, 1937.

Litchfield, Frederich. *Pottery and Porcelain: A Guide to Collectors*. New York, N.Y.: The Macmillan Company, 1925.

Lichten Frances. *Folk Art of Rural Pennsylvania*. New York, N.Y.: Charles Sribner's Sons, 1963.

Lord, Priscilla Sawyer and Foley, Daniel J. *The Folk Arts and Crafts of New England*. Philadelphia, Pa.: Chilton Book Company, 1965.

McClinton, Katharine Morrison. *Antique Collecting*. Greenwich, Conn.: Fawcett Publishing, 1952.

——. *The Complete Book of American Country Antiques*. New York, N.Y.: Coward–McCann, Inc., 1967.

Mercer, Henry Chapman. *Tools of the Nation Maker*. Doylestown, Pa.: Historical Society of Bucks County, Pa., 1897.

Needham, Walter and Barrows Mussey. *A Book of Country Things*. Brattleboro, Vt.: Stephen Greene Press, 1965.

Noel–Hume, Ivor. *Artifacts of Colonial America*. New York, N.Y.: Alfred A. Knopf, Inc., 1970.

——. *Here Lies Virginia*. New York, N.Y.: Alfred A. Knopf, Inc., 1963.

Pennsylvania German Arts and Crafts.

New York, N.Y.: Metropolitan Museum of Art, 1949.

Polley, Robert L. ed. *America's Folk Art*. New York, N.Y.: G. P. Putnam's Sons, 1968.

Putnam, Hazel Elizabeth. *Bottled Before 1865*. Los Angeles, Cal.: Rapid Blue Print Co., 1968.

Rawson, Marion Nichols. *Antiques Picture Book*. New York, N.Y.: E. P. Dutton & Co., Inc., 1940.

——. *Handwrought Ancestors*. New York, N.Y.: E. P. Dutton & Co., Inc., 1936.

Robacker, Earl Francis. *Pennsylvania Dutch Stuff, A Guide to Country Antiques*. Philadelphia, Pa.: University of Pennsylvania Press, 1944.

——. *Touch of the Dutchland*. New York, N.Y.: A. S. Barnes & Co., Inc., 1965.

Robins, Frederick William. *The Story of the Lamp*. New York, N.Y.: Oxford University Press, 1939.

Sabine, Ellen S. *American Folk Art*. Princeton, N.J.: D. Van Nostrand Company, Inc., 1958.

Shepard, Anna Osler. *Ceramics for the Archaeologist*. Washington, D.C.: Carnegie Institute of Washington, 1956.

Sherman, Frederic Fairchild. *Early Connecticut Artists and Craftsmen*. New York, N.Y.: Privately Published, 1925.

Smith, Elmer Lewis. *Antiques in Pennsylvania Dutchland*. Witmer, Pa.: Applied Arts, 1963.

——. *The Folk Art of Pennsylvania Dutchland*. Witmer, Pa.: Applied Arts, 1966.

Steinmetz, Rollin C. and Rice, Charles S. *Vanishing Crafts and Their Craftsmen*. New Brunswick, N.J.: Rutgers University Press, 1954.

Stoudt, John Joseph. *Early Pennsylvania Arts and Crafts*. New York, N.Y.: A. S. Barnes & Co., Inc., 1964.

Thwing, Leroy Livingstone. *Flickering Flames: A History of Domestic Lighting Through the Ages*. Rut-

land, Vt.: Charles E. Tuttle Co., Inc., 1958.

Tunis, Edwin. *Colonial Craftsmen and the Beginnings of American Industry.* Cleveland, O.: World Publishing Company, 1965.

Van Wagenen, Jared. *The Golden Age of Homespun.* Ithaca, N.Y.: Cornell University Press, 1953.

Walter, Leo G. *Walter's Inkwells of 1885.* Akron, O.: Privately Published, 1969.

Wearin, Otha Donner. *Statues That Pour: The Story of Character Bottles.* Denver, Colo.: Sage Books, 1965.

Weiss, Harry Bischoff. *American Baby Rattles From Colonial Times to the Present.* Trenton, N.J.: New Jersey Printing Office, 1941.

——. *Trades and Tradesmen of Colonial New Jersey.* Trenton, N.J.: Past Times Press, 1965.

Whitaker, Irwin. *Crafts and Craftsmen.* Dubuque, Ia.: William C. Brown Company, Publishers, 1967.

White, Margaret E. *Decorative Arts of Early New Jersey.* Princeton, N.J.: Van Nostrand Company, Inc., 1964.

Williamson, Scott Graham. *The American Craftsman.* New York, N.Y.: Crown Publishers, Inc., 1940.

Winchester, Alice. *The Antiques Treasury.* New York, N.Y.: E. P. Dutton & Co., Inc., 1959.

DESIGN

Cahill, Holger. *American Design.* Newark, N.J.: 1937.

——. *Emblems of Unity and Freedom.* New York, N.Y.: The Metropolitan Museum of Art, 1942.

Carrington, Noel. *The Shape of Things.* London: Nicholson and Watson, 1939.

Christensen, Erwin Ottoman. *Early American Designs: Ceramics.* New York, N.Y.: Pitman Publishing Corp., 1952.

Dickson, Eldert. *The Elements of Design.* London: Sir Isaac Pitman & Sons, 1933.

Dow, Arthur W. *Composition.* Garden City, N.Y.: Doubleday, Doran & Co., Inc., 1929.

Ferguson, George Wells. *Sign and Symbols in Christian Art.* New York, N.Y.: Oxford University Press, 1959.

Hamlin, A. D. F. *A History of Ornament.* New York, N.Y.: The Century Company, 1916.

Holmes, William Henry. *Origin and Development of Form and Ornament in Ceramic Art.* Washington, D.C.: U.S. Government Printing Office, 1886.

Horth, Arthur Cawdron. *Design and Handicraft.* London: Sir I. Pitman & Sons, Ltd., 1932.

Leach, Bernard Howell. *A Potter's Book.* London: Faber and Faber, 1940.

——. *A Potter's Portfolio.* London: Lund, Humphries, 1951.

March, Benjamin. *Standards of Pottery Description.* Ann Arbor, Mich.: University of Michigan Press, 1934.

Meyer, Franz Sales. *Handbook of Ornament.* New York, N.Y.: Dover Publications, Inc., 1957.

Norton, F. H. *Ceramics for the Artist Potter.* Cambridge, Mass.: Addison-Wesley Publishing Company, Inc., 1956.

Payant, Felix. *Design Technics.* Syracuse, N.Y.: Keramic Studio Publishing Company, 1934.

Rhead, George Woolliscroft. *The Principles of Design.* New York, N.Y.: Charles Scribner's Sons, 1905.

Shepard, Anna Osler. *The Symmetry of Abstract Design with Reference to Ceramic Decoration.* Washington, D.C.: Carnegie Institute of Washington, 1948.

Smith, Janet K. *Design: An Introduction.* Chicago, Ill. & New York, N.Y.: Ziff–Davis Publishing Company, 1946.

Stoudt, John Joseph. *Pennsylvania Folk Art; An Interpretation.* Allentown, Pa.: Schlechter's, 1948.

Valentine, Lucia N. *Ornament in Medieval Manuscripts.* London: Faber and Faber, 1965.

ENGLISH POTTERY

Barnard, Harry. *Chats on Wedgwood Ware.* London: T. F. Unwin, 1924.

Binns, Charles Fergus. *The Manual of Practical Potting.* New York, N.Y.: D. Van Nostrand Company, Inc., 1901.

——. *The Story of the Potter.* London: G. Newnes Ltd., 1905.

Blacker, J. F. *The ABC of English Salt–glazed Stoneware.* London: S. Paul and Company, 1922.

——. *The ABC of Nineteenth–Century English Ceramic Art.* London: S. Paul & Company, Ltd., 1924.

Burton, William. *A History and Description of English Earthenware and Stoneware.* London: Cassell & Co., Ltd., 1904.

Coggeshall, William Turner, ed. *Five Black Arts.* Columbus: Follett, Foster & Company, 1861.

Eyles, Desmond. *"Good Sir Toby"; The Story of Toby Jugs and Character Jugs Through the Ages.* London: Doulton, 1955.

A Guide to the English Pottery and Porcelain. London: British Museum, 1923.

Haggar, Reginald George. *English Country Pottery.* London: Phoenix House, 1950.

Harrison, Herbert Spencer. *Pots and Pans: The History of Ceramics.* London: G. Howe Ltd., 1928.

Hayden, Arthur. *Chats on English Earthenware.* London: T. Fisher Unwin, 1909.

Hillier, Bevis. *Master Potters of the Industrial Revolution.* London: Cory, Adams and MacKay Ltd., 1965.

Hodgkin, J. E. *Examples of Early English Earthenware, Named, Dated, and Inscribed.* London: Cassell, 1891.

Honey, W. B. *English Pottery and Porcelain.* London: A & C Black, 1933.

Howard, Geoffrey Eliot. *Early English Drug Jars.* London: The Medici Society, 1931.

Hughes, George Bernard. *English and Scottish Earthenware: 1660–1860.* New York, N.Y.: The Macmillan Company, 1961.

Hughes, William B. *The Collector's Encyclopaedia of English Ceramics.* London: Lutterworth Press, 1956.

Jewitt, Llewellynn Frederick Wm. *The Ceramic Art of Great Britain from Pre-Historic Times Down to the Present Day.* 2 vols. London: Virtue and Co., Ltd., 1878.

Mankowitz, W. and Haggar, Reginald George. *The Concise Encyclopaedia of British Pottery and Porcelain.* New York, N.Y.: Hawthorn Books, Inc., 1957.

Marryat, Joseph. *Collections Toward a History of Pottery and Porcelain in the 15th, 16th, 17th and 18th Centuries.* London: J. Murray, 1850.

——. *A History of Pottery and Porcelain: Medieval and Modern.* London: J. Murray, 1857.

Meteyard, Eliza. *Life of Josiah Wedgwood.* 2 vols. London: Hurst and Blackett, Publishers, 1865.

Monson-Fitzjohn, Gilbert John. *Drinking Vessels of By-Gone Days.* London: H. Jenkins, Ltd., 1927.

Plot, Robert. *The Natural History of Staffordshire.* Oxford: Printed at the Theatre, 1686.

Rackham, Bernard. *Medieval English Pottery.* London: Faber and Faber, 1948.

——. *Early Staffordshire Pottery.* London: Faber & Faber, 1951.

——. *A Key to Pottery and Glass.* New York, N.Y.: Chemical Publishing Company, Inc., 1941.

——. *Medieval English Pottery.* New

York, N.Y.: D. Van Nostrand Company, Inc., 1949.

Rackham, Bernard and Read, Herbert. *English Pottery*. London: Ernest Benn, 1924.

Rhead, George Wolliscroft. *The Earthenware Collector*. London: H. Jenkins, Ltd., 1920.

Rhead, George Woliscroft and Alfred, Frederick. *Staffordshire Pots and Potters*. London: Hutchinson & Company, 1906.

Sandeman, Ernest Albert. *Notes on the Manufacture of Earthenware*. London: C. Lockwood & Son, 1917.

Savage, George. *English Pottery and Porcelain*. New York, N.Y.: Universe Books, 1961.

——. *Pottery Through the Ages*. London: Cassell, 1963.

Searle, Alfred Broadhead. *The Clay Workers Hand-Book*. London: C. Griffin & Co., Ltd., 1906.

——. *An Encyclopaedia of the Ceramic Industries*. London: E. Benn, Ltd., 1929–30.

Shaw, Simeon. *The Chemistry of the Several Natural and Artificial Heterogeneous Compounds Used in Manufacturing Porcelain, Glass and Pottery*. London: Scott, Greenwood, 1900.

——. *History of the Staffordshire Potteries*. Hanley, England: G. Jackson, 1829.

Solon, Lewis Marc E. *The Art of the Old English Potter*. New York, N.Y.: D. Appleton, 1886.

EUROPEAN POTTERY

Blacker, J. F. *The ABC of Collecting Old Continental Pottery*. London: S. Paul & Co., 1913.

Cox, Warren E. *The Book of Pottery and Porcelain*. New York, N.Y.: Crown Publishers, Inc., 1944.

Haggar, Reginald G. *The Concise Encyclopedia of Continental Pottery & Porcelain*. New York, N.Y.: Hawthorn Books, Inc., 1960.

Honey, William B. *European Ceramic Art From the End of the Middle Ages to About 1815*. London: Faber & Faber, 1952.

Knowles, W. Pitcairn. *Dutch Pottery and Porcelain*. London: B. T. Batsford, 1913.

Neurdenberg, Elisabeth. translated by B. Rackman. *Old Dutch Pottery and Tiles*. London: Benn Brothers, Ltd., 1923.

Piccolpassi, Cipiano, 1524–1579. translated by Bernard Rackham. *Three Books of the Potters Art*. London: The Victoria and Albert Museum, 1934.

Savage, George. *Pottery Through the Ages*. London: Cassell, 1963.

Solon, Lewis Marc E. *The Ancient Art of Stoneware of the Low Countries and Germany*. 2 vols. London: Chiswick Press, 1892.

FOOD AND BEVERAGES

Appert, Nicholas. *The Art of Preserving All Kinds of Animal and Vegetable Substances for Several Years*. London: Black, Barryard Kingsbury, 1812.

Brown, John Hull. *Early American Beverages*. Rutland, Vt.: Charles E. Tuttle Company, Inc., 1966.

Carson, Jane. *Colonial Virginia Cookery*. Williamsburg, Va.: Colonial Williamsburg, 1968.

Cummings, Richard Osborn. *The American and His Food*. Chicago, Ill.: University of Chicago Press, 1940.

Eaton, Mary. *The Cook and Housekeepers' Complete and Universal Dictionary*. Bungay and Childs, 1823.

Encyclopedia of Domestic Economy. Boston, Mass.: Little, Brown and Company, 1852.

Francis, Clarence. *A History of Food and its Preservation*. Princeton, N.J.: The Guild of Brackett Lectures, 1937.

Information on Common Objects for the Use of Infant and Juvenile Schools and Nursery Governesses. London: For Home and Colonial School Society, Darton and Clark, 1845.

Lief, Alfred. *A Close-Up of Closures: History and Progress.* New York, N.Y.: Glass Container Manufacturers Institute, 1965.

Nowak, Carl Alfred. *Non-Intoxicants.* St. Louis, Mo.: C. A. Nowak, 1922.

Nurnberg, John J. *Crowns: The Complete Story: Bottle Caps and Seals.* Wilmington, Del., 1967.

Owens, R. Stuart. *On the Science of Sealing Bottles and Jars, A Concise History of Corks, Stoppers, Caps and Seals.* Brooklyn, N.Y.: National Seal Co., 1923.

Simmons, Amelea. *American Cookery, 1796.* Grand Rapids, Mich.: Errdmans, 1965.

Standage, H. C. *Sealing Waxes.* London: Scott, Greenwood & Co., 1902.

Stearns, Martha. *Herbs and Herb Cookery Through the Years.* Sturbridge, Mass.: Old Sturbridge Village, 1965.

Swank, Edith Elliott. *The Story of Food Preservation.* Pittsburgh, Pa.: H. J. Heinz Co., 1942.

Thomas, Gertrude Ida. *Food of our Forefathers.* Philadelphia, Pa.: F. A. Davis Co., 1941.

Twamley, Josiah. *Dairying Exemplified,* Providence, R.I.: Carter and Wilkinson, 1796.

Tyree, Marion Cabell. *Housekeeping in Old Virginia.* Louisville, Ky.: John P. Morton, 1890.

Wandle, Mrs. Jennie Taylor. *Extracts and Beverages.* New York, N.Y.: Butterick Publishing Company, 1892.

Whitehill, Jane Revere Coolidge. *Food, Drink and Recipes of Early New England.* Sturbridge, Mass.: Old Sturbridge Village, 1963.

Wilkie, Herman Frederick. *Beverage Spirits in America.* New York, N.Y.: Newcomen Society of England, American Branch, 1947.

NEWSPAPER GLEANINGS

Craig, James Hicklin. *The Arts and Crafts in North Carolina 1699–1840.* Winston–Salem, N.C.: Museum of Early Southern Decorative Arts, 1965.

Gottesman, Rita Susswein. *The Arts and Crafts in New York.* New York, N.Y.: New York Historical Society, 1938.

Prime, Alfred Coxe. *The Arts and Crafts in Philadelphia, Maryland, and South Carolina.* New York, N.Y.: Da Capo Press, 1969.

POTTERY MARKS

Barber, Edwin Atlee. *Marks of American Potters.* Philadelphia, Pa.: Patterson and While Co., 1904.

Burton, William and Hobson, R. L. *Handbook of Marks on Pottery and Porcelain.* London: Macmillan & Co., Ltd., 1928.

Chaffers, William. *Collector's Handbook of Marks and Monograms on Pottery and Porcelain.* London: W. Reeves, 1968.

Crooke, Earl Edwin. *Crooke's Manual of Marks.* Indianapolis, Ind.: E. E. Crooke, Inc., 1937.

Elliott, Charles Wyllys. *Pottery and Porcelain.* New York, N.Y.: D. Appleton & Co., 1878.

Hartman, Urban. *Porcelain and Pottery Marks.* New York, N.Y.: Hartman, 1942.

Hooper, William Harcourt. *A Manual of Marks on Pottery and Porcelain.* London: Macmillan & Co., Ltd., 1936.

Jervis, William Percival. *A Book of Pottery Marks.* Philadelphia, Pa.: Press of Hayes Bros., 1897.

Kovel, Ralph M. *Dictionary of Marks.* New York, N.Y.: Crown Publishers, Inc., 1953.

Prime, William C. *Pottery and Porcelain of All Times and Nations.* New York, N.Y.: Harper, 1878.

Thorn, C. Jordan. *Handbook of Old*

Pottery and Porcelain Marks. New York, N.Y.: Tudor Publishing Co., 1947.

ARTICLES AND PERIODICALS

"The A-B-C's of Good Salt Glazing." *Brick and Clay Record*, CIII (September, 1943), 17–19.

Abraham, Evelyn. "The Pottery of Greensboro and New Geneva," *The Antiquarian* XVII (September, 1931), 25–29.

Aiken, A., "Lecture on Pottery before Royal Institution, London," *Franklin Institute Journal* XI, no. 3 (March, 1833).

Albright, Frank P. "The Crafts of Salem," *Antiques*, 88 (July, 1965), 94–98.

"American Ceramics." *Antiques* XLV (February, 1944), 86–89.

Andrews, Edward Deming. "Designed for Use—the Nature of Function in Shaker Craftsmanship," *New York Historical Society Quarterly Bulletin* XXXI (July, 1950), 331–341.

Armstrong, Henry R. "The Norwich Pottery Works," *Antiques* IV (October, 1923), 170–173.

Atherton, Carlton. "Early American Stoneware Craftsmanship," *Design* XXXVI (December, 1934), 14–15.

——. "Tulipware, Pennsylvania German Ceramics," *Design* XXXIII (March, 1932), 245–247.

Barber, E. A. "Rise of the Pottery Industry," *Popular Science Monthly*. Part I, XL (December, 1891), 145, Part II, XL (July, 1892), 289.

Barber, Edwin Atlee. "The Earliest Decorative Pottery of the White Settlers, in America," *House and Garden* II (June, 1902), 233–239.

Barker, Eva M. "Potters of Pottersville" (Somerset, Mass.), *American Collector* XV (February, 1946), 8–9.

Barret, Richard Carter. "The Porcelain and Pottery of Bennington, I,"

Antiques LXIX (June, 1956), 528–531.

——. "The Porcelain and Pottery of Bennington, II," *Antiques* LXX (August, 1956), 142–145.

"Butter Jugs and Potters Souls," *Antiques* VIII (August, 1925), 76.

Bement, Alan. "Is There an American Design?" *Antiques* XLI, (January, 1942) 30–33.

Bivins, John Jr. "Old Salem Pottery: 1770 vs. 1970," *Salem College Bulletin* XII (March, 1970), 15–16, 40.

Bleininger, A. V. "Development of the Ceramic Industry in the United States," *Journal of the Franklin Institute*. vol. 183 (February, 1917), 127.

Bognar, E. J. "The Rooftiles of Zoar," *Antiques* XXV (February, 1934), 52–54.

Bowles, Ella S. "Pioneer Pottery," *House Beautiful* LX (December, 1926), 732.

Breese, J. M. "Jugtown Pottery," *Country Life* XLII (October, 1922), 64–65.

Burbank, Leonard F. "Lyndeboro Pottery," *Antiques* XIII (February, 1928), 124–126.

Burslem, Alexander Y. "The Development of Pottery Industry in the United States," *Bulletin of the Pan American Union* LV (August, 1922), 139–160.

Buxton, Bessie W. "The Making of a Flower Pot" (Potteries of Peabody, Mass.), *Antiques* XXVIII (August, 1935), 62–63.

Camehl, Ada Walker, "Mehwaldt, a

Pioneer American Potter," *Antiques* VII (September, 1922), 113–116.

Carr, James. "Reminiscence of an Old Potter, *Crockery and Glass Journal*. Part I: LIII, 27–28 (March 21, 1901). Part II: LIII, 23–24 (March 28, 1901). Part III: LIII, 17–18 (April 4, 1901). Part IV: LIII, 15–16 (April 11, 1901). Part V: LIII, 23–24 (April 18, 1901). Part VI: LIII, 15–16 (April 25, 1901).

Carter, Bobby G. "Folk Methods of Preserving and Processing Food," in Thomas G. Burton and Ambrose N. Manning, *A Collection of Folklore By Undergraduate Students of East Tennessee State University*. Monograph #3, Johnson City, Tenn.: Institute of Regional Studies, East Tennessee State University, 1966, pp. 27–31.

"Catalogue of Earthenware, Boggs, Thompson & Co., N.Y.," *Antiques* XXVI (November 1934), 196–197.

Chandler, L. Reginald. "The Methods of Early American Potters," *Antiques* V (April, 1924), 174–178.

Clark, William H. "Pottery and Potters," *Americana* XXXII (July, 1938), 425–460.

Clement, Arthur W. "Ceramics in the South," *Antiques* LIX (February, 1951), 136–138.

——, "New Light on the Crolius and Remmey Potteries," *American Collector* XV (September, 1946), 10–11.

Clements, Laura Lee, "Early American Cake Forms and Pudding Molds," *American Collector* XI (July, 1942), 8–9.

Cochran, Jean. "An Investigation of the 19th Century 'Pot Shops' of Ohio's Hocking and Vinton Counties," *Bulletin of the American Ceramic Society* XXI (September, 1942), 188–89.

Cook, Charles D. "Early Rhode Island Pottery," *Antiques* XIX (January, 1931), 37–38.

Coolidge, Edwin H. "The Pottery Business in Sterling Mass," *Old Time New England* XXIII (July, 1932), 17–21.

Cooper, N. "Early American Pottery Whistles," *House Beautiful* LXV (January, 1929), 72.

Cornelius, C. O. "Early American Ceramics," *Country Life* XL (June, 1921), 61–62.

——. "Early American Household Pottery," *House and Garden* XL (June, 1921), 61–62.

Davidson, Marshall. "Early New York Stoneware Jugs," *Design* XXXVII (December, 1935), 14.

Davidson, Mary E. "William H. Farrar, Potter," *Antiques* XXXV (March, 1939), 122–123.

Decatur, Stephen. "English Pottery and the American Cotton Trade," *American Collector* IX (June, 1940), 10–11.

Dennett, Mary Ware. "The Arts and Crafts," *Handicraft* II (April, 1903), 1–10.

Dent, G. "Frog Pots," *Connoisseur* LXXXVII (May, 1931), 309–311.

Donley, A. S. "The Homely Pottery of Old New England," *Country Life* XIX (November, 1910), 46.

Drake, T. G. H. "Antique English Delft Pottery of Medical Interest," *Canadian Medical Association Journal* XXXIX (December, 1938), 585–588.

Driemen, Domina. "The English Drinking Jug Comes Back," *American Home* XIX (February, 1938), 36.

Dyer, Walter A. "Early Art Industries of the Pennsylvania Dutch," *Country Life* XXX (May, 1916), 100–106.

——. "Early Pottery of New England", *Antiques* I (January, 1922), 19–22.

——. "Stoneware for the Collector", *Arts and Decorations* XXIX (July, 1928), 58–59.

——. "Two Thousand Mugs." *Antiques* XV (April, 1929), 287–289.

"Early American Pottery," *Antiques* VIII (December, 1925), 337.

"Early Art Industries of the Pennsylvania Dutch," *Country Life* XXX (May, 1916), 100.

Eberlein, H. D. "The Decorated Pottery of the Pennsylvania Dutch," *Arts and Decorations* V (January, 1914), 109–112.

"A Family of Potters" (Crafts of Whately, Mass.), *Antiques* VIII (August, 1925), 77–78.

Fitz–Gibbon, Costen. "Tulipware," *American Home and Garden* XI (January, 1914), 27–29, 32.

Flint, William W. "The Millville Pottery, Concord, N.H." *Old Time New England* XVII (January, 1927), 99–106.

Freeth, Frank. "Old English Salt Glazed Teapots," *Connoisseur* V (February, 1903), 108–115.

"From Days of Tygs and Posset Pots," *Arts and Decorations* XXXVIII, (March, 1933), 26–27.

Gardner, B. Bellamy. "Pottery ware used in Medicine," *Apollo* XLI (May, 1945), 127.

Gates, Burton N. "Boston Earthenware: Frederick Mear Potter," *Antiques* V (June, 1924), 310–311.

"Genuine Pennsylvania German Ware." (Thomas and Isaac Stahl) *Bulletin of the American Ceramic Society* XIX (January, 1940), 22–24.

"Glaze Mill Stones From Hervey Brooks Pottery, South End, Goshen, Connecticut," *Industries* III, no. 5. (September, 1945).

Goldsmith, Margaret M. "Jugtown Pottery," *House Beautiful* LII (October, 1922), 311, 358–360.

Graham, John Meredith II. "The Earthenware of Bonnin and Morris," *Antiques* XLV (January, 1944), 14–16.

"Grandfather's Thumb (Bergholtz Pottery)" *Antiques* III (January, 1923), 11.

Green, Charles. "American Salt Glaze," *Antiques* XVII (June, 1930), 258–259.

Guild, L. V. "Antiquer's Almanack: Bell Potteries Strasburg, Va." *Country Life* LX (September, 1931), 72.

Guthman, Patricia R. "Castleford Pottery for the American Trade," *Antiques* XCII (October, 1967), 552–554.

Haddon, Rawson W. "Early Slip Decorated Canister," *Antiques* IX (March, 1926), 166.

Haggar, Reginald G. "Some Early Examples of Traditional Technique," *Apollo* L (February, 1949), 105–106.

Harwell, Converse. "Construction and Operation of the Harwell 'Ground Hog' Kiln," *Bulletin of the American Ceramic Society* XX (January, 1941), 10–11.

Hayden, Arthur. "Some Sunderland Mugs" (Frog Mugs), *Connoisseur* IX (June, 1904), 94–97.

Hettinger, E. L. "Importance of Pottery to the Early Settlers," *Ceramic Industry* XXXIX (July, 1942), 48.

Hoagland, Jane. "Jugtown Pottery," *Art Center* I (April, 1923), 167–168.

Holden, M. "Early American Household Pottery," *House and Garden* XXXIX (April, 1921), 30–31.

Hough, Walter. "An Early American Pottery" (Morgantown, West Virginia) *House Beautiful* XI (January, 1902), 85–92.

Hudson, J. Paul and Watkins, C. Malcolm, "The Earliest Known English Pottery in America," *Antiques* LXXI (January, 1957), 51–54.

Hughes, G. Bernard. "The Development of Cobalt Blue," *Country Life* CXV (June 3, 1954), 1824–1828.

Hummel, Charles F. "English Tools in America: The Evidence of the Dominys," *Winterthur Portfolio* II (1965), 27–46.

Huntley, Richmond. "An Antiques Primer" (Pottery). *American Collector* XI (March, 1942), 15–17.

——. "An Antiques Primer, Varied Forms of Early Redware," *American Collector* XI (April, 1942), 15.

Jewell, Margaret H. "The Corliss Pottery of Woolwich Maine," *Old-Time New England* XXII (April, 1932), 180–183.

——. "Notes on Maine Potteries," *Old-Time New England* XXII (April, 1932), 184–187.

"Jugs From the Carolina Hills," *Christian Science Monitor Weekly Magazine Section* (May 18, 1938), 14.

Keyes, Homer Eaton. "Spatter," *An-*

tiques XVII (April, 1930), 332–337.

Keyes, Willard Emerson. "Toy Banks," *Antiques* X (October, 1926), 290.

Klindig, Joe Jr. "A Note on Early North Carolina Pottery," *Antiques* XXVII (January, 1935), 14–15.

Knittle, Rhea Mansfield. "Henry McQuate, Pennsylvania Potter," *Antiques* VIII (November, 1925), 286–287.

——. "Muskingum County, Ohio Potters," *Antiques* VI (July, 1924), 15–18.

——. "Ohio Pottery, Jars and Jugs," *Antiques* XXIV (October, 1933), 144–145.

Landis, Henry Kinzer. "Early Kitchens of the Pennsylvania Germans," *Pennsylvania German Society Proceedings* XLVII, Part II, Norristown: Pennsylvania German Society, 1939.

Lank, David. "Early American Kitchens," *Gourmet Magazine* (November, 1969), 17–21, 42–50.

Leach, Mary James. "Louisville (Kty.) Potters and Potteries Before 1850," *Antiques* LII (November, 1947), 320–322.

LeFevre, E. "Meaning of Pennsylvania-Dutch Antiques," *Saturday Evening Post* CCVII (April 27, 1935), 82.

Lewis, Don and Bennie Lee. "Graveyard Pots" *Ceramics Monthly* XV (April, 1967), 20–21.

"Long Island Pottery", *Antiques* IX (January, 1926), 145–146.

Lorenson, Laura. "European Folk Pottery", *Antiques* XXIV (October, 1933), 136–139.

MacDonald, Bennett. "Out of the Bake Shop" (Pottery used in early bakeries) *Antiques* IV (December, 1923), 286–288.

MacFarlane, Janet R. "Nathan Clark, Potter," *Antiques* LX (July, 1951), 42–44.

March, Benjamin. "Standards of Pottery Description," *Burlington Magazine* LXV (September, 1934), 142.

"The Mark of the Maker," *Antiques* VIII (August, 1925), 76.

McKearin, Helen. "According to the Papers: The Launching of the Henderson's Flint Stoneware," *Antiques* LV (June, 1949), 432–433.

Minton, Leroy H. "New Jersey's Part in the Ceramic History of America," *The Ceramist* II (Winter, 1922–23), 270–289.

"More Anna and More Serpent," *Antiques* XXIII (June, 1933), 204.

"More About Burlington Potters," *Antiques* VIII (August, 1925), 78.

Nelson, Edna Deupree. "Pennsylvania Pin–Decorated Slipware," *American Collector* IX (December, 1940), 6–7.

"New York Pottery Bowl, Dated 1792" (picture), *American Collector* X (January, 1942), 4.

"New York Stoneware Jug, 1775, Attributed to J. Crolius," *Metropolitan Museum of Art Bulletin* XXX (July, 1935), 146.

Noel-Hume, Ivor. "A Late Seventeenth–Century Pottery Kiln Site Near Jamestown," *Antiques* LXXXIII (May, 1963), 550–552.

Norton, F. H. "The Crafts Pottery in Nashua, New Hampshire," *Antiques* XIX (April, 1931), 304–305.

——. "Exeter Pottery Works", *Antiques* XXII (July, 1932), 22–25.

Norton, F. H. and Duplin, V. J. Jr. "The Osborne Pottery at Gonic, New Hampshire," *Antiques* XIX (February, 1931), 123–124.

"A Note on Salt and Lead Glazes," *Antiques* V (January, 1924), 25.

"Old Pennsylvania Dutch Pottery," *Brick and Clay Record* LXII (June, 1926), 1142.

"Oldest Pottery in America," *Art World* III (December, 1917), 252–254.

Ormsbee, Thomas H. "Poughkeepsie was also a Jugtown," *American Collector* V (February, 1936), 4–5.

Payant, Felix. "The Art of North Carolina Potters," *Design* XXIX (December, 1927), 124–125.

——. "A Lesson in Design From the

Sand Hill Potters of North Carolina," *Bulletin of the American Ceramic Society* VII (September, 1928), 256–259.

——. "North Carolina Pottery—An Early Survival," *Design* XXIX (October, 1927), 91–92.

Pearl, Christopher A. "Tankards and Housemarks on Early Measures," *Antiques* XLIX (June, 1949), 157–159.

"Pennsylvania Potter" (Henry Miller, York, Pa.), *Antiques* LXXXVIII (July, 1965), 101.

"Perplexities in Pottery" (Florida Pottery), *Antiques* XXIII (February, 1933), 54–55.

Peterson, Charles E. "Some Recent Discoveries at Jamestown, Virginia," *Antiques* XXIX (May, 1936), 192–194.

"Potter and Potter's Wheel," *Antiques* XIX (January, 1931), 23–25.

"A Pottery Pig" (Anna Pottery, Anna, Illinois), *Antiques* XXXV (January, 1939), 27.

"Pottery Pup" (Bell Pottery, Winchester, Va.), *Antiques* XLI (January, 1942), 26.

Prentice, Joan. "The ABC's of European and American Ceramics III," *Antiques* XLVI (December, 1944), 350.

Ramsay, John. "Early American Pottery," *Antiques* XX (October, 1931), 224–229

——. "Economy and Its Crafts," *Antiques* LVII (May, 1950), 366–367.

——. "Zoar and Its Industries," *Antiques* XLVI (December, 1944), 333–335.

Raymond, W. Oakley. "Colonial and Early American Earthenware," *Antiquarian* IX (January, 1928), 38–41.

——. "Remmy Family: American Potters," *Antiques*. Part I, 31 (June, 1937), 296–297. Part II, 32 (September, 1937), 132–134. Part III, 33 (March, 1938), 142–144. Part IV, 34 (July, 1938), 30–31.

Reinert, Guy F. "History of the Pennsylvania German Potteries of Berks County," *Bulletin of the American Ceramics Society* XIX (1940), 24–28.

——. "Pennsylvania German Potteries of Berks County," *Historical Review of Berks County*, I–II (January, 1937), 42–49.

——. "Slip Decorated Pottery of the Pennsylvania Germans," *The American German Review* II (March, 1936), 12–13.

Remensnyder, John P. "The Potters of Poughkeepsie," *Antiques* XC (July, 1966), 90–95.

Ross, Denman W. "The Arts and Crafts," *Craftsman* VII (October, 1904), 335.

Ruge, Clara. "American Ceramics—A Brief Review of Progress," *International Studio* XXVIII (March, 1906), 21–28.

Sammis, Mrs. Irving S. "The Pottery at Huntington, Long Island," *Antiques* III (April, 1923), 161–165.

Scoon, Carolyn, "New York State Stoneware in the New York Historical Society," *The New York Historical Society Quarterly Bulletin* XXIX (April, 1945), 83–91.

Sim, Robert J. and Clement, Arthur W. "The Cheesequake Potteries," *Antiques* XIV (March, 1944), 122–125.

Spargo, John. "Burlington Pottery," *Antiques* VI (November, 1924), 254.

——. "The Facts about Bennington Pottery: I. The Stoneware of the Norton Potteries," *Antiques* V (January, 1924), 21–25.

——. "The Facts about Bennington Pottery: II. The Work of Christopher Webber Fenton," *Antiques* V (May, 1924), 230–237.

——. "The Fentons: Pioneer American Potters," *Antiques* IV (October, 1923), 166–169.

"Specimens of Ohio Pottery" (pictures), *Antiques* XXXII (October, 1937), 142.

Spinney, Frank O. "The Collection: Pottery," *Antiques* LXVIII (September, 1955), 250–251.

Stillwell, John E. "Crolius Ware and Its Maker," *New York Historical Society Quarterly Bulletin* X (July, 1926), 52–66.

"Stoneware Temperance Jug" (a picture of Anna Pottery), *Antiques* XXIII (April, 1933), 125.

Stow, Charles Messer. "The Deacon Potter of Greenwich," *The Antiquarian.* XIV (March, 1930), 46.

——. "Pennsylvania Slipware," *The Antiquarian* XIII (November, 1929), 46–47, 82.

"A Strange Face From Whatley," (Grotesque Jug) *Antiques* VIII (August, 1925), 77.

Swan, Mabel M. "The Dedham Pottery," *Antiques* X (August, 1926), 116–121.

Tackett, Nancy Lee. "The Glass and China Cupboard: From Alexandria, Va. Cupboards," *Antiques* XLVII (February, 1945), 118–120.

Taylor, Marjorie. "Stoneware of Ripley, Illinois," *Antiques* LVI (November, 1949), 370–371.

"A Taylor Toby", *Antiques* XXIII (January, 1933), 4.

"Tioughnioga Pottery" (Cortland and Homer, New York) *Design* XXXVII (December, 1935), 15.

Truax, William J. "Early Pottery Lighting Devices of Pennsylvania," *Antiques* XXXVII (May, 1940), 246–247.

"Tulipware," *Antiquarian* III (August, 1924), 24–25.

"Tulipware," *Design* XXXIX (February, 1938), 12–17.

"Uncle Sam's Uncle Toby," *Antiques* XXIII (January, 1933), 4.

Van Doren, Harold L. "Designing for Appearance," *Design* XXXVII (March, 1936), 10.

Varick, V. "Notes on Early New Jersey Pottery," *Hobbies* XLIX (July, 1944), 64.

Vaughn, M. "Crolius and Early American Stoneware," *International Studio* 87 (August, 1927), 56–60.

Wallis, Cyril. "Scottish Pottery," *Apollo* XLIX (March, 1949), 70.

Watkins, Lura Woodside. "The ABC's Of American Pottery," *Antiques* XLII (September, 1942), 134.

——. "The ABC's of Early American Pottery II," *Antiques* XLII (October, 1942), 196.

——. "American Pottery Lamps," *Antiques* LXIV (August, 1953), 108–110.

——. "The Bayleys: Essex County Potters," *Antiques.* Part I, XXXIV (November, 1938), 253–255; Part II, XXXV (January, 1939), 22–27.

——. "Beans and Bean Pots," *Antiques* XLVI (November, 1944), 276–277.

——. "The Brooks Pottery at Goshen, Connecticut." *Antiques* XXXVII (January, 1940), 29–31.

——. "A Check List of New England Stoneware Potters," *Antiques* XLII (August, 1942), 80–83.

——. "Early English Yellow-ware," *Antiques* LII (September 1947), 190–191.

——. "Early New England Redware Potters," *The Chronicle of Early American Industries* III; No. 2 (December, 1944).

——. "The Glass and China Cupboard: Concerning Handles," *Antiques* XLV (March, 1944), 143–144.

——. "Henderson of Jersey City and His Pitchers," *Antiques* L (December, 1946), 388–392.

——. "Old Time Foot Stoves," *Antiques* XXXV (March, 1939), 132–136.

——. "The Potters of Whately, Massachusetts," *American Collector.* Part I, VII (July, 1938), 6; Part II, VII (August, 1938), 10.

——. "The Stoneware of South Ashfield, Massachusetts," *Antiques* XXVI (September, 1934), 94–97.

Webb, E. H. "Folk Art in the Shelbourne Museum," *Art in America* XLIII (May, 1955), 14–22.

Wells, Helen E. "Pottery in the Early American Home," *American Home* XVI (November, 1936), 44.

Wenham, Edward. "Toby Jugs," *Antiques* LI (May, 1947), 323–325.

Weygandt, Cornelius. "A Maker of Pennsylvania Redware," (Jacob Medinger) *Antiques* XLIX (June, 1946), 372–373.

Wheeler, Robert G. "The Potters of Albany," *Antiques* XLVI (December, 1944), 345–347.

"Why Old-Time Potters of America Neglected to use Cobalt Blue Glazes for Red Ware Products," *Antiques* XXIV (October, 1933), 154–156.

"William H. Bloor," *Bulletin of the American Ceramic Society* XVI (January, 1937), 25–31.

Williams, Jonathan. "The Southern Appalachians," *Crafts Horizons* XXVI (June, 1966), 46–67.

Willis, K. "Early New York Pottery," *Country Life* LIV (September, 1928), 72–78.

Winton, Andrew L. and Barber, Kate. "Norwalk Potteries", *Old-Time New England*. Part I, XXIV (January, 1934), 75–92; Part II, XXIV (April, 1934), 111–128.

Wolfe, J. W. "History of Pottery in America: Morgantown Pottery," *School Arts* XXVIII (December, 1928), 201–204.

Wood, Ruth Howe. "Memories of the Fentons," *Antiques* VIII (September, 1925), 150–154.

Zimerman, M. K. "The Pottery Industry in East Liverpool," *Crockery and Glass Journal* XCIX (December 18, 1924), 116.

W.P.A. ART PROJECT RECORDS: INDEX OF AMERICAN DESIGN

National Gallery of Art, "Records," *Index of American Design*, Illinois and Iowa Division (Washington, D.C., 1935–1941).

National Gallery of Art, "General Research on American Ceramics," *Index of American Design* (Washington, D.C., 1935–1941).

Index

3969

14